The Many Resurrections of Henry Box Brown

The Many Resurrections of Henry Box Brown

Martha J. Cutter

PENN

University of Pennsylvania Press

Philadelphia

Published by
University of Pennsylvania Press
Philadelphia, Pennsylvania 19104–4112
www.upenn.edu/pennpress

Printed in the United States of America on acid-free paper

10 9 8 7 6 5 4 3 2 1

A Cataloging-in-Publication record is available from the Library of Congress

Hardcover ISBN 9780812254051

eBook ISBN 9780812298642

Contents

Acknowledgments

A book such as this one—deeply historical as well as archival, not to mention transnational—could not be written without the help of a host of research libraries and librarians. I thank all these people in no particular order: Natasha Henry, President, Ontario Black History Society; Arthur G. W. McClelland, MLS Ivey Family London Room Librarian, London Public Library; Sue Perry, Public Service Librarian at Windsor Public Library; Richard Bleiler (Humanities Reference Librarian at UCONN) for consulting with me about Box Brown and for expediting many interlibrary loan and electronic books requests; Joe Natale of UCONN's Interlibrary Services staff; Valérie Noël, Librarian, Lord Coutanche Library, St. Helier, Jersey, England; and the many other librarians and archivists who have helped me along the way.

I heartily thank the following UCONN scholars for help with the intellectual contents of this book: Alexis Boylan, Shawn Salvant, Chris Vials, Peter Baldwin, Nancy Shoemaker, David Yalof, Jeffrey Dudas, Pam Brown, and Cathy J. Schlund-Vials. I am grateful to Dan Graham for citation checking, help in transcribing the plays discussed in Chapter 3, and for his thoughts on nineteenth-century spiritualism. I thank Lucie Turkel for amazing research assistance in creating a Box Brown timeline, and Rebecca Rumbo for proofreading. I also thank Box Brown scholars Jeffrey Ruggles, who generously shared his research with me, and Rory Rennick, who was invaluable in providing biographical research and in our numerous phone chats about Box Brown. Nineteenth-century scholars such as Shawn Michelle Smith, Teresa Goddu, Jeannine DeLombard, Alan Rice, Britt Rusert, Fionnghuala Sweeney, Celeste-Marie Bernier, Karolyn Smardz Frost, Hannah-Rose Murray, Janet Neary, and Kathleen Chater have very much influenced my thinking about Box Brown. I thank anonymous readers from the press who gave me incisive feedback. A warm thanks must go to Walter Biggins at the University of Pennsylvania Press; it is an honor and pleasure to have Walter as my editor and enthusiastic supporter of my research.

A special thanks to Michael Lynch and Brendan Kane of the UCONN Humanities Institute for encouraging me to work on this book and for feedback on my successful NEH grant proposal. I was invited by Amritjit Singh in 2018 to present my work on Box Brown at Ohio University; I am grateful for this early opportunity to get feedback and for Amritjit's friendship. I also thank Kenyatta Berry for genealogical research assistance. I thank Robert Hasenfratz, Melina Pappademos, and Davita Silfen Glasberg for release time during my sabbatical to continue work on this project. I am especially grateful to Melanie Hepburn and Peter Carcia for processing my many requests for books and other materials to complete this project. Shirley Samuels and John Ernest have written me countless letters of support for fellowship and spent much time discussing my research with me. Thanks also to John Lowe for always being one of my most ardent supporters.

This book was expensive to write, due to its archival nature and the number of illustrations in it. I owe a huge debt of gratitude to the National Endowment for the Humanities, which granted me a much-needed fellowship in 2019–2020 to work on this project and other financial assistance. I thank the UCONN Humanities Institute, the Africana Studies Institute, and the American Studies Institute for subvention funding. I also thank OVPR (Office of the Vice President of Research) at UCONN for much-needed financial assistance over the years. I am also indebted to Karl Jenkins ("Dice Raw") and Sheldon Jones at Forge Recordings for permission to use an image from *Henry Box Brown: A Hip Hop Musical* on my cover.

Family and friends have listened to me talk about Henry Box Brown for many years now. I thank them for their patience and love. They include my mom and dad, Eve and Phil Cutter, my sister Amy Cutter, and my brothers, David Cutter and Michael Cutter, as well as my aunts Selma Cutter and Carol Bortman, uncles Ed Cutter and Eli Bortman, and my cousins Lisa Cutter and Cindy Bortee. A very, very special thanks to my husband Peter Linehan, who has driven all around the United States and Canada with me taking photographs and has cooked me countless delicious meals while I sat in my office and wrote and wrote and wrote.

Finally, I wish to acknowledge all the scholars of visual culture and Africana Studies whose work I have benefited from, and who have profoundly changed my way of thinking not only about visual culture but also about the enduring meanings of slavery. Their thinking has revolutionized the way we contemplate not only the afterlives of slavery but also our own contemporary moment.

For permission to reprint parts of Chapter 3, I thank *Slavery and Abolition*, where some parts of this chapter first appeared. For permission to reprint a small portion (in revised form) of Chapter 1, I thank *InMedia: The French Journal of Media Studies*. All images from *BOX: Henry Brown Mails Himself to Freedom* reproduced by permission of the publisher, Candlewick Press, Somerville, MA; text © 2020 by Carole Boston Weatherford; illustrations © 2020 by Michele Wood.

Abbreviations for Archives Consulted

African American Newspapers (AAN)
 http://www.accessible-archives.com.ezproxy.lib.uconn.edu/collections /african-american-newspapers/
American Historical Periodicals (AHP)
 https://gdc-galegroup-com.ezproxy.lib.uconn.edu/gdc/artemis?p=AAHP&u =22516
Ancestry (ancestry .com)
 https://www.ancestry.com/
British Library Newspapers (BLN)
 https://gdc-galegroup-com.ezproxy.lib.uconn.edu/gdc/artemis /AdvancedSearchPage?p=BNCN&u=22516
British Newspaper Archive (BNA)
 https://www.britishnewspaperarchive.co.uk/
Canadiana (Canadiana)
 https://www.canadiana.ca
Digital Kingston (DK)
 http://vitacollections.ca/digital-kingston/search
Early American Newspapers (EAN)
 https://infoweb-newsbank-com.ezproxy.lib.uconn.edu/apps/readex /welcome?p=EANX
Family Search (familysearch)
 https://www.familysearch.org/en/
INK - ODW Newspaper Collection (ODW)
 http://ink.scholarsportal.info
Library of Congress (LOC)
 https://chroniclingamerica.loc.gov/
Newspapers.com (Newspapers.com)
 https://www.newspapers.com/

Nineteenth-Century US Newspapers (19CN)
 https://www.gale.com/c/nineteenth-century-us-newspapers
Paper of Record (POR)
 https://paperofrecord.hypernet.ca/default.asp?
ProQuest Historical Newspapers (PRO)
 https://search-proquest-com.ezproxy.lib.uconn.edu
Welsh Newspapers Online (WNO)
 https://newspapers.library.wales/

Introduction

The Many Resurrections of Henry Box Brown, the Man Who Mailed Himself to Freedom

On March 23, 1849, a man named Henry Brown was nailed into a large wooden postal crate marked "this side up with care" and mailed from slavery in Richmond, VA, to freedom in Philadelphia, a voyage of two hundred and fifty miles.[1] Twenty-six hours later, he emerged from this box singing a psalm of thanksgiving, and he would never again be a slave.

These sentences may sound like the start of an electrifying fictional story, but they are factual and well documented. They are also the only truths that many individuals today know about the man who would later become known as Henry Box Brown.[2] Brown was, quite literally, "the Slave Who Mailed Himself to Freedom," and would ever be known as "Box Brown" after this feat. From these scant details, an entire mythology has grown up around the man. Both in Brown's time and in ours, stories were created, invented, and embellished about him, and today a host of artists, musicians, writers, performers, and even filmmakers have continued to recreate his intriguing, albeit fragmentary and elusive, story. As I show in this book, Brown went on to become an abolitionist lecturer, hypnotist, magician, healer, singer, ventriloquist, and actor, dying in Toronto almost fifty years after his escape-by-box (in 1897), after stints performing in the US, England, and Canada. He had his own panorama of his escape—huge painted pictorial scrolls that he would unfurl onstage and narrate—with which he toured the US and England. On one occasion, his "original box" was even shipped to a performance location, where he popped out of it as part of his act and led a parade through the streets of England before a stage show. Yet it is, more than anything else, the single fact of his escape-by-box that intrigues people today.

This book excavates fragmentary elements of his story from his time, using archival documents, as Brown made himself a spectacle on abolitionist circuits via his outlandish performance work, and then fell off these same circuits and went on to recreate himself in other guises—as the King of all Mesmerists,[3] as Prof. H. B. Brown, as the African prince, as the actor Henry Brown (playing himself onstage), and as a magician known at times as "Box Brown, the Wizard." In England he sometimes wore the costume of (as one reviewer termed) a "savage Indian" and would traverse the streets of towns in this guise to drum up an audience for his shows. Before, during, and after his exhibitions he gave away prizes (including "expensive" watches, silver teapots, meat, and even a "smart" donkey) and sometimes he even staged donkey or foot races to whet interest in his performances. He hypnotized British individuals onstage, embarrassing them by making them believe they were sheep and gobble down raw cabbage or paste. He held dark séances and practiced clairvoyance, or second sight. He sang and danced onstage, at times appearing alongside and even embedded within minstrel shows. In other words, Brown did all manner of things to attract people to his shows, and he continued to perform up until the last few years before his death, perhaps even returning to England in 1890 and 1896. He reinvented himself over and over, performatively resurrecting himself again and again. His astounding life as a performer—and his "out of the box" thinking about how slavery and freedom could be staged—are detailed in this book.

I also have an eye in this book on Brown's resurrection in our own time, and particularly in the last thirty years, when leading poets, writers, and artists have paid homage to him. Even though most contemporary artists know little about Brown other than the two sentences that start this book, they have felt compelled to engage in what I term *boxology*—a word that mixes mythology, mixology, and (of course) the idea of the box itself. The box symbolically and literally was both womb and tomb to Brown—had it never been opened, Brown could have suffocated or starved to death in it, but because the box did reach freedom it became a symbol of his rebirth as a "free man." Brown's escape-by-box was referred to in his era as a miraculous "resurrection" and visualized as such (see Figure I.1). The men in this lithograph, who receive Brown at Philadelphia, look astounded by his survival, while Brown stares straight at a viewer with an expression that is a little hard to read; he is sitting but his arms are bent at a slight angle, as if he is getting ready to push himself out of the box. Brown's feat was certainly viewed as a magical propulsion into freedom; one 1850 source writes about "the magical **box** into which a slave was put, worth a few hundred dollars; the **box** was jolted a few miles by railroad and other conveyances, and when opened, up sprung a freeman, worth a sum beyond computation."[4] No wonder, then, that Brown's resurrection by box fascinated individuals in Brown's time

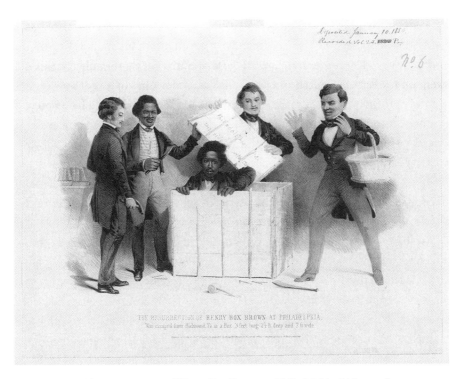

Figure I.1. *The Resurrection of Henry Box Brown at Philadelphia*. Lithograph.
Samuel Rouse. 1850. https://www.loc.gov/pictures/item/2004665363/.
Library of Congress.

and has continued to intrigue magicians, novelists, children's book writers, artists, performers, and poets today (see Appendix).

The image of Brown's resurrection from the living death of slavery is reiterated in multiple ways throughout his life and into our era. Versions of this image were, for example, replicated visually (within other "Resurrection" prints), onstage (when Brown acted as himself and was boxed and reboxed again), and in numerous newspaper illustrations into the late 1870s. Pictures of Brown emerging from his box have been repeated in our era in sculpture, performance art, illustrated children's books, and visual poetry, as I discuss in the last two chapters of this book and show in my Appendix. The photographic theorist Ariella Azoulay encourages us not only to *look at* photographs but also to *watch* them as they move through time and space and take on diverse meanings within different historical contexts.[5] I endeavor to apply this insight not only to physical images of Brown (portraits) but to the spectacular visual event of his unboxing, which is reproduced visually or in other ways throughout his own life and into our era. I *watch* Brown's image as he moves through geographical space: from the US, to England, back to the US, and then to Canada. I also watch Brown as

he moves through chronological time, from 1849, when he is configured as a fugitive slave; to the 1850s–1890s, when he takes on multiple personae that might enable a type of performative liberation; into our own era when he becomes a symbol of both hope (the ingenuity of African Americans to invent new modes of freedom) and pessimism (what one theorist has called "the unfinished project of emancipation" and the unfree state of African Americans living in the wake of slavery today).[6] Beyond the biographical realm, I am interested in what diverse incarnations of Brown, when appraised carefully as mobile rather than static images, tell us about the ongoing and incomplete business of African American freedom, and also about the creative ways this unfinished work has been dramatized and contested.

In many of his performances, Brown turned his life into art and spectacle, amusing and fascinating viewers. I use the term "spectacle" deliberately here, and it is worth thinking about the meanings (both positive and negative) of this term in relationship to slavery. Slavery was and is an abysmal trauma; slavery scourged the enslaved both physically and emotionally, and it continues to haunt US culture today in ways that we have not fully comprehended. "Two hundred fifty years of slavery. Ninety years of Jim Crow. Sixty years of separate but equal. Thirty-five years of racist housing policy. Until we reckon with our compounding moral debts, America will never be whole,"[7] writes Ta-Nehisi Coates. Toni Morrison puts it more directly in her representation of the child lost during slavery, Beloved, in her watershed novel by the same name: "Disremembered and unaccounted for, she cannot be lost because no one is looking for her, and even if they were, how can they call her if they don't know her name?"[8] Slavery's trauma is indelibly scratched into US cultural memory, yet for many white Americans it is a shadowy and ghostly terrain—something in the past for which they cannot quite account. For African Americans, slavery may be something that still lurks, like the ghost Beloved, ready to grab them at any moment, in a police officer's gun, in a man's "stand your ground" claim that causes the death of an unarmed seventeen-year-old, or in a white cop choking a Black man for over nine minutes until he dies. Yet the horror of slavery is also beyond representation in some ways; as the formerly enslaved writer William Wells Brown noted in 1847, "Slavery has never been represented; Slavery never can be represented."[9] The anguish of slavery is real and enduring, and yet many individuals—from Frederick Douglass, to Morrison, to Colson Whitehead, to Coates—have written about the failure of this trauma to ever end or even to be fully depicted (either in language or art).

Yet Henry Box Brown was able to transgress and remake this trauma as part of his performance art. For example, while he was a free man in England in 1857, he acted onstage in dramas in which he played himself, even being auctioned

off—something that never happened to Brown in his real life. And he boxed and reboxed himself throughout many years of his life. Brown created, in short, a spectacle centered around slavery and indeed around his difficult and traumatic voyage in his box, playing onstage not only with the boundaries between his factual self and a fictional one, but also with the more entrenched divisions between slavery and freedom, death and life, past and present, the physical world and the spiritual one, and trauma and its opposite (joy? spectacle? transgression?). I am not saying that Brown overcame the traumatic memories of his enslavement but that over time he learned to manage and even stage-manage (or perform) them. Some theorists argue that trauma persists as a painful and irretrievable gap in memory, in part because it cannot be brought into language or representation and is literally unspeakable. Yet others contend that traumatic happenings interrupt but do not entirely foreclose memory and speech's capability to retrieve and remake them.[10] This book employs this second understanding of trauma, analyzing how Brown's painful memory of slavery was turned into a spectacle that he could reperform and even stage-manage as a mode of survival (he earned his living via his performance work) as well as social and perhaps psychic redress.

Brown broke many unspoken abolitionist dictums about the respectful treatment of slavery in books, lectures, and visual genres such as panorama, portraiture, and photography, as I demonstrate in Chapter 1 through analysis of five key Black abolitionists who worked in such visual modes. Brown also transgressed dictums about how a formerly enslaved individual was supposed to live, turning his whole life into spectacular performance art. His transformation of slavery into a performative spectacle caused him to be written out of abolitionist history (at least in part). As Daphne Brooks argues in a trenchant analysis, Brown successfully engineered "multiple ruptures in the cultural arm of mid-century transatlantic abolitionism," leading him to embark on a performance circuit of his own making, without the help of abolitionists (white and Black).[11] Fugitive speakers and performers were often presented as evidence of slavery's wrongs, rather than being recognized as activists, theoreticians, moral guides, or political strategists in their own right, as Janet Neary notes; moreover, "performances in excess of this mandate produced discomfort within white anti-slavery ranks."[12] Yet Brown's performative self-engineering is precisely what enabled him to be written back into the history of enslavement in our own era, when he has emerged as a latter-day hero to many artists and writers. Perhaps, indeed, it is Brown's transgression of the usual modes by which individuals understand slavery that fascinates artists and writers today. For instance, even thinking of oneself as a piece of property that could be shipped by mail to freedom in an eerie way succumbs to the enslaver's logic (for the enslaver saw the

enslaved as chattel, human property) while it also transgresses it; Brown ironically and via a twenty-six-hour performance in a box literalizes the metaphor of a man as "thing" to reconstruct himself as a free man. Moreover, as I will show, the box becomes one of the creative spaces through which he revises and remakes his "thingness," the idea of the enslaved as a piece of material property.

This book fills a significant intellectual gap, because scholarship has lagged a recent swell of public interest in Box Brown. To date there are only two scholarly books on Brown: one by Jeffrey Ruggles published nineteen years ago in 2003, and another by Kathleen Chater published in 2020. Ruggles's book assiduously lists many performances until 1875, but fails to bring full interpretive weight to the range of performance art that Brown manipulated throughout his life; moreover, over the past two decades numerous electronic archives have become available, making the full scope of Brown's performance work even more evident.[13] Chater's book, on the other hand, mainly eschews interpretation of Brown's art and is biographical and heavily focused on Brown's time in England; I also have accessed databases that Chater did not, so my analysis of his life and performance work has more depth. Articles or chapters by scholars tend to focus on either Brown's published narratives or the stage panoramas that he created, as well as the mechanisms of his escape-by-box.[14] However, no attention has been paid to how performance work was threaded into Brown's life as a whole, from his early days as a slave practicing conjuration in Virginia in the 1840s to his last shows in Canada in the late 1880s and perhaps even in England in the 1890s.

I also contextualize Brown's long history of multimedia performance work within a mid- to late nineteenth-century media frenzy during which various technological developments—such as the emergence of panorama and photography—seemed to dissolve the boundary between local and global vision, and (in the case of Brown) between the formerly enslaved persona and the free viewer. I am especially attentive to why, among the proliferation of new interest in the media technologies used by Douglass, Sojourner Truth, and others from this time period, a fascination with Brown has emerged such that almost all major African American authors have recently touched on his persona, including writers such as Coates, Whitehead, and the Pulitzer Prize–winning poet Tyehimba Jess, to say nothing of visual artists such as Pat Ward Williams, Glenn Ligon, and Wilmer Wilson IV, as well as many writers of contemporary children's books.

By considering a broad visual and popular performance terrain that included numerous types of cultural activity, this book builds up an understanding not only of Brown but also of an unruly strain of Black abolitionist performance work that crossed genres and cultural formats and used visuality in subversive ways. As Alexis Boylan writes in a recent book, visual culture

(which she defines as *everything* we see but also an awareness about what lies unseen) has been inscribed by domination, "yet it has always also contained resistance, reversal, and subversion."[15] Indeed, as Boylan further notes, much scholarly work on the visual realm over the last fifty years has been interested in uncovering moments of resistance, making them visible in new ways. This book recognizes that visual genres are often coercive for the enslaved or formerly enslaved individual, putting them on display either to denote their inferiority or to showcase the inhumanity of enslavement. Yet I also look for modes of visual resistance not only in the work of Brown, but in the other Black abolitionists studied in Chapter 1. Given gaps in the archive of what we know about these individuals, and especially Brown, this has not been easy. Saidiya Hartman writes that "every historian of the multitude, the dispossessed, the subaltern, and the enslaved is forced to grapple with the power and authority of the archive and the limits it sets on what can be known, whose perspective matters, and who is endowed with the gravity and authority of historical actor."[16] I have tried to read Box Brown and other Black abolitionists as historical *actors* rather than passive entities caught within a visual realm that only controls them; in images and other visual performances, I have tried to watch for spaces in which we can discern an insubordinate practice of looking back or taking control of visuality in other ways.

My work also builds on recent theories of surveillance to reconsider the ways that performative art about slavery can employ what the scholar Nicholas Mirzoeff terms "counter-visuality": the performative claim of a right to look where none technically exists.[17] I assess how Brown's practices of looking back at his audience (he put them onstage during his mesmeric acts, for example) subvert the idea of the enslaved or formerly enslaved individual as always under the watchful eye of the enslaver, or of a white-dominant society. Many critics argue that slavery exists in an "eternal now" via current modes of incarceration of African Americans and remnants of the devastation that the Middle Passage (the journey from Africa to the Americas) wrought.[18] Brown's persistent performances with his box embody what Christina Sharpe has referred to as "wake work." Sharpe uses the word "wake" and its many meanings—the wake of the trans-Atlantic slave ship, wakes for the dead, and conscious wakefulness and awareness—to contend with the manner in which the "means and modes of Black subjugation may have changed, but the fact and structure of that subjection remain."[19] Sharpe insists upon a past that is not over even as she maintains a focus on tracking how African Americans artistically and in other ways resist subjugation. Such efforts she terms "wake work."[20] Brown's performance work and its re-presentation by contemporary artists is a form of wake work that endeavors to both *dramatize and interrupt* a mode of thinking in which African

Americans are always enchained, literally, visually, or in other symbolic ways. Such visual modes illustrate not only how to live in the wake of slavery, the afterlife of being property, but also how to *rupture* this afterlife via material, aesthetic, and performative practices.[21] Ever the escape artist, Brown fractured nineteenth-century culture's prescriptions for appropriate African American behavior, as well as for the visual representation of enslavement. For these reasons, he holds much fascination for Black artists today who are also living in the afterlife of slavery and in the unfinished project of emancipation.

This book consequently is organized in three parts. The first part (Chapter 1) investigates the emergence of slavery into a performative and visual space in the mid-nineteenth century via photography, panorama, and portraiture, scrutinizing five well-known formerly enslaved individuals who were also leading Black abolitionists. As I very briefly touch on in Chapter 1, white abolitionist visual documents (illustrations and photographs) as well as the minstrel show, in different ways, fashioned images of the enslaved that were negative and derogatory. I focus more extensively in this chapter on accepted modes of visual self-fashioning that existed for formerly enslaved individuals that transgressed the representation of African Americans as powerless. Special attention is paid to portraiture, panorama, and photography, as these were the primary emerging and accepted visual art forms by which formerly enslaved individuals attempted to negotiate and perform the representation of their stories. I use the term "performance" regarding slavery because I believe that the individuals discussed in this chapter—William Wells Brown, William and Ellen Craft, Frederick Douglass, and Sojourner Truth—consciously manipulated their photographs, portraiture, and panoramas to present a kind of performative persona that foiled a white viewer's gaze. In speeches and lectures they were required to exhibit a version of their selves physically or linguistically on the transnational stage of the abolitionist lecture circuit. White abolitionists also expected that the narratives that formerly enslaved individuals authored would present hard and factual evidence of the violence and debasement of slavery; as a literary genre the slave narrative was often "authenticated" by white abolitionists and highly controlled and contained by them, as numerous critics have noted.[22] I am most attentive to the genres of portraiture, panorama, and photography, however, because I believe that this is where Black abolitionists developed and performed their most subversive and sophisticated critiques of the dominant codes for the representation of enslaved or formerly enslaved individuals, speaking back in some ways to the constraints of the slave narrative within these visual forms. Viewers must seek out and find traces of resistance within these visual forms. Tina Campt argues that visual modes "provide historians not so much with unmediated sources of historical evidence" but instead with "traces" that bear

witness to things that perhaps could not be put into words.[23] I scrutinize visual traces of resistance deployed by five mainstream Black abolitionists who created complicated visual personae that allowed them to question and resist visual media.

Yet even still, Box Brown's outrageous acts of boxology transgress these visual practices, and this is the subject of the second (and longest) part of this book (Chapters 2 to 5), in which I analyze not only what is known about Brown's performances, but what I have discovered about his unknown performance work. Brown multiplied his personae and his performance modes, even flirting with minstrelsy. In the 1850s, he was viewed as immodest and showy in his self-presentation and ousted from abolitionist circles, but he continued to perform until the last decade of his life. Several critics have discussed Brown as a type of performance artist, but in the middle chapters of this book I give a much greater sense of the types of performance he created, and what these performances symbolize in his renovation of the meaning of slavery, his life and identity, and the space of fugitivity, a realm located somewhere outside of slavery, but not yet precisely in freedom.[24] I watch Box Brown as he manipulates and transforms his identity in startling ways via visual genres such as panorama, stage shows, and acting, but also within the visual scenes enacted and deployed in his 1851 autobiography, *Narrative of the Life of Henry Box Brown, Written by Himself*.

The third section of this book (Chapters 6 and 7) traces Brown's startling reemergence via contemporary boxology and boxologists—individuals who pay homage to Brown in their writing, art, and performance work. I analyze fascination with Brown that has occurred in the last thirty years, when stories about him have circulated among magicians, and performance work and art featuring him has proliferated. I contemplate what Brown, as a larger-than-life hero, provides now, in this specific cultural moment. One chapter considers Brown's presence in contemporary memorials and museum exhibits, as well as in artworks and performance pieces by Pat Ward Williams, Glenn Ligon, and Wilmer Wilson IV that creatively reinvent Brown's fugitivity, in the past and in the present. Another chapter investigates Brown's reinvention in children's literature, discussing works by Ellen Levine and Kadir Nelson, Sally M. Walker and Sean Qualls, and Carole Boston Weatherford and Michele Wood, and in poetry for adults, analyzing three contemporary poets (Elizabeth Alexander, Joshua Bennett, and Tyehimba Jess). Writers search for a usable past but also try to remake the present through their innovative resurrections of Box Brown. In these chapters, I *watch* Brown as he emerges into our present tense moment.

Brown's story is a mesmerizing or hypnotic one, and, as elusive as it is, it continues to be retold and remade in our era. Yet despite some excellent recent scholarly work on Brown, a great deal remains unknown about him, such as

whether his living descendants possess any performance materials or written records that he or other family members (such as his daughter Annie, who lived into the 1970s) might have kept. Furthermore, to date there are no known photographs of him, but photography was becoming prevalent in the 1850s and certainly by his death in 1897 family photos were not uncommon. Even with this limited historical record, Brown has lured many an artist into his life story. I hope that by watching and excavating his fascinating transformations, and paying careful attention to his later resurrections, a new group of readers will be mesmerized by his ongoing legacy as an innovative and radical performance artist who is always in flux, and who moves creatively not only through the past, but into our own contemporary moment.

Slavery and Freedom in US Visual Culture

The Performative Personae of William Wells Brown, William and Ellen Craft, Frederick Douglass, and Sojourner Truth

Frederick Douglass was the most photographed nineteenth-century man in the US—more photographed than even President Lincoln—yet he rarely smiled in his pictures; one stated goal of his photographs was to counteract stereotypical images of "fancy-free" enslaved African Americans that he felt were endemic within photographs and illustrations of them. Sojourner Truth sold and marketed images of herself, sometimes with an enigmatic motto that read: "I sell the shadow to support the substance." William and Ellen Craft escaped slavery through a ruse in which Ellen Craft—who was light-skinned—temporarily "passed" as (or pretended to be) not only white but also male, and William (who was darker-skinned) passed as her servant; to raise funds they sold an image of Ellen Craft in disguise, but in this image many parts of the costume she wore during her escape were removed, creating yet another persona for her. And the abolitionist author William Wells Brown exhibited a panorama of his escape from slavery called *William Wells Brown's Original Panoramic Views of the Scenes in the Life of an American Slave* (1850) in which the protagonist and creator (Wells Brown) barely appears at all.

In photography, portraits, and panorama, these individuals seemed to present a version of their "true self" to the US public. Yet if examined closely, their imaging reveals that they were manipulating or visually performing some version of their identity. All these individuals were expected to realistically enact

their enslavement and escape in speeches and lectures on the abolitionist stage and in their narratives. However, in the terrain of these various visual media they created subversive personae that allowed them to negotiate their self-representation, as well as remake and critique the visual realm via a fugitive performance that contests and complicates the ways they were viewed.[1]

This chapter uses the visual performances of these five leading abolitionists in portraiture, panorama, and photography as a context to understand the radicalism of Box Brown's performance work and visual self-presentation. I am most interested in how these five individuals—some of the most well-known Black abolitionists in the antebellum era—manipulated visual media to perform resistant versions of themselves yet did not entirely break from abolitionist codes for the proper and realistic presentation of stories of slavery, escape, and freedom. Visual media such as illustrated books, drawings, and photography were used extensively by white abolitionists to document the horror of slavery, and such visual modes were expected to be truthful. The five individuals discussed in this chapter played with the line separating the factual self from a performative or dramatized one, yet never quite crossed over this line in the way that Box Brown did, nor did they play with enslavement as if it were a toy, prop, or show. Because of this, at least in part, Wells Brown, the Crafts, Douglass, and Truth kept their names alive within the historical story of abolition, while Box Brown became a minor footnote in abolitionist history.

The Black abolitionists discussed in this chapter create complicated personae that allow them to question the realm of the visual. The visual personae created by Wells Brown, the Crafts, Douglass, and Truth cloak them in a certain invisibility, even as they seem to be proffering themselves to the world as true and valid representational subjects.[2] More importantly, these personae mediate their own visual representations but also allow them to gain a degree of agency within a visual domain. These individuals also create a type of visual static that interferes (often) with the smooth processing of their images. In using the term "visual static," I go beyond Janet Neary's very useful concept of "representational static." Neary argues that in written narratives of enslavement, representational static constitutes "resistance to the speculative gaze" and takes the form of "unruly narrative gestures embedded in texts" that draw attention to the forces that produce, transmit, and authenticate images of enslavement.[3] In using the term "visual static" I draw on a more pictorial domain in which images are distorted or muddled by captions that are oblique and elusive, disguises, and other specifically visual practices. I draw metaphorically on the concept of visual static or snow, an eye syndrome in which visual information is processed by the brain and eyes in such a way that individuals see flickering dots, like snow or static, within their visual field, as well as other visual distortions. In my usage of this

term, visual static or snow makes something harder to see, contain, and surveil, blurring the image of the "real" person.[4] Certain practices deployed by the Black abolitionists discussed here create a form of visual static within the images so that viewers see a hazy, flickering image of the formerly enslaved individual. This visual static constitutes resistance to a white gaze that would capture their image and (by extension) their full identity.

The story I tell in this chapter is complex, for we find individuals reacting in different ways to the two engines of the dominant culture that had created the prevailing visual representation of the enslaved: white abolition and the minstrel show. Many white abolitionists, both in England and in the US, tended to rely on a visual exhibition of the enslaved as abject, pitiful, passive, and tortured viewed objects, as Jasmine Cobb, Marcus Wood, Simon Gikandi, and I have argued.[5] The popular nineteenth-century minstrel show, for its part, portrayed the enslaved as foolish, stupid, docile, or servile spectacles on the nineteenth-century stage. It therefore was vital that Black abolitionists attempt to circumvent this depiction of the enslaved as the abject and powerless objects of a white gaze, while also protecting themselves from incessant visual surveillance.

Like Box Brown, the individuals discussed in this chapter were fully aware of the problematic nature of visual media for those who were marginalized and disenfranchised by the dominant culture; visually, the enslaved often were represented as passive objects, rather than individuals with any degree of agency or power, or with any ability to look *back* at a viewer. In a discussion of changing modes of penal surveillance, the French philosopher Michel Foucault analyzes a circular prison structure called a panopticon whereby guards could constantly view their prisoners from within a central tower; in discussing this structure, he argues that "visibility is a trap."[6] What he means by this in a broader sense is that visibility can be a coercive social force, a means by which individuals are surveilled and controlled, and they often internalize this idea of perpetual scrutiny. Metaphorically the panopticon (whereby enslaved or formerly enslaved individuals are under continual surveillance by the overseer, the enslaver, or a white-dominant society) reflects the prevalent way of apprehending the politics of visuality under slavery. Moreover, as Nicholas Mirzoeff has argued, slavery itself depended on a structure in which the enslaved were deprived of the right to look (literally or symbolically blinded) and became the object of constant surveillance.[7]

However, as I show in this book via Brown and other African Americans who engaged visual modes, formulations such as those by Foucault are not seamless; there are ways in which formerly enslaved individuals exploit gaps and cracks in social structures of visuality that would seek to contain or surveil them, finding a resistant mode of looking back or performances that foil the spectator, turning him or her into the spectacle. Judith Butler argues that what

we might call agency, freedom, or possibility is always "produced by the gaps opened up in regulatory norms, in the interpellating work of such norms, in the process of their self-repetition."[8] What she means by this is that freedom or agency as such is never pure but produced instead by exploiting fissures in systems of power and regulation. In this case we might say that Black abolitionists manipulate the visual realm to exploit gaps in its control, and from these fissures new modes of self-empowerment and resistance emerge via the visual realm itself. Before assessing their use of various visual media, however, I briefly turn to visual representations of enslavement within white abolition and the minstrel show to give context for the struggle of Black abolitionists to avoid being caught in a visual space that would only encourage stereotypical views of African American identity.

Visual Representations of Enslavement Within White Abolition and the Minstrel Show

While it might seem evident that the minstrel show would promote an image of the enslaved as less than fully human, the case with white abolitionists, both in England and in the US, is more complicated. To create sympathy for the enslaved, white abolitionists (with a few notable exceptions) tended to rely on a presentation of the enslaved as pitiful, passive, and tortured objects without the right to look back at a viewer. As Marcus Wood has carefully documented, abolitionist books, broadsides, pamphlets, and other visual materials were filled with the splayed and broken, half-naked and beaten bodies of the enslaved. Perhaps in the short term such a practice was effective, at least as a fundraising tactic; such presentations of the enslaved sold well, as I have already documented.[9] Yet, in the longer term, this replication of debased images of the enslaved kept them within the space of abjection and pity, rather than equality.

Some theorists have argued against reproducing any of these derogatory images either verbally or via illustrations in order not to contribute to the dehumanization of the enslaved, while others have argued that such a reproduction is unavoidable and necessary.[10] For my part, I consciously reproduce a few of these images to support my argument in this chapter and this book about modes through which Box Brown and other Black abolitionists performed themselves visually to resist dominant practices of looking at, and being *seen* by, predominantly white viewers. I include such images not to shock readers but because they demonstrate how enslaved or formerly enslaved individuals struggle to be represented as agentive or empowered within a visual realm controlled by white abolitionists.

One very popular image used by abolitionists in the US and England was that of the so-called "supplicant slave"—an enslaved man (or woman) down on his

hands and knees, pleading to a white viewer with the question, "Am I Not a Man and a Brother?" In 1800 or thereabouts the New-Jersey Society Promoting the Abolition of Slavery created a certificate of membership using this image; it depicts a white man gesturing toward a semi-naked and chained slave while holding a Bible in his hands. As if to bless this example of white benevolence toward the enslaved and the Christianization of a "savage," divine light from Heaven shines down through a break in the clouds (see Figure 1.1). The viewer's perspective in this type of imaging is directed at a low body (the slave) who begs to be granted his humanity by a white man who stands above him. In this pictorial image, the enslaved figure seems to query his own human identity, asking: "Am not I a Man and a Brother?" He looks up at the white man, rather than out at the viewer. Viewers cannot meet his glance because it is directed inward; we cannot perhaps see our own image in him due to this type of looking-in rather than looking-out. The figure depicted therefore lacks "I-sight," a term that I will later explicate as a practice of sighting (seeing or envisioning the self), citing (authorizing the self via citation), and siting (placing the self within time and space; see Chapter 3). The enslaved man is instead represented as an object to be examined, rather than a human subject. I have discussed the imaging of the enslaved extensively elsewhere, so I will not belabor the point here except to say that many white abolitionist visual illustrations fail to depict the enslaved as self-possessed, resourceful human beings with the right to their own visual practices of looking and being seen by the viewer.[11]

Moving forward to the mid-nineteenth century, we find a more technologically sophisticated usage of this same type of imaging in white abolitionist photography; as the historian Matthew Fox-Amato documents, from its earliest days photography "powerfully influenced how bondage and freedom were documented, imagined, and contested."[12] In famous photographs created by abolitionists and in publications with abolitionist sentiments, formerly enslaved individuals exhibited their naked and scarred backs (turning away from the camera) or were photographed in chains, leg irons, and other instruments of enslaved torture to document the harms of slavery. In the case of a formerly enslaved man who was known as Gordon, and who was believed to have escaped and fought for the Union during the Civil War, three drawings purporting to represent him appeared in *Harper's Weekly* on July 4, 1863, as a triptych: Gordon (described as self-emancipated) "as he entered Union lines"; Gordon "under medical examination"; and "Gordon in his uniform as a US Soldier."[13] Of these images, however, it was the representation of Gordon "under medical examination" with a bare and maimed back which caused the most sensation and which was widely exhibited (beginning in August of 1863) on the small, cheap, and popular photographic cards known as *cartes de visite* (CDVs; see Figure 1.2). Unlike two out of three of the images in *Harper's*, in the CDV Gordon turns away from the

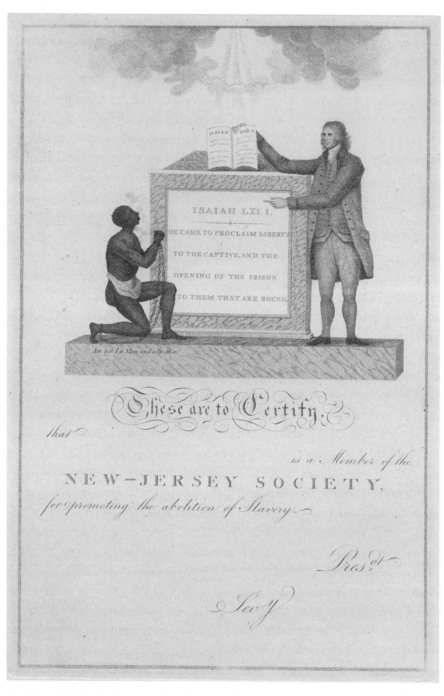

Figure 1.1. Membership certificate from the New-Jersey Society Promoting the Abolition of Slavery, ca. 1800. Stipple engraving. Courtesy Haverford College Quaker & Special Collections. https://digitalcollections.tricolib.brynmawr.edu /object/hc136540.

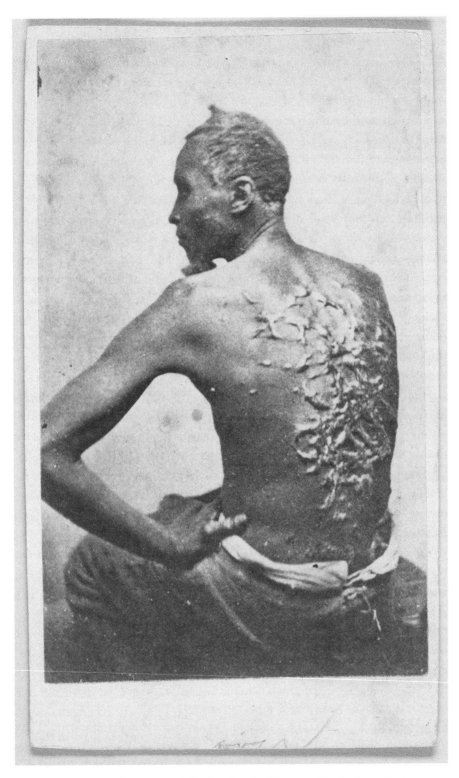

Figure 1.2. Escaped man named Gordon showing his scarred back at a medical examination. Baton Rouge, LA, McPherson & Oliver, photographer. 1863. Collection of the Smithsonian National Museum of African American History and Culture. http://n2t.net/ark:/65665/fd51909f11b-6b0a-49f8-9934-640a8107f1bf.

viewer and the camera, and the focus of the image is obviously his horrible scarring rather than his escape or freedom, or even his having fought as a solider on the Union side; if such facts were emphasized instead the man might have been seen as beginning to articulate a position as a political subject. His turned gaze in the photograph was read by at least one viewer as a "patient expression . . . [that] makes his condition seem more pitiful"; his "scar[r]ed, wilted" back "makes every nerve in one's body shrink to look at the thing." This image evokes pity and fear for this viewer, rather than recognition of Gordon's emergent political identity.[14]

This picture used on the CDV seems to participate in the scientific and political exhibition of Black bodies common in this era. The image abstracts the man from his individual story and refuses "to let the subject gaze back at the viewer," as Fox-Amato writes.[15] Whether Gordon himself consented to its circulation is unclear, but what is evident is that it is meant to be an image of horror rather than of self-possession. Ariella Azoulay comments that a photographed individual "can become a citizen of photography and yet remain a noncitizen in such a way that this conflict between being and not being a citizen turns the photograph into a complaint that attests to the fact that the photographed figure is fundamentally a political entity, an entity that is governed, and that this political being was robbed of its citizenship,"[16] and such might be the case with this CDV. While abolitionists verified the harms of slavery in the CDV, the image also documents a visual process whereby the individual represented is robbed of claims to various types of citizenship (as a freeman and as a soldier), even as the picture keeps him in the space of a maimed, viewed noncitizen other.

Similarly, in the case of Wilson Chinn, a man who had been freed in 1862, the dominant image of him that circulated within popular culture portrayed him as a tortured and branded slave (see Figure 1.3). Like Gordon, Chinn appeared in print in other contexts: a drawing of him in good clothing with other "emancipated slaves" appeared in *Harper's Weekly* on January 30, 1864, and there is at least one photograph of him reading with some freed children.[17] Yet in the popular *carte de visite* he is represented in his plantation clothing, which is primitive and tattered, and he is wearing wooden clog shoes common to field hands. The mark of the brand is clearly visible on Chinn's forehead, stamping him in perpetuity as having been enslaved. Wilson does gaze back at the viewer, which could be understood as an act of resistance, but his gaze is overshadowed by the instruments of torture that he wears and that lie on the ground around him. Chinn's left arm, however, is held in front of him, frozen in a loose fist held against his body, which perhaps denotes a level of resistance within the photograph that a viewer might be able to observe.

Laura Wexler argues that photographs concern *choices* and that it is only by "understanding the choices that have been made between alternatives" that "the meaning of the past can appear."[18] So let us assume that Wilson Chinn made

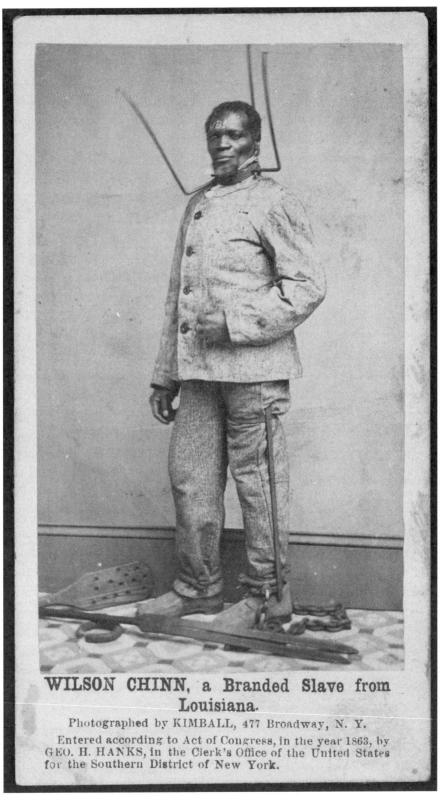

WILSON CHINN, a Branded Slave from Louisiana.

Photographed by KIMBALL, 477 Broadway, N. Y.

Entered according to Act of Congress, in the year 1863, by GEO. H. HANKS, in the Clerk's Office of the United States for the Southern District of New York.

Figure 1.3. Wilson Chinn, 1863. Photograph shows a formerly enslaved man from Louisiana with a forehead branded with the initials of his enslaver, Volsey B. Marmillion, wearing a punishment collar and posing with other equipment used to punish slaves. M. H. Kimball, photographer. Library of Congress. https://www.loc.gov/resource/ppmsca.57689/.

the choice to put on what were for him at this point the props of his former enslavement for this photograph, and that he chose to look out at the viewer as a human subject in defiance of these props and perhaps as an ironic contrast to them. His resistance (in his left hand and his gaze at the viewer) is a vital trace of an attempt to rupture the notion of his passivity and captivity. However, this resistance may be overridden by the caption of the photograph, which is branded in large, dark, blocky letters at the bottom of the image and in fact seems to enslave Chinn once more; Chinn is called "a Branded Slave from Louisiana," even though he was legally free in this historical moment. The caption on an image directs a viewer's interpretation toward a specific meaning; Chinn is thereby kept within the visual space of abjection; he is always enslaved, never free. Box Brown, by contrast, as we will see, is most frequently pictured as he starts to come out of his box and into a space of fugitivity, a space somewhere between enslavement and freedom; this space of "resurrection" from the death of slavery ultimately become a performative terrain that he can manipulate. Of course, as Tina Campt argues, photographs are complex articulations of self-fashioning that "are neither wholly liberatory vehicles of agency, transcendence, or performativity nor unilateral instruments of objectification and abjection."[19] Yet this photograph of Chinn seems to slide him into the realm of objectification and abjection, rather than transcendence of enslavement.

I focus on the images of Gordon and Wilson Chinn because both were popular and widely circulated as small, cheap CDVs, and because they were emblematic of a visual practice that was widespread within white abolition. As Fox-Amato has shown, these and other similar images were "mass-produced and mass-consumed"; thousands of US citizens bought and gazed upon images of branded, beaten, maimed, and suffering slaves.[20] Minstrel shows, on the other hand, debased African Americans in more overt ways, also relying on a series of visual motifs. These shows, which included first white and then Black performers, were a transnational phenomenon (popular in the US, the UK, and Europe); they made light of slavery via music, song, and dance. More importantly for the purposes of this book, they portrayed African Americans onstage but also in visual print materials as deceitful, foolish, dim-witted, and lazy (see Figure 1.4). In sheet music from "Dandy Jim from Caroline," the central figure looks happy to be enslaved, as he frolics with his banjo; several of the other enslaved individuals merrily play "the bones" (making music this way) or wield work tools as they dance and sing. The show will center around "A Nigger[']s Courtship, Marriage an what come ob him arterwards." The enslaved individuals will be portrayed onstage (as the poster makes evident) with stereotypically large lips and teeth as well as bulging eyes.

A poster for Bryant's Minstrels advertising a performance in New York in 1859 features a similar visual imaging of the enslaved (see Figure 1.5). The poster

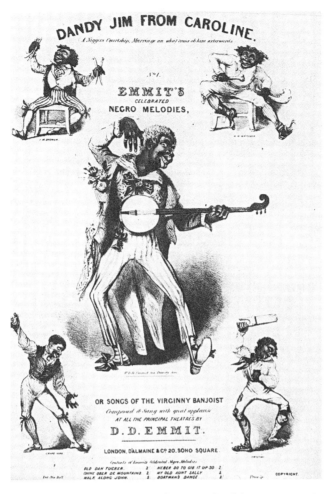

Figure 1.4. Sheet music from "Dandy Jim from Caroline" featuring D. D. Emmit, ca. 1844. Reprinted in Lindsay V. Reckson, "A 'Reg'lar Jim-Dandy': Archiving Ecstatic Performance in Stephen Crane," *Arizona Quarterly* 68, no. 1 (2012): 61. Image in public domain.

also displays slaves happily singing and dancing, and a farcical "Burlesque Italian Opera" is performed; most minstrel shows ended with a one-act play about carefree life on the slave plantation. In nineteenth-century visual materials, slavery's trauma was reduced and mocked, not only in promotional materials but in performances in which people were encouraged to laugh at the foolish antics of the "happy-go-lucky" (if enslaved) people.

While minstrel shows began in the US in the 1830s, the height of their popularity corresponds strikingly with the era just before and after the Civil War (1850–1870).[21] Eric Lott has argued that mixed in with their vicious parodies and appropriation was a genuine longing for the potency and power that white,

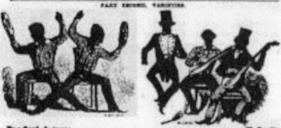

Figure 1.5. Poster for Bryant's Minstrels, Mechanics Hall, New York, April 4, 1859. Taken from the Google print version of Mark Knowles's, *Tap Roots: The Early History of Tap Dancing* (2002), 97. Image in public domain.

working-class minstrel actors perceived in the (male) African American body.[22] Yet it cannot be denied that the *dominant* goal of such shows was to denigrate African Americans as a group and minimize their trauma; the shows visually implanted in viewers' minds an idea of African Americans as satisfied with their lives in slavery and too stupid to understand the benefits of freedom. African Americans were certainly aware of the way this visual mode made fun of them, and they sought to craft images of dignity that would stand against the incredible popularity of these depictions.[23]

Some critics have contended that minstrel shows in England (where Brown eventually lived and performed) did not debase African Americans as much as US shows,[24] and this is evident in some performances. Yet "Dandy Jim from Caroline" and other minstrel songs popularized by D. D. Emmit were prevalent in England and demonstrate that stereotypes abounded on both sides of the Atlantic. Douglass himself felt that the minstrel shows' popularity in England during the 1850s had made the English people more racist.[25] Moreover, by the 1850s and 1860s, shows within the US and England had become similar in many ways. As Robert Nowatzki argues, by this period minstrelsy was ubiquitous in British theater and its depiction of Blacks was denigrating. For example, one theater notice for a show in London in 1866 describes "the Brothers Dean" as "a particularly thick-lipped, hoarse-voiced, droll couple of darkies, who in visage and grinning as nearly resemble blacks of the coarsest grade as if they were genuine natives of Negroland."[26] Derogatory visual stereotypes of African Americans were perpetuated by the minstrel show in the US and UK, and in the 1850s and 1860s in England in particular (where all the individuals discussed in this chapter would speak and work) portrayals of slavery became rosier.

Through these visual engines—the minstrel shows and white abolitionist exhibitions of abject enslaved bodies—African Americans were presented as enslaved (even when free), broken, beaten, and powerless, or foolish and freakish. Therefore, the visual realm was a highly suspect one well before Wells Brown, the Crafts, Douglass, and Truth entered it. As I explore below, if we watch their visual work carefully and even listen to some of their images, we can locate traces of resistant performative personae that circumvent the limits of this visual realm and carve out new modes of both imaging and renovating African American identity.

Ellen Craft's Second Skin: Visual Passing and the Performance of the Role of the In/valid Master

Like Henry Box Brown, William and Ellen Craft became famous for the ingenious ruse that they used to escape slavery: passing for something they were not

deemed to be. Box Brown passed in a certain sense as a box (a postal crate) and as cargo; William and Ellen Craft escaped from slavery in 1848 when Ellen Craft (who was light-skinned) passed temporarily as white, male, and free, while her husband, William, passed as her servant. In addition to adopting male clothing and cutting her long hair, Ellen Craft wore a bandage on her arm so that she would not have to sign hotel registers (she could not write, and literacy was a sign of whiteness), a poultice to cover her smooth (hairless) chin, and dark-green glasses so that she could avoid direct eye contact with individuals. I begin with Ellen Craft's visual passing to show how a media technology that preceded photography—the frontispiece portrait—could be used to create a performative persona that allowed for the manipulation of the visual realm.

Passing is a complicated discourse, as I have elsewhere discussed, one which sometimes challenges the distinctions between categories of race such as Black versus white (as well as other divisions such as male versus female, straight versus gay, or upper-class versus working-class); if one can "pass" for white, is whiteness real?[27] Yet passing also sometimes reinforces racial categories, in that a racial passer sometimes feels he or she must pick one race, or "return" to his or her "true race." As to Ellen Craft's passing as white, male, upper-class, and disabled, a great deal has already been written. For instance, in an influential reading, P. Gabrielle Foreman calls the Crafts' memoir of their escape an anti-passing narrative; Ellen Craft only passes through (not into) whiteness because she wishes to use her body to challenge legal constraints that would mean that her children would also be enslaved; this legal doctrine stipulated that the children of enslaved women would also be enslaved.[28] However, I focus not so much on whether Ellen Craft is passing for white (or through whiteness, as Foreman argues) but instead on what I call visual or pictorial passing: the way that the portrait of Ellen Craft—which circulated before the Crafts' account of their escape, *Running a Thousand Miles for Freedom* (1860) was even published—created a performative second skin for her that played with the line between real and fictive identities, between a "valid" drawing of the self (realistic) and an invalid (misrepresentational) realm where identity is more fluid and performative.

As Ellen Samuels astutely notes, during the Crafts' four-day voyage to freedom, Ellen Craft feigned disability so that she would not have to perform certain expected behaviors associated with whiteness (such as writing); she also simulated rheumatism and faintness to avoid social interactions that might reveal her identity.[29] Keith Byerman observes that "problems of possible recognition, of hotel registration, and of reading are all solved by more and more complete adoption of the role of invalid master."[30] The portrait of her that circulated by itself and later in the Crafts' 1860 narrative contains some (but not all) of these physical disguises: her face is not bandaged and her green glasses are replaced by

ones with clear lenses (see Figure 1.6). Moreover, as Samuels writes, "the only remaining element of the invalid disguise is the white sling, which no longer supports the figure's arm, but simply hangs around [Ellen Craft's] neck, slightly tucked between elbow and body."[31] The engraving claims to show Ellen Craft in her disguise, but it is a portrait *passing* for a person in disguise, a portrait that is partially in disguise and partially out of disguise. It is also a portrait that is *passing for* a person who is *passing for* something else—not only a white man, but an in/valid enslaver, a fake master, a master who has no right (morally or legally) to be an enslaver. The portrait is labeled "Ellen Craft, A Fugitive Slave." But when looked at carefully, it manifests something else: a hybrid identity somewhere in between the space of what a viewer might perceive as the "real person" Ellen Craft and the disabled, male, white identity of the "invalid master" that she assumes during the voyage. Gender seems ambiguous here, as well as race—is this a man or woman, a white person or an African American? It is, in some ways, an ironic or wry portrait. In the drawing, the in/valid master even seems to assume

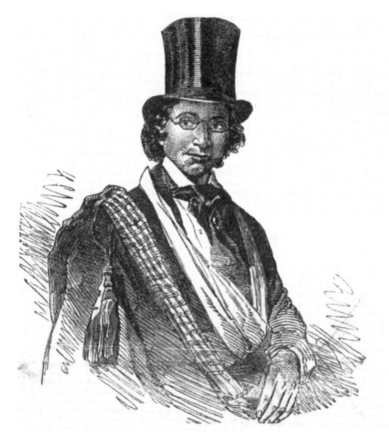

Figure 1.6. Portrait of Ellen Craft in her disguise. *Illustrated London News*, April 19, 1851, p. 315, HathiTrust Digital Library.

a tiny smile, almost a smirk, which I read as a troubling, almost undecipherable presence that resists being caught up within this visual domain.

It is important to keep in mind that the portrait is a commodity, one that can be bought and sold. In the narrative, William Craft tells of selling the image to buy his sister out of slavery and notes that "through the sale of an engraving of my wife in the disguise in which she escaped . . . I have nearly accomplished this."[32] The portrait of Ellen Craft therefore becomes something exchangeable within the marketplace economy of slavery; the selling of the image of an enslaved woman in disguise as a free white male generates money, which is then used to buy (and free) another enslaved woman. It is therefore *quite* important that individuals not be allowed to buy an image of one woman (Ellen Craft) to free another (William Craft's sister); it must be made clear that what individuals buy is not Ellen Craft, nor even Ellen Craft in disguise, but a portrait of an in/valid master—an enslaver who is literally invalid (in that he isn't the master) but more symbolically invalid because "owning" someone goes against the Crafts' belief in the innate humanity of the enslaved. Management of the enslaved body is a vexed subject for formerly enslaved authors. Frontispiece portraits and other devices were used problematically to validate their experiences as true ("this happened to a 'real' person") and authenticate the identity of the formerly enslaved person as human; however, this created a paradox because enslaved individuals did not want to succumb to a cultural logic that configured them as less than fully human. Therefore, these writers "must not only recover their bodies within their narratives but also, more importantly remove their bodies from these narratives."[33] The portrait of Ellen as an in/valid master both authenticates her story in a certain way yet also absents her body from the text as well as from an inhumane marketplace where an African American body was an entity that could be bought and sold because it was configured as less than fully human.

As discussed below, Sojourner Truth cannily marketed images of herself, while creating visual static about whether the image was or was not Truth; the images she sold may have represented a shadow of herself, but not the substance. Ellen's portrait functions in a similar way, blurring her image. In the text, William Craft states that because his wife was "nearly white," he at some point decides to "get her to disguise herself as an invalid gentleman, and assume to be my master, while I could attend as his slave." Later he comments, after he shears her hair and dresses her in her new outfit, that "she made a most respectable looking gentleman."[34] In the text proper, Ellen Craft passes both for a "most respectable looking gentleman" and for an "invalid master." But as regards the portrait of her in disguise, William Craft states: "The poultice is left off in the engraving, because the likeness could not have been taken well with it on."[35] Sterling Bland writes: "What is unclear is whose likeness would be obscured by

the poultice. Is the engraving intended to represent Ellen Craft, William's wife? Or is the engraving intended to show her in the disguise she used to pass as a white gentleman traveling with his black slave? The engraving fully succeeds at neither, thus forcing the reader to ponder the reason for the apparent deviation."[36] Dawn Keetley also notes that the picture depicts "a permanent state of racial and gender ambiguity."[37] Yet the phrase "because the likeness could not have been taken with it on" is slippery; who—or what—is a "likeness" being taken of here? If this portrait was based on a daguerreotype (now lost), which some inscriptions seem to imply, what exactly is the photograph trying to "capture"? Are we supposed to be seeing a likeness of Ellen Craft, the in/valid master, the respectable gentleman, or some hybrid fusion of all these identities?

This ambiguous portrait of "Ellen Craft" also moves through time and space. For example, the 1860 edition of the Crafts' narrative contains a very similar image to her portrait as it appeared in 1851. The name under the frontispiece confounds a simple reading of this drawing; "Ellen Craft, the Fugitive Slave," it reads, in the 1860 edition (see Figure 1.7). Yet, again, this does not *appear* to be a woman, nor does it appear to be an enslaved person. Such slippages between caption and image are deliberate and create visual static, interfering with a viewer's ability to read, process, or consume the image; they also interfere with the viewer's ability to *see* Ellen Craft herself. Instead, a reader sees a fragmented image of her—pieces of her (multiple) identities are made evident by the portrait, but these slivers do not allow the viewer to recognize Ellen.[38] This image is a performative façade that she wears, while the actual woman slips free from the viewer's grasp and evades being visually captured. Such a portrait may in fact expose and dismantle a reader's desire for visual and racial certainty and refute the idea of visuality as providing "evidence" of Ellen's reality and humanity.[39]

Samira Kawash has argued for the "power of fugitivity." As Kawash explains, neither master nor slave, neither person nor property, the fugitive sometimes occupies the space of silence and invisibility.[40] Yet there can be power in this invisibility. The portrait of Ellen Craft is one of a fugitive but also of invisibility; the more we examine it, the more the "real" Ellen Craft seems to be escaping from a viewer's grasp. The portrait may therefore grant her a degree of freedom from the racist visual codes that would confine her. In the portrait, she is neither free nor enslaved, man nor woman, Black nor white. She slips beyond these categories not only by a type of drag (pretending to be male), but also by blurring and obfuscating them visually, by allowing the portrait itself to pass as "Ellen Craft." There is power in this blurring of her visual identity, given the usual hypervisibility of enslaved African American bodies and their confinement within a space of enslavement, even when free, as we saw with the illustrations of Gordon and Wilson Chinn. Perhaps the Crafts deliberately chose to use the picture

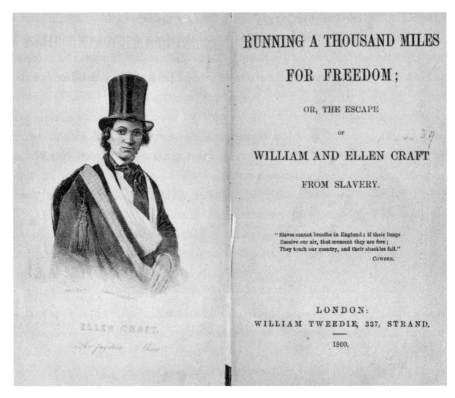

Figure 1.7. Portrait of Ellen Craft engraved by S. A. Schoff after Hale's daguerreotype. From William and Ellen Craft, *Running a Thousand Miles for Freedom; or, the Escape of William and Ellen Craft from Slavery* (London: William Tweedie, 1860). Internet Archive.

of the invalid master, the respectable gentleman, to obscure the creation of an image that a viewer might perceive as the "real" Ellen. What is clear, however, is that the portrait is a performative icon for Ellen Craft and her escape—the portrait performs her fugitivity, invalidity, and her complicated visual presence; in it she is both seen and unseen, visible and invisible, momentarily caught by the image and continually fleeing from it via her multiple layers of disguise.

An Endless and Atemporal Visual Space: William Wells Brown's Panorama

Wells Brown (1814–1884) was a brilliant abolitionist lecturer; he was also a pioneering historian, travel writer, playwright, and novelist. He had escaped from slavery when he was nineteen, in 1834, fifteen years before Henry Box Brown, and the two men knew each other and spoke together on several occasions. Box

Brown and Wells Brown competed in England in 1850 when both exhibited panoramas about their experiences in enslavement, but Wells Brown found Box Brown to be too showy and florid in his dress and presentation, as discussed in the next chapter. They were also frequently confused with each other, but the two men had radically different attitudes toward their art and toward the visual realm, as discussed below. Whereas Box Brown eventually turned slavery into an entertaining but also subversive spectacle, Wells Brown managed to make his own panorama more educative than sensational, more serious than entertaining. Both men played with visual media and with the visuality of slavery, but Box Brown appears to have pushed his own panorama too far into the realm of the spectacular, whereas Wells Brown (like the Crafts) managed to perform slavery in ways that stayed within the limits of abolitionist representation yet also granted him a type of power over his visual persona.

Wells Brown experimented with the visuality of slavery via several media. In 1852, for example, he began exhibiting a magic lantern show featuring scenes of enslavement. He also wrote plays about slavery that were never performed but that he read in 1847 and 1858.[41] In 1851 he organized a protest in the Crystal Palace in England at the World's Fair where he and William and Ellen Craft strolled through the exhibition's statues of enslavement and daguerreotypes of famous Americans to showcase themselves as a sort of living exhibit against the ways slavery and their race were being embodied and visually characterized.[42] And he used and manipulated various frontispiece portraits to create a symbolic representation of himself that seemed real *enough* to convince the viewer that he was the actual man who lived through slavery (see Figure 1.8). In the top part of this portrait, Wells Brown looks solid, but as a viewer glances down, his body seems to fade out; his left hand, folded over his breast, is unfinished and his chest floats on a fragmentary torso. While this is a convention of some (but not all) nineteenth-century frontispiece portraits, it gives this one an ethereal quality; the unfinished portrait may shield Wells Brown from a viewer, who may ponder whether they are seeing the "whole man."

In short, as Lisa Merrill argues, Black abolitionists such as Wells Brown created a range of embodied performances and visual spectacles to destabilize the ways that enslaved or formerly enslaved individuals were viewed.[43] Wells Brown played most substantively and subversively with the question of the representation of himself and enslavement in his panorama, however. The panorama, which Wells Brown exhibited successfully in England from October 31, 1850, until late 1851,[44] has been lost, but Wells Brown authored an elaborate description of it in 1850 (published by the London publisher Charles Gilpin) that allows us to consider what he attempted to represent. About Wells Brown's panorama, Sergio Costola writes that Brown creates "a space which *defies fixity* and in which

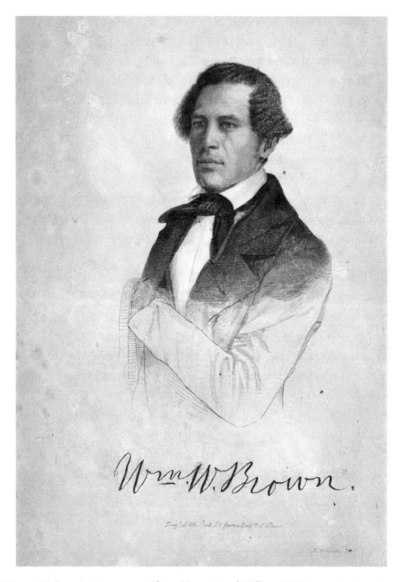

Figure 1.8. Frontispiece portrait from *Narrative of William W. Brown, An American Slave. Written by Himself* (London: Charles Gilpin, 1850). From *Documenting the American South*, https://docsouth.unc.edu/fpn/brownw/menu.html.

time is endless, because the speaker, the audience, the slave, and the slave-holders are all put together in the *now* of an always present time."[45] In other words, Wells Brown did not perform his life, or the lives of other individuals within slavery, but rather some subversively atemporal version of enslavement that served his own psychic and political ends and enmeshed the audiences within his show. A few critics have examined Wells Brown's panorama,[46] but I scrutinize here how, when watched carefully, it can be seen to create visual static or snow that dis-

torts the image of the real man, even as he (like the other abolitionists discussed in this chapter, but unlike Box Brown) stayed within the limits of abolitionist visual codes for the truthful depiction of his identity and life.

The full title of the panorama implies that it will be a realistic depiction of his enslavement and freedom: *William Wells Brown's Original Panoramic Views of the Scenes in the Life of an American Slave, from His Birth in Slavery to His Death or His Escape to His First Home of Freedom on British Soil.*[47] Like Box Brown, Wells Brown traveled to England and found a degree of freedom there, yet part of the title is a bit more obscure—what does Wells Brown mean when he writes that the panorama will show "His Birth in Slavery to His Death or His Escape to His First Home of Freedom"? As we have seen, Box Brown had a sort of metaphorical resurrection within his box; in it he could have died, but he rose to freedom in Philadelphia, so the box has been described as both womb and tomb. Does Wells Brown mean something similar—he could have died in slavery but escaped instead to British soil, where he is reborn as a free man? Or is he alluding to what the historian Orlando Patterson has called the social death of slavery—the way it denied personhood to the enslaved,[48] a kind of living death that some theorists have argued carried through into freedom and up into contemporary times?[49] Wells Brown's text also plays with the line between fact and fiction, even from its title page; he quotes as "fiction" a phrase from the US Declaration of Independence ("We hold these truths to be self-evident: that all men are created equal") and as "fact" a line of poetry written by the British poet William Cowper: "They touch our country, and their shackles fall." Cowper's line alludes to slavery's abolishment in England, but as poetry it should hold less truth status than a political document. From the start, then, there is blurring of the line between reality and representations of reality, a strategy that Wells Brown deployed extensively in novels such as *Clotel; or, The President's Daughter: A Narrative of Slave Life in the United States* (1853).

There are twenty-four scenes, or what Wells Brown calls "views," in the panorama, and many focus on depictions of the trauma of enslavement; he presents, for example, views of "two Gangs of Slaves Chained and on their way to the Market," the "Cruel Separation of a Mother from her Child," "Sale of Slaves," and "The Whipping Post Punishment," as well as scenes of prisons for the enslaved, chain gangs, and diverse modes of torture. Wells Brown describes an iron slave punishment collar once worn by a woman and mentions that it "can be seen at the close of each exhibition of the panorama."[50] This collar would have been like the one worn by Wilson Chinn (see Figure 1.3); it contained multiple prongs designed to prevent the individual's escape and would be extraordinarily painful to wear; therefore the instrument of this woman's horrific torture becomes an exhibit and passive spectacle in Wells Brown's show. On the other

hand, there are also powerful stories of enslaved activity and heroism; for example, a man named Leander ingeniously disguises himself as a woman, foiling visual surveillance, to escape and rescue his wife from slavery.

Wells Brown struggles to create throughout the panorama not only spectatorship of the enslaved, but also interrelatedness or intersubjectivity—a sharing of emotions and feelings—with his viewers so that they become part of the panorama. He constantly refers to his audience as "you" and daringly places the viewer into the scenes of the show through phrases such as "we are enabled to see some of the prominent buildings in the city . . . where we may now imagine ourselves to stand."[51] "You must now imagine yourself as having crossed that river, and as standing with the slave, upon the [free] soil" of Canada," he remarks at the close of the panorama.[52] Wells Brown tries to create what Azoulay might call a "civil contract"[53] with the viewer by urging his audience to walk in their shoes for the journey from the trauma of slavery to the joy of freedom; he endeavors to create a vivid perception of the actuality of enslavement that the audience will share.

Yet in scenes featuring Wells Brown himself, he takes up a different mode of visual depiction. If, as Foucault has argued, visibility is a trap, Wells Brown may escape this trap by stressing that the viewer sees a persona, rather than the man himself. Panoramas have been called by one scholar "illusions in motion,"[54] and the illusion here is that the viewer watches Wells Brown perform in the panorama; instead, we watch his performative personae. Of the twenty-four scenes in the panorama, only three represent Wells Brown at all, and they are buried deep within the panorama:

View Twelfth: First View in the Life of William Wells Brown
View Nineteenth: W. W. Brown and his Mother arrested and taken back into Slavery
View Twenty-First: Last Scene of the Escape of Wm. W. Brown

The descriptions of Wells Brown and his escape in the panorama are brief and refer to his 1847 memoir, the *Narrative of William W. Brown, a Fugitive Slave, Written by Himself*, which was a bestseller across the US and was also republished in 1849 in England.[55] On the one hand, by referring to his earlier narrative, Wells Brown may seek to increase sales of it, but perhaps he distrusts visual media to represent him. Indeed, Wells Brown is critical of the "very mild manner" in which some panoramas portrayed slavery, and his panorama was judged by British abolitionists and others to be highly educational and moving.[56] Yet even in the scenes "about" Wells Brown, who is being represented? The panorama contains three different versions of his name: "William Wells Brown,"

"W. W. Brown" and "Wm. W. Brown." This slippage multiplies Wells Brown's iden-tities and creates visual static that interferes with a viewer's apprehension of him. Like Box Brown, Wells Brown has numerous names that cloak his identity and ask a viewer to *watch* his fluctuating image rather than capture the "real" man.

The narrative contents of all the scenes featuring Wells Brown are also very short. In contrast (for example) to the long description of the heroic Leander, the escape of Wells Brown and his mother in View Nineteenth receives only three abrupt sentences: "In a former view we have shown the writer and his mother escaping in a boat from St. Louis to the Illinois side. Although they succeeded in reaching a free State, they were not beyond danger. After travelling by night about 150 miles, they were taken up and returned to their masters."[57] The chap-ter then segues into a discussion of the hypocrisy of the fugitive slave law. View Twenty-First is even briefer in its depiction of Wells Brown: "We have before us a representation of the writer, as he appeared on a cold winter's night, in the month of January, 1834 (see 'Narrative,' page 98), travelling in the direction of the North Star."[58] These are brief factual descriptions; it is unclear whether this briefness was because Wells Brown had detailed these escapes in other works or whether he was shielding himself and his mother from scrutiny; in either case, the descriptions of these scenes are opaque in giving any sense of how Wells Brown and his mother were visually represented in the panorama.[59]

View Twelfth (halfway through the panorama), on the other hand, where "the writer" (Wells Brown) is first presented, gives a more complete picture of his story: he has fled St. Louis and is hiding in the woods when he hears the barking of dogs that are tracking him. Knowing that there is no possibility of escape, the author "determined to climb a tree to save himself from being torn to pieces." He has been in the tree for only a few minutes when "the dogs came up, and, soon after, two men on horseback." He is then ordered to descend and is tied and taken home.[60] After this brief description, the chapter (like the other two) segues into another topic (this time, the use of dogs to hunt the en-slaved). However, the illustration that accompanied this scene of the panorama—modeled on one in his 1849 narrative of his life, published in England, *Narrative of William Wells Brown, an American Slave, Written by Himself*—does not depict the spectacle of Wells Brown being re-enslaved, as a viewer might expect (see Figure 1.9).

This was likely the prototype used for View Twelfth of the panorama, and in it we can see an almost abstract representation of the author—he seems to hover in space, supported by a branch that appears frail, spindly, and decayed; how is it bearing his weight? He is represented in a liminal space somewhere between slavery and freedom—he has not yet jumped down into the waiting hands of his captors (or the mouths of the dogs). If we listen to this image, we can hear the

The author caught by the bloodhounds. (See p. 21.)

Figure 1.9. This drawing was used as a model for View Twelfth in Wells Brown's panorama. Image from *Narrative of William W. Brown, An American Slave, Written by Himself* (London: Charles Gilpin, 1850 [1849]); n.p., Google Books.

noisy barking of the dogs and the shouting of the man on horseback, but the figure of the author is motionless and quiet within this domain, giving it a sense of being almost outside of time and of reverential stillness. As Michael Chaney has noted, the man's body is bent into the supplicant slave icon.[61] Yet because his figure appears in the upper portion of the illustration, a viewer's eyes must tilt up to see him, and he seems to hang above the reach of normal vision; this positioning of Brown frustrates the usual downward and pitying glance of the viewer onto the low and debased body of the enslaved. The caption tells us that this is "the author caught by the bloodhounds," but it is important to note that we do not in fact see him being "caught" or tied to be taken back into slavery. It is an image of the fugitivity of someone whom we can *watch* hanging between freedom and slavery, between being objectified by the viewer and leaping into nonrepresentational space and time.

This image features an apocalyptic, almost surreal landscape of burnt-out trees and bushes that represent the social death of slavery not only for Wells Brown, but for all the enslaved who have not yet found the means to escape either slavery or visual surveillance. It is an atemporal moment that blurs time and space; as viewers in England see the panorama, narrated by the man who was free in England, Wells Brown, "the author" of said panorama, narrates

himself as a slave being "caught by the bloodhounds" and yet not captured. As Costola notes, Wells Brown's panorama creates "dialectical images that could bring present and past into collision,"[62] and View Twelfth in the panorama presents a pictorial example of how this collision works. Wells Brown creates a deliberate confusion between the enslaved individual, the author telling the story via the panorama, and the free man living in England. Perhaps this temporal blurring creates a moment in which Wells Brown cannot be spectated, caught within a viewer's ethnographic gaze. As we will see, this strategy of multiplying personae and blurring time is something Box Brown deploys in many of his performances, including his panorama, but also during his stint acting on the British stage.

Wells Brown's panorama at times turns slavery into a spectacle for viewers to gaze upon, yet also creates a type of civil contract with the viewer by attempting to place the viewer in the space of enslavement. It protects Wells Brown from the prying eyes of viewers via a series of personae that create visual static about who is being represented and illustrations in which he hangs in a liminal space between slavery and freedom. John Ernest argues that Wells Brown understood the futility of trying to represent the reality of the slave system, a system that both "resist[ed] and require[d] representation."[63] Wells Brown creates a facsimile of the representation of slavery in his panorama but also gestures to a more symbolic and ethereal, atemporal realm of portrayal. And finally, as Box Brown will also do, Wells Brown plays with a mutating *representation* of himself within his panorama—a persona who cannot be precisely caught within the web of racialized scrutiny and pity that generally confined the fugitive ex-slave.

Living Theater: Frederick Douglass and Photography

Like the narratives of the Crafts and William Wells Brown, the works that Douglass and Truth published based on the stories of their lives contained illustrated (engraved) frontispiece portraits. While we do not know how the Crafts, Wells Brown, or Truth felt about these portraits, Douglass (who wrote a great deal about various visual modes) did not like many of these engravings. In fact, he hated the illustrated portrait that accompanied the 1845 Dublin edition of his *Narrative*, in part because it represented him with a slight smile; he accused the engraver of drawing him "with a more kindly and amiable expression than is generally thought to characterize the face of a fugitive."[64]

Because both Douglass and Truth were able to consciously manipulate the photographic genre to craft identities that counteracted the dominant culture's attempt to control them, I focus here exclusively on their photographic work

rather than on their illustrated, engraved portraits. In photographs, both endeavored to create an image of themselves that could not easily be consumed by the dominant culture. Douglass and Truth present a performative self, one that is highly curated, especially when compared with earlier icons of themselves that they did not stage-manage to the same degree. Performance, as Elin Diamond notes, is always "a doing and a thing done," something that drifts between present and past, and presence and absence.[65] Theorists such as Roland Barthes and Herbert Blau consider photography highly performative, a form of living theater.[66] When watched carefully over time, it becomes evident that Douglass and Truth manipulate past and present versions of their identity within the living theater of photography. Their fugitive performances create personae who represent them but also protect and conceal them, and often critique processes of visuality, of what can and cannot be seen within the photographic frame.

Turning first to Douglass, it is vital to note that in addition to being the most photographed US man in the nineteenth century, Douglass was a sophisticated theorist of photography; he spoke and wrote extensively about it in three lectures. In a speech that he gave in the mid-1850s, Douglass critiqued the visual portrayal of Blacks in scientific treatises about race, saying that the "Negro" is pictured "with features distorted, lips exaggerated—forehead low and depressed—and the whole countenance made to harmonize with the popular idea of Negro ignorance, degradation and imbecility."[67] As regards photography, he was more inclined to believe that it could help others see a truer (if not exactly true) reality of their image. Due to the advent of photography, he writes, "Men of all conditions and classes can now see themselves as others see them and as they will be seen by those [who] shall come after them."[68]

Scholars have argued that Douglass was one of the first individuals to use photography as a public relations instrument.[69] Fox-Amato writes that Douglass understood how sitting for a photographic portrait could help him project "humanity and dignity amidst northern racism" and reveal how a formerly enslaved person could become a "citizen and bourgeois subject."[70] Yet photography, as Fox-Amato notes, was entwined with what we might term a progressive impulse (toward freedom and self-dignification) and also an oppressive one; for example, photographs of enslaved individuals were used by slaveholders to document the "beneficent" nature of slavery and even sometimes deployed in the recapture of fugitives.[71] Douglass's relationship with the visual realm therefore was complex; he comprehended its power to project self-possession for African Americans but also to caricature, surveil, and capture them.

Douglass also was aware of racist scientific theories and more particularly the work of the noted Harvard scientist Louis Agassiz.[72] In 1850 Agassiz had daguerreotypes made of enslaved individuals in Columbia, South Carolina, to

attempt to visually validate his theories on racial difference.[73] In these photographs (taken by Joseph T. Zealy), enslaved men and women are pictured nude or seminude, often with genitalia or breasts on display; they stare forcefully at the camera as if it is violating or wounding them. As Azoulay reminds us, "large parts of disenfranchised populations are prone to turn into photographs taken by others, more than they tend to become photographers themselves or self-photographed subjects."[74] Zealy's subjects most likely did not consent to this visual depiction; indeed, what consent might mean in this context is not evident because the individuals most likely *could not* decline being photographed without grave harm to themselves. On the one hand, in these photographs we can glimpse an insubordinate gaze (the gaze of what Christina Sharpe calls "Black resisting objects"[75]) that stares past the viewer instead of employing a downcast glance that might allow a viewer to smoothly process the image or take visual possession of it. On the other hand, Agassiz clearly meant to use his photographs as "evidence" of the debasement of Africans and African Americans and their status as a separate race, and the photographs seem dehumanizing due to their nakedness or semi-nakedness and the clinical gaze of the camera. All this points to the ways that, for Douglass, the camera would not have been a neutral instrument; he understood that a photographer could have the intention of either humiliating or ennobling individuals. Douglass further comprehended the irony of having to provide "evidence" of his innate humanity via the photograph to contradict the demeaning portraits of African Americans created by others.

Much has been written about Douglass's attitude toward photography,[76] but I analyze one claim that has been postulated repeatedly: that Douglass equated photography with truth and reality. In contradistinction to this view, I argue that Douglass comprehended that photography could be manipulated through background, lighting, facial expression, and other aspects of the photographic *mise-en-scène* to mediate and negotiate African American identity; Douglass's photographic portraits perform resistant versions of African American selfhood and at (at times) critique visual surveillance and the use of photography for socially progressive agendas. Over the arc of Douglass's fifty-year-long public life (he emerged as an abolitionist in the early 1840s and continued in various political roles until his death in 1895), he consciously brings himself back as a revenant via photography (using Wexler's terms)[77] from the "social death" of slavery, a state in which the enslaved is equated with property rather than humanity. While Box Brown used visuality subversively for social transformation, Douglass saw visuality as an instrument for more direct political renovation because photography could performatively challenge derogatory images of African American identity and so further enable civil rights. Yet Douglass also stressed limitations

of the visual realm; his photographic persona over time came to reflect his disillusionment not only with his country but also with the ability of photography to foster social or political change.[78]

Rather than focusing on all the photographs of Douglass that exist (and the archive is vast), I discuss several that reflect, first, his articulation of himself as a subject-in-the-making; second, the creation of the heroic and at times angry icon of abolition; third, his commentary on political struggle through the use of symbolic objects; and fourth, how his photographs come to reflect disillusionment with photography during the era that historians refer to as the Nadir (roughly 1877–1901), the period of time after Reconstruction when the progress made for African Americans in political rights was curtailed and lynching was rampant. I watch Douglass's imaging of himself as it changes over time to comprehend his conceptualization of the role of visuality in enabling social or political change.

In early daguerreotypes, Douglass had not yet assumed his most characteristic formal expression, one often filled with anger, indignation, and even scorn. Instead, he appears to perform an image of himself as a thoughtful and intellectual young man, a subject-in-the-making; such an enunciation is necessary, given that formerly enslaved individuals were not always recognized as possessing full human subjectivity and identity. Tina Campt contends that photographs that exist serially (which is the case with Douglass, as he was photographed repeatedly) must be understood as part of "complex processes of cultural articulation, improvisation, and reiteration. Far from constituting a replication, they are repetitions with a difference." Campt also suggests that we understand such portraits as representing "subjects in becoming" and "forms of identification and subjectivity that perhaps, at the time, had yet to be articulated."[79] We must therefore first carefully consider early photographs of Douglass (from 1841) to grasp the ways in which they represent a "subject-in-the-making" who will be repeated (with a difference) in later sittings.

In the first known photograph of Douglass (from 1841), he directly faces the camera, which seems to illuminate his torso (head, neck, and face). Douglass had escaped from slavery in 1838, only three years earlier, and he was just becoming known for his abolitionist speaking. He was twenty-three, and still subject to recapture by his former enslaver (see Figure 1.10). Douglass is well dressed in sophisticated formal clothing: a black suit, high-necked white shirt, and a speckled bow tie; his hair is neatly arranged. The darkness of Douglass's suit blends into the darkness of the photograph's background, creating a chiaroscuro effect that emphasizes the light on Douglass's face and his white shirt, almost as if his head and neck are caught in a spotlight and floating in space. Such an early image resembles engraved frontispiece portraits by African American authors

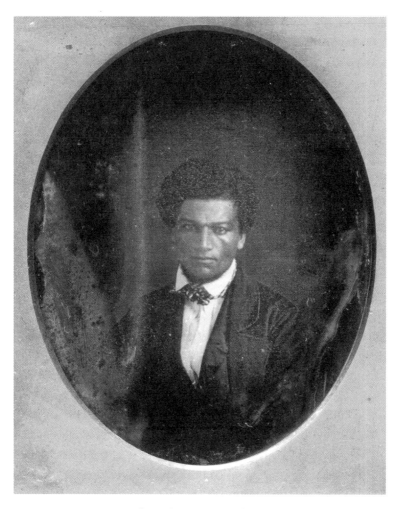

Figure 1.10. Daguerreotype of Douglass, ca. 1841. This is, most likely, the earliest photographic image of Douglass. Collection of Greg French. Used with permission.

such as Moses Roper and Henry Bibb, which guaranteed a type of authenticity and dignity to the formerly enslaved writer in the face of white skepticism toward Black authorship. Of course, as Neary notes, such authenticating gestures create a paradox: the reader might "*see* the ex-slave narrator as simultaneously an object and a subject": the formerly enslaved individual was forced to adopt the absurd position of having to prove his or her own selfhood via the visual realm.[80]

In focusing on Douglass's face and head via lighting to such a large degree, the photograph highlights his intellect and intelligence. Moreover, by stressing his sophisticated and tasteful dress, especially in contrast to enslaved or formerly enslaved individuals who were pictured in their "slave outfits" (such as

Wilson Chinn, discussed above) or in tattered rags or little clothing, the image makes the point that this man is *no longer* a slave. Although he may not yet have entered the space of *legal freedom*, his right to such is enunciated via this respectful, careful, and conscious curation of himself as a political subject-in-the-making. His gaze meets that of the viewer squarely and seems calm and even; he does not appear to *demand* anything from viewers other than that we look back at him with respect. Other photographs from this early period represent Douglass as a composed and even quiet young man who is beginning to shape a political subjectivity but has not yet created the persona of the defiant abolitionist that will challenge the viewer more directly.[81]

Even in these early years, Douglass apprehended that if he did not direct the creation of his image, others would control it. As mentioned, Douglass did not like the engraved frontispiece portraits in many of the early editions of his *Narrative* because he thought they showed him as happy or content. Therefore, it is perhaps not so startling that Douglass eventually crafted a radically different image of himself in his photographs, beginning in 1852. In a famous daguerreotype taken in Akron, Ohio, by Samuel J. Miller, Douglass maintains an expression of just-barely-suppressed anger (see Figure 1.11). Douglass is again elegantly dressed and coiffed, and he wears a stylish, richly brocaded vest. However, in this picture Douglass's torso is a bit twisted away from us and his brow is furrowed; due to this configuration, one of his eyes is in partial shadow. Perhaps the darkness that covers part of the right side of Douglass's face is meant to symbolically evoke those individuals who still reside in the darkness of slavery proper. Most strikingly, the calm icon of Douglass in the prior photograph is gone. Douglass now performs a type of righteous indignation—his eyebrows are furrowed, his eyes are focused, and his mouth is set gravely—as he attempts to galvanize the viewer into action.

Douglass understood how to sit for a daguerreotype, and he could certainly have chosen any number of expressions to manifest such as sadness, pain, or stoicism. Yet he consciously chose an expression of wrath, one which he would consciously perform in at least seven other photographs taken in the 1850s and early 1860s.[82] He ran the risk of reifying white stereotypes of African Americans' violence and brutality; his stylish clothing enunciates African American civility, yet his expression of anger was in some ways a risky choice. Donna Wells calls Douglass a "co-creator of this image,"[83] but something more is going on here. In this period, the process of taking the daguerreotype had become swifter, but subjects needed to hold a pose perfectly still for twenty to sixty seconds so that an unblurred image could be created. Douglass carefully selected the photographers with whom he would work, adopting an active rather than a passive relationship with them, leading Celeste-Marie Bernier and Bill Lawson

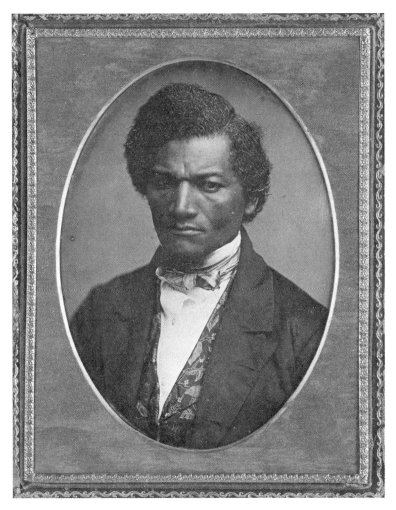

Figure 1.11. 1852 daguerreotype of Frederick Douglass by Samuel J. Miller. Chicago Art Institute. Used with permission.

to argue that in his photographic portraits he assumed the role not only of an artist but of a "performer and trickster."[84] So it is important to consider what Douglass's choice to present anger and indignation in front of the camera might say, and to whom he might be saying it.

Azoulay writes that in photographs a civil contract exists that "enables the injured parties to present their grievances, in person or through others, now or in the future."[85] In this photograph, Douglass's performance of anger may present his grievances about his country's lack of progress in abolishing slavery and attempt to create a community in which spectatorship might foster human rights. Sharon Sliwinski posits that photographs create a "virtual community" where the ideal of a "shared humanity literally comes into view."[86] Yet it is evident

that in this moment (1852) a virtual community and a sense of "shared human-ity" do not yet exist. For example, Douglass had published an attack on the Compromise of 1850, which allowed the new and updated version of the Fugitive Slave Act to go forward, a law that *required* the North to help in the pursuit of fugitives and made it illegal for anyone to aid them in any way. Despite the dan-ger this new law caused, in 1851 Douglass helped three fugitive Maryland slaves wanted for the murder of their former enslaver escape to Canada in his role as "Station Master" of the Rochester terminus of the Underground Railroad.[87] In 1852, just about one month before this photograph was taken, Douglass also de-livered his famous and scathing speech, "What to the Slave Is the Fourth of July?" The speech is fiery, and the above image may channel Douglass's perfor-mance of anger at his country for not making better progress toward emancipa-tion, as he says:

> This Fourth [of] July is *yours*, not *mine*. *You* may rejoice, *I* must mourn. . . . Fellow-citizens; above your national, tumultuous joy, I hear the mourn-ful wail of millions! whose chains, heavy and grievous yesterday, are, to-day, rendered more intolerable by the jubilee shouts that reach them. . . . Standing, there, identified with the American bondman, making his wrongs mine, I do not hesitate to declare, with all my soul, that the char-acter and conduct of this nation never looked blacker to me than on this 4th of July![88]

The 1852 daguerreotype focuses this type of righteous anger and attempts to cre-ate a virtual community of viewers who would mirror his indignation and enact political change. This photograph also speaks to the ways that Douglass shaped his image and his persona, while still, unlike Box Brown, staying within accepted abolitionist norms for the visual representation of the formerly enslaved individual.

In "Pictures and Progress," Douglass says that man is the "only picture-making animal"[89]—which has been taken to mean that humans are the only animal with the desire to replicate visually the world or images of themselves. But if we think of this phrase more symbolically, it can also mean that humans are the only animals with the desire to *shape*, create, and reconstruct reality, which we see Douglass attempting to do in the above photograph via his indignation, which he hopes to transmit to the viewer. Douglass also states that the "picture-making faculty" is "capable of being harnessed to the car of truth or error: It is a vast power to what-ever cause it is coupled."[90] This statement relates to pictures of all kinds, including photographs, which would be harnessed to *either* "truth" or "error." Of course, this statement does not mean that Douglass believed any one photograph or other visual medium could convey the *entire truth* of his (or any person's) life,

but it is to say that he believed pictures could move a viewer along a spectrum, away from mistruths (such as the idea of his race as debased or servile) and *toward* certain kinds of truths (such as the agency and self-possession of formerly enslaved individuals) via their manipulation and staging.

Like the photograph above, several of the portraits of Douglass from the mid-1850s stage an image of Douglass as an angry, determined advocate for abolition, a man with agency, volition, strength, and power. For instance, in a daguerreotype from 1859 where he is (unusually) standing up, he faces the camera with crossed arms that seem to symbolize his resolute self-possession and his determination, but he glares at the camera as if it is a hostile presence.[91] There is also a *carte de visite* from 1862—one year into the war—which closely resembles the expression in the 1855 engraved frontispiece to *My Bondage and My Freedom,* an illustration that he was fonder of than the 1845–1856 frontispieces; in the 1862 *carte de visite* there is still a degree of wariness in his furrowed brow and in the slight tilt of his head away from the camera.[92]

Photographs taken after the Civil War in 1870, however, suggest a movement beyond the angry abolitionist into a type of performance as an elder statesman with long-term political goals and a critique of the nation's progressive agenda. For example, in one of these photographs, Douglass poses with a highly symbolic item, but one that is also paradoxical—the cane of the (now dead) Abraham Lincoln. The cane is gripped in his two hands at the bottom of the picture (see Figure 1.12). The photographer Henri Cartier-Bresson writes that "in photography, the smallest thing can be a great subject."[93] So Lincoln's cane (certainly a small detail within the picture, at least by virtue of its visual space) might say a great deal about Douglass, Lincoln, or the larger subject at hand—the nation's fate five years after the end of the Civil War.

Douglass had met Lincoln twice in the White House before his death in 1865, and after his death Lincoln's widow, Mary Todd Lincoln, gave the cane to Douglass. It is, of course, an item fraught with historical and symbolic significance. Yet perhaps the most unusual aspect is that the cane is buried in Douglass's hands and can barely be seen. This photograph was used on a *carte de visite* that would circulate widely, and Douglass could have made more of the fact that he possessed Lincoln's cane and was proud of it; instead, it is a sort of absent presence in the photograph, at the bottommost edge. Douglass looks off over his left shoulder, with a pronounced turn of his head *away* from Lincoln's cane. What is he looking at? And why is the cane so submerged?

Azoulay explains that photography is much more than what is printed on photographic paper: "the photograph bears the seal of the event itself, and reconstructing that event requires more than just identifying what is shown in the photograph. One needs to stop looking at the photograph and instead start

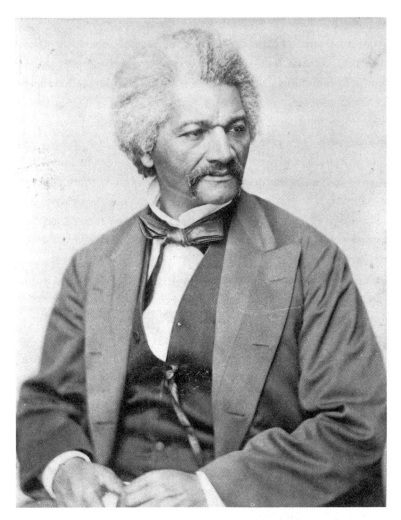

Figure 1.12. Frederick Douglass sits for a portrait in April 1870, George Francis Schreiber/Library of Congress, https://www.loc.gov/pictures/item/2004671911/. In his hands he holds the top of Lincoln's cane.

watching it."[94] So if we *watch* Douglass holding Lincoln's cane in his hand and looking *away* from it, we find a trace of not only what is seen but what lies below the photographic surface. An address that Douglass gave six years later (in 1876) offers insight into his thoughts on the legacy of Lincoln. Douglass's speech was crafted for the unveiling of a monument that depicted Lincoln as the "Great Emancipator," freeing a kneeling, shackled, enslaved man.[95] Yet Douglass states: "truth compels me to admit . . . [Abraham Lincoln] was preeminently the white man's president. . . . He was ready and willing at any time during the first years of his administration to deny, postpone, and sacrifice the rights of humanity in the colored people to promote the welfare of the white people of the country."

Indeed, during the Secession crisis of 1860–1861 and continuing into 1862, Lincoln supported protections for slavery in the southern states; he was "willing to pursue, recapture, and send back the fugitive slave to his master." In 1862 Lincoln met with five Black ministers at the White House and told them "strangely . . . to leave the land in which we were born." He told this group that he would "save the Union with slavery"; in other words, he was not (at this juncture) for the abolition of slavery.[96] In 1865, Douglass eulogized Lincoln by saying that while he was "unsurpassed in his devotion to the welfare of the white race," he was also "emphatically, the black man's President: the first to show any respect to their rights as men."[97] Yet by the 1876 speech, Douglass states: "My white fellow-citizens . . . you are the children of Abraham Lincoln. We are at best his stepchildren, children by adoption, children by forces of circumstances and necessity."[98] Douglass's views on the "Great Emancipator" were filled with a sense that Lincoln was not always or primarily a true hero to African Americans, but more of an accidental one.

In his photograph with Lincoln's cane, Douglass tries to put this paradoxical relationship into play in a type of visual language that could be read by his viewers. The philosopher and literary theorist Roland Barthes describes photographs as "a kind of primitive theater,"[99] so we might consider what Lincoln's cane represents in the living theater that the photograph of Douglass enacts. In a sense, Lincoln's cane is so submerged that we might call it part of the background of the photograph, yet by its absence and erasure, the cane says something more. The inclusion of Lincoln's cane may ask viewers to meditate carefully and even skeptically on Lincoln's legacy and achievements. In this photograph, Douglass's eyes do not meet the viewer's and have a far-off look to them. Viewers of the photograph can *watch* Douglass looking away from the past (Lincoln's cane) and into a possible future but not seeing anything particularly hopeful there; it is as if neither past not future give him any comfort. Given that 1876 (six years after this photograph was taken) would mark the end of Reconstruction, perhaps this performance of pessimism and wariness is justified.

Toward the end of his life, Douglass may have also become cynical about visual media entirely, seeking not performance or negotiation of identity within it but sheltering invisibility. In a photograph from 1893 at his home (Cedar Hill) in Washington, DC, Douglass has his back to the camera, and he almost seems to be hiding from it (and from viewers; see Figure 1.13). An earlier photograph of Douglass is on the wall to the left, making this in some ways a metapicture—a picture about a picture (or perhaps about picturing, as he faces numerous portraits on the wall). This 1893 photograph is filled with personal details, which are not always evident in photographs of Douglass. We see, for example, his mastiff Frank lying on the ground to his right. And we see the books he has read (in his

Figure 1.13. Frederick Douglass at his home in Washington, DC, 1893. Courtesy of the Moorland-Spingarn Research Center, Howard University Archives, Howard University, Washington, DC. Used with permission.

library) or hopes to read (to his right), and the violin on his desk, an instrument which he learned to play while enslaved. But most importantly, we see Douglass's white hair and his somewhat weary-looking back because he *looks away* from the camera.

This is one of the few photographs from this era that has survived, so it is necessary to consider the import of Douglass's conscious choice to turn his back and disregard the camera and the viewer; for someone who had carefully crafted images of himself for more than fifty years, this detail is fraught with symbolism. Shawn Michelle Smith writes that African Americans used photography to declare their status as subjects, yet she also notes that even as such portraits objectify individuals, these visual works allow them to see themselves in unique ways. About Douglass, she notes that the objectification proffered through representation, and especially through photography, "was a necessary foundation for self-evaluation and critique, which in turn provided the basis for social progress."[100] Yet perhaps by the 1890s, Douglass felt that he needed to turn away from the

idea of using photography to advance human or civil rights and social progress. At this point the US had entered what historians call the Nadir—the worst period in US history for African Americans in terms of lynching, other acts of illegal violence, the institutionalization of Jim Crow segregation, and the retrenchment of many of the voting reforms put in place during Reconstruction. In the 1893 photo, Douglass's turned back may perform negativity toward the idea that African Americans would ever have full citizenship, as well as a rejection of the visual as a domain that could enact lasting psychological or political change or create a virtual community of spectators. The wake of slavery, Sharpe argues, has positioned African Americans even today as "non-citizens."[101] Perhaps Douglass was aware of this, in 1893, and his turned back represents a type of wake work in which he depicts this peculiar position, even absent the "peculiar institution" of enslavement.

Thirty years earlier, in an 1862 speech called "Age of Pictures," Douglass says, "There is a prophet within us, forever whispering that behind the seen lies the immeasurable unseen."[102] In photographs where Douglass does not face the camera (and there is at least one other from this era, where Douglass looks down at his desk rather than out at the viewer),[103] he gestures to the "immeasurable unseen" that lies behind the photographic surface, or beneath the photographic trace. In other words, he notates what *cannot* be caught within this highly visual realm. This 1893 photograph encourages a viewer to think beyond visual media (to consider what is left silent or *uncaptured* by them) and grants Douglass a certain protective concealment or even camouflage. In this sense, this last picture epitomizes a fit ending for a discussion of Douglass's use of photography as a mode of performance and sociopolitical change. Whereas earlier he had staged righteous anger in his expressions and political critique via symbolic objects, here he turns away from the camera. Douglass creates an image of himself in which, as in the portrait of Ellen Craft in her disguise, we see only pieces of his identity. In so doing, he speaks to what is *unseen* and even *unheard* within a photograph, which in this case might be a future when he is understood as a human individual, one who no longer must authorize and perform his selfhood via the visual realm.

Selling "The Shadow": The Photographic Performance Work of Sojourner Truth

Sojourner Truth's photographs also create performative personae that grant a degree of protective invisibility within the folds of the guises she wears; these images critique society and delineate limitations of the visual realm as an

instrument of self-empowerment. Her pictures gesture to time and the unseen realm (the shadow world) even as they create a space for her self-representations within living memory. As mentioned, many of her portraits and photographs appeared with the motto "I sell the shadow to support the substance." What Truth means by "shadow" and "substance" has been the topic of some debate. But before unpacking this phrase, we must consider earlier illustrations in which this phrase did not appear, and in which Truth lets others stage-manage how her picture is created. These earlier instances of having someone else visually construct her may have led to a desire to perform her images more overtly in later photographs, which she asserts not only in her motto, but also by the insertion of highly allegorical objects into the visual frame.

Like Douglass, Truth comprehended that illustrations *and* photographs could be manipulated, that they could betray the person whose image was being captured, and like Box Brown she understood that visuality could turn her into a spectacle. In the earliest known photograph of Truth—an uncaptioned *carte de visite* that can be dated to the start of the Civil War, likely 1861—she fails to fully manage the visual items that construct her and becomes an object at which viewers might gawk, rather than the conscious producer of her own visual presence (see Figure 1.14). Azoulay argues that, when possible, the situation from which a photograph was taken should be reconstructed,[104] and the unusual and dramatic circumstances surrounding the creation of this photograph have in fact been recorded and bear directly on Truth's inability to fully control her image here.

In June 1861, Truth was giving a speech to a hostile, proslavery crowd in Angola, Indiana.[105] Her supporters took it upon themselves to gird her for the battle, as she relates in the 1875 updating of *Narrative of Sojourner Truth* (originally published in 1850):

> The ladies thought I should be dressed in uniform. . . . So, they put upon me a red, white, and blue shawl, a sash and apron to match, a cap on my head with a star in front, and a star on each shoulder. When I was dressed I looked in the glass and was fairly frightened. Said I, "It seems I am going to battle." My friends advised me to take a sword or pistol. I replied, "I carry no weapon; the Lord will reserve [preserve] me without weapons. I feel safe even in the midst of my enemies; for the truth is powerful and will prevail."[106]

Truth had to be escorted by a military guard to her speaking engagement; along the way individuals called her several vile racial slurs. To "prepare" her for this, the ladies dressed her in strange clothing; she makes clear that she does not need

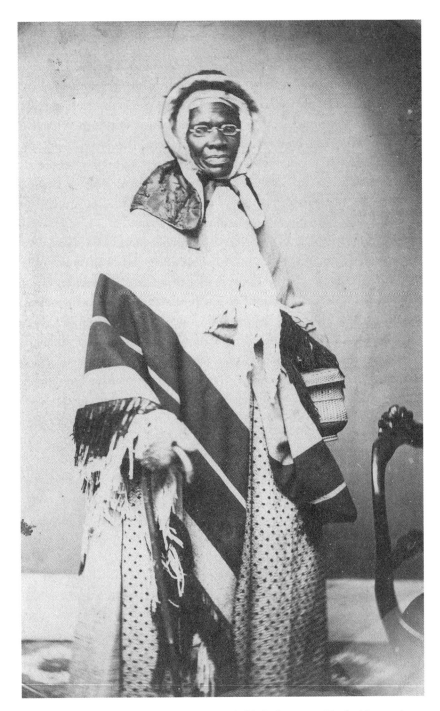

Figure 1.14. *Carte de visite* of Sojourner Truth, likely from 1861. Used with permission, courtesy of Chicago History Museum.

these accoutrements and even refuses a gun, ironically playing with her own name: "The Lord will reserve [preserve] me. . . . The truth is powerful and will prevail." In this photo Truth is, as Darcy Grimaldo Grigsby puts it, "all but overwhelmed by clothing and accessories"; she is covered by layers of fabric and in what seems to be a "theatrical, enveloping costume."[107] Yet this clothing was not her choice and did not reflect the way Truth wanted to present herself. This photograph and Truth's comments about it indicate that she was not always able to direct her photographic imaging. Of course, as Campt reminds us, no photograph is entirely liberatory, and photographs contain a play between self-fashioning and subjugation, but this photograph seems to slide Truth into the realm of the captured entity who is fashioned by others.

White abolitionists could play with costuming the formerly enslaved person in various guises—such as the patriotic colors of the flag or its stars—to allow their speaker to enact a particular role that they would present on the stage of the antislavery lecture circuit. For Truth, this instance of being costumed against her will to the point where she sees herself in a mirror and is "fairly frightened" functioned as a sort of cautionary lesson. In her later photographs she develops a subtler visual persona, one with multiple messages and enigmatic meanings. As Nell Irvin Painter notes, Truth raised money by selling her photographs, and she had as many as fourteen photographic portraits made in at least seven different sittings.[108] She also took advantage of the craze for *cartes de visite* in the nineteenth century.[109] Yet she was not merely making money from these photographs. As Painter argues, Truth could have taken advantage of the craze for battered, formerly enslaved bodies that was evident in the mid-1850s to 1860s by exhibiting (for example) her right hand, which had been maimed while she was enslaved.[110] Instead she chose to include other details to stage-manage herself in these photographs and create a visual persona that might contradict this trend. In so doing, she engages in the process that Campt calls "reassemblage in dispossession"—redeploying relations of power in unintended ways with unexpected consequences so that she reconfigures her status within a field of limited and often compromised resources.[111]

Two types of photographs illustrate how Truth developed an understated visual photographic presence and even language in later images that redeployed relations of power in unexpected ways. The first type of photograph directly references visuality by including other photographs within the frame. In one set of images, she is photographed with a small daguerreotype of her grandson James Caldwell; he was a prisoner of war at James Island, in South Carolina. These photographs were taken in 1863 and there are at least four of them, with Truth in different poses. Yet in each, the daguerreotype of James rests carefully in her lap (see Figure 1.15).

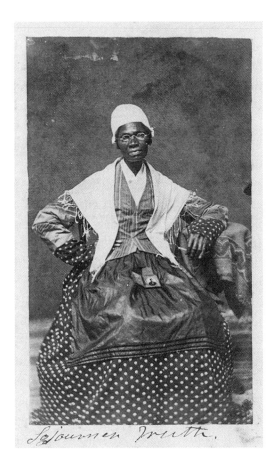

Figure 1.15. *Carte de visite* of Sojourner Truth with a photograph of her grandson, James Caldwell, on her lap, ca. 1863–1865, Library of Congress. https://www .loc.gov/pictures/item/2017648645/.

Truth confronts viewers directly, looking into their faces. By looking back at the viewer, she may try to implicate readers into what Azoulay calls a civil contract which assumes the existence of a hypothetical spectator who could be moved toward indignation or anger by images. In discussing photographs in which the individual looks at the viewer, Azoulay argues that such images may formulate a series of questions: "Why are these men, women, children, and families looking at me? . . . At whom, precisely, did they seek to look—was it truly at me? And why? What am I supposed to do with their look? What is the foundation of the gaze I might turn back toward them?"[112] She argues that this looking back may gesture toward a realm in which relationships between the viewed and the viewer are not mediated by the dominant power but by a type of civil contract that imagines a new conceptual framework of partnership and solidarity between the oppressed and the viewer. This may be a virtual or symbolic partnership (rather than an actual and localized one) but given that Truth's gaze turns itself directly on the viewer, her text may be gesturing to a hypothetical

community of viewers who can understand the political content of this gesture and respond to it with something like solidarity. Truth may have lost a grandson (at this time, she did not know where he was; he had been captured by rebel soldiers and would survive, but Truth knew only that he was missing). Her look at the viewer may ask them to understand her sacrifice for her country and to extend human rights not only to him, but also to her.

Moreover, Truth's inclusion of a grandson who is fighting on the Union side demands a type of recognition of his (and perhaps her own) symbolic citizenship. In this era, some abolitionists argued that, once freed, all African American men should have full citizenship rights, including the vote, but Lincoln had not yet acquiesced to this idea. Truth's photograph attests to her feelings on this subject—if her grandson could fight in the war, he deserved inclusion in the nation as a full citizen. Campt contends that photographs of African Americans place people historically and socially by articulating "a profound aspiration to forms of national and cultural belonging, inclusion, and social status."[113] We can see Truth's inclusion of this photograph, then, as her staging of an aspiration toward Black citizenship for her grandson that might even drift into her own enunciation of citizenship rights, at least within a virtual or symbolic social community. Azoulay writes that women's citizenship status is impaired under most forms of rule, but also that "when an injured person tries to address others through a photograph, she is becoming a citizen in the citizenry of photography."[114] If citizenship rights could be extended to her grandson, might they also one day be extended to *her* and other Black women? In other words, the "citizenship of photography" might eventually extend out from the photograph to society itself.

The picture-within-the-picture of her grandson also speaks to contemporaneous conflicts about the status and treatment of Black soldiers. African Americans who fought for the Union were underpaid, denied commissions, and often had to endure racist violence; they also suffered an astronomically high rate of death due to the dangerous missions they were given, poor health facilities, and deplorable living conditions in their encampments. If we watch this photograph carefully and investigate the picture-within-the-picture, then, we can see Truth reminding viewers of these facts. This is a personally wounding detail that might hurt a viewer who has lost a relative or friend in the war, yet it is part of the larger political story and context, the historical background, of the picture as a whole—a backdrop in which the service of Black soldiers to the Union demanded greater recognition.

Truth was sophisticated in her manipulation of objects that could function as both personal and political objects. In this regard, a series of portraits in which she knits is particularly intriguing. Truth liked to knit and had even taught other women this skill; in this sense, her knitting functions as a personal

detail. Knitting was also an element of middle-class femininity and domesticity and has been interpreted as an aspect of her motherliness.[115] Knitting therefore represents Truth's public performance of a status denied to Black women, who were configured in the nineteenth century as slaves, servants, or even animals. In photographs where Truth knits, she is usually surrounded by other accoutrements of domesticity, such as books, flowers, and a white shawl and cap (see Figure 1.16). Truth sits in an elaborately carved chair and there are heavy draperies in the right-hand side of the picture, symbols of middle-class gentility. She wears glasses that perhaps to some degree shield her eyes from a direct gaze by the viewer, but she looks at us with a slight tilt to her head. In another context, Campt argues that recognizing a possibility of an enslaved or formerly enslaved person's ability to possess a gaze does not mean granting her the power of dominance, but it does allow for the possibility of agency, resistance, and opposition.[116] In this photograph, Truth's persona appears to gaze back at a viewer with a direct look that grants her a degree of resistance to being merely the object of a white gaze.

Yet what happens if we *watch* Truth knitting in this photograph as an active performance, rather than seeing it as only a static event? What we might notice if we actively watch the photograph is that that the ball of yarn is twisted into a tangle and even into the fringes of her shawl; it would not feed easily into her knitting needles. The detail of the twisted yarn is repeated in many of the photographs from this era, so what might it symbolize?[117] Given the date (1864–1865), the Union had already been unraveling for several years (since 1861) because of the Civil War. Moreover, in the last few years of the war, heated debates disrupted Lincoln's Republican Party and the nation over the status of African American Civil War soldiers who served under horrific conditions, as previously mentioned. In New York, when soldiers protested all of this, a series of draft riots broke out, and Black soldiers were maimed, wounded, or killed. Beyond this, there was great conflict over the status of now freed, formerly enslaved individuals (in states in the South that the North had taken), with some politicians suggesting that they could go free and others (horrifically) that they stay with their enslavers until the conclusion of the war. Debates about colonization—the idea of sending former slaves to Africa, which Lincoln at the time endorsed—also agitated the nation. Then, too, many controversies about voting rights and citizenship roiled the political landscape. The messy yarn in Truth's photographs may allude to such controversies, and questions about whether the nation, now unraveled by war and controversy, could ever be made whole again, or knit back together. Moreover, such photographs, if taken after Lincoln's death on April 15, 1865, could also allude to fear for the safety of the nation under the disastrous presidency of Lincoln's vice president, Andrew

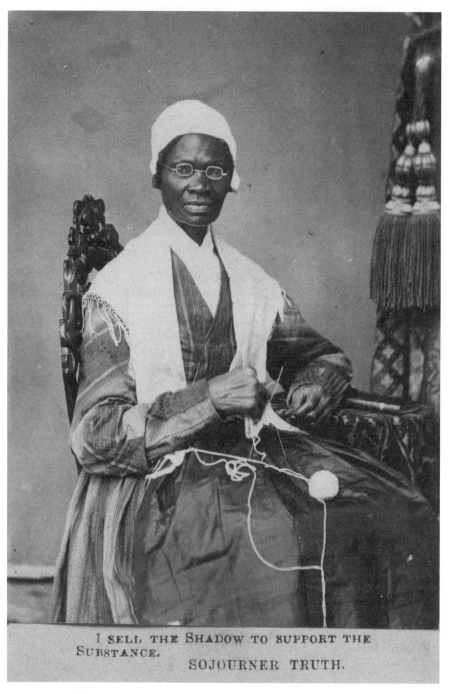

I SELL THE SHADOW TO SUPPORT THE
SUBSTANCE.
SOJOURNER TRUTH.

Figure 1.16. Photograph of Sojourner Truth, 1865. Albumen silver print; National Portrait Gallery, Smithsonian Institution.

Johnson, an avowed white supremacist who advocated for the disenfranchisement of African Americans and the lenient treatment of former Confederate generals. In photographs of Truth from long after the war and Johnson's presidency, taken for example in the 1880s, the unspooled yarn is absent, although we do see the seated pose, elaborate accoutrements of middle-class domesticity, and her motto.[118]

Like the unraveling ball of yarn, there is also a symbolic and metaphorical quality to the caption on the photograph that we must watch and *hear*. Truth writes to Mary Gage in a letter dated February 25, 1864, "They will see by my card that I sell the shadow to support the substance."[119] Theorists of visual media argue that captions on illustrations function like authors' voice-overs: they usually encourage a particular interpretation of a picture.[120] But Truth's motto ("I sell the shadow to support the substance") may not push forward a specific conceptualization of her image; it may instead propose a series of topics to ponder. The most overt reading is that she sells a simulacrum of herself—the photograph— to support the substance (the internal self or soul). Yet other critics argue that because in religious contexts (with which Truth was very familiar) the shadow was associated with the soul (not the body), Truth could be making the point that she is selling her soul to support her physical self (her body).[121] Still others have postulated that Truth implies that she sells her external (Black) self, which is a shadow of her true essence, to support her real internal identity. Augusta Rohrbach argues that "shadow" in this formulation can be understood as physical race; Truth therefore engages in a "race trade" in which images of herself became marketable items, things that could be bought and sold.[122] But this phrase is opaque, and we must remember that in the end Truth sells a photograph of herself, or of something viewers assume is her "real" self; in a trickster-like fashion, Truth plays with the idea that people believe they own other people, by way of either slavery or photography. Visibility may sometimes be a trap, but her motto complicates this idea by implying that the "real" Truth (the substance of her identity) is not caught in her photographs; her real self exists somewhere beyond, or perhaps outside of, this visual space. She pushes a viewer who owns or views one of these *cartes de visite* to contemplate the relationship between the external self in the photograph and the internal person, between soul and body, shadow and substance, "reality" and a depiction of reality. Moreover, if we hear this motto as words, we also bring in another sensory register—of sound—which also might complicate and vex a purely visual understanding of this photograph.

Painter (among others) has argued that Truth used photography for empowerment and to "present the images of herself that she wanted remembered."[123] Yet something more complicated occurs when we contemplate this caption and even *listen* to it, as Fred Moten has encouraged viewers to do when looking at

images of African Americans. Moten asks us to engage in forms of looking that pay attention to the whole sensual ensemble of what is looked at, because the meaning of a photograph is sometimes "cut and augmented by a sound or noise that surrounds or pierces its frame."[124] If we listen to this ambiguous phrase, what does it tell us not only about Truth, but about the conditions of her photographic visibility? About civil rights activist and entertainer Josephine Baker, Anne Anlin Cheng comments that her "iconography is most intriguing when it disrupts the conditions of its own visibility."[125] If we listen to this motto, if we really try to *hear* it in our heads, it may cut or interfere with the smooth processing or enjoyment of her picture, creating a type of static that distorts an easy reading of her image. The bold, blocky, capitalized letters of the caption are spatially set between the image of Truth and Truth's name, as a possible bar or barrier to connecting the two unambiguously; these words are visual (we see them as they comment on the picture), linguistic (being written in language), and auditory (if we hear them). By operating on so many different registers (of sight and of sound), the motto critiques a reader's desire for visual or racial certainty and complicates an easy processing of this image as one merely of representation.

This motto is a troubling presence that resists being caught up within this visual domain. So much confusion is created by the motto, in fact, that it can stop a viewer dead in his or her analysis of the image, as I found when discussing these images with several classes, both graduate and undergraduate. Students were quick to comment on the meaning of Truth's cap, shawl, chair, facial expressions, and so on. But when I asked what the motto meant and how it connected to the photographs, for several moments there was a contemplative silence. As viewers ponder the domain of shadow and substance, they are forced to reflect more on the subtle and covert meaning of photography—what it captures, and what it leaves unspoken and ambiguous—via the motto and its multiple meanings within the frame of the image.

Certainly, Douglass and Truth utilized their photographs to perform dignified images of themselves that contradicted the visual politics of both white abolition and the minstrel show; they also laced their photographs with political messages and used them to demand recognition of their symbolic citizenship. Yet in photographs that portray (for example) Douglass's turned back or Truth's complex motto, they also undermine what Neary has termed an "evidentiary paradigm of visuality"[126] in which photographs or other visual materials substantiate the humanity of formerly enslaved individuals. Truth and Douglass also deploy their photographs to perform various personae that critique the dominant society's desire to capture, know, or surveil the formerly enslaved individual. There is a trickster-like quality to the way that they embed complex symbolic items with subversive messages in the visual frames, such as Lincoln's

cane or the unraveling ball of yarn. As we have seen, photographs were deployed by abolitionists to protest slavery, but many of them symbolically re-enslave the individuals depicted. In Douglass's and Truth's photographic work, there is resistance to symbolic re-enslavement within visual media. Visibility, as practiced by Douglass and Truth, becomes not a trap (*pace* Foucault) but a way to query photographic representation and gesture to new forms of partnership with a spectator that might be more imagined than real. Like Wells Brown and Ellen Craft, neither Douglass nor Truth was precisely "caught" by visual representations of them. Instead, if we watch these images carefully they may exist for the viewer somewhere between shadow and substance, between the real world in which these individuals are still disenfranchised and a more symbolic or even virtual world where their human and civil rights have been recognized, if not yet enacted.

Conclusion

Leading African American abolitionists such as the Crafts, Wells Brown, Douglass, and Truth played with the visuality of enslavement, creating visual static and personae for themselves that they performed in portraits, panoramas, illustrations, and photographs. All these individuals are trickster-like and canny in their manipulation of visual genres and use modes of masking and disguise to veil and cover their identities, while forwarding subversive messages about whether the viewer can grasp their "true" selves.

Like these individuals, Box Brown created personae for himself that had subversive social and even political content. But he took these personae out of the enclosed space of the abolitionist circuit, performing on the stage in at least one drama in which he played "Henry Brown," and roaming the streets of England dressed as an African prince or a "Savage Indian." Ultimately, Box Brown's showmanship was one of the reasons he was ousted from the circles of abolitionism proper. Box Brown was also shunned in abolitionist circles because he was perceived as turning slavery into entertainment. The Crafts, Wells Brown, Douglass, and Truth performed identities within various visual genres without turning themselves into spectacles. Yet it seems that it was not so much a matter of a different type of representation that set Box Brown off from other abolitionists. Rather Box Brown pushed too hard and overtly against the idea that he could *ever* be represented or caught in a net of racialized surveillance, creating not educational visual representations of slavery but spectacular, hugely entertaining ones. Slavery became, in Box Brown's hands, a lucrative toy that he could manipulate, and his story became one of grander and grander illusions, as we will see in the next few chapters of this book.

Becoming Box Brown, 1815–1857

In 1849, devastated by the sale of his pregnant wife and three children to a slaveholder who planned to take them to North Carolina, where he would presumably never see them again, Henry Box Brown poured sulfuric acid onto his hand, burning his finger so that it was "soon eaten through to the bone."[1] This was not, however, a desperate act of self-maiming but a careful part of his escape-by-box. Brown already had an injured hand, but the overseer for whom he worked did not think it was severe enough to absent him from work. With the help of two men—a white shoemaker and shopkeeper named Samuel Smith and a free African American named James C. A. Smith—Brown already had purchased from a carpenter the postal crate in which he would make his escape, but he needed time to prepare for his journey and to have his absence from work go unnoticed. So, he burned his hand to the bone and showed it to the overseer, receiving what he terms a "precious furlough" from work. In this instance, Brown made his body into a medium that he could employ literally and symbolically to enact his own liberation; onto this stage, he "writes" in acid a script for his own freedom.

This would not be the first or last time that Brown would use his body in a performative manner. After his infamous escape-by-box in 1849, he became known as Henry Box Brown, but later he would perform with his "original box," climbing into and out of it (or a replica of it) onstage in front of audiences as late as 1877 (see Chapter 5). This bit of performance work—using a three-foot by two-foot box shipped by Adams Express, in which he could have suffocated or been retaken into slavery, as part of his stage act—might seem audacious, daring, and even a bit macabre. Yet from an early date Brown's life was shot through with spectacle and with daring moments of pushing even

beyond the performances of identity developed by William and Ellen Craft, William Wells Brown, Frederick Douglass, and Sojourner Truth. Box Brown created multiple personae and even moved past the facts of his own life, deliberately becoming a kind of spectacle. As discussed in the previous chapter, other abolitionists performed the events of their lives, escapes, and identities with subversive self-fashioning and critiqued visuality. However, Brown took these types of performances over some sort of symbolic line, to the point where his displays were viewed as more fictive than real, more spectacular than true or educational.

This chapter examines how Brown repeatedly stage-managed, performed, and recreated his own life in his 1851 narrative, early shows, and first two panoramas. I focus primarily on the period from his birth (1815 or 1816) to 1857, when he began performing on the British stage as an actor (the period from 1857 to his death in 1897 is detailed in later chapters). I watch how the fugitive slave transformed into the famous "Box Brown"—a man invested in the idea of staging more and more elaborate shows, in part for financial reasons, but also for symbolic ones. Some historians have argued that slavery is an ongoing trauma that can never be escaped; what Christina Sharpe calls the "wake of slavery" persists not only in cultural memory but in the treatment of African Americans via racist behavior, police surveillance, and incarceration.[2] It is vital to keep this in mind when considering whether Brown "escaped" his history of enslavement. Brown's earliest performances allowed him to turn slavery into a performative spectacle, but one that he could manipulate and remake for his own social and economic benefit; yet it is not clear that they constituted a psychic break from the afterlives of slavery. Instead, we must see his performances as "wake work" that aesthetically ruptures the representation of enslavement without necessarily creating permanent liberation for the enslaved or formerly enslaved persona.

Daphne Brooks contends that Brown's panorama "transcended the discursive restrictions of the slave narrative and redirected the uses of the transatlantic body toward politically insurgent ends."[3] Yet critics such as Brooks and others have not investigated the multiple performance modes that Brown manipulated into the late 1850s, including his deployment of panoramas of *Uncle Tom's Cabin*. I argue here and in the next chapters that Brown's performance modes did not fashion a transcendence of depictions of enslaved selfhood, but instead rendered them as permeable and open spectacles and performance terrains; within these performative spectacles he could exert power over enslavement via the manipulation of an embodied incarnation—not Brown himself, but his stage personae. These personae also create visual static about

whether a viewer can ever "capture" the "real" Box Brown by blurring, multiplying, and distorting his image.[4]

I start, however, by examining in more detail a term that is important in this study—the idea of spectacle. Many dictionaries define spectacle in terms of two aspects: something that is exhibited *visually* as unusual, notable, or entertaining, and something that has the potential to be an object of *contempt or curiosity*.[5] Douglass and Truth, as we have seen, used visual representations of themselves (and their own physical bodies) to stage various social and political messages. Wells Brown displayed, after his panorama, the actual metal torture collar worn by an enslaved woman, perhaps giving in to some viewers' voyeuristic desire to be aroused by pain and punishment. And the Crafts' image of Ellen in drag as an in/valid master might have visually titillated or amused nineteenth-century viewers. These individuals had an astute sense of how to manipulate visual media, to use them to create multiple messages, and to partially slip free from being surveilled by the dominant viewer. Yet they were not considered spectacles, whereas Brown was. Why?

Amy Hughes offers a theory of spectacle that helps apprehend why Brown's displays and exhibitions of slavery, magic, and mesmerism were considered more outlandish than those of other formerly enslaved individuals. Spectacles are often defined against those cultural norms that are destabilized in the process of representation, especially regarding the spectacle of the body. Hughes defines spectacle more specifically as a violation of a *visual* norm; visual spectacles exceed the accepted customs for the representation of the human body.[6] Spectators' amazement as they watch Brown's emergence as a *living man* from inside the box implies that the escape-by-box is already a visual spectacle, even from its earliest incarnation. For example, in a print by Langton that accompanied Brown's *Narrative of the Life of Henry Box Brown, Written by Himself* (1851), Brown's onlookers and especially the man on the right appear astounded by his miraculous unboxing (see Figure 2.1).

Intensity and excess, for Hughes, are other aspects of spectacle.[7] As already discussed, the viewing of pitiful, enslaved bodies was a key part of abolitionist visual propaganda; these bodies were intensely marked with scars and suffering and contained a superabundance of evidence of the harm of slavery. Brown recognized that slavery was often presented as a spectacle in which the intensity and excess of the torment of enslaved bodies was meant to elicit a white viewer's pity. In his narrative and in his early performance works, he tries to make himself an object of spectacle via various personae but also an individual in charge of the spectacle of his life, one who regulated its visual excess and intensity. He sought not merely to be a spectacle but to use spectacle to his psychological or

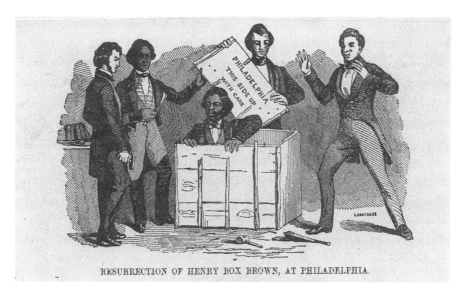

RESURRECTION OF HENRY BOX BROWN, AT PHILADELPHIA.

Figure 2.1. Frontispiece to 1851 *Narrative of the Life of Henry Box Brown, Written by Himself. Documenting the American South*, https://www.docsouth.unc.edu/neh /brownbox/brownbox.html.

financial advantage by staging it over and over, multiplying his personae, and performing it in a manner that granted him visual dominion.

A Spectacular Life: *The Narrative of Henry Box Brown* (1851)

Even before his escape-by-box, Brown's life was spectacular in many ways, as his 1851 autobiography shows. Two versions of Brown's life exist: one written and edited by Charles Stearns in 1849 (and published in the US) and one that was authored by Brown and published in England in 1851, where Brown was legally free (England had abolished slavery in 1833). I focus on the 1851 autobiography for several reasons. First, Brown claims it was "written by himself."[8] Second, whereas the 1849 narrative in many ways keeps Brown imprisoned and entombed in his history, the 1851 version allows him more narrative voice and agency, as John Ernest has suggested.[9] Finally, I examine this version of Brown's life because it is most performative and visual, and because in it Brown takes command over the spectacle of his enslavement.[10]

Brown was born in 1815 or 1816 in Louisa County, near Richmond, VA, and lived his first thirty-three or thirty-four years in slavery, before escaping in 1849.

Brown does not appear from his own biography to have been physically abused under slavery. He was fed and decently clothed by his first enslaver, John Barret, which caused amazement in the minds of other enslaved individuals. Moreover, while many enslaved people never knew their family, Brown's early years were spent with his parents and his four sisters and three brothers. Nonetheless, Brown's narrative manifests his understanding of the spectacular quality of slavery—the way it was traumatic, both psychologically and visually—and this may have shaped his desire to stage-manage this spectacle through perfor-mance. For example, he meets a group of slaves that he describes as "abject" because they have little food or clothing and no knowledge of their relatives. Brown also delineates the actions of "licentious" slaveholders who keep slaves as mistresses and narrates at least one brutal whipping in highly visual terms.[11] In recounting his own life, at this juncture Brown seems to be just outside the visual and psychic horror of slavery, rather than within its objectifying grip.

This changes dramatically in 1830, when Brown's first enslaver dies, bequeath-ing his property to his four sons, who divide it among themselves. Brown is only fifteen or so at this time, but in 1851 (more than twenty years later) he narrates these events "as present in my mind as if but yesterday's sun had shone upon the dreadful exhibition."[12] By using the word "exhibition" Brown highlights the spectacular, visual quality of these occurrences, but he goes on to clarify their excess and intensity: "My mother was separated from her youngest child, and it was not till after she had begged most piteously for its restoration, that she was allowed to give it one farewell embrace, before she had to let it go for ever." Re-counting this in 1851, Brown notates that this visual trauma is etched into his memory:

> This kind of torture is a thousand fold more cruel and barbarous than the use of the lash which lacerates the back; the gashes which the whip, or the cow skin makes may heal, and the place which was marked, in a little while, may cease to exhibit the signs of what it had endured.... [The] pangs which lacerate the soul ... only grow deeper and more piercing, as memory fetches from a greater distance the horrid acts by which they have been produced.[13]

Memories become a source of trauma, as the visual spectacle is fetched from within the mind's eye. This spectacle stays with the formerly enslaved person and in fact returns with "increasing force and vividness"; even long afterward "the mind retains the memoranda of the agonies of former years."[14] Enslavers claim that the enslaved do not feel this pain,[15] but Brown counteracts this idea by indicating that he, like other enslaved individuals, deeply felt the terrible

agony of the separation; moreover such traumas are made more painful by their specifically visual nature. Yet in narrating these painful memories, Brown begins the challenging memory work of shaping and garnering a degree of control over them.

In this division of property, Brown was bequeathed to Barret's son William and sent to Richmond to work in a chewing-tobacco factory. Brown's siblings were sent to various plantations, except for his sister Martha, who, according to Brown, became William Barret's "keep miss,"[16] an ambiguous phrase that could imply housekeeping or sexual assault and enslavement. In Richmond, Brown met his first wife, Nancy, and the two married in 1836. Brown also learned to be an excellent tobacco maker and earned enough money by working overtime to set up his family in their own home. Nancy's enslaver Mr. Cottrell, though, extorted more and more money from Brown for Nancy's board and the hiring out of her time. Then, in 1847 or 1848, when Brown was thirty-two or thirty-three years old, Nancy's enslaver abruptly sold her and their three children to a man living in North Carolina; Nancy was pregnant with the couple's fourth child. All the furniture in Brown's house (which he had paid for) was even taken (illegally), and Brown was given no formal opportunity to say goodbye to his family; in fact, he was told that he would be arrested if he visited them while they were in the county jail awaiting relocation to North Carolina. When Brown sent a friend with a message for Nancy, this friend was arrested in his stead, a series of events that would be reworked almost a decade later when Brown acted (in England) in the play *The Fugitive Free*.

Brown managed to say goodbye to his family while they were enchained in several wagons. Brown, his wife, and children are pitiful and pathetic objects within a visual spectacle, but it must be comprehended that this is Brown's remembrance and shaping of these events and his narration of them three or four years after they have occurred. I quote this scene in detail to show the way it utilizes the emotional impact and intensity of visual spectacle; Brown deliberately narrates the separation in highly emotional and charged language that places Brown in the role (first) of observer of the spectacle of misery:

> I . . . placed myself by the side of a street, and soon had the melancholy satisfaction of witnessing the approach of a gang of slaves, amounting to three hundred and fifty in number. . . . These beings were marched with ropes about their necks, and staples on their arms. . . . This train of beings was accompanied by a number of wagons loaded with little children of many different families, which as they appeared rent the air with their shrieks and cries and vain endeavors to resist the separation which was thus forced upon them, and the cords with which they were thus bound.[17]

The oddly chosen phrase here—Brown has the "melancholy satisfaction" of see-ing the huge spectacle of three hundred and fifty people chained together for sale and hearing the shrieks and cries of the children—perhaps implies that Brown is outside the spectacle. But then the sight of his own children plunges him deeply within it: "What should I now see in the very foremost wagon but a little child looking towards me and pitifully calling, father! father! This was my eldest child, and I was obliged to look upon it for the last time that I should, perhaps, ever see it again in life; if it had been going to the grave . . . my grief would have been nothing in comparison to what I then felt."[18] Brown perhaps models a process where a reader who is initially outside the spectacle of enslave-ment is suddenly plunged into its painful center. Brown feels more grief in this moment than if he had been at a funeral procession for his child, and the dark and somber imagery implies that slavery is a living death worse in some ways than a physical one. It is, as he says, a scene of "unusual horror," a macabre and grim entrance into the living agony of memory that his life will become.

The trauma of memory again becomes a central topic when Brown narrates the unspeakable pain of his separation from his wife, Nancy, who is also "loaded with chains." He sees her "precious face," but her "glance of agony" is too much for him:

> That glance of agony may God spare me from ever again enduring! My wife, under the influence of her feelings, jumped aside; I seized hold of her hand while my mind felt unutterable things, and my tongue was only able to say, we shall meet in heaven! I went with her for about four miles hand in hand, but both our hearts were so overpowered with feeling that we could say nothing, and when at last we were obliged to part, the look of mutual love which we exchanged was all the token which we could give each other that we should yet meet in heaven.[19]

Brown focuses on the traumatic impact of what he witnesses here. Yet the looks the couple exchange may be read as a visual trace of their resistance to the dehu-manization of the events. Because the two are finally outside of language— "unable to speak"—a visual practice (the "look of mutual love") must stand in for the words they would say. Visuality is here employed to denote the failure of language and is vital to comprehending this trauma.

In the earlier account of his life from 1849, written by Charles Stearns, the parting from Nancy is much shorter—only one paragraph.[20] Brown's later nar-ration of events deliberately prolongs the scene, making of it a spectacle that is in excess of the dominant culture's understanding of enslaved subjectivity.

Certainly, he wants to create empathy, and Brown also employs sentimental discourse to appeal to the reader's pity: "My agony was now complete . . . and I must continue, desolate and alone, to drag my chains through the world."[21] Penned in 1851 while Brown was legally free in England, this sentence points to the ongoing status of the fugitive as never-quite-free; Brown's comment that he must "continue . . . to drag my chains through the world forever" speaks to his unfree state. Hughes writes that in a culture that enforces normalcy, moderation, and efficiency, excess is viewed as abnormal and undisciplined; spectacles therefore can deny the power of the dominant culture's control over specific types of bodies. Bold, self-conscious displays of bodies in extremity are, in her view, "inherently radical" as well as political because they reject the dominant culture's regimes of control over the body.[22] Saidiya Hartman makes a similar point when she discusses the ways that, under slavery, individuals still found modes of resistance via everyday practices such as "stealing away from the master, and 'performance' itself." Hartman also notes that the pain of African Americans under slavery (whether physical or psychological) has been "largely unspoken" due to the "sheer denial of black sentience" and the "purported immunity of blacks to pain." Brown's long depiction of the pain he feels can be read as an act of resistance that uses spectacle; in other words, Brown here narrates and manages what Hartman terms "the history that hurts."[23]

As we have seen, Brown recounts in detail the horror of the separation of the family. However, there are moments in his narrative when Brown seems to be trying to turn the spectacle around, to make himself both an object of spectacle and also an individual *in charge* of the spectacle of his life, one who manipulates its visual excess and intensity for his own purposes. About Frederick Douglass, critics have argued that he finds a mode of selfhood that involves making himself an object (objectification). Viewing the self as an object, Ginger Hill has argued, was fundamental to conceiving new forms of identity. Photographic visuality functions, then, not only via objectification but also to enable different modes of selfhood.[24] Douglass writes that "the process by which man is able to *possess* his own subjective nature outside of himself, giving it forms, color, space, and all the attributes of distinct personalities, so that it becomes the subject of distinct observation and contemplation is at [the] bottom of all efforts, and the germinating principle of all reform and all progress."[25] In other words, making oneself the subject of observation can lead to social progress and even dominion over processes of objectification. Brown's detailed narration of the spectacle of separation can be understood as a kind of performance work that shares photography's ability to allow an individual to possess his own subjective experience via externalization of it (in different forms, colors, and spaces).

Brown's narrative may be an attempt to find a mode of personhood in objectification—and to turn spectacle around so that it becomes a performative arena for the creation of an early Brown persona. This process begins shortly after the family's sale, with the boxing act. Brown makes the decision to escape and contacts a free Black man named James Smith; Brown describes Smith as a local "conductor of the under-ground railway." Brown's interactions with James Smith are facilitated by their singing together in a choir in the First African Church in Richmond. In one pivotal scene in the 1851 narrative, while Brown and James Smith are singing in church they both have revelations about the horrors of slavery, especially given that the church is led by a white preacher with substantial connections to slavery and that they are singing in a benefit concert to raise funds for this church.[26] Smith stops singing abruptly and sinks down to his seat with tears in his eyes, and Brown makes up his mind to never again help his church. It is just after this incident that Brown resolves to make his escape.

Yet no plan seems feasible until the box idea comes to Brown while he is praying, as he narrates:

> One day, while I was at work, and my thoughts were eagerly feasting upon the idea of freedom, I felt my soul called out to heaven to breathe a prayer to Almighty God. I prayed fervently that he who seeth in secret and knew the inmost desires of my heart, would lend me his aid in bursting my fetters asunder, and in restoring me to the possession of those rights, of which men had robbed me; when the idea suddenly flashed across my mind of shutting myself up in a box, and getting myself conveyed as dry goods to a free state.[27]

The language is highly pictorial and even sensual; Brown has a sort of vision as he is "feasting upon the idea of freedom"—and freedom is here depicted as a type of nourishment. His vision entails literalizing his status as property: he imagines turning himself into "dry goods" to be "conveyed" metaphorically and literally "to a free state."

The symbolic overtones of death and rebirth are already manifest in the boxing scheme, as well; Brown states that he is "willing to dare even death itself rather than endure any longer the clanking of those galling chains [of slavery]."[28] Brown procures a box that is three feet one inch wide, two feet six inches high, and two feet wide, and on the morning of March 23, 1849, goes into the box with only a bladder of water and a gimlet in case he needs to bore more holes into the box (he has already created three out of which to breathe). Then, "being thus

equipped for the battle of liberty, my friends nailed down the lid and had me conveyed to the Express Office."

As previously discussed, Brown configures the box as both tomb (where he could die) and womb (where he could be reborn as a free man). Instead of drinking the water he has brought, Brown pours it onto himself to stay cool, so that he exits the box covered in this fluid, like an infant leaving his mother's womb; the water therefore symbolizes aspects of birth (the water of the womb, the fluid of the birthing process) and his birth into freedom (or so he thinks). On the other hand, the nailing down of the lid symbolizes death (the sealing of a body into a coffin). Brown's status during this voyage fluctuates between box and man, a dead thing and a living person, as he literally passes as a piece of luggage, calling himself at various times "baggage" and worrying that "death was about to terminate my earthly miseries."

Brown represents himself suffering a near-death experience when the box is turned upside down and he is placed on his head for an hour and a half: "I felt my eyes swelling as if they would burst from their sockets. . . . I felt a cold sweat coming over me which seemed to be a warning that death was about to terminate my earthly miseries." Brown is on his head, like a child coming down a birth canal; but he cries out to God like an infant and his "cry was soon heard."[29] His box is finally turned on its side when two men need a place to sit. After a few more painful stretches of the voyage in which his box is tumbled around and his neck is badly injured, he reaches Philadelphia and is delivered to the house of James Miller McKim, a leader of the Pennsylvania Anti-Slavery Society who had been active in Underground Railroad activities.

When Brown emerges from his box the overtones of death and resurrection are even stronger. In a scene that has hints of a spiritualism séance, the men at McKim's house rap on the box to see if Brown is alive:

> Immediately a rap ensued and a voice said, tremblingly, "Is all right within?" to which I replied—"all right." The joy of the friends was very great; when they heard that I was alive they soon managed to break open the box, and then came my resurrection from the grave of slavery. I rose a freeman, but I was too weak, by reason of long confinement in that box, to be able to stand, so I immediately swooned away.[30]

He has his "resurrection from the grave of slavery," arises as a "freeman," but immediately faints. He depicts a rising and falling movement, a transition into and out of the deathly thingness of slavery and into identity as a freeman. In his preface to Brown's 1851 narrative, McKim emphasizes the spectacle of this emergence:

"I consider it one of the most remarkable exploits on record. . . . I confess, if I had not myself been present at the opening of the box on its arrival, and had not witnessed with my own eyes, your resurrection from your living tomb, I should have been strongly disposed to question the truth of the story." Brown's story is already fabulous, "a tale scarcely to be believed,"[31] a miraculous rebirth from the living tomb of slavery.

Brown's narrative manifests awareness of the ways in which the visual realm was meant to disempower him—he was viewed as an abject thing under slavery, and a miraculous spectacle after his escape-by-box. Yet Brown also apprehends from his early days that he could manipulate the spectacle and the visual realm by his performance of it and perhaps, even more tantalizingly, by using magic. The claim has been made that Brown knew magic and performed it under slavery. In *Magical Heroes*, Jim Magus quotes an African American magician who maintained that he knew Brown and that Brown claimed to learn secrets of "sleight of hand" from an enslaved man called Tricky Sam when Brown was nine years old; Tricky Sam knew "secrets of conjuring and misdirection."[32] As an adult, Brown "developed a reputation for being the area's Tricky Sam" and would do conjuring tricks such as holding a nail in his hand and then magically metamorphosing it into an acorn.[33] While Magus's sources are unverified, oral stories have merit when other types of history have been erased. It is tantalizing to consider that even in his early life Brown considered himself a conjurer, and was contemplating ideas about things disappearing and reappearing, or being magically transformed. His escape-by-box can be understood as one of these actual as well as symbolic transformations: like the nail, he could become something else—an acorn or even a living tree. Brown would enter the box as an inhuman thing (a tool) but would magically emerge from it as a living, breathing man.

Exit Box, Singing: The Symbolic Role of Musical Performances in *Narrative of the Life of Henry Box Brown* and in Brown's Earliest Songs

"I had risen as it were from the dead," remarks Brown in his 1851 *Narrative*, as he "burst[s] forth" from his box with a hymn of thanksgiving to the Lord.[34] Music plays a pivotal role in his unboxing, but also in his turning of his escape into a spectacular performance that he could stage-manage in much of his later performance work. Upon his exit from the box, Brown first sings a song based on Psalm 40, which in the Bible begins:

> I waited patiently for the Lord;
> and he inclined unto me, and heard my cry.
> He brought me up also out of an horrible pit, out of the miry clay, and
> set my feet upon a rock, and established my goings.
> And he hath put a new song in my mouth,
> even praise unto our God: many shall see it, and fear, and shall trust in
> the Lord.
> Blessed is that man that maketh the Lord his trust, and respecteth not
> the proud, nor such as turn aside to lies.[35]

Brown significantly condenses and remodels this song for his exit from the box and creates his own lyrics for it, with the following first stanza:

> I waited patiently for the Lord;—
> And he, in kindness to me, heard my calling—
> And he hath put a new song in my mouth—
> Even thanksgiving—even thanksgiving,
> Unto our God.
> Blessed—blessed is the man
> That has set his hope, his hope in the Lord![36]

Brown deletes the verse about how the Lord has "brought me up also out of an horrible pit," which might seem appropriate for his own escape from slavery. Gone also is the idea of fear of the Lord: "many shall see it, and fear, and shall trust in the Lord." The effect is one in which Brown and the Lord appear to have a more intimate and positive spiritual relationship—one in which the Lord hears Brown "calling" and "hath put a new song in my mouth," a song of thanksgiving and hope rather than fear and darkness.

Brown is reported to have sung this piece not only upon exiting the box but also at abolitionist meetings in the US and later in England. Such meetings may have been the first visual–verbal performatives of Brown's resurrection from the death of slavery, because broadsides (large posters) with this psalm and a portrait of Brown's box were created shortly after his escape and distributed at such meetings. The broadside contains the hymn and notes that the psalm was "sung by Mr. Brown on being removed from the box" (see Figure 2.2).

As we will see, music was often an important part of how Brown resisted dominant notions of visuality via an alternative soundscape. Therefore it is intriguing that in this early moment, he has already added vocal work to his repertoire. Brown has not yet published any version of his story in book form, so

Engraving of the Box in which HENRY BOX BROWN escaped from slavery in Richmond, Va.

SONG,

Sung by Mr. Brown on being removed from the box.

I waited patiently for the Lord ;—
And he, in kindness to me, heard my calling—
And he hath put a new song into my mouth—
Even thanksgiving—even thanksgiving—
 Unto our God !

Blessed—blessed is the man
That has set his hope, his hope in the Lord !
O Lord ! my God ! great, great is the wondrous work
 Which thou hast done !

If I should declare them—and speak of them—
They would be more than I am able to express.
I have not kept back thy love, and kindness, and truth,
 From the great congregation !

Withdraw not thou thy mercies from me,
Let thy love, and kindness, and thy truth, alway preserve me—
Let all those that seek thee be joyful and glad !
 Be joyful and glad !

And let such as love thy salvation—
Say always—say always—
The Lord be praised !
 The Lord be praised !

Laing's Steam Press, 1 1-2 Water Street, Boston.

Figure 2.2. "Engraving of the Box in which Henry Box Brown escaped from slavery in Richmond, Va. Song, Sung by Mr. Brown on being removed from the box." Boston Laing's Steam Press, 1-1-2 Water Street, ca. 1849. Library of Congress. https://www.loc.gov/resource/rbpe.06501600/?sp=1.

this song—which he sang at abolitionist meetings in August 1849[37]—was a very early performance of his sentiments upon reaching freedom. The broadside encapsulates the dual sides of Brown's identity at this historical juncture—slave/thing and freeman/Christian. On the one hand, it artistically and compellingly displays a three-dimensional visual image of the box in which he escapes, an item that could be said to represent his entombment within the living death of slavery, as the box here is still strapped shut. On the other hand, the song floating below the box (with ornate and even mobile typography around the word "Song" that sets it apart from the box) transitions the man back into life and functions as a sort of prequel to his unboxing; it forwards the action because it is represented to be the very song "sung by Mr. Brown on being *removed* from the box" (emphasis added). In this song Brown claims spiritual and performative liberation, especially in the last two stanzas; the "new song" in Brown's mouth bespeaks his identity as a freeman and Christian who is loved by God and so can be "joyful and glad" while singing His praises.

In late 1849 or early 1850, Brown also composed lyrics for a second song—"Uncle Ned"—as he writes in his 1851 narrative, "in commemoration of my fete in the box."[38] By calling this a "fete in the box" rather than an ordeal, Brown begins the work of reshaping (via music and language) the spectacle of his escape and its lasting trauma; the word "fete" makes it sound as if Brown underwent not a frightening and harrowing journey but a celebratory voyage. This song recounts his exploits in detail and is a remodeling of a minstrel tune written and composed by Stephen Foster in 1848, as John Ernest and Jeffrey Ruggles note. This song appeared on an attractive and stylish broadside (see Figure 2.3). According to Ruggles, the second song circulated between September 1849 and March 1850.[39] While the first song was largely one of thanksgiving for Brown's successful escape, the second has a stronger narrative thread concerning the man himself. It is possible therefore that this song was the first *full* performative introduction that a US audience had to Brown's escape, as it may have preceded the publication of his narrative.[40]

Either way, the song "Escape from Slavery" reveals much about Brown's ability to subversively restage the spectacle of his escape. The original song by Foster—"Old Ned"—is a racist minstrel tune about a faithful slave who after a life of hard toil with shovel and hoe finally has his "freedom" in death. The song ends with these words: "No more hard work for poor Old Ned—/ He's gone whar de good Niggas go." Brown explicitly remodels the persona of Uncle Ned in his version of the song's lyrics, finding freedom not in death but in escape-by-box:

SONG COMPOSED BY
HENRY BOX BROWN,
— ON HIS —
ESCAPE FROM SLAVERY.

AIR—Uncle Ned.

I.

Here you see a man by the name of Henry Brown,
Ran away from the South to the North,
Which he would not have done but they stole all his rights,
But they 'll never do the like again.
> Chorus—Brown laid down the shovel and the hoe,
> Down in the box he did go,
> No more Slave work for Henry Box Brown,
> In the box by *Express* he did go.

II.

Then the orders they were given and the cars they did start,
Roll along—Roll along—Roll along,
Down to the landing where the steamboat met,
To bear the baggage off to the North.
> Chorus—Brown laid down the shovel and the hoe,
> Down in the box he did go,
> No more Slave work for Henry Box Brown,
> In the box by Express he did go.

III.

When they packed the baggage on they turned him on his head,
There poor Brown liked to have died,
There were passengers on board who wished to set down,
And they turned the box down on its side.
> Chorus—Brown laid down the shovel and the hoe,
> Down in the box he did go,
> No more Slave work for Henry Box Brown,
> In the box by Express he did go.

IV.

When they got to the cars they throwed the box off,
And down upon his head he did fall,
Then he heard his neck crack, and he thought it was broke,
But they never throwed him off any more.
> Chorus—Brown laid down the shovel and the hoe,
> Down in the box he did go,
> No more Slave work for Henry Box Brown,
> In the box by Express he did go.

V.

When he got to Philadelphia they said he was in port,
And Brown he began to feel glad,
And he was taken on the wagon and carried to the place,
And left "this side up with care."
> Chorus—Brown laid down the shovel and the hoe,
> Down in the box he did go,
> No more Slave work for Henry Box Brown,
> In the box by Express he did go.

VI.

The friends gathered round and asked if all was right,
As down on the box they did rap,
Brown answered them saying "yes, all is right,"
He was then set free from his pain.
> Chorus—Brown laid down the shovel and the hoe,
> Down in the box he did go,
> No more Slave work for Henry Box Brown,
> In the box by the Express he did go.

Figure 2.3. 1849 or 1850 representation of a second song by Brown. Brown University, https://repository.library.brown.edu/studio/item/bdr:266747/.

Here you see a man by the name of Henry Brown,
Ran away from the South to the North;
Which he would not have done but they stole all his rights,
But they'll never do the like again.
 Chorus—Brown laid down the shovel and the hoe,
 Down in the box he did go;
 No more Slave work for Henry Box Brown,
 In the box by *Express* he did go.
Then the orders they were given and the cars did start,
Roll along—Roll along—Roll along,
Down to the landing, where the steamboat met,
To bear the baggage off to the North.

Brown's lyrics play with the symbolism surrounding man/thing via the line "down to the landing . . . to bear the baggage off to the North." He insubordinately co-opts the construction of faithful old Uncle Ned laying down his work only in death: Brown lays down his shovel and hoe to go into a "box," but not the box of the coffin—instead, he enters the resurrectionary womb/tomb of the postal crate. Then in the final lines of the song, he revises his emergence from the box; in this iteration he exits without fainting and is set free:

The friends gathered round and asked if all was right,
As down on the box they did rap,
Brown answered them, saying; "yes all is right!"
He was then set free from his pain.

Brown's song emphasizes his agency and resiliency—both his past ability to make the decision to throw down his shovel and hoe to escape the regime of slavery, and his current ability to answer his friends with the phrase "yes all is right!" and be "set free from his pain." It is fascinating to think about abolitionists singing the words of the chorus, clearly set on the song sheet in a way that emphasized that they should be sung *with* the singer. Brown is already asking his audience to become part of his story, and even placing them sonically into the spectacle of his own enslavement through the words they would sing, such as "No more Slave work for Henry Box Brown, / In the box by *Express* he did go."

Brown's two songs—the revision of "Old Ned" and the "Thanksgiving Hymn"—circulated in different forms, but never with a drawing of Brown himself; in a certain sense, then, his voice was protectively separated from his body at this juncture. Brown's songs may have had a subversive performative function and allowed him to steal back his body and his identity, previously possessed by

his enslaver. As mentioned, Hartman has remarked on the phenomenon of enslaved individuals finding symbolic redress or reparation via various modes of psychic or physical freedom such as stealing back their time from their enslavers, stealing away to spaces beyond the enslaver's authority, controlling their sexuality, or making music.[41] Perhaps, then, Brown's songs allow him to "steal back" some aspects of his experience under enslavement. In his 1851 narrative, Brown mentions an enslaver named Allen who brutally punishes an enslaved man for singing.[42] The psychic threat that music represented is apparent not only to Allen, but also to Brown. Moreover, as we have seen, music was pivotal in Brown's interactions with the free African American man who helped him to escape—James Smith; so that potential of music to be an enabler of modes of freedom and certain kinds of "wake work" was apparent to Brown. Brown makes the liberating aspects of music evident in his rewriting of "Old Ned."

Moreover, if we consider how these songs crafted images in the public's mind of Brown in 1849 and 1850, his persona is already multifaceted. In the lyrics of these songs, there is a man who waits "patiently" for the Lord to set him free and one who actively devises an ingenious escape plan, throws down his shovel, and almost gleefully consents to become baggage. Because these songs were often printed side-by-side, on large song sheets, the contrast might have been apparent to audiences singing these songs.[43] Brown's lyrics create a type of sonic static about who he *really* is and whether a viewer can spectate and capture his identity, as he begins to perform alternative and even contradictory versions of his personae.[44]

New Images of Box Brown and His Evolving Role as an Abolitionist Speaker

In 1849–1850, music was therefore crucial to Brown's crafting of a persona that moved beyond the flatness of stereotypical portraits of the enslaved. Music also allowed Brown to craft an identity that deviated from the physical portraits of Brown and his box that were beginning to circulate. Brown's first narrative about his life (authored by Charles Stearns) was published in September 1849 and had the lumbering and pedantic title *Narrative of Henry Box Brown, Who Escaped from Slavery, Enclosed in a Box 3 Feet Long and 2 Wide. Written from a Statement of Facts Made by Himself. With Remarks Upon the Remedy for Slavery.* This edition of Brown's story contained two illustrations—a frontispiece portrait of Brown at the start (Figure 2.4) and a rendition of his famous box (see Figure 2.5) at the conclusion.

Figure 2.4. Frontispiece to *Narrative of Henry Box Brown, Who Escaped from Slavery Enclosed in a Box 3 Feet Long and 2 Wide. Written from a Statement of Facts Made by Himself. With Remarks upon the Remedy for Slavery. By Charles Stearns* (1849). *Documenting the American South.* https://docsouth.unc.edu /neh/boxbrown/menu .html.

In the 1849 portrait in Stearns's narrative, Brown looks off to his left, and this gives him a somewhat untrustworthy look; his jacket is unbuttoned in a slovenly way, and his vest strains at its button, suggesting corpulence. His arms are posed at an awkward angle and he appears to be slouching in the chair. This is an almost stereotypical image, in short, of a Black man who looks a bit shifty. Moreover, the rendering of Brown's box in the 1849 edition has Stearns's tedious and long-winded sentences, not Brown's songs (as on the song sheets), emblazoned at the top and bottom of the drawing. The box is closed; we do not see Brown exiting the box, as in some of the lithographs and engravings that would appear in the early 1850s. As Brooks states about this image, "Brown is present and yet discursively entombed, forced underground into a manhole of his own making."[45] Moreover, in one of the comments above the illustration, Brown is called merely "a fellow mortal" who "travelled a long journey" in his box; his potential for creativity and agency is eclipsed by the material artifact of the box

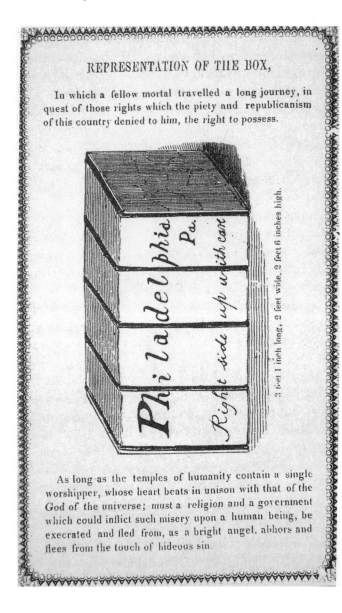

Figure 2.5. From *Narrative of Henry Box Brown, Who Escaped from Slavery Enclosed in a Box 3 Feet Long and 2 Wide. Written from a Statement of Facts Made by Himself. With Remarks upon the Remedy for Slavery. By Charles Stearns* (1849), page 92. *Documenting the American South.* https://docsouth.unc.edu/neh/boxbrown/ill1.html.

and its captioning. Perhaps Brown did not like either of these images, for they are not included in any subsequent versions of his story.[46]

Brown's images circulated within several other formats in 1849–1851. As John Ernest, Marcus Wood, Jeffrey Ruggles, and I have analyzed in detail, drawings of Brown were created in Ann Preston's *Cousin Ann's Stories for Children* (1849) and in 1850 and 1851 in lithographs, etchings, and the second version of Brown's narrative (1851). These illustrations often made a profit for Brown; according to Ruggles, Brown was selling copies of the 1850 lithograph of his unboxing (see Introduction, Figure I.1) less than a week after it was deposited for copy-

right.[47] Because I have already analyzed many of the images of Brown in this early era,[48] I will not do so here. However, I would note that in the illustration that appears in the 1851 version of Brown's narrative, *Narrative of the Life of Henry Box Brown, Written by Himself* (1851; see Figure 2.1), Brown seems to be manipulating the spectacle of his body. His left elbow is raised up just a bit, as if he is already pushing himself *out of the box*. His expression appears more determined, as well—he seems to have a plan. Brown may already be manipulating the spectacle of unboxing to suggest agency and fortitude, especially by choosing which illustrations would appear in his 1851 narrative.

In these early years, Brown also took power over his public image in his speeches, as he became an effective antislavery speaker in the US. Brown was a headliner for and spoke briefly at the New England Anti-Slavery Convention held May 29–31, 1849; Brown was said by one newspaper to arouse "a thrill of sympathy and admiration in everyone who listened" to his story.[49] Brown first spoke on Tuesday, May 29, and then again on Wednesday, May 30; on May 30 he was brought back later in the program to sing his hymn of thanksgiving, after which the "air was rent with loud applause." At this gathering, Ellen and William Craft also spoke. "What an exhibition!" exclaimed Frederick Douglass. "Are the slaves contented and happy? Here are three facts that sweep away all the sophistry." Brown was being exhibited, and his speech was greeted with "deafening shouts," much applause, and "a generous contribution" to his cause[50]—but Douglass's remarks seem to imply that he was not an object of pity, but an example of the resourcefulness of the enslaved.

Another talk by Brown occurred on July 15, 1849, at an antislavery picnic and celebration held at Abington under the auspices of the Massachusetts Anti-Slavery Society.[51] This was a large gathering that included notable abolitionists such as William Lloyd Garrison, Wendell Phillips, and William Wells Brown. Douglass's newspaper the *North Star* reports that "Henry Box Brown narrated his hazardous escape from slavery in a box as merchandise marked 'this side up'" and that the "appeal seemed to reach every heart, even those who had not before been moved by a recital of suffering and perils peculiar to American Slavery."[52] In other words, Brown was effective at fostering empathy in those who heard his story. Brown also spoke on November 16, 1849, in Milford to a crowded hall; extra chairs had to be brought in, and some people even stood in vacant spaces in the aisle. His audience was sympathetic, here, too: "The earnest attention of this large company bore ample testimony to the thrilling interest which his sufferings and escape created in their minds." At the Milford gathering, Brown sang one of his songs, which was greeted with a large round of applause.[53]

By early 1850, Brown was on his way to becoming a valued part of the abolitionist movement in the US. He was even speaking with other well-known

fugitives—such as Henry Bibb—in performances that drew crowded houses.[54] Two events happened in 1850, however, that moved him away from abolitionism "proper" and into more unorthodox modes of performance and self-styling. First, Brown created a panorama of his experiences under slavery and began exhibiting it; and second, after an attack in Providence (perhaps by someone seeking to re-enslave him, although the evidence is unclear), Brown fled to England, where he would engineer even more audacious visual modes to represent the spectacle of slavery and his performative liberation.

First Panoramic Performances: Henry Box Brown's *Mirror of Slavery*

On April 11, 1850, *Henry Box Brown's Mirror of Slavery*, a panorama, opened in Boston, Massachusetts, at the Washingtonian Hall on Bromfield Street. Moving panoramas—large painted scrolls that would be unfurled in a theater or hall as the narrator (known as the delineator) explained the action—were all the rage in this period, in both the US and England. For the nineteenth-century viewer, watching these panoramas was akin to seeing a movie today; this was a powerful and vivid form of virtual reality, allowing audiences to become immersed in experiences, to imagine they were voyaging in space and time and seeing other worlds.[55] In an era when travel was difficult and expensive, panoramas frequently contained pleasing (often foreign) scenes of landscape, natural wonders, and individuals at work in various occupations. They were highly popular, entertaining, touristic spectacles. As Hughes observes, panoramas contended with other sensational shows for the nineteenth-century viewer's attention: "Freak shows, panoramas, lectures, and world's fairs were also dubbed 'sensational.' In publications ranging from newspapers to almanacs to children's books, provocative stories and incendiary images competed fiercely for readers' attention and fostered an appetite for sensation."[56] To succeed, Brown's panorama would need to harness the power of the incendiary images of slavery that had already been circulated, as well as the provocative stories that many sensational shows put forward.

However, panoramas were more than spectacular entertainment. Several panoramas that preceded Brown's dealt with slavery, as well as with an evolving derogatory theory of racial science that attempted to classify African Americans as inferior to whites. Moreover, while some panoramas ignored the reality of slavery, others confronted it. Brown's panorama walked carefully between these extremes, luring viewers in with a speculative and entertainment-oriented veneer,

while eventually asking them to confront the visceral brutality of slavery, and the potential activism of the enslaved. As Chapter 1 discussed, another formerly enslaved man—Wells Brown, who had escaped from slavery in 1834—was also exhibiting his panorama of slavery in England in the 1850s. Wells Brown seems to have made the decision to treat the panorama form as a serious educational medium even while he protected his own visual presence within it. Box Brown, on the other hand, marketed his panorama as an entertaining spectacle, although much of it was graphic and disturbing, and created a larger-than-life persona within it for himself.

The most famous of the panoramas of the nineteenth century—and the one that perhaps started what the British humor magazine *Punch* would call (in 1849) "the Monster Panorama manias"—was a panorama by John Banvard called *Panorama of the Mississippi Valley*, which opened in Boston in 1847 and ran there for a full six months, playing to massive audiences. According to Ezra Greenspan, Banvard's panorama was "one of the most celebrated artifacts of the 1840s; in Boston alone roughly a quarter of a million spectators paid fifty cents for the "pleasure of taking a mythic steamboat voyage down the Mississippi River to New Orleans."[57] Banvard's show was so famous in the US that he even received a medal from Congress. When he took it to England in 1849, he was asked to show it to Queen Victoria in Windsor Castle, and again it was hugely popular.

Banvard's panorama was advertised in such a way that its entertainment value was clear. For example, some posters had multiple exclamation points, boldface type, and an emphasis on the panorama's mammoth size ("the panorama is printed on THREE MILES! OF CANVASS!").[58] Such advertisements were meant to whet potential viewers' appetite to see the spectacle of the panorama, and to make them feel as if this would be a grand and entertaining event. Most importantly for the subject of this chapter, although parts of Banvard's panorama were set in the South, slavery was glossed over so as not to interfere with a viewer's enjoyment of the show.[59] In his catalogue for the show, Banvard described a scene on the Mississippi that enabled viewers to look at "extensive sugar fields, noble mansions, beautiful gardens, large sugar houses, groups of negro quarters, lofty churches, splendid villas, presenting, in all, one of the finest views of the country to be met in the United States."[60] The "sugar fields," "beautiful gardens," and "negro quarters" mask the reality that a viewer is seeing a *slave plantation*, and a kind of touristic gaze is emphasized over the idea of a socially progressive (or even critical) viewing of the US; in one scene "slaves working in the cotton fields" are set alongside "beautiful mansions of the planters" and "lofty cypress trees, the pride of the Southern forests."[61] Banvard

cast slavery as a beneficent system and delineated a peaceful and pastoral view of the South and its "laborers" over the horrific racialized violence and trauma of slavery.

Panoramas were implicated in debates of the day about slavery, then, but they were also part of an evolving discourse on racial hierarchy and difference. In this era, some racist scientists (such as Louis Agassiz, mentioned in Chapter 1) were trying to collect "data" that would show that African Americans and Caucasians were separate races (a theory known as polygenesis) or that African Americans were a link between primates and human beings, rather than fully human individuals. As Hazel Waters notes, such views were prevalent not only in the US but in England in the 1850s, popularized by Robert Knox, one of the major proponents of scientific racism, who in 1845 began giving lectures that were later collected as a book called *The Races of Men* (1850); Knox mainly updated earlier racist scientific views that Blacks were "brutish, ignorant, idle, crafty, treacherous."[62]

At times, both scientists and the makers of panoramas looked to Egypt to shore up their claims about racial difference, arguing that Egyptians (considered an advanced civilization) were white and not African in origin. As we will see, Box Brown's panorama and at least one of the plays that he acted in made a point of calling Africans "Nubians." Because Nubians are an ethnolinguistic group of Africans indigenous to southern Egypt and the Sudan, placing Black Nubians in Egypt ties them to the birth of civilization. On the other hand, some popular panoramas of this period looked to Egypt and its purported white inhabits to "prove" racial difference. The *Grand Moving Panorama of the Nile*, for instance, was created by the British Egyptologist Joseph Bonomi and shown in England in 1849, just a year before Box Brown arrived with his own panorama. It appears that Bonomi did not have a political agenda, but his panorama was soon bought by the racist amateur ethnographer George Gliddon.[63] Gliddon's book *Indigenous Races of the Earth* (1857) infamously classified African Americans as a link between chimpanzees and humans; and in 1844 Gliddon's colleague and later collaborator Josiah C. Nott endeavored to demonstrate "that the Caucasian or White race" and the Negro races "were distinct at a very remote date, and *that the Egyptians were Caucasians*."[64]

While Gliddon's panorama has been lost, there is no doubt that it would have been used to support his racist viewpoints. Gliddon lectured alongside the panorama on the mystery and wonder of Egypt, peddling the idea that "Egyptian hieroglyphics and history proved that whites and blacks were already distinct species" in the distant past.[65] Gliddon exhibited his panorama in the US throughout the 1850s, sometimes even unveiling and unwrapping what he called "real mummies" during his shows. In one famous incident, which resonates in

interesting ways with Box Brown's emergence from his box onstage during some of his (later) stage shows, Gliddon even employed the famous ventriloquist Bobby Blitz so that it would sound like a voice was calling out from one of his boxes of mummies and saying, "Open the box! Open the box!"[66] Gliddon took Bonomi's original panorama back to the US, but a duplicate was rapidly created to be shown in England. Gliddon's panorama therefore was one of the few to be shown in England and the US simultaneously.[67] Moreover, Gliddon's *Egyptian Collection and Grand Moving Transparent Panorama of the Nile Egypt and Nubia* opened on June 21, 1850, in Boston, so Gliddon and Brown were direct competitors.[68]

Panoramas, then, were highly popular transnational spectacles implicated in debates about slavery and race; they were also (possible) instruments of social power and resistance. As a media form, they were fundamental to the idea of spectacle, as Angela Miller writes: "the panoramic medium" is considered "the first step toward the society of the spectacle, in which representation replaces reality." But Miller also points out that such a view neglects the important question of who controls the medium, and what political and ideological purposes undergird the deployment of these panoramas.[69]

In the early 1850s, only two panoramas were created by formerly enslaved individuals—Henry Box Brown and William Wells Brown.[70] Wells Brown's panorama was exhibited in England a few months after Box Brown's had opened in the US. Wells Brown appeared to focus more on the educative and serious aspects of the panorama, and his panorama, although popular, ran for only about a year (from October 1850 to late 1851). Box Brown's panorama, on the other hand, was more entertaining in some ways and he was able to show it for more than thirteen years (1850–1863) in the US and the UK. In a savvy manner, Brown was able to intertwine the entertainment and educative goals of the panoramic form to create a popular and long-lasting performative spectacle that allowed him to recreate and revise his experiences under enslavement. Yet did *Mirror of Slavery* trap him within a repressive cycle of always having to representationally re-enslave himself to entertain his audience?

Certainly, the public found Box Brown's panorama both entertaining and enlightening. It was well received when it premiered in the US at a special invitation-only performance in Boston on April 11, 1850. It then opened to the public on April 23, 1850.[71] Large crowds gathered to see Brown's show, and the *Boston Daily Evening Traveler* named it "one of the finest panoramas now on exhibition."[72] The panorama contained forty-nine scenes, eight to ten feet in height, painted on a canvas scroll that would be slowly unfurled as Brown narrated the contents of each scene. Brown (and the free African American man James Smith who had helped him escape from slavery) exhibited the panorama

in New England from April to September of 1850 before the pair fled to England in October after Brown was attacked on the streets of Providence, RI.

The panels of the original show have been lost, but various descriptions of them in the press have been located. One early advertisement for the panorama was published in the *Liberator* on May 10, 1850, for a performance in Worcester, MA (see Figure 2.6). The titles of scenes demonstrate that one strong emphasis of Brown's panorama was a realistic portrayal of slavery. Moreover, the panorama has a geographic scope that visually charts the Middle Passage, beginning in Africa ("The African Slave Trade" and "The Nubian Family in Freedom"), moving to the West Indies, and then to the US (Charleston and Richmond). Yet beyond this geographical reach, it also has a touristic impulse. The perilous march of the captured slaves to the coast in Africa is bracketed by an exotic spectacle of "Religious Sacrifice" and picturesque landscapes: "Beautiful Lake and Mountain Scenery in Africa" and "View of the Cape of Good Hope." The scene titled "Interior of a Slave Mart" is followed by "Gorgeous Scenery of the West India Islands."

In part two of *Mirror of Slavery*, which takes place entirely in the US, the panorama becomes more visceral and haunting; scenes such as "Whipping Post and Gallows at Richmond, Va.," "Tarring and feathering in South Carolina," and "Burning Alive" would feature graphic violence, yet even here they are surrounded by scenes with inoffensive content such as "View of the Natural Bridge and Jefferson's Rock," "Fairmount Water Works," and "Washington's Tomb, at Mount Vernon." There is, in short, a dialectical push–pull in Brown's panorama between presenting the best (and most graphic) sources of information on slavery's horrors, and feeding an audience's desire to see new lands, to gaze upon exotic places. Aston Gonzalez writes: "The *Mirror of Slavery* traded in the performance of persuasion by depicting both beauty and horror. One attendee celebrated the panorama as a 'brilliant work of art' which also 'represent[ed] in a graphic manner the chief features of that fearful scourge—slavery.' The choice of the word 'scourge' allowed for a double meaning both as a 'whip'—a physical threat and punishment—and as a source of calamity."[73] According to Gonzalez the most common word used to describe *Mirror of Slavery* was "horror," but as we can see from the above titles the terror of slavery was at times lightened by giving in to the audience's wish to spectate not only slavery, but pleasant and interesting scenery.

Another explicit focus of Brown's panorama is visualization of the enslaved escaping, as we see in scenes such as "Henry Box Brown, Escaping," "Henry Bibb, Escaping," and "Ellen Crafts [sic], Escaping" (perhaps an image of Ellen Craft in her disguise as an in/valid master; see Chapter 1). The emphasis on illustration of the heroism and agency of the enslaved—to escape, seek freedom,

NEW AND ORIGINAL
PANORAMA!

HENRY BOX BROWN'S MIRROR OF SLA-VERY, designed and painted from the best and most authentic sources of information.

☞ The Diorama will be exhibited This Evening, May 10, at WORCESTER, and continue every evening until further notice.

From the pressing invitation of the friends at Worcester, Mr. Brown has been compelled to comply with their request for the present. There are numerous invitations from other places, which will be attended to in due time.

The following are the scenes :—

PART I.
The African Slave Trade.
The Nubian Family in Freedom.
The Seizure of Slaves.
Religious Sacrifice.
Beautiful Lake and Mountain Scenery in Africa
March to the Coast.
View of the Cape of Good Hope.
Slave Felucca.
Interior of a Slave Ship.
Chase of a Slaver by an English Steam Frigate.
Spanish Slaver at Havana.
Landing Slaves.
Interior of a Slave Mart.
Gorgeous Scenery of the West India Islands.
View of Charleston, South Carolina.
The Nubian Family at Auction.
March of Chain Gang.
Modes of Confinement and Punishment.
Brand and Scourge.
Interior View of Charleston Workhouse, with Tread-mill in full operation.

PART II.
Sunday among the Slave Population.
Monday Morning, with Sugar Plantation and Mill.
Women at Work.
Cotton Plantation.
View of the Lake of the Dismal Swamp.
Nubians, escaping by Night.
Ellen Crafts, Escaping.
Whipping Post and Gallows at Richmond, Va.
View of Richmond, Va.
Henry Box Brown, Escaping.
View of the Natural Bridge and Jefferson's Rock.
City of Washington, D. C.
Slave Prisons at Washington.
Washington's Tomb, at Mount Vernon.
Fairmount Water Works.
Henry Box Brown Released at Philadelphia.
Distant View of the City of Philadelphia.
Henry Bibb, Escaping.
Nubian Slaves Retaken.
Tarring and feathering in South Carolina.
The Slaveholder's Dream.
Burning Alive.
Promise of Freedom.
West India Emancipation.
Grand Industrial Palace.
Grand Tableau Finale—UNIVERSAL EMANCIPATION.
May 10

Figure 2.6. Advertisement for a performance of the *Mirror of Slavery* in Worcester, MA. *The Liberator*, May 10, 1850 (EAN).

and revolt—is crucial, given the frequent picturing of the enslaved as passive or pitiful. However, the panorama again moves dialectically between scenes that grant the enslaved volition and those that make them the object of visual surveillance. As Joon Hyung Park argues, Brown's own body becomes part of the spectacle as "a real-life object to enhance the simulated reality of the moving panorama."[74] But because Brown was no longer enslaved, the panorama presents not his "real life" or his "real body" but rather a heavily mediated spectacle centered on "Box Brown."

As discussed above, panoramas were implicated in debates about the supposed racial inferiority of Africans and African Americans, and Brown's panorama responds to such debates. One strong motif is that Africa is a beautiful, refined continent and that Africans are a civilized race not substantively different from the white race. Brown primarily portrays the equality of the African race via his borrowings from an illustrated poem by Charles C. Green called *The Nubian Slave* (1845). Green's illustrated poem plays up an interest in Egyptology and portrays Africans with noble features, proportions, and habits of behavior. Based on the titles of Brown's scenes, it appears that he reused many of Green's illustrations, such as scenes showing an African family in freedom amid an Eden-like landscape before they are taken into slavery; such images make evident the fact that freedom for Africans preexisted slavery.

Yet *Mirror of Slavery* also includes many scenes of bondage in which a viewer is encouraged to pity the enslaved. The scene "Brand and Scourge," for example, based on Green's own plate titled "Brand and Scourge," would have been a scrupulous and careful depiction of several slaves being tortured; none of the enslaved individuals visually resist the torture, which appears to be excruciating. It may be here that spectacle does not function in a way that empowers these bodies, as they are depicted as flat, gazed upon, and without resistance or agency, a noted strategy of white abolitionism, as discussed earlier. Reformers such as Theodore Dwight Weld marshaled the sensationalism associated with the torture of Black bodies to support their cause in texts that focused on *witnessing* and gazing on these bodies, such as *American Slavery as It Is: Testimony of a Thousand Witnesses* (1839). Stephen Browne has shown that Weld's book was "the largest-selling anti-slavery tract in American history."[75] It appears that Box Brown attempted, like Weld, to harness the sensational spectacle of the enslaved body.

Brooks has postulated that *Mirror of Slavery* formulates "a chaotic zone that foregrounds the creative agency of the African American activist turned artist."[76] However, within the circular visual–rhetorical matrix of *Mirror of Slavery* the fugitive artist had to keep enslaving and freeing his own body for the edification and entertainment of his audience.[77] The panorama does end with a scene

titled "Universal Emancipation," which presumably would be a generalized scene of freedom. But the painted canvas of the panorama may limit the flexibility of Brown's own escapes—he may always be represented as escaping, but never represented performatively as free. It may be that Brown turned to magic and mesmerism because they exemplified more flexible and *open* ways of imagining and performing not only his story and history, but also the spectacle of enslavement, as I discuss in Chapters 4 and 5.

Regardless of why Brown eventually stopped performing *Mirror of Slavery* (and it might simply have gone out of fashion after the Civil War), it is important to note that panoramas were respected as a powerful visual-verbal method for increasing abhorrence of slavery. For these reasons, Brown's performances were well attended and positively reviewed. An article about a performance in Boston in the *Liberator* on April 19, 1850, notes that Brown attracted a "considerable number of ladies and gentlemen" and compliments his "industry, zeal, and talent."[78] The *Boston Herald* on April 30 noted that the panorama was "becoming the topic of conversation in all parts of the city and vicinity" and that famous individuals such as Daniel Webster had been invited to see it. The panorama was a hit—but also a sensation. On May 1, this same newspaper reported that the demand to see the "great production of art" was so strong in some of the nearby towns that Brown had resolved to tour it for most of May of 1850 and then return to Boston on May 28 for a weeklong Massachusetts Anti-Slavery Society meeting.[79]

Brown exhibited his panorama (as reported in the *Liberator* on May 3, 1850), in Worcester, MA, on May 10, 1850, and at Hampden Hall in Massachusetts on May 22, 1850.[80] By July Brown seems to have moved on to New Hampshire and Maine to perform. A short review of a performance in July of 1850 in Limerick, Maine, for example, calls the panorama "well worth seeing" and notes that it will "increase the abhorrence of slavery."[81] The *Liberator* reported on the performance in Worcester, saying that it is "the universal belief here that this novel method of showing up the evils of slavery will do more for the increase of friends to the issue of philanthropy than the efforts of a score of lecturers"; this same article notes that Sunday evening "the house was thronged and all went away satisfied."[82] At this point, it appears to be a "universal belief" that the power of pictures and words together would create an immersive experience that would move the audience effectively toward antislavery action. The powerful effect of the performance was enhanced by the fact that Brown was a participant in the drama (living it out once again as he spoke the scenes of his boxing and unboxing) and the observer/narrator of it. Brown exists, then, in a temporal space somewhere between his past as a slave and his present as the creator of a panorama about his experiences.[83]

Brown's shows would grow more ornate once he arrived in England, but even from the start there was a strong performative strain to them that is clearly reflected in advertisements and tickets that have been located. Brown had new and original art created for his panorama by the painter Josiah Wolcott, and in advertisements he continually emphasizes the originality of his visual imagery. An advertisement placed by Brown in the *Liberator* on April 26, 1850, emphasizes that his "new and original PANORAMA" was painted by Wolcott "from the best and most authentic sources of information"; the editor comments below Brown's advertisement that the "visitor will see an affecting delineation of slavery and the slave-trade, without any exaggeration."[84] Tickets to the panorama are well-designed and appear almost festive, in a dark orange color with ornate black lettering and a distinctive decorative frame; Brown's initials (H. B. B.) are on the back with a ticket number (see Figures 2.7 and 2.8). Such tickets emphasize the originality of Brown's panorama and highlight Brown's name and the title of his work: *Mirror of Slavery.*

It is worth pondering, for a moment, the representational implications of the phrase "Mirror of Slavery," especially in contrast to Wells Brown's more plain title, "Panorama of American Slavery." The word "mirror" on one level emphasizes reality—a mirror is presumed to show a valid reflection. Yet an onstage mirror (if one existed) might reflect an image not of slavery, but of the audience

Figure 2.7. Front side of a ticket to Box Brown's *Mirror of Slavery.* Cornell University Archives, Digital Collection. https://digital.library.cornell.edu/catalog/ss:1312471. Also see color inset, Plate 1.

Figure 2.8. Back side of a ticket to Box Brown's *Mirror of Slavery*. Cornell University Archives, Digital Collection. https://digital.library.cornell.edu/catalog/ss:1312472. Also see color inset, Plate 2.

members. By this title, Brown might have been suggesting that his audience take a good hard look at themselves, in other words, and consider whether they were effectively participating in the antislavery movement. Last, mirrors reflect items, but these items are backward, and can also be distorted. They are dense symbols not only of truth or "reality" but also of perception, distortion, and visuality. So the idea of an onstage mirror may have been (from the start) symbolic of Brown's attempts not just to reflect his own experiences (or the experiences of the enslaved) but also to refract and manipulate these experiences toward a new and perhaps more radical end, beyond pity for the enslaved or titillation of the viewer.

A "Fabulous" Escape from Slavecatchers and the Performance of Fugitivity

Before Brown went to England in October of 1850, he may have already begun to experiment with a more overt mode of performance. As I have already noted, many contemporary historians and literary critics have argued that former fugitive slaves may never completely escape the specter of enslavement, psychologically as well as

in terms of how they are viewed. Douglass, for example, was constantly config-
ured by US popular culture (visually as well as linguistically) as an *ex-slave*,
rather than a freeman. Yet the figurative and metaphorical space between free-
dom and slavery has been categorized by some as a liminal realm of possibility
in which fugitivity becomes a source of empowerment. Symbolically, fugitivity
might demarcate a radical form of identity, a "fugitive insurgency" or rebellion
against being configured as an ex-slave.[85] For Brown, the space of fugitivity—of
being neither precisely free nor enslaved—might have become a realm in which
to craft alternative narratives of insurgency, heroism, and agency.

It is possible that Brown's first true performance of a radical form of fugitiv-
ity that crossed over into the realm of the fictional begins with an incident in
1850 when Brown was attacked on the streets of Providence, RI. On August 30,
Brown was strolling peacefully when he was brutally attacked by two men who
struggled to force him into a carriage. But Brown valiantly fought off his attack-
ers, whose plan was to shove him on board a ship going to Charleston or some
other part of the South so that he could be re-enslaved.[86] Shortly after this,
Brown fled to England, due to his fear of being recaptured.

This narrative about the attempt to kidnap Brown back into slavery was told
repeatedly in the newspapers, and as time passed it became part of his "true"
story. But is this what really happened? The police record in the *Providence Post*
simply states that Brown "was passing quietly up Broad Street . . . when he was
attacked by Kelton and others, and severely beaten without any known cause. It
was admitted, however, that Kelton was intoxicated."[87] Kelton was fined fifteen
dollars, but he appealed the fine. Some newspapers—such as the *Liberator*—
reported that Brown was not present when the appeal occurred and that the fine
was dismissed.[88] Yet other newspapers report that the idea that Brown was being
kidnapped into slavery "turns out to be fabulous"[89] and that "upon investigation
it was ascertained that the attacking party were returning from a drunken spree,
and knocked him down without any knowledge as to who he was."[90] Was this a
kidnapping attempt or merely a drunken brawl? The *Providence Post* police re-
port states that Kelton and another man—Simon A. Bates—were accused of at-
tacking Brown, and that in court Bates even advanced on Brown in a "threatening
manner." The attack by Bates on Brown could not be confirmed by witnesses.
Ultimately Kelton's appeal against Brown was "discontinued" and the costs
were paid by Kelton.

Of course, many fugitives (and even free people) were kidnapped into slav-
ery in this period, or legally remanded under prior versions of the Fugitive Slave
Law. However, if this were a (lawful) attempt to take Brown back into slavery,
further litigation would have ensued. There had been several famous cases
in this era of attempts to return fugitives residing in the North to the South;

throughout the nineteenth century these types of cases were argued up to state Superior Courts, State Supreme Courts, or the Supreme Court of the United States.[91] Rhode Island had passed a Personal Liberty Law in 1848 meant to foil the attempts of slave-catchers to return slaves to their enslavers, but such laws had often been overturned.[92] If the Providence court believed this to be a valid legal attempt to return Brown to slavery, a more lengthy trial would have ensued; conversely, if this was deemed to be an illegal attempt to kidnap Brown the court might have taken more action than simply fining Kelton fifteen dollars.

Perhaps, then, this is the first time that Brown created a story that was more invented than truthful. The purported attempt to kidnap was repeated and widely recounted upon his arrival, several months later (October 30, 1850), in Liverpool, England, with embellishments to the story, and became part of what we might call his "publicity package." "Armed with the powers of the Fugitive Slave Bill, an attempt [was] made to arrest him. Two such attempts were made, and it was with the greatest difficulty Brown made his escape to this country," writes one Liverpool newspaper.[93] At the time of the event in Providence, the infamous Fugitive Slave Compromise of 1850 had not yet been passed by the US Congress, so it is unclear whether his pursuers were "armed" with the powers of this law.[94] Moreover, in this account there are now *two* attempts being made, not one. Brown becomes not only the slave who mailed himself to freedom, but the slave who heroically and valiantly resisted armed attempts to rebox him and made his way steadfastly to England, where he could be truly free. Or so the story would go.

Mirror of Slavery and Other Performances in England: "Horrors Without Parallel" and a Lawsuit

Regardless of what happened during the Providence incident, by November 12 of 1850 Brown was weaving this event into his shows and successfully staging his *Mirror of Slavery* in Liverpool, where he would perform it until December 5; he would then move on to perform in Manchester from December 14, 1850, to January 1, 1851.[95] James C. A. Smith performed the panorama with him until June of 1851, when they had a bitter dispute about financial and other matters. Smith later claimed that Brown was not saving money to buy his wife and children out of slavery but instead was a showman, cheat, and fraud, and he wrote multiple letters to key members of the abolition movement lambasting Brown's behavior.[96] Yet there is no evidence against Brown beyond Smith's one-sided recounting of this dispute. Regardless, Brown was ousted from the abolitionist speaking circuit in England, in part because of Smith's allegations and in part because his

shows were growing more spectacular and outlandish. Brown would continue to perform his panorama of American slavery in England until at least 1863, as discussed in Chapter 4. How was his panorama received in its first few years of performance in England and what other modes of performance did he utilize that might have contributed to his slide from the abolitionist lecture and performance circuit, where numerous prior individuals such as Douglass, Wells Brown, and the Crafts had been successful?

As noted, *Mirror of Slavery* was well reviewed in England in its first years and had good audiences. However, there is evidence that some of Brown's early performances in England were embedded within minstrel shows where he sang antislavery duets. For example, in November of 1850 one Liverpool newspaper reports that Brown would perform on the following Saturday evening (November 16) in a concert that will feature "the minstrel fairies" who will give their "fairy entertainments"; then "Mr. Henry Box Brown, the Fugitive Slave, who was packed in a box and forwarded from a slave to free state, will appear, and with his friend Mr. James Boxer Smith, who assisted him to escape, sing some anti-slavery songs and duets, their own composition."[97] This was a small bit performance by Brown and Smith as part of a larger bill, but this would not be the only time Brown had liaisons with minstrel troupes.[98] Other Liverpool notices reveal that Brown and Smith would, just one week later, sing "plantation melodies, serenades, duets, and anti-slavery songs" while exhibiting their panorama;[99] the phrase "plantation melodies" is a bit ambiguous, and could mean songs from J. H. Bufford's popular songbook *Plantation Melodies*, a minstrel songbook used by the Christy Minstrels and others (see Figure 2.9).

Whether James Smith and Box Brown sang minstrel songs in November 1850 is unclear, but it is evident that at this juncture Box Brown was not averse to performing alongside a minstrel show, if not exactly *in* it. A few years later, after he had separated from Smith, Brown would perform with a group known as the "Sable Harmonists" or the "Negro Harmonists," who also might have performed minstrel tunes. The first performance I have located with this group is from October 22, 1853: "On Tuesday evening last, Mr. Henry Box Brown, a fugitive slave, gave a musical entertainment in the Public Hall, Baillie-street, Rochdale, with his *troupe* of negro harmonists."[100] I have also located a performance on November 3 and 4, 1853, for a performance by "Mr. H. B. Brown's real Negro troupe of SABLE HARMONISTS, from the United States."[101] These shows are interesting because they list Brown as the organizer of this troupe: "THE SABLE HARMONISTS.—On Thursday and again last evening, Mr. Henry Box Brown's troop of Sable Harmonists from Vauxhall Gardens, London, gave their Negro entertainment in the Philosophical Hall. There was a numerous but not a crowded audience on both occasions, and the approbation which they manifested was that

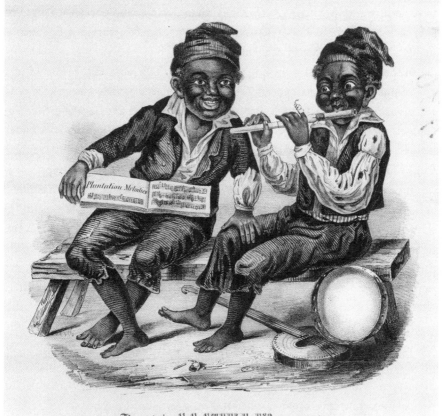

Figure 2.9. *Plantation Melodies* cover, 1847, Library of Congress, https://www.loc
.gov/item/94502291/.

of genuine enthusiasm."[102] I have been unable to determine the content of the shows featuring the Sable Harmonists that Brown organized, because this moniker ("Sable Harmonists") was used by a variety of troupes. I do, however, think that it is likely that Brown's troupe performed "plantation melodies" and perhaps some minstrel content, based on the phrasing used to describe them ("real Negroes"), which echoes that of many minstrel shows. For example, a show for a group with this same name ("Sable Harmonists") in 1852 in Surrey claims to have performing "SIX REAL NEGROES" who electrify audiences with minstrel acts such as "burlesque operas, summersaulting, dances, varied vocal, instrumental, laughable, and quizzical entertainments."[103]

In the era of 1850–1853 in England, however, it appears that Brown's bread and butter was the more subversive *Mirror of Slavery*, which was greeted with enthusiasm by the respectable British public as a valid antislavery artifact; as Audrey Fisch has noted, "the British penchant for the 'genuine' black extended beyond the street and the music hall to 'respectable' antislavery gatherings."[104] Brown's *Mirror of Slavery* at first fed into this penchant for realistic representations of enslavement. The *Liverpool Mercury* on November 15, 1850, notes that it exhibits "all the horrors of the slave trade, with its demoralizing effects on the slave and slaveholder" and comments that "the exciting scenes reflected on this mirror are such as description fails to convey to other minds."[105] In other words, there is something *beyond language* in this mirror, in this performance. A notice in the *Preston Chronicle* in January of 1851 calls the panorama "a brilliant work of art" that "represents in a graphic manner the chief features of that fearful scourge—slavery" and goes on to state that "a vast number of individuals, including a great number of school children, have visited the exhibition, all of whom have been gratified by their visit."[106] The panorama was incredibly popular in the first few years of its performance, often being performed to packed houses,[107] and Brown enacted it at least two hundred times over the next ten years.[108]

It is also vital to note that Brown voluntarily engaged in (new) acts of boxing, re-enslaving himself for the entertainment of his audience, and this is where he began to split off from abolitionism proper. One advertisement from May 17, 1851, gives an excellent feel for the character of Brown's voluntary boxing schemes:

Great Attraction Caused in England by Mr. Henry Box Brown, a Fugitive Slave who made his escape from Richmond, in Virginia, packed up in a box, 3 feet 1 inch long by 2 feet wide, and two feet 6 inches high. Mr. Brown will leave Bradford for Leeds on Thursday next, May 22nd, at Six o'clock, p.m., accompanied by a Band of Music, packed up in the identical Box,

arriving in Leeds by half past Six, then forming a Procession through the principal streets to the Music Hall, Albion Street, where Mr. Brown will be released from the Box, before the audience, and then give the particulars of his Escape from Slavery, also the Song of his Escape. He will then show the GREAT PANORAMA OF AMERICAN SLAVERY, which has been exhibited in this country to thousands.[109]

Brown's performance now includes a band and procession, and he jumps out of his box "before the audience" on stage. He sings his song of escape and narrates his panorama, presenting an entertainment that is aural (the songs and music), visual (the scenes of the panorama), and verbal (Brown's narration of his escape). This multimodal and multisensory show is meant to viscerally engage the audience, but it is far from the recitation of facts in which even a skilled stage performer such as Douglass (who sometimes vividly reenacted on stage his own experiences of traumatic enslavement) engaged, and it is also distant from the dignified, angry abolitionist that Douglass performed in his photography. As Ruggles notes, Brown's panorama "had more of the popular show about it than the usual forms of antislavery advocacy"[110] and his publicity played up its entertainment value.

Taking seriously the spectacle Brown creates, Alan Rice refers to this performance as a "kinetic or guerilla memorialisation that brought home to a population thousands of miles from the US plantation economy the horrors of a system that would force a man to risk death by suffocation in order to escape it."[111] Reviewers in this time period were quick to note the kinetic energy and the power of Brown's shows; an 1855 article opined that Brown's "vivid and genuine description of each passing scene" and his interspersing of songs makes the panorama "a most effectual mode of instructing the generation to come on the appalling subject" of slavery.[112] In this instance the panorama was judged to be true, gripping, and educational for those (such as younger people) who knew little about slavery, because it had been abolished in England in 1833. Brown was said to have great descriptive powers and to speak from the heart; "every word comes from the fountain of truth and finds its way into the bosom of his hearers," notes one reviewer in 1857.[113] Brown was viewed as genuine and (perhaps more importantly) able to move audience members and make them believe that they were hearing the truth.

Of course, not all reviews of Brown's show were positive, and he sometimes faced covert and overt racism. His show was sometimes referred to a "nigger panorama" and derided.[114] Brown attempted to counteract such labeling via prizes and contests; for example, in October of 1851, he initiated an essay competition in Rochdale and gave prizes for the "best essay against slavery"; prizes were

given out after his panorama performances and "there was a tolerably good attendance each night the prizes were awarded."[115] Despite the generation of positive publicity via such marketing of his shows, Brown often faced negative criticism and racism.[116]

The most devastating examples of the racism that Brown faced were two long and libelous reviews published in the *Wolverhampton and Staffordshire Herald* on March 17 and 24, 1852. According to Ruggles, the author of these reviews was the paper's editor, T. H. Brindley, who just a month earlier had published a derogatory account of a lecture on slavery in Dudley by an African American.[117] Brindley and two companions attended the show and heckled Brown, and then Brindley published two scathing articles. Brindley calls Brown's panorama and his oral representation of slavery "a gross and palpable exaggeration" and explicitly recommends Banvard's panorama instead; as we have seen Banvard glosses over the harm of slavery. Brindley accuses Brown of being a fraud, especially in comparison to other slaves, and calls his show a "jumbled mass of contradictions, absurdities, assertions without proof, geography without boundary, and horrors without parallel." Slavery was in fact a geography without boundaries and horrors without parallel, but Brindley seems to believe that Brown turns slavery into "a series of inquisitorial chambers of horrors . . . for the destruction, burning, branding, laceration, starving, and working of negroes." Brown's panorama is called a "disgusting exaggeration" of the horrors of slavery, as well as a foul "calumny" on slaveholders. Brindley's real purpose comes through when he states, "the fact is that bad as slavery is, the condition of the American slave generally is infinitely superior" to many agricultural or other laborers. In other words, Brindley is an apologist for slavery, one who feels that some people are better off enslaved, and he disguises his attacks on Brown under the guise of wanting the "truth" to come out. Not content to impugn the accuracy of Brown's shows, Brindley evinces disgust at Brown's "foppery, conceit, vanity, and egotistical stupidity," calls him a "bejeweled 'darkey' whose portly figure and overdressed appearance bespeak the gullibility of our most credulous age and nation" and a "bejeweled and oily negro." Brown is supposed to speak in "the richest nigger style"; when asked where the Dismal Swamp was, Brown is represented as saying, "Well, he daint know; you might put it in Carolina, but he taut it was in Virginay." Brindley is happy that attendance has dropped off for the shows in which Brown "played, with ludicrous and semi-baboonish agility, his nocturnal antics."

However, Brown turned the tables on the racist editor: he sued Brindley for libel and loss of income and won. Brown testified in court on his own behalf, as did a schoolteacher, and Brown was awarded damages of one hundred pounds (he claims he had been earning fifty to seventy pounds a week,[118] so this judg-

ment represents perhaps two weeks of lost wages). On the one hand, this is a positive development; Brown learned that in England he could defend his reputation in court and get the money he was owed, and he would use this recourse multiple times in his career, often with success. On the other hand, he lost several *months'* worth of wages over this controversy, and perhaps Brindley's words caused long-lasting harm to his image and reputation. The trial and its result were widely covered in numerous newspapers throughout the summer months of June, July, and August of 1852, and harmed Brown's ability to get future employment; he performed only once in these months.[119]

Moreover, some parts of this attack would cling to Brown's persona. Brown's dress in court was described as "rather fine" and he "displayed some jewelry about his person," although his manner was described as credible and his way of speaking "very correct." Brown was a performer who often gave away "valuable presents" as part of his show, so he needed to look prosperous, but it might be too easy for people to connect this appearance in court with the "bejeweled darkey" that Brindley had described, and the term was repeated in several responses to this verdict that critiqued it.[120] Brown's "exaggerations" were also explicitly and unfavorably compared to the "truths" presented in Harriet Beecher Stowe's *Uncle Tom's Cabin* (first published in novel form on March 20, 1852) in the influential *London Daily News*,[121] a point to which I will return.

I have found only one performance for Brown between March, when he performed in Wolverton, and August 19, 1852, when he began performing in Scotland, and this review (in the *Westmorland Gazette*) is clearly influenced by the Wolverton trial, referring to Brown's "nigger melodies."[122] By Brown's own words, prior to the Wolverton incident he had exhibited his panorama in Manchester, Bolton, Blackburn, Preston, and again in Bolton, as well as many places in Yorkshire, before coming to Wolverton on March 15, 1852, after which his performances dropped off almost entirely.[123] The next performance I find for him in England is on October 2, 1852,[124] and it appears that by this time the Wolverton controversy had been glossed over in light of the larger agitation for abolition in which Brown's work, as well as *Uncle Tom's Cabin*, was invested. But the Wolverton incident cost Brown at least three months of work, so the payment for the libel seems a small token, not fully compensating Brown for his financial losses.

A Scotland Interlude

Brown began performing in Scotland shortly after the Wolverton trial, in August of 1852, perhaps to allow a sort of "cooling-off period" while the news of the

judgment in his favor filtered its way through the press. In general, Brown's shows appealed to audiences outside of mainland England, such as Jersey (still French-speaking in this era) and Wales, and Scotland was no exception. In 1852, Brown was in Scotland performing for more than a month—from August 17 to September 25. In Scotland, the audience seemed to relish his shows, and he drew large crowds. One review in the *North British Daily Mail* on September 15, 1852, for a performance in Edinburgh gives an excellent example of how Brown's performances were understood:

> PANORAMA OF AMERICAN SLAVERY: This panorama continues to draw a crowd to see it and Mr. Box Brown, its proprietor and expositor. Slavery being still an existing and most cherished institution across the Atlantic, every Christian philanthropist must feel a deep interest in knowing what exactly that condition is to which two million of human beings are subject in America alone. A single visit to this Panorama will give them more light on the subject than a dozen eloquent lectures, or even highly wrought descriptions in books. It is like visiting the scenes themselves, and their truth is rendered palpable by the presence and explanations of a real genuine specimen of the human being doomed to be a slave, and who was a slave for nearly the whole of his life, but is now, thanks to the air of Great Britain, as free as the whitest man.[125]

Brown's panorama is judged to be an accurate depiction of the condition of the slave system—not an exaggeration as the Wolverton articles so strenuously argued. Moreover, the combination of pictures and words *together* sheds more light onto this subject than words alone, creating a virtual reality. The panoramas foster a sense that viewers are "in" this visual environment: "It is like visiting the scenes themselves, and their truth is rendered palpable." Brown's participation greatly enhances the show, as he is perceived as a "real genuine specimen of the human being doomed to be a slave," even though by this time he had been legally free in England for almost two full years.

The reviews indicate that not only the panorama, but Brown's box, voyaged to Scotland with him. In one lecture on August 19 that did not include the panorama, Brown gave a "very thrilling account of the manner in which he escaped from the galling bondage of slavery . . . but not before being almost bruised and suffocated to death," and he spoke "in a very graphic manner" of "the awful horrors of slavery." Then, as the finale, he "exhibited the identical box in which he made his escape" but also "went into [the box] and showed his audience the way in which he was packed into it."[126] The writer notes that Brown will be giving a lecture on Saturday and the lecture is highly recommended as a way

of acquiring more knowledge of the "debasing system" of slavery. Yet it is also evident that the infamous Wolverton account of Brown's shows followed him to Scotland; a mention of his performances in the *Greenock Advertiser* on September 7, 1852, specifically references the libel trial (but not the decision in Brown's favor) and notes that "Mr. Brown is in good physical condition, looking more like a sable alderman than an itinerant dealer in notions." Brown seems like a prosperous alderman; perhaps this line is meant to be a veiled nod to what the *Staffordshire Herald* called his "portly figure" and foppery. As we have seen, Brown had been attacked previously for his showy dress and gold jewelry, and he would be attacked again for what some termed his vanity.[127]

Brown placed notices for his Scotland shows in the *Witness* (Edinburgh) on September 4, 1852, the *Edinburgh Evening Courant* on September 7, 1852, the *North British Daily Mail* on September 11, 18, and 25 of 1852, and the *Caledonian Mercury* on September 23, 1852.[128] In some of these shows, a man named Mr. Glyn will sing "some beautiful Plantation Melodies,"[129] and Brown sings his own songs, so music was again part of his performance repertoire, along with his other visual and verbal modes—the panorama, his box, and his lectures.

New Challenges in England

After the Scotland interlude, in late September of 1852, Brown returned to England, where he faced several new threats to his already precarious ability to earn a living via performance. One of these threats was personal: claims about his wealth and showy dress led some to question why he was not trying to purchase his wife, Nancy, and their children. Certainly, James C. A. Smith had repeatedly alleged in 1851 that Brown was frivolous, a drunkard, and a fop, as well as that he wanted to remarry in England and had no interest in even attempting to purchase Nancy. But I find these claims suspect, given the bitter feud between the two men. In December of 1852, however, the editor of the *Sunderland News* repeated claims about Brown's failure to purchase his wife. Brown wrote back to this newspaper in detail to plead his own case. Brown's letter to the editor was widely reprinted, word for word, in a variety of newspapers in England and across the British Isles, including in Ireland throughout 1852 and 1853,[130] and it is worth quoting in detail to give a sense of Brown's mastery of rhetoric and persuasion:

There is no man, I care not who he be, black or white, has felt the loss of his wife and children more than I. I have borne the galling chains, the tyrant's threat; and more than that, I have seen my wife sold and bartered

from one villain to another, and still clung to her and my children, so long as they remained in Richmond. At length, a fatal hour arrives; my wife is sold off to a wretch, not to work in a cotton field or rice plantation, but, as she was handsome, for a purpose I cannot here name but leave you and the public to judge. Bereft of my wife and children, and all the comfort that even the helpless slave enjoys, I resolved to be free. I obtained my liberty. I travel in the free States, and denounce slavery and slaveholders. I appeal to the public for assistance to buy my wife and children—I obtain the money—I offer it—I am refused. I raise more money; I offer twice their commercial value, and the reply of their owner is—you shall not have them. I have tried, Sir, and others have tried, and the remorseless slaveholder still holds her and my children in bondage; and before I left the States, behold! My wife gave birth to another slave; her master is, sir, its father![131]

Some details of this letter—such as the attempt to purchase Nancy—correspond to a note inserted into the 1849 narrative of Brown's life written by Charles Stearns, which states that while lecturing in the US Brown was "endeavoring to raise money to purchase his family. Twelve hundred dollars being the sum demanded for them."[132] But did Brown obtain this money, in the short time that he was lecturing in the US, and did he offer it? Was his offer refused? And was Nancy pregnant by her enslaver? Those details remain unverified.

Nonetheless, as a specimen of Brown's writing and rhetoric—and his appeal to the hearts and minds of his British audience—this is a fascinating piece. First, Brown starts by establishing his equality with other men—he feels the loss more (in fact) than *any* man, be they Black or white. Second, he validates his patience and fortitude as a husband and father who is willing to stay by his wife's side, even when she is sold "from one villain to another." Yet when she is sold away from Richmond to be sexually enslaved to a white man, Brown finally "resolved to be free." Much of this part of the letter is written in past tense, but Brown then vividly switches into present tense, marking his entrance into his current identity as a freeman. But even with this present-tense identity, his attempt to buy his wife is refused, again and again. As his appeals to his enslaver grow more frantic, so does the present-tense speaking voice, and dashes proliferate, giving the letter a frenetic quality compounded by its short, staccato sentences: "I obtain the money—I offer it—I am refused." The letter reaches its dramatic climax, which feels like a terribly long and fraught sentence after the short staccato ones and contains both an internal and ending exclamation point: "I have tried, sir, and others have tried, and the remorseless slaveholder still holds her and my children in bondage; and before I left the States, behold! My wife gave birth to

another slave; her master is, sir, its father!" Brown's letter reaches its height of eloquence and despair in the last sentence, when the present tense "freeman" finds out that his wife has been raped and impregnated by her enslaver. Brown's indignation and sorrow at this outcome are clear, and the letter no doubt had a forceful impact on the British public, as it was widely reprinted for almost four months (from November 1852 to February 1853).

If Brown had indeed made such strenuous efforts to purchase Nancy, it seems likely that other abolitionists would be aware of this activity; but because Brown had (by 1852) been ousted from the abolitionist circuit, there appears to be no corroborating evidence for these claims. Such evidence may come forward in the future, of course. What is clear is that this was an extremely effective presentation on Brown's part and a scathing indictment of the slave system. Perhaps after Brown's successful lawsuit in the Wolverton incident and this letter, his reputation was clean in the minds of the British public, and he was (once again) a heroic ex-slave.

Uncle Tom's Cabin: A New Panorama, a New Lawsuit, New Partners, and a New Rivalry with James C. A. Smith

Harriet Beecher Stowe's blockbuster novel *Uncle Tom's Cabin*—serialized in an abolitionist newspaper beginning on June 5, 1851, and published as a full novel on March 20, 1852—had a colossal impact on US and British culture, as well as on antislavery sentiments and on the depiction of enslavement. *Uncle Tom's Cabin* was the best-selling novel of the nineteenth century on both sides of the Atlantic—in fact, it outsold everything but the Bible. The historian Thomas Gossett estimates that more than a million copies were sold in England, and in its first year of publication alone the novel sold 350,000 copies in the US.[133] Stowe's characters, moreover, such as Topsy, Uncle Tom, and Simon Legree, were burned into popular consciousness on both sides of the Atlantic, not only by the novel but by the plethora of visual and material cultural artifacts that it spawned—plays, panoramas, prints, songs, and cartoons, but also decorative plates, card games, jigsaw puzzles, vases, wood carvings, statues, playing marbles, handkerchiefs emblazoned with graphic scenes from the novel, paper dolls, decorative figurines featuring key characters such as Uncle Tom and Little Eva, and even card games printed in several different languages (see Figure 2.10).

As a careful reader of popular culture, Box Brown would have noticed the impact of the novel in the US and England. But more importantly for his own

Figure 2.10. Card Number 1 for *Uncle Tom's Cabin* card and dice game, ca. 1852–1870. Caption: Onkel Tom. L'oncle Tom. Uncle Tom. Tom, Eva, Augustine St. Clare. The Harriet Beecher Stowe Center Collection, Catalogue No. 69.104. Used with permission.

livelihood, panoramas about *Uncle Tom's Cabin* proliferated in the same period that he was trying to make his livelihood by marketing his *Mirror of Slavery*, and his panorama was frequently compared to Stowe's novel. There is some evidence that the publication of Stowe's novel might have increased interest in Brown's work. For example, a brief article about Brown's panorama in the *York Herald* mentions that Stowe's novel throws "greater interest around the slave, and awakens sympathies on [Brown's] behalf."[134] The *Durham County Advertiser* on November 26, 1852, postulates that Stowe's novel has "prepared the way" for Brown's shows by rousing "very general sympathy" for him,[135] forgetting that Brown's narrative and panorama preceded *Uncle Tom's Cabin*. Yet the sheer proliferation of panoramas, musicals, and "Tom Shows" (derogatory, minstrel-like adaptions of the novel) in the 1850s certainly cut into Brown's business.

Ever the pragmatist, Brown responded by creating his own *Uncle Tom's Cabin* panorama, and even enticed viewers to see *Mirror of Slavery* by using *Uncle Tom's Cabin* as a sort of teaser. From 1852–1857, Brown exhibited his *Mirror of Slavery* in England alongside a panorama of *Uncle Tom's Cabin* that he developed, although not without some legal difficulties. In November of 1852 Brown first advertised that he would be employing scenes from *Uncle Tom's Cabin* in his performance work. As reported by the *Hull Packet and East Riding Times* of November 26, 1852, and December 3, 1852, Brown's "one Hundred Magnificent views, representing 'SLAVERY AS IT IS,'" will be "illustrative of many vivid and interesting Incidents depicted in Mrs. Stowe's universally admired Work, 'UNCLE TOM'S CABIN.'"[136] The details of this show—and how much it relied on *Uncle Tom's Cabin*—are unclear, but subsequent shows elucidate that Brown first cherry-picked some key scenes from the novel and then ultimately created a full-fledged panorama centered on it.

On May 7, 1853, the *Lancaster Gazette* reports that Henry Box Brown "has been exhibiting his Pictorial Illustrations of Uncle Tom's Cabin in the Exchange Rooms, Preston, during the past week with great success."[137] By late May, he began performing a program entirely based on *Uncle Tom's Cabin*, which subsequently led to a lawsuit against the owner of the venue. On June 4, 1853, the *Sheffield Free Press* reported that on "Saturday Evening last" (May 28, 1853), "Mr. Box Brown, an escaped negro," "Mr. Glynn (singer)," and "two juveniles" who "presided at the piano-forte" performed a vocal entertainment titled "Musical and Pictorial Entertainment, Illustrative of Mrs. Beecher Stowe's celebrated Work—'Uncle Tom's Cabin.'" A playbill for the show—now lost, but described in the University of Bristol, Kathleen Barker Collection—lists the names of the pianists as Reuben and Joseph Rowland, and advertises Brown's "Inimitable Vocal, and Pictorial Illustration of Uncle Tom's Cabin."[138]

Despite Brown's "inimitable" presence, the performances did not go well. On July 30, 1853, the *Sheffield and Rotherham Independent* reported that Brown had a legal agreement to perform a show called "Uncle Tom's Cabin" at the Adelphi Casino for two weeks for £34 (May 28–June 10); the sum he was supposed to be paid would be equivalent to about £2723 today, or roughly £227 ($300) per performance (if he performed twelve times during a two-week period).[139] Brown might have been considered a star headliner to justify this amount of money, or perhaps (and this is most likely) the money was to be shared in some fashion between the four performers (Brown, Glynn, and the two Rowlands). When the entertainment failed to generate large audiences, the proprietor of the venue (a man named James Scott) tried to cancel it, but as the newspaper article about Brown's successful lawsuit notes, Brown "continue[d] to tender his services daily, until the expiration of his agreement," kept copies of the contract, hired a lawyer, and obtained not only the salary but also fees for his time, his lawyer's, and his witness's. Once again Brown was successful in the British Court, but in this case he obtained something like a just recompense for the money he was owed, unlike in the Wolverton incident (he was granted £40 plus expenses and court costs).[140]

In May to June of 1853, it is unclear whether Brown was performing a panorama at the Adelphi Casino or some other type of show based on *Uncle Tom's Cabin*; I suspect that, given the novel's recent publication, it was an oral show based on the novel, with a few illustrations and some songs. By January 1854, however, Brown had his own *Uncle Tom's Cabin* panorama, which he successfully exhibited, often alongside his *Mirror of Slavery*. Advertisements for these shows—such as this one placed on January 21, 1854—contain many revealing details about the performances:

> *Town Hall, Hanley*
>
> ON MONDAY and TUESDAY, January 23 and 24, 1854, Mr. H. Box Brown will exhibit his grand pictorial illustrations of UNCLE TOM'S CABIN, painted by Sig. Antonia Abecca, and Sig. Vincent di Lornardo, late artistes of Naples, for Two Nights Only. Mr. JACOB SAMES, the celebrated performer on the Accordeon and Flutina, will give several of the most difficult airs from some of the most admired authors. Among others—Napoleon's Grand March, Airs from Sonambula, &c., and he will also introduce his celebrated Cuckoo Solo. Mr. T. Frodsham, who will also perform on the Accordeon and Flutina, will accompany Mr. Sames.[141]

Brown will exhibit his "grand pictorial illustrations of *Uncle Tom's Cabin*," a panorama painted by two Italian artists with grand-sounding names—Signor

Antonia Abecca and Signor Vincent di Lornardo—for "two nights only."[142] Then Mr. Jacob Sames will play the accordion and flutina (another type of accordion), accompanied by Mr. T. (Thomas) Frodsham. This performance employs an oral narrative (Brown's description of the panorama), a visual element (the panorama itself), and several aural (musical) modes—the songs and music. Brown would no doubt orchestrate the entire show and serve as its main attraction, but it is fascinating to find him working with two partners, Jacob Sames and Thomas Frodsham, men with whom he had a seven-month partnership, from January to July of 1854.

Brown's work with Sames and Frodsham gives insight into his involvement in Britain with a group of individuals who were able to turn art, music, and other types of performance into business. Sames was a member of a well-known family firm that built pianos and organs in Birmingham starting in 1855, and this company also made harmoniums (pump organs).[143] Sames was also a music seller, and it is possible that he sold sheet music to Brown, or helped Brown transpose his own songs onto sheets that he would later sell during his performances. The Sames firm had started, however, by making accordions at 8 Suffolk Street, Birmingham. The family appears to be a musical one, since many members of it were involved in the business, much as Brown's own family would eventually be involved in his act. Frodsham's identity is less clear; he appears to be a musical individual who played two different instruments, so a fitting part of Brown's performance troupe.

Brown's association with Sames and Frodsham lasted seven months, and we have more insight into the nature of these performances from advertisements they placed in newspapers and even one surviving playbill for a show that I have located. For the sake of clarity, I will discuss this alliance (and the new playbill) here and then return to Brown's work with the *Uncle Tom's* panorama. It appears that these three men worked together beginning in January of 1854, exhibiting not only their *Uncle Tom's* panorama but also *Mirror of Slavery*. The playbill—never discussed by any scholar—would have been papered up on posts, shop windows, and streetlight poles in towns in which the trio performed (see Figure 2.11).

The playbill indicates that on February 1 to 4 of 1854, Brown, Sames, and Frodsham performed together in a "Panorama of African and American Slavery." This eye-catching playbill uses a variety of fonts and typefaces to draw attention to the show. Brown's name is in the largest and blockiest font, and would certainly jump out from the poster, but Sames and Frodsham are also given good billing at the bottom of the bill. The words "Panorama of African and American Slavery!" literally jump out at the viewer, grabbing his or her attention, because the first word is etched in a font that stretches across the page. The

Figure 2.11. Poster for performances by Box Brown, Sames, and Frodsham on February 1–4, 1854. From Ricky Jay, *Extraordinary Exhibitions: Broadsides from the Collection of Ricky Jay* (New York: Quantuck Lane Press, 2005).

language here is very similar to that in the January 23–24 Hanley performance, which may mean that the three men first performed the *Uncle Tom's* panorama to whet the audience's appetite for Brown's slavery panorama, which they then performed several nights later (in the New Market Hall in Stoke) on February 1–4. Hanley and Stoke are about two miles apart, so if audiences liked the first panorama, they might travel to Stoke to see the second one.

The poster claims that Brown's slavery panorama has met with the greatest success in many towns in England and been under the patronage of many eminent clergymen and mayors. It also claims that Brown is giving his "farewell exhibitions in England, previous to his embarkation for America," a claim that Brown would make several times in his career and that seems to be a marketing ploy to entice people to come see the show. Jacob Sames is once again listed as "the most renowned and successful performer on the accordeon [sic] and flutina that has ever appeared in the country." Overall, it is an enticing playbill, and no doubt attracted a considerable audience.

Brown continued to perform his panorama of American Slavery and of *Uncle Tom's Cabin* with Sames and Frodsham in Longton and the Potteries into mid-February of 1854. A review in the *Staffordshire Sentinel and Commercial and General Advertiser* in February of this year indicates that these performances were successful and enhanced antislavery sentiments: "[Brown] has had overflowing audiences, who have learned from his pictures, to view Negro Slavery with greater detestation than ever."[144] The three also performed together in Nottingham on May 16 of 1854, where Sames was called in publicity for the show "the most renowned and successful performer on the Accordeon and Flutina *that has ever appeared before the public of England*" and Brown's panorama of African and American slavery is called (hyperbolically) the "*first and only one of the kind that has ever appeared before the public* of this country, and the *only one of the kind now in existence*."[145] Of course, other panoramas had preceded Brown's, but the rhetoric seems to have worked, as the Nottingham shows were "nightly visited by large, respectable, and delighted audiences" who came to hear "Mr. Brown deliver . . . his lecture on the history and horrors of slavery with much eloquence and effect," leading to "repeated bursts of applause."[146] These performances lasted nine successive evenings and also featured a local man—Mr. S. Chettle, of Nottingham, "the great original Swinging Accordionist."[147]

The three men next moved on to Loughborough and Leicester, where a show featuring Brown, Sames, and Frodsham is listed on July 1, 1854.[148] The same advertisement was printed in this newspaper at least once previously, which means that these three men performed together from June 27–30 in Loughborough and then performed in Leicester from July 3 onward.[149] What is most interesting about this announcement is its comment that "Mr. Brown has been Exhibiting for the last three months in the Mechanics Hall, Derby, and Exchange-room, Nottingham, to large and crowded audiences."[150] Since the July 1 advertisement also contains the names of Sames and Frodsham, it is evident that the three men performed together continuously during all these months. Brown's partnerships with other artists were sometimes long-standing, as we will see in Chapter 4 in

his relationship with a mysterious medium named Miss Pauline. Brown was adept at associating himself with a group of men (and sometimes women) who turned art into a lucrative business practice, but one that also sometimes had political content (such as generating antislavery reactions).

Brown did not perform with these men after July of 1854, but he did continue to perform materials related to *Uncle Tom's Cabin* into 1856.[151] What was the specific nature of the *Uncle Tom's Cabin* performances? *Uncle Tom's Cabin* was a pivotal, if troubling, novel for many, both because of the impact it had on popular culture, and because of its racist portrayal of some of its characters, such as Topsy, who for most of the novel fits the stereotype of the "pickaninny"—a depiction of Black children that has done lasting harm, cordoning them off from innocence, morality, and purity, as Robin Bernstein notes.[152] The novel's titular hero—Uncle Tom—also dies in slavery rather than attempting to escape or resist his beatings, which to modern-day audiences makes him seem passive. On the other hand, some have seen in Tom's strong faith a hero that a nineteenth-century audience would respect, one who refuses to whip another slave to save himself, and one who says to his main tormentor (the villainous Simon Legree), when Legree asks if he does not own Tom, body and soul, "No! no! no! my soul an't [ain't] yours, Mas'r! You haven't bought it,—ye can't buy it!"[153] Stowe also portrays resistance in other African American characters who escape and are willing to use violence to accomplish this end. Yet still, her most resistant and intelligent characters are light-skinned African Americans who can "pass" for white (and the novel even at times implies that it is their "white blood" that gives them strength and intelligence), and they end up in Liberia, not the US, cordoned off safely from the body politic of the United States. For readers in the nineteenth century as well as today, these depictions and plot resolutions are vexing.

What did Brown do with the material from *Uncle Tom's Cabin* in his panorama? In some ways, Brown seems to be the perfect foil for the fictional Uncle Tom. Brown refused to stay in his place; instead, he escaped and made performance art out of his experiences. Whereas the character of Tom is deadly serious and sincere throughout Stowe's novel, Brown seems to play with the materials of his own life, turning them into myth, legend, and a tall tale in which he is always the hero. Brown also walked a fine line between fact and fiction, and between turning his life into an escapade (or spectacle) and turning elements of slavery into a joke, or at least something at which audiences could laugh, as they did during minstrel shows. Given the popularity of *Uncle Tom's Cabin* and of the "Tom Shows" that grew out of the novel—shows that made light of slavery and of Stowe's characters—it is possible that Brown employed the pathos of Stowe's original novel but also minstrelized it, to some degree. There are hints

that Brown did not always perform his *Uncle Tom* in a straight fashion—that is, he may have twisted and curved the famous novel into new meanings, shaped it like a malleable block of clay, for his own purposes.

For example, in early February of 1855, a Welsh newspaper—the *Monmouthshire Merlin*—contained a detailed review of a performance in which Brown exhibited his own panorama and some scenes from Stowe's novel. This article is worth quoting in full for the fascinating details it reveals about Brown's adaptation of the novel:

> Mr. Box Brown's Panorama—A very interesting exhibition has been drawing large assemblages to the Town Hall during the week. Mr. Box Brown, a fugitive slave, who had, as he states, witnessed many of the cruelties, in their revolting phases, of slavery, and had happily made his escape from the tyranny and lash of the Legree masters, to the land of real freedom, has got up a series of panoramic views, which represent, in detail, pictorial illustrations of the slave trade and its results; and accompanying this exhibition, and in addition, he produces several well painted pictures of the chief features in Mrs. Beecher Stowe's celebrated work—"Uncle Tom's Cabin." As each scene of the panorama becomes unfolded to the observer, the clever ex-slave vividly describes the incidents portrayed. A band of music (the Newport Band) accompanied the views with (occasionally appropriate) airs. The whole exhibition would, perhaps, be improved by Mr. Brown doffing the gold-frogged and be-laced coat and cap of the mere showman, while delivering his marvelous adventures, and assuming the quieter gait of the respectable and enlightened society among which he nightly appears. In making this observation, we merely speak of him as a portion of the public spectacle which persons go to see, the *whole* of which should be in perfect keeping. Mr. Brown has, we understand, been very successful in his expositions; and his complaints of Nigger wrongs are worthy of public notice.[154]

Brown's show, in which he is said to escape from "the tyranny and lash of the Legree masters" has been drawing large audiences, and Brown (a real man, of course) is directly paralleled to fictional characters in Stowe's novel. The reviewer is pleased that Brown represents detailed and graphic scenes of the slave trade and calls him "the clever ex-slave" who can "vividly" describe the incidents portrayed both in Stowe's novel and in slavery. Yet the reviewer is bothered by Brown's costume, which is called the "gold-frogged" and "be-laced coat and cap of the mere showman," and the reviewer opines that not all the music the band plays is appropriate. According to this article, Brown is making a "public

spectacle" of himself, and perhaps of Stowe's novel, while he delivers his "marvelous adventures." There is skepticism, I think, here toward Brown's decorum as well as his truthfulness about his "complaints of Nigger wrongs." The piece concludes by saying that his show is worthy of public notice, but the tone wavers between respect and disdain, gentle criticism and outright racism. Brown was known to dress in a showy fashion, a complaint that other reviews had voiced, as well as individuals such as William Wells Brown. This was part of his costume, a sort of second skin he wears while he narrates his "marvelous adventures." Moreover, fictionalizing and even employing *Uncle Tom's Cabin* in a humorous way might have been part of his show and his persona, or an aspect of how he enticed audiences to see his performances. He plays with the spectacular aspects not only of his own life, in other words, but also of Stowe's novel, perhaps transforming the characters into larger-than-life individuals or minstrelizing them.

Often, and especially as time went on, Brown would perform his own panorama first and then perform his show based on *Uncle Tom's Cabin*.[155] Perhaps one show would be serious and the other more humorous—there were many reports, in the nineteenth century, of individuals being convulsed with laughter by some of the scenes featuring minor characters in Stowe's novel (such as Sam and Andy), whereas Brown's own panorama of American slavery had little humorous content. The two shows therefore might play off each other as modes of drama and melodrama, tragedy followed by comedy, realism followed by sentimentalism, and so on. But both could highlight the wrongs of slavery.

And yet, fascinatingly, it appears that Brown could shape his material to his audience, turning each panorama into an instrument of *either* comedy or tragedy, and sometimes both at once. The *Brighton Gazette* on July 31, 1856, has a long review of Brown's performance of both his own slavery panorama and his illustrated views of *Uncle Tom's Cabin*, noting that Brown's "plain, unvarnished tale" of his escape is stamped "with the impress of truth." Some of the scenes are "credibly painted," and Brown "draws a vivid picture of the horrors of slavery"; the reviewer notes that the pictures convince one of the "disgrace" of slavery. Yet the reviewer also opines that Brown's voice sometimes rises to "too high a pitch" and his "utterance is rapid," perhaps because of his "excitement" over the "cruel scenes to which he has been an eye witness." At times Brown's persona would convey that emotions were overtaking him, and he was in the traumatic grip of slavery once more, vocally and psychologically; in these moments he represents himself both as an "eyewitness" to the cruelty of slavery but also as experiencing it once again. Yet Brown enlivens the show with his "amusing anecdotes" while a woman named Mrs. Woodman performs instrumental music on the harp, violin, and flute; she also sings "interesting ballads." Brown sings and exhibits his

box. In short, he manages to use anecdotes and music to make this show vibrant and emotionally powerful, but also amusing and entertaining.[156]

Throughout this period, we can watch Brown marshaling the power of *Uncle Tom's Cabin* for his own purposes—sometimes using it for humor, and sometimes to verify the terrible truths of slavery. Brown's use of *Uncle Tom's Cabin* as a vehicle for activism, entertainment, and profit in this era may also have been driven by a need to earn a better living after his marriage to a British woman named Jane Floyd. Jane Floyd was a white schoolteacher who had been the supervisor of the National School in Copperhouse (an eastern suburb in West Cornwall, England). Little is known about how Brown met Jane, but they were married at Falmouth Church on December 5, 1855.[157] As discussed in Chapters 4 and 5, Jane would later perform with Brown, and the couple would remain married until Brown's death in 1897.

Intriguingly, Brown's former partner was also endeavoring to make a profit from *Uncle Tom's Cabin* in this era. In April and May of 1853, James C. A. Smith—now using the name "Mr. J. D. C. A. Smith"—exhibited his own panorama of *Uncle Tom's Cabin* (see Figure 2.12).[158] Smith apparently owned this panorama; a May 7, 1853, advertisement for his "Original" "Panorama of *Uncle Tom's Cabin*" lists him as "the Sole proprietor."[159] Like Brown's, Smith's shows often included "appropriate music"; they were called by Smith both "a first rate work of art" and a "faithful representation of American Scenery and Slavery."[160] Smith furthermore claimed that *his* panorama was "the largest in England . . . the figures as large as life, being by far the most attractive Panorama illustrating Mrs. Stowe's astonishing book." But Smith had never been a slave, so his shows were perceived as lacking authenticity; in any case, they were not popular with the British public. One newspaper notice of a performance in Bolton pointedly refers to Smith's former status (in Richmond) as a "surgeon dentist" but says nothing about the show itself.[161] It also appears that Smith frequently had to offer his shows at reduced prices to obtain an audience, suggesting that they were not particularly well attended.[162]

Because Box Brown successfully exhibited his shows based on *Uncle Tom's Cabin* beginning in May of 1853, the two men's panoramic rivalry no doubt fueled ongoing hostility between them. There was money to be made off the popularity of Stowe's famous novel, but only one of the rivals—Brown—was able to successfully harness this lucrative vehicle as a showcase for his talents. Only Brown was able to play with the flexible medium of a popular novel, turning it to his own unique purposes.

Brown's stage shows not only of *Uncle Tom's Cabin* but also of his own *Mirror of Slavery* were judged to be entertaining and powerful, but also at times irreverent. "The people of this town . . . have been amused with the stories of this

Figure 2.12. An advertisement for an *Uncle Tom's Panorama* created by Brown's former partner, James C. A. Smith. *Bolton Chronicle*, April 23, 1853 (BNA).

gentleman," writes one reviewer in 1855 about a performance in Bethany Chapel, and they have been "no less entertained by the exhibition of his panorama."[163] Brown was becoming more of a showman and an entertainer than an educator, it seems. Yet sometimes his "amusing" stories and his "entertaining" panoramas hit their mark more squarely and with greater gravity, giving a "vivid picture of the horrors of slavery" and the "disgrace of a civilized county," as the review in the *Brighton Gazette* in 1856, cited earlier, proclaimed.[164] As Wood notes, Brown "shattered the ceremonial and rhetorical proprieties of the formal lecture hall. He introduced elements of his own art and folk culture and fused them with the visual conventions of the circus, beast show, and pictorial panorama."[165] In so doing, he may have challenged the notion of enslaved subjectivity as flat or stereotypical; he may have turned the visual or imaginative picture of enslaved identity into something the viewer must carefully watch (rather than only see) as it transforms itself across time and space. If not everyone who attended his shows heeded this visual multiplicity, they still paid their fees, enabling him to earn a good living from his performance work. Moreover, these performances

allowed Brown to keep his own image mobile in the mind's eye of the British public. Douglass notes that when a man's image becomes widely known, the public insists on conformity to this image; the man is now considered "a fixed fact, *public* property" and "his whole *personae* must now conform to, and never contradict the immortal likeness."[166] But the remarkable thing about Brown is that although he was known for his escape by box, he constantly manipulated and renovated his image in his writings, songs, and shows, creating new identities for himself. Brown was never precisely stabilized as "public property," because he ceaselessly strove to reinvent his own history and image.

Conclusion

Brown was able to continue to perform *Mirror of Slavery* into June of 1857 and other panoramas beyond this date, as I discuss in the next chapter.[167] But in 1857 Brown's career took a startling turn, as he moved into yet another realm of performance—acting on the British stage. Brown was the main attraction in plays written for and about him by a dramatist named E. G. Burton; Brown crafted here his own theatrical mode of self-passing, and became in some ways even more of a spectacle as he played himself (or some version of himself) on-stage in live performance events in which several realities could be watched in the same moment: the reality of his past enslavement, the reality of his current freedom, and a virtual (unlived) reality in which he would craft a new means of escape from slavery and "steal back" (symbolically) his enslaved wife. Because no other critic has closely analyzed Brown's work as an actor, and because acting is complex in terms of the idea of spectacle, I examine in detail in the next chapter how he manipulated onstage the trauma of slavery not only for his own economic profit, but also as a potential mode of social or psychic liberation, creating visual static that undermined viewers' ability to "capture" him in their gaze.

CHAPTER 3

Performing Fugitivity

Henry Box Brown on the Nineteenth-Century British Stage, 1857

A s we have seen in Chapter 2, Henry Box Brown crafted a multifaceted performance identity in England through music, stage shows, and several panoramas. Brown presented and narrated his life in *Mirror of Slavery*, taking power over some of its trauma by turning it into a story that he could stage-manage. Brown was therefore already acting in various ways (as himself and other versions of himself), but in July of 1857, Brown's story took a new twist as he became an actor on the British stage. From July to November, Brown acted in at least four plays at small theaters in Margate, Ramsgate, Liverpool, Wigan, and Hanley.[1] These plays, written by the minor British dramatist E. G. Burton,[2] received favorable reviews, but their runs were not extended, and it appears that Brown never acted in any other dramas.[3] In these dramas Brown played himself as well as an African prince; he also acted as Powhattan (*sic*), a "Red Indian Chief" in a play about Pocahontas.[4]

Two of these plays—*The Fugitive Free* and *The Nubian Captive*—directly incorporate and substantively revise Brown's autobiographical background and were most likely written with his input, as they contain details of his life not widely known.[5] Because the other two plays that Brown acted in—*Pocahontas; or, the English Tar* and *The Secret*—were not written for him, nor do they concern his life, I do not discuss them here. These two autobiographical or semiautobiographical handwritten plays (which I have now recovered and transcribed) are intriguing in their theatricalization of Blackness and slavery. I therefore begin with an assessment of what Brown's performances signified within the context of mid-nineteenth-century British drama. I argue that across the two plays

we can watch the evolution of Brown's persona into a Black hero. I am particularly concerned with how the plots of Burton's plays contest (via Brown's personae) the storylines of many onstage configurations of Blackness and enslavement in the 1850s. I also have an eye on how these dramas dynamically stage Brown as a multivalent trickster who foils the audience's ability to capture him in their gaze, in contradistinction to plays from this era in which radical Black characters are either absent or (if present) flattened, controlled, or contained.

The second part of this chapter more theoretically probes Brown's acting as a form of "wake work" that formulates modes of symbolic liberation from the afterlife of enslavement and its denial of the right to look, particularly given that he continued to perform and stage them for several months after he lost his financial backers. Brown plays himself and a Nubian enslaved prince named Hameh, but he also manipulates the visuality of slavery, creating what Daphne Brooks has called (in her discussion of Brown's panorama) a "spectacular opacity"[6] that undermines not only slavery's visual codes but also racialization. In the world outside the theater, Brown was defined by his box, which became part of his name and which he exhibited in his shows throughout his long life. Onstage, however, we see an eventual transition away from Brown's definition via this symbol. Brown's acting therefore stages a challenging mode of performative fugitivity—of "running up against" the social and visual fixity of Blackness and its attendant social death.[7] Brown's objectification of himself within the plays generates a substantive complication of his identity: audience members might become confused about who he "really" is—the main character in the plays, the man who lost his first wife and family under slavery and famously escaped by box, or the legally free man who was living in England during this time period with a new British wife, whom he had married in 1855. Janet Neary argues that Brown's work in general confounds the objectification of the enslaved by viewers or abolitionists.[8] In these semiautobiographical plays viewers might seek, but never find, the "real man," and the plays therefore work to undermine Brown's objectification within this highly visual domain.

Multiple selves of Brown are posited within the objectified medium of the plays, and via these multiple selves a mode of personhood becomes visible that cannot be caught in the narrow lens of a stereotypical representation of enslavement and racialized subjectivity and must be understood as a subversive mode of performative fugitivity. Paula von Gleich defines fugitivity as a "running up against" the social death of slavery and a refusal "to accept and to remain within the structurally ostracized position of social death."[9] Whether we believe that the social death of slavery can ever be overcome, I agree with her contention that fugitivity is not only a physical act of stealing back the captive body from the

captors but also a mode of intellectual resistance to the division of the world into two categories: the human (white, surveilling, dominating) subject and the non-human (Black, surveilled, passive) other. For von Gleich, fugitivity refers to the *struggle* for the transformation from enslavement to freedom that may not be within actual reach but is found in flight, running, escape, and in performances of such actions. In these plays Brown's personae facilitate his audience's apprehension of fugitive processes of running up against the social death of enslavement, especially in the face of the enduring (onstage and off) destruction of Black heroism.

Both dramas also imagine the ways that enslaved individuals can obtain a mode of resistant visuality or what I term here (as well as in other chapters of this book) *I-sight/site/cite*: a sighting (seeing/envisioning the self), siting (placing the self within time or space), and citing (calling the self into being via language, via citation). This mode of I-sight critiques racialized surveillance and claims a vision that exceeds social definitions of the oppressed, passive, surveilled slave. Simone Browne adds the modifier "dark" to the race-neutral term sousveillance— watching from below (coined by surveillance theorist Steve Mann by replacing the French prefix *sur-*, above, with *sous-*, below). The concept of dark sousveillance encompasses a "critique of racializing surveillance" and a consideration of the "freedom practices" that aim to evade and subvert racialized scrutiny.[10] By acting in these plays, Brown develops a form of performance art that manipulates his own objectification via an onstage character who cannot be caught within a viewer's ethnographic gaze and who has his own mode of envisioning the worlds through which he escapes, runs, and travels. These onstage personae dramatize not only his *struggle* for freedom but also the provisional form of liberation he achieves within performance itself.

Becoming a Black Hero: Performances of Slavery and Blackness on the British Stage in the Nineteenth Century

Hazel Waters argues that there is a transition from "racial flexibility" in British performances of African American subjectivity to "racial rigidity" around the mid-nineteenth century, when stereotypical depictions became dominant on the stage.[11] Especially after 1835 when the well-known Blackface performer T. D. Rice came to England and started a "Crow Mania," serious drama was gradually displaced by comic modes that featured minstrel-like characters, and as discussed previously minstrel shows in England became more derogatory toward African Americans and less harsh toward slavery in the 1850s and 1860s. E. G.

Burton's two plays written for Brown may have been unpopular for this reason, but even when set within the context of British drama of the 1840s and 1850s, Burton's plays are provocative in their staging of a heroic Black man who obtains his freedom. The plays also represent Brown's transition into a type of Black Avenger figure—but one who survives and recovers from his losses; in this sense they are unusual as well. Last, except for the US actor Ira Aldridge, who began acting in England in 1832, there were few Black actors playing major roles on the British stage in this time and none who were (actual) former slaves.[12] In this regard Burton's dramas—written specifically for Box Brown to star in—were also radical.

The plays were first advertised in June of 1857 in the *Era* (see Figure 3.1). Based on the hyperbole of this announcement (Brown's panorama is said to have "entertained millions of the English Public"), it appears that Brown authored this advertisement and placed it in the newspaper; Burton's name is not even mentioned as the playwright, suggesting that Brown viewed himself as the co-owner and perhaps cocreator of these dramas. The plays initially were produced by Richard Samuel Thorne, who was an actor and (in this era) the owner and manager of the Theatre Royal in Margate. Other newspaper accounts indicate that Thorne took initiative in having the plays written and staged specifically for Brown to star in, but that Thorne and Brown had a dispute over financial matters, leading to Brown's (unsuccessful) lawsuit against Thorne on September 22, 1857.[13] Therefore from September 27 to November 7 Brown performed these plays in theaters outside of Margate, without Thorne's aid, sometimes simply reading all the parts, but sometimes with other actors.

The storylines of Burton's two plays contest some plots common on the British stage in this era by depicting a mode of Black (enslaved) heroism and agency. In Burton's first play written for Brown (*The Fugitive Free*), Brown plays himself—a man named Henry Brown—although there are substantial revisions to his life narrative. *The Fugitive Free* revolves around an enslaved family composed of Henry Brown, his wife, Nancy, his mother, Betsey, and his sister, Jane. In Brown's own life, as narrated in his 1851 autobiography, after the death of Brown's first enslaver his four sons inherit his enslaved property; the Brown family is split between the sons, with Brown, his mother, and his sister, Jane, going to William Barret.[14] The play parallels these events in Brown's life but radically remakes the details of his escape. In Burton's drama, Brown and his family are promised freedom by their enslaver, a man named Captain Ambler, as a birthday present to the Captain's daughter Amelia. But the villain of the play—a corrupt clerk called Allen—foils the family's legal manumission by throwing Captain Ambler into bankruptcy.[15] Henry Brown is auctioned off, jailed, and

> **MR. HENRY BOX BROWN**, Proprietor of the GREAT AMERICAN PANORAMA, which is well known to have entertained millions of the English Public during the last six years will, in a very short time, make his appearance on the Stage of the London Theatres, first appearing in three new Dramas, "The Fugitive Free," "The Nubian Captive; or, Royal Slave," and "Pocahontas; or, The English Tar and Indian Princess," all of which Dramas have never yet been brought before the Public. Mr. Brown will shortly be open to Engagements.
>
> All communications to be addressed Royal Hotel, Margate, Kent, where Mr. Brown will remain till the end of the summer.

Figure 3.1. Advertisement for Brown's acting in three new plays, *The Era*, June 28, 1857 (BNA).

beaten, but he escapes by passing for a white British man named David and is then sent in a box to his former enslaver, who has moved to Philadelphia, presumably so that Henry Brown can be free. In the play, Henry's sister, Jane, is also freed, but his wife, Nancy (as in Brown's own life), stays in slavery. In Brown's actual life, as discussed in Chapter 2, he conceived of the escape-by-box and then approached several individuals who helped him with his plan. In Burton's play Brown's freedom comes (in large part) via his association with the white British man named David and the intercession of a young white woman, who urges her father to free Brown.

In the second play, *The Nubian Captive*, however, Brown is metamorphosed into a type of Black Avenger figure. Hazel Waters and Grégory Pierrot both argue that this transnational trope can be traced back in part to Aphra Behn's infamous novella *Oroonoko* (1688); this figure stands "at the crossroads of African (and the African diasporic) cultures and Western culture, always extraordinary, always implied as new."[16] Burton sets his second play, in fact, in a crossroads culture—Nubia exists along the Nile river and encompasses parts of Aswan (in southern Egypt) and Khartoum (in central Sudan),[17] and as we have seen was the source of much debate as a potential (Caucasian or Black) cradle of civilization. In *The Nubian Captive*, Brown plays a Black royal prince of this kingdom who owns slaves (Hameh). However, Hameh is betrayed by his archenemy, a man named Konac, who sells both Hameh and his wife, Medona, into slavery in Cuba. Hameh escapes, rescues his wife, and in defense of his freedom kills several of the white men who have enslaved them. The play also features a subplot involving a mystical character named Phonissa, who has clairvoyance, obtains revenge on her son's enslavers, and functions as a type of double for Box Brown's

persona; in later years Brown engaged in "dark séances" and second-sight performances, as will be discussed in Chapters 4 and 5.

The plots of Burton's plays contain important divergences from contemporary stagings of Black enslavement, freedom, heroism, and agency. For example, Burton's second play—*The Nubian Captive*—echoes in some ways Aphra Behn's *Oroonoko*, adapted for the British stage by Thomas Southerne; Southerne's *Oroonoko: A Tragedy* was first performed in 1695 but remained popular into the mid-nineteenth century. Like Hameh in Burton's play, Oroonoko is a royal prince forced into slavery and separated from his wife, Imoinda, who is also enslaved; eventually he learns of his wife's location and tries to free her. Prince Oroonoko is portrayed as noble in both the original novel and the play, and in Southerne's play Oroonoko does get revenge on two of his enslavers. However, over time, as Waters notes, but especially in the 1830s and 1840s, different versions of the play diluted Oroonoko's noble character, taking away many of his key speeches and the amount of agency he was granted.[18] Moreover, neither Oroonoko nor his wife Imoinda survive—they commit suicide in a joint pact at the play's end. In Burton's play *The Nubian Captive*, conversely, Hameh and Medona outlast their enslavement and Hameh even recovers his kingdom. Most daringly, Hameh enacts justified revenge on his captors (in protection of his wife, Medona) and (unlike Oroonoko) abjures slavery, making him a more radical character than the doomed Oroonoko.

Burton's plays written for Brown can also be compared to John Fawcett's popular melodrama about slavery titled *Obi; or Three-Fingered Jack*. *Obi* was first performed in 1800, but versions of it were staged into the late 1850s, including one starring Ira Aldridge, who acted in it in 1857.[19] *Obi* has a revolutionary male lead, a slave turned rebel (Jack). Jack is given powerful speeches in the play about vengeance, such as the following:

> I had a daughter once; did they spare her harmless infancy? Where is my wife? was she spared to me? No! with blood and rapine the white man swept like a hurricane o'er our native village, and blasted every hope! . . . No more, no more! the vext spirits of my wife and child hover o'er me like a holy curse, and claim this due revenge.[20]

Jack has his own vision of the world and nothing will stop his revenge against the whites who harmed his family. However, he is defeated at the hands of a more stereotypical character named Quashee, a good Christian slave. As Jeffrey Cox writes, an audience must give up "freedom-fighter Jack and embrace Quashee, the good slave who accepts both Christianity and freedom as gifts given by

his white masters."[21] In this sense the play forwards a message of Black inferiority and white domination, of Black objectification and white scopic surveillance, as Jack becomes an object to be gazed upon and pitied. In Burton's two plays, the central enslaved male characters (Hameh and Henry Brown) are somewhat trickster-like and transformative in their identities, but they are also wise and powerful; each maintains the integrity of his own world view and envisions new ways of visualizing the harm slavery has done.

An analysis of Black enslaved heroism in theater in this era would be incomplete without discussion of stage adaptations of Harriet Beecher Stowe's *Uncle Tom's Cabin* (1852). As we saw in Chapter 2, Brown utilized *Uncle Tom's Cabin* in his panoramas, and onstage versions of the novel were incredibly successful on the British stage. It is impossible to do justice here to the complicated history of the staging of this work, but some key instances can be surveyed of how it was staged in ways that eroded the notion of enslaved agency and therefore differed significantly from Burton's two plays for Box Brown.

The influence of Jim Crowism made its way quickly into dramatic adaptations of *Uncle Tom's Cabin*, undermining the portrayal of key characters. One of the earliest versions was staged on September 8, 1852; a review of it in the *Era* judged it to be successful for the "interesting nature of its plot."[22] Yet even in this version, the hero is not Tom or George Selby, but Van Trompe, a white character who is a minor figure in the novel; it is Van Trompe who fights off oncoming slaveholders, instructs George about how to escape, and is almost killed by bloodhounds. Serious versions also tended to turn Tom into an icon of passivity or humor; for example, one reviewer describes the role of Uncle Tom on November 14, 1852, as a "quiet, low comedy part."[23] As will be discussed below, Burton's dramas, on the other hand, make clear that Henry Brown and Hameh (the roles played by Box Brown) are heroic and dignified individuals with their own visions of freedom.

Adaptations of Stowe's novel of course ran the gamut, from those that were weighty investigations of slavery to those that were entirely farcical, such as a production staged at the Astley's Royal Amphitheatre in London on December 11, 1852, featuring "the superior Equestrian Spectacle of *Uncle Tom's Cabin*" and "unparalleled Equestrian and Gymnastic Achievements."[24] There were also versions that involved much chasing and fighting on horseback, dogs on stage, pantomimes, and even a trick pony belonging to Topsy.[25] Such plays turned the enslaved into an exhibition or entertainment, and audience members could engage in a mode of ethnographic spectatorship as they gazed on the weird antics of minstrel-like figures.

In the US, the version of *Uncle Tom's Cabin* that had been adapted for the stage and was considered the most "moral" (rather than humorous or burlesque)

and faithful to Stowe's abolitionist sentiments was penned by George Aiken in 1852. However, one important aspect of Stowe's novel that Aiken presented on-stage could not be preserved in any British performance of the novel: Tom's careful study of the Bible and his deep faith in Christianity, both of which made him heroic to many nineteenth-century US spectators. British licensing laws commonly viewed presentation of religious matters onstage as blasphemous, and it was even forbidden to mention the Bible or use it as a prop onstage. There-fore, as Sarah Meer notes, what made Aiken's play moral for audiences in New York would have made it immoral in London.[26] Instead of presenting Tom's Christianity, some of the plays in London emphasized the violence of slavery and British heroism in ending this horror; others minimized the harms of slav-ery and were indebted to US Blackface practices.[27]

Versions of *Uncle Tom's Cabin* were also performed in the same year that Burton's plays were staged. However, by 1857, the focus turned to the white characters, such as the angel child Eva. A production at the Britannia Theatre in Hoxton focuses on the "charming and accomplished Vocalist, Miss Clara St. Casse, as Eva"; indeed, the listing of key scenes never mentions Uncle Tom, or even George Harris.[28] As time wore on there was also a tendency to cherry-pick key scenes from the novel and ignore its critique of slavery. An incredibly suc-cessful show from 1857 at the Marylebone theater featured actors and singers from the US—the Howard family, who had starred in the "moral" version of *Uncle Tom's Cabin* authored by Aiken and staged with incredible success in New York. Yet in the Howards' acting of the British version the focus shifts away from Uncle Tom's Christianity and his potential heroism to the play's less controver-sial characters. "Little Cordelia Howard" (in this version) played Eva, her mother played Topsy, and her father acted St. Clare. Mrs. Howard's representation of Topsy was full of "grotesque vigour," noted one reviewer, and "whether she sings, dances, screams, gesticulates, or throws herself into odd and hardly possible at-titudes, all is done with suddenness and force that deserves to be called original-ity."[29] African American enslaved characters such as Topsy become something at which spectators can gape and gawk.

Waters identifies several adaptations of *Uncle Tom's Cabin* that treated Black characters as heroic and were faithful to the novel's critique of slavery, as does Sarah Meer, who offers a comprehensive discussion of the variety of stagings of the novel in London theaters.[30] Yet in general most versions displayed "the rejec-tion, by and large, of any meaningful attempt to portray a serious black-skinned character."[31] In most portrayals the characters were not strictly heroic, as Virginia Vaughan further notes, using terms from Eric Lott; instead they reflect the "love and theft, desire and derision" evident in minstrel performances of Blackness on the British stage in this era.[32] Therefore, these plays often "kept something in

common with proslavery material" and failed to fully showcase the humanity of African American characters.[33]

Burton's plays have some stereotypical characters in them and a degree of melodrama. Brown acted the part of Hameh and himself, but other Black characters may have been played by whites in Blackface, with a degree of seriousness or minstrelsy.[34] And yet they also attempt to craft heroic Black figures—intelligent, rational, strong, and moral individuals who gain their freedom and endure. Moreover, while Burton's two plays at times utilize the visual pathos of slavery found in popular plays about enslavement, they also significantly complicate what we might call a pathetic spectacle of slavery by way of their staging of racial passing, counter-visuality, and what Simone Browne has termed "dark sousveillance"—looking back at the enslaver via a different mode of visuality.

Impersonating and Staging the Self:
The Fugitive Free

As we have seen, the storylines of Burton's two plays undermine some portrayals of Blacks common on the British stage in the 1840s and 1850s. More theoretically, these plays contest a mode of Black objectification and the ethnographic gaze of audience members via Brown's acting of himself in these plays, and his acting of (alternative) versions of a self he wished to claim. These plays locate, for enslaved characters, a mode of I-sight/site/cite that undermines racialized surveillance and claims a vision that exceeds society's dominant definition of the oppressed, passive, surveilled slave. Brown's acting also enacts various freedom practices, especially in music, which becomes an alternative soundscape for the oppressed.[35] In his discussion of the Black Atlantic, Paul Gilroy defines sound and music as crucial to a "politics of transfiguration,"[36] and as we will see Brown's use of music in the plays functions as a vital mode for reconfiguration of enslaved experience and identity. If we not only *watch* Brown onstage, then, but also *listen* to his image of himself as it is performed, we can better comprehend how Brown's onstage persona uncovers a political subjectivity, a collective vision of freedom, and what one theorist had termed "the right to look."

By 1857 slavery had been abolished in Britain,[37] yet it continued to exist in virulent forms in other locations. The intended audience for Burton's play might then be those who would sympathize with the continuation of slavery in diverse parts of the world or those who might not fully comprehend the trauma of enslavement. To show the harms of this institution, the first play that Brown acted in—*The Fugitive Free*, in which he played himself, a man named Henry Brown—

stages many degrading events common in slave narratives, such as pathos-filled scenes of family separation; verbal degradation of the enslaved (they are compared to hogs); potential rape of women; whippings and other torture; and a long scene centered on a dehumanizing slave auction. The auction scene—where the character Henry Brown is sold (something that never happened to Brown)—makes the horror of slavery patent. Auctions were violent, visceral sites of slave disempowerment that occurred on both a literal and optical level; in some locations, auctions were even staged in opera houses and public squares. And yet, even in exhibitions such as this, is it possible that visual power was exercised, especially via their restaging? Joseph Roach terms performance "restored behavior" or "twice performed behavior"; dramatic performance is a representation that can be rehearsed, repeated, and readapted.[38] So it is intriguing that Brown's stage work performs auctions; by renovating the way he is surveilled, Brown may strive to repossess his body and identity.

The auction in Burton's play *The Fugitive Free* takes place in the public town square in Richmond and is a violent and drawn-out passage set at the very center of the play. A large gang of enslaved individuals sits on stage with "tallies and numbers on their breast,"[39] suggesting the techniques that slavery used to degrade humans into numbers and money. Henry Brown is brought out with this description:

> Henry Brown, the lot for sale you see, is first rate—all square and straight as a yard and three quarters of a poplar—he is 29 or thereabouts—is a first rate scholar, writes like print and talks like an almanac. Had a first rate education; I assure you will make a tarnation good clerk or book-keeper. Could manage a small estate in the absence of the proprietor and is very honest.[40]

Performance here allows Brown to create a type of visual static that blurs a reading of him: he is himself (Henry Brown, an enslaved man separated from his wife) but also not himself; the actual man Henry Brown was not a "first rate scholar" who could read and write, and the real Henry Brown was not given any formal education by his enslaver, according to his narrative.

In this play, Brown's wife, Nancy, is sold away by her enslaver, Cottrell, a detail that echoes painfully with Brown's own life. As recounted in Brown's autobiography, his first wife, Nancy, was sold to a Mr. Cottrell, who swindles and dupes Brown out of money. Cottrell then sells the couple's three children and Nancy (who is pregnant with the couple's fourth child) to a slave trader who takes them to North Carolina.[41] These details are daringly and audaciously replicated in the play. Cottrell's name is even directly interpolated. Yet in the play

the character Henry Brown is given a voice to protest Cottrell, the oppressive enslaver, when he speaks these lines:

> Monster . . . have you no mercy—have you no feeling—not one generous spark of humanity? Man, Man—are you a man or has nature formed some hideous creature to walk the earth in human form? But mark me thou hast not yet subdued the soul that now burns with fiery indignation in my breast. . . . Such an hour will come when I shall trample on thy worthless carcass, as I would the reptile that has stung me.[42]

Henry Brown and his wife are forcibly separated, yet Brown gets the last word, as the enslaver is equated with the subhuman (a monster and a reptile). Henry Brown (the character in the play) also vows revenge and lives on, something that rarely happens in other dramas portraying Black individuals in this period.

In the plot of *The Fugitive Free*, however, Henry Brown is allowed only a certain amount of redressing of his life, and the degree of heroism he obtains is limited. In Brown's 1851 narrative the boxing scheme is created by Brown, whereas in Burton's play it is invented by a white British man named David. David is also instrumental in Brown's escape from jail; David passes as Brown and switches places with him in the jail cell so that Brown can walk free. Both these transformations play up British heroism while playing down Brown's agency. Furthermore, even in the play's unboxing scene, Brown's passivity is emphasized, and his unboxing is reduced to a stage spectacle:

> *Stranger*
>
> I have invited a few friends to witness the opening. I have explained all to them. Should [Henry] Brown live this will be one of the wonders of the age. 350 miles closed in a small box is almost beyond belief.
>
>
>
> Now let a dead silence prevail—have some wine ready.
> (The stranger raps on the box and says are you well—)
> HENRY (inside)
> I am thank God.
> (The box is opened and Henry is lifted out and placed on it).
> (They give him wine, he is very faint but soon recovers).[43]

Beyond speaking four words ("I am [well] thank God") the character Henry Brown does little and is actually lifted out of the box; then he faints. On the level of the plot, then, his agency is elided in this scene.

And yet when this play's staging of Brown's persona as a whole is analyzed, it becomes apparent that some of the binaries that subtend the distinctions between an empowered, white, free, civilized, viewing individual and a disempowered, Black, enslaved, uncivilized, viewed subhuman other are obscured by his performance within the play. In 1853 the racist French author Joseph Arthur de Gobineau writes that Blacks and whites are "two completely foreign races" and will never "amalgamate"; moreover he claims that "the tribes which are savage in the present day have always been so, and always will be."[44] De Gobineau's views were extreme, but versions of them were not uncommon in England in this time period.[45] In Burton's play, such a logic of Black inferiority and white superiority is challenged via dramatic characterization; Henry, Jane, Betsey, and many other enslaved individuals are portrayed as highly civilized, literate, heroic, and humane. Conversely, some of the whites (such as Allen and Cottrell) come across as vicious, cruel, lascivious, and uncivilized.

Brown's passing and impersonation of himself within this play also challenges a larger logic regarding the African American body and African American identity. As Carolyn Sorisio contends, the Black body was always public and a spectacle.[46] Yet there are key moments in the play that confuse the idea of the African American body as stable and fixed, and therefore able to be scrutinized. Frequently, this happens via songs within the play that blur identity and time. For example, before he is free, Brown sings a freedom song that complicates the bodily persona he is enacting and creates a temporality that merges present and future:

Oh how merry will my days now be
Since I'm released from slavery
Tomorrow's dawn will see me free
And all around will be mirth and glee

I will rise each morn by break of day.
And toil a pleasure then will be.
For at my work I can be gay.
For all my labour will be free.[47]

Because the song is set in the future tense ("Tomorrow's dawn will see me free") but also in the present ("Oh how merry will my days now be / Since I'm released from slavery") and continually shifts between these tenses, it muddles the identity of the free man Henry Brown in England playing the enslaved man in the US (Henry the character) who is singing about a fate he has already enacted. The song can therefore be read as a kind of soundscape with what Gilroy would term

political transformations that enable the character Henry Brown's movement into a mode of agency and counter-visuality. Fred Moten has called attention to performances that are multisensory and argued for an acoustic practice that emanates from scenes of domination.[48] Sound, for Moten, may belong to a history of revolutionary action, a concept that was certainly evident in Brown's own life and that later artists such as Glenn Ligon will invoke in their homages to him. Brown's song in the play emerges quite literally from a scene of subjugation (slavery); it is also a multisensory (visual, verbal, and aural) performance that instates his belief in his performative freedom. The song enacts a mode of vision that is speculative and even clairvoyant, in that it has not yet occurred within the play's plot; an audience needs to watch (and hear) the ways in which Brown sees into a future that has not yet occurred. Moreover, in its emphasis on productive labor in freedom ("toil a pleasure then will be.... For all my labour will be free"), Brown's song speaks back to degrading, minstrel-like songs and images of the supposed "laziness" of the Sambo-like figures common on the stage in both England and the US in this time; the song also intervenes in debates about whether the enslaved would work once liberated.

As we have seen in previous chapters, music was integral to Brown's escape from slavery and to his formulation of his own emergence from his box, in the songs he sang when unboxed and the lyric sheets he circulated at abolitionist meetings and elsewhere. In Burton's play about Brown music is also crucial to Brown's symbolic freedom, as the songs (perhaps written by Brown) employ a mode of radical temporality in which past, present, and future impinge upon each other. They also gesture to a realm when slavery will be abolished for everyone: "all around will be mirth and glee," sings Henry Brown, the character. Yet this is a fate, it seems, that Henry Brown (within the play) has already grasped ("I'm released from slavery") and that echoes in powerful ways with the Henry Brown who exists (now) outside the play, collapsing temporal boundaries and making it hard to comprehend which body, exactly, is being viewed.

This focus on an activist I-sight and counter-visuality that becomes possible only when one enters a speculative, radical, and atemporal time frame is also evident in another exchange between Henry and Jane involving music. Henry sings the chorus of his freedom song and encourages Jane to do the same. She repudiates this idea and says, "Look at the dark prospect before us." Henry responds, "No I won't look at any such thing, I'll never look at *anything dark any more*."[49] Henry refuses the enslaver's vision of his subjectivity as subhuman, uncivilized, dark, low, and therefore deserving of enslavement. As previously noted, Nicholas Mirzoeff argues that slavery entailed a combination of both violence and "visualized surveillance" that granted "the right to look" to the enslaver and not to the enslaved. Mirzoeff uses the term "counter-visuality," which

he defines as a subjugated person's claiming of a "right to look" when none technically exists.[50] In singing a freedom song when he is not free and refusing to abide by the "dark prospect" of perpetual enslavement (or social death) that the enslaver puts before him, Henry Brown insists on his right to look and a mode of counter-visuality that figuratively sees his own entrance into a mode of freedom. He engages in a subversive performative mode that ruptures the enslaver's envisioning of both the world and enslaved subjectivity.

Manifested in such scenes is a radical, atemporal projection into the future and an *envisioning* of the self as a free man that acts as a prelude to physical freedom. At another point in the play, Henry (the character), having been promised his and Jane's freedom, declares: "I am no longer a slave. . . . Jane prepare yourself . . . the earth is now our own and here I stand upon the face of nature a free man."[51] Henry Brown's freedom has not yet been legally executed (Ambler has signed no manumission papers), yet he claims that he has always had "a vision [of freedom] that . . . haunted me by day and night" and that now "the vision is realized."[52] In other words, the character has always had a mode of counter-visuality that speculatively envisions his own freedom, even while he was enslaved. The focus is again on I-sight: a method of performativity "citing" and "sighting/siting" the self as an "I" (as fully human) that surpasses the enslaver's technique of seeing the enslaved as a surveilled and passive, subhuman piece of property. I-sight itself may be a form of wake work, in short, that aesthetically runs up against enslavement, interrupting its visual and social logic.

Brown's performance in this play further inculcates the right to look and a type of sousveillance (seeing from below) by foiling the biometrics of slavery: the way bodies were marked and controlled by the enslaver, and (beyond slavery) through performance of various types of passing. Simone Browne argues that biometrics such as branding and scarring, identity documents, and other technology of the nineteenth century "made it possible for the black body to be constantly illuminated from dusk to dawn, made knowable, locatable and contained."[53] Such practices are referenced in Burton's play. Parson Brown, for instance, is said to have "no scarcity of red ink when he writes his name on [his slaves'] backs,"[54] a phrase that painfully alludes to the condition of Black bodies being written on (in blood) by the dominant culture to contain them.

Yet such biometrics are defied in key places by the play's deployment of racial passing. David (who is white and British) passes twice for a Black man—once to get a note to Nancy while she is visiting Henry Brown in prison (David blackens his face here) and then to free Henry Brown. During the second instance of passing, David enters the prison "disguised as a Doctor [in] a long cloak and broad brimmed hat" which he places on Henry so that Henry can escape; David takes Henry's place on the bed after placing himself in a medically induced

sleep.[55] In the moment when David passes for Henry and Henry passes for David, however, many kinds of divisions are vexed: Black versus white, enslaved versus free, English versus American, and so on. Britt Rusert argues that "Black performers regularly trafficked in—and worked to emphasize—the ambiguity of race on stage, while resisting the public spectacularization and visual consumption of their bodies,"[56] and this is certainly the case for Brown. Consider that throughout the play Box Brown is really passing for himself—he both is and is not the character he plays. So, when David passes for Henry Brown, he is passing for a simulacrum of Box Brown, his performative identity, perhaps. And when Brown the character passes for David, he is passing for an actor who is already passing for something he is not (a character in a play named David).

In short, there is no "true" self for Box Brown in this play, but rather a series of mutating identities that performatively undermine the biometric markers of enslavement but also categories of identity and race. If watched carefully, Box Brown's performances of identity/the body in this play theatricalize race in a way that might (at least temporarily) break open rather than stabilize the boundaries of racial legibility. Brown becomes the play's unknowable and unknown center—as he comes to embody both a white man and a Black man, a slave and a free man, and an actor and a real man. As an important mode of wake work, Brown's persona in these plays lives in the afterlife of slavery but also transgresses and ruptures this afterlife, precisely through subversive modes of seeing, singing, hearing, watching, and envisioning his own subjectivity.

Re-Performing the Self: *The Nubian Captive*

Stage notes on *The Nubian Captive; or, The Royal Slave* indicate that it was "Written Expressly for Mr. H. B. Brown"[57] and that it was penned after *The Fugitive Free*. Brown stars as Hameh, an African prince, which echoes with Brown's own later life in that Brown would (in 1859) begin to perform under the moniker of "The African Prince." Moreover, at one point slave traders threaten to sell Hameh, who has been sold into slavery in Cuba, into slavery in the US, a detail that echoes (perhaps titillatingly for the audience) the facts of Brown's life. In these ways the story of Henry Box Brown's life and later performance work invade the character of Hameh and the drama as a whole.

As we have seen, *The Fugitive Free* allows Brown a degree of reparation of his own life via performance; the play also challenges the visuality of slavery in favor of a mode of symbolic I-sight that transcends the enslaver's definition of the enslaved. *The Nubian Captive* goes even further in being a mode of aesthetic wake work that subversively performs but also fissures events of Brown's life to

represent radical freedom practices. In *The Fugitive Free*, Brown's wife, Nancy, remains in slavery, but in *The Nubian Captive* Brown's character succeeds in rescuing his wife after both have been sold into slavery. Brown/Hameh formulates his escape plan when he learns that the man who enslaves Medona plans to rape her:

> Yes—yes there is a moon tonight—the trial shall be made if I die in the attempt—once certain it shall be death or liberty—to delay is to plunge her into the gulph of Despair and shut her from my eyes forever— . . . my blessed wife. . . . Oh, Heaven give me the lightning speed to fly to her rescue.[58]

Hameh uses the moon as part of his escape, and, as we will see later, light—and specifically the North Star—is integral to his envisioning of a new world in which he will enact his own freedom via a mode of I-sight. His objective is "death or liberty" and his sighting/siting/citing of himself entails recovering his "blessed wife" in a way that Box Brown never could.

Chapter 2 examined how the 1851 autobiography of Brown's life tries to exercise power over the harrowing scene depicting the separation from Nancy and the couple's children via narration. However, the painful parting scene drags on as if Brown cannot quite attain the sovereignty over it that he seeks. This is a primary trauma that *The Nubian Captive* attempts to refigure, as Brown/Hameh steals back his wife. Hartman argues that various practices of "stealing away" are a "redemptive figuration" that contradicts the enslaved person's status as chattel and begins the project of "redressing the pained body" and of reinvesting in the body as a site of possibility.[59] When Brown's character in *The Nubian Captive* in effect steals back his wife, we can see a mode of symbolic reparation that moves beyond Brown's inability, in the real world, to steal away Nancy from her enslaver Cottrell. Of course, the world created onstage is a virtual (imagined) one, but it enables a certain symbolic and psychic movement beyond the facts of Brown's real life.

There is also a measure of (justified) revenge extended to Brown/Hameh when he steals back his wife from the enslaver. When Hameh finds Medona, she is in the process of using a dagger to fight off her would-be rapist. As Medona struggles, two shots are heard, and it transpires that Hameh ends up killing two white men—Colonel Calvert (the man who has enslaved Medona and now plans to rape her) and his assistant Goswell (a slave driver). When Medona worries that this action might lead to Hameh's death, Hameh responds with a speech showing that he recognizes his deeds as part of a logic that transcends the system of enslavement: "Fear not Medona, had not a power on high sent me to thy

aid thou wouldst have been dragged to a fate ten times more terrible than death itself. . . . I have dared death—yes Medona, Death or Liberty."[60] This verbatim quoting (twice) of Patrick Henry's famous 1775 phrase from the US revolutionary period ("Give me liberty, or give me death!") configures Hameh as a heroic figure, as does his assertion that he was sent to save Medona by a higher power. Perhaps more importantly, Hameh/Brown becomes the hero of this play by virtue of initiating and planning his own liberation. Hameh is eventually helped by a Dutch man named Von Clatz and by British sailors, but Hameh is represented as having resourcefulness and agency in the initial planning and enacting of his escape. Scenes such as this move beyond the popular image of Brown jumping out of his box as well as away from the onstage paradox of enslaved passivity or rebellious (but doomed) heroism.

The Nubian Captive also stages Brown/Hameh's ability to revise his life via reclamation of visuality, of the right to look. When Hameh is first presented with the possibility of liberating his wife, he says that his belief in Medona's return will be "the warm beam of hope which bears me up. I see it glimmering through the dark clouds that now surround me."[61] Like the character Henry Brown in *The Fugitive Free*, Hameh uses visuality to imaginatively *see* a future that has been obscured by the psychological effects of slavery (the dark clouds) but still exists. Furthermore, Hameh attempts to extend this counter-visuality to Medona. After Hameh and Medona have escaped from captivity but are not yet back in Nubia, Hameh reminds Medona of the "song of joy" they used to sing together on watching the rising of the North Star and asks her to sing it again with him; once more, music is a freedom practice or soundscape with political valences that might transfigure the material or psychic effects of slavery. Medona is worried that "the darkness" will overshadow them; here she refers on a literal level to the nighttime, but more symbolically she implies that the darkness of slavery, its social death and denial of the right to look, might confound her.

Hameh, however, explicitly translates his mode of I-sight to Medona and encourages her to be guided by their own active envisioning of the world:

> Medona behold yon bright and glittering star—a few moments since it was dull and overcast—see how it now shines forth as the harbinger of hope to us—tis the North Star that guides the wanderers on to peace and safety—its bright beams will guide us on to the haven of bliss—Methinks that somewhere on the outskirts of this wild morass there stands a lonely dwelling where many a hapless fugitive has found repose and succor. Could we but find it we might find some disguise that would add safety to our flight.[62]

This natural and even supernatural light contrasts and even supersedes the enslaver's technology of surveillance and tracking, such as lanterns and dogs used to hunt slaves, referred to in other scenes in the play. The play explicitly echoes slave narratives, in which fugitives were often said to be guided by the North Star. It alludes to a practice of fugitive disguise that foils the biometric markings of slavery via multiple modes of passing, masquerades, and physical subterfuge that resonate with Brown's own narrative (as we have seen he disguised himself, or passed as, a box or cargo to escape). *The Nubian Captive* here showcases a mode of recompense via its deployment of a technique of dark sousveillance—of looking from below, looking back, but also looking *differently*—that stands in opposition to the enslaver's denial of the right to look. The passage also blurs time and space: when it references following the North Star and a "fugitive" finding repose in a lonely dwelling, it is unclear whether England or the US is being referenced, or whether this is an antebellum or postbellum time frame. This also is a moment of atemporality in which an audience might become perplexed about who they are viewing—the Brown of the past (who escaped US slavery), the Brown of the current moment (acting as an enslaved prince named Hameh), or the Brown of the future (who is free once he steps off stage).

In *The Nubian Captive* Box Brown (who never owned a slave and was a US-born fugitive) passes for Hameh, a slave owner and Nubian prince, and then (during his escape) as an African slave trader named Cassim and a British sailor. Moreover, Medona (once a slave but elevated to a royal princess) passes for a male sailor (a "lad"[63]) to enact her escape. Such performative crossing and inversions of multiple categories of personhood (from enslaved to enslaver, from US-born to African or British, from royal to unroyal, from white to Black, and from male to female in the case of Medona) may muddle the salience of such divisions by making them seem permeable and porous. Brooks describes opaque performances that "confound and disrupt conventional constructions of the racialized and gendered bodies" and protect the body from the "imposition of transparency" produced when Black bodies on stage become spectacles.[64] These passings themselves create visual static that may shroud Brown's body from being clear, knowable, or transparent—perhaps he cannot be read by the audience in any straightforward way. Brown becomes a constantly metamorphosing figure who undermines the audience's ability to capture him in their gaze.

This mode of characterization is evident not only in Brown/Hameh, but also in the play's depiction of Phonissa, a mysterious enslaved Abyssinian (Ethiopian) woman who has lost her child under slavery. Her onstage portrayal echoes Brown's real life in several ways, so she may function as a symbolic double for Brown who expands the representational parameters of his life and dramatic characterization. Like Phonissa, Brown lost his own children, transitioned to a

more nontraditional identity in a foreign culture, and practiced (in his performances on the British stage) mystical arts such as second sight, séances, and clairvoyance, as will be discussed in the next chapter. Brown was also something of a trickster figure, jumping out of his box on stage, or hypnotizing the British public during his acts and making them look foolish.[65] In a scene that echoes Brown's own miraculous "resurrection" by box from slavery, a conversation between Zona and Fatima (two of Medona's ladies-in-waiting) implies that Phonissa, like Brown, seems to arise from the dead. Fatima asks where Phonissa has been for "all this time" (the three years of her imprisonment), to which Zona responds: "Perhaps dead and come to life again." Phonissa is described as "an unearthly woman, a mysterious woman, a wild woman" and many characters in the play believe that she can see into the future.[66]

Phonissa is also categorized as an excessive character; as such she might undermine the audience's way of reading racial identity and the world in a transparent or straightforward manner. Amy Hughes argues that excess is political because it violates cultural norms, and that bodies in extremity are inherently radical.[67] Phonissa represents the social death of slavery, but also a running up against this social death via her ability to resurrect, to see beyond the physical world, and to exercise a mode of power and control that exceeds the constraints of the dominant society. She foreshadows many of the excessive modes of power that Box Brown would take up in his later performance work, as he moved beyond the traditional formats by which slavery was visually presented and closer to his own mode of performative counter-visuality through his use of séances, magic, second sight, hypnosis, and healing.

Conclusion: Black Heroism on Stage and the Right to Look

The Fugitive Free and *The Nubian Captive* both deploy a radical and at times excessive mode of counter-visuality that performatively runs up against the social death of slavery. Both plays are insistent that the enslaved have not only the right to look (a discursive practice, as Mirzoeff notes), but also the *right to act*— the right to speak out against slavery, the right to escape, and the right to use violence (when necessary) in the pursuit of freedom. They also grant to their characters a mutative, transformative onstage body and identity that may escape the objectifying gaze of audience members.

Many plays on the British stage in this period failed to enact a mode of Black heroism and survival. Burton's plays are unusual in that both Henry Brown (in the *Fugitive Free*) and Hameh (in *The Nubian Captive*) find freedom within the

drama. Yet what most distinguishes these plays from others of this era is the formulation of I-sight and counter-visuality: the ability to both see *and enact* a future in which enslaved and formerly enslaved individuals will be conceptualized as human and free, and will have the right to look, defined by Mirzoeff not only as a visual politics but also "autonomy, not individualism or voyeurism, but the claim to a political subjectivity and collectivity."[68] This future is presented visually and performatively so that the audience can become part of a virtual community where the ideal of a shared humanity comes into view.[69] Moreover, via tropes of self-impersonation and passing, Brown's work as an actor within these plays functions as a radical performance practice that begins to destabilize formulations of racial identity and foundations of white spectatorship, as he thwarts the audience's ability to know and spectate Black bodies.

We cannot know with any definitive certainty whether Brown's acting in these plays allowed any emotional release from the pain of enslavement; unfortunately, no records exist about how he felt while performing or why he stopped acting. The staging and restaging of his life (and alternative lives that he did not live) on the British stage, however, may have given him a modicum of *control* over his role as a surveilled, passive individual. Live stage drama is a visceral spectacle that is "real" (at least momentarily) in the audience's and performer's minds, but also highly controlled and curated. Brown enacts onstage a moment of performative fugitivity in which he runs up against the social death of enslavement—which always configured him as an ex-slave rather than as a human being—and this may have been a mode of self-emancipation, a freedom practice that has valences outside the world of the plays. By acting in these plays, Brown becomes a revenant—someone who returns to scenes of subjugation yet emerges revivified into the present moment, having turned his trauma into a spectacle that he could manipulate and stage-manage, if not exactly escape.

Performing New Panoramas, Mesmerism, Spiritualism, and Second Sight, England, 1857–1875

Brown's work as an actor ended in November 1857. But even without a formal stage, he continued to engage in vivid and dramatic modes of performance, including new panoramas, magic, mesmerism (hypnosis), second sight, ventriloquism, and even conducting a "dark séance." During one performance in 1868, he tossed raw cabbage to his hypnotized subjects, which they allegedly devoured onstage, believing themselves to be sheep; many claimed to be chagrined after they learned what fools they had made of themselves on Brown's stage. I argue in this chapter that Brown's later modes of performance—and especially hypnosis and magic—are an important form of wake work. Such performances exist in the afterlife or wake of slavery, in the unfinished business of emancipation, but also aesthetically or materially interrupt this afterlife and the dominant society's configuration of Black identity. Brown's later performances enabled him to turn his audience into a spectacle and to play subversively with representations of enslavement. Of course, Brown had to earn a living via such performances, but some of his more spectacular shows allowed him to manipulate his audience so that they became imprisoned to his will, an idea that we should think seriously about as we watch Brown (still understood as an "ex-slave") move into these new incarnations of identity. Moreover, via magic, second sight, and other mystical modes of performance, "Box Brown, the wizard"[1] seemed to have extraordinary and even supernatural powers over a hidden world that his audience was unable to control or even comprehend.

Brown did not abandon earlier modes of performance and marketing of his story entirely, however. For example, he continued to sell his narrative for a

shilling, most likely during many of his performances, and this seems to have been a source of profit to him. As late as 1860 reprints were still being published, with diverse visual layouts. The title page of the 1860 Rugby edition (labeled as the "Tenth English Edition," which implies that there were at least nine earlier reprints) has a "Resurrection" illustration based on the 1850 lithograph. However, in this case, the image of Brown emerging from his box moves to the title page, rather than being presented as a separate frontispiece within the book (see Figure 4.1).

In this 1860 iteration of the unboxing, the cost of the book ("PRICE ONE SHILLING") is listed in bold below the figure of Brown emerging from the box, as if the reader is buying Brown himself. This detail is perhaps an ironic nod to the fact that in the US slaves were still considered property to be bought and sold, and may function like Sojourner Truth's motto ("I sell the shadow to support the substance") to highlight the ways in which "ex-slaves" were still caught within the market logic of slavery. There are other minor changes to the 1860 edition; for example, the pseudonym "M. McRoy" is changed to "Miller McKim," and there are differences in pagination, layout, and orthography. But the most significant difference is the first line of Chapter 1, which reads: "I was born about forty-five miles from the city of Richmond, in Louisa County, in the year 1822."[2] The 1849 and 1851 editions use the dates of 1816 and 1815 (respectively) for Brown's birth. In fact, the 1851 edition begins: "I was born about forty-five miles from the city of Richmond, in Louisa County, in the year 1815." Brown was (once again) creatively reinventing himself—this time as a man who was seven years younger than he had previously portrayed himself to be.

Brown developed several new panoramas between 1857 and 1863, while continuing to perform his original panorama of American slavery. After 1863, however, he seems to have mostly ended his panoramic work to take up magic, mesmerism, second-sight performances, electro-biology, and even phrenology, modes that would dominate his performance work until at least 1875. But in the period of 1857–1862, Brown's work with his panoramas was extensive and perhaps exhausting, as he introduced new ones and staged them frequently. These performances tell us much about how Brown both cultivated and manipulated his audience, so they deserve careful analysis.

New Panoramas: The War in India and the Civil War (1857–1863)

The subjects of Brown's panoramas in the period of 1857–1863 included African and American slavery, the Indian War, a panorama of the Holy Land featuring views of Jerusalem and key scenes from the life of Jesus Christ,[3] and the US Civil

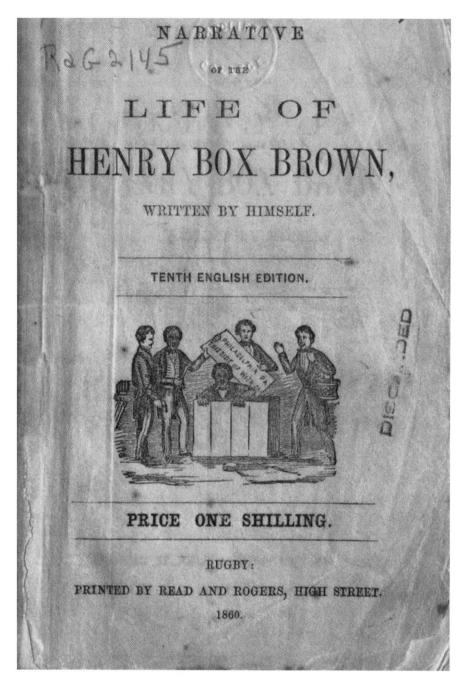

NARRATIVE

OF THE

LIFE OF

HENRY BOX BROWN,

WRITTEN BY HIMSELF.

TENTH ENGLISH EDITION.

PRICE ONE SHILLING.

RUGBY:
PRINTED BY READ AND ROGERS, HIGH STREET.
1860.

Figure 4.1. Title page of 1860 Rugby Edition of *Narrative of the Life of Henry Box Brown*. Printed by Read and Rogers. Courtesy of Brandeis Library Special Collections.

War. From 1858 onward, Brown's second wife, Jane Brown, whom he married in England in 1855, took over the narration of some panoramas, but she also performed panoramas and lectures on her own, beginning in 1861. As Jane was white, no doubt her presence fueled some of the interest in Brown's performance work.

Brown often seized on current events—and especially wars—to create new panoramas. Commencing in March 1858, Brown took advantage of a rebellion in India against British control and began performing his *Panorama of the Indian War*, and in January of 1862, building on interest in the Civil War, he began performing a panorama of the US Civil War—known variously as *Panorama of the Great American War* and *Grand Moving Mirror of the American War*. As discussed in Chapter 2, the contents of Brown's "Mirror of Slavery" have been located and analyzed by several scholars. Yet little scholarly attention has been paid to his later panoramic work, so I examine his panoramas of the War in India and the American Civil War extensively here.

The full contents of the "War in India" panorama—as performed at a venue on the Channel Island of Jersey known as Cornwall's Riding School—are listed in the *Jersey Independent and Daily Telegraph* on March 10, 1858 (see Figure 4.2).[4] The illustrations were created by "Mr. Mills, of London" who is described as "one of the most faithful painters of the day."[5] Brown emphasizes both the educative and entertainment value of the panorama: in the poster he is said to "have spared neither trouble nor expense in procuring the most truthful and thrilling information respecting the all-engrossing topic of the day."

The panorama portrays the Mutiny in India of 1857. In May of this year, soldiers of the Bengal army rebelled, shot their British officers, and marched on Delhi. This mutiny led to many Indian civilians revolting against the British, and for several months British forces were reduced to a few strained barracks, until Britain launched troops to restore imperial authority in 1858. The rebellion may have been sparked by British interference in Indian religious and social customs. A rumor circulated that pig and cow fat, forbidden in the Muslim and Hindu religions, was used as lubricant on cartridges for rifles issued to some of the soldiers, and soldiers had to bite open these cartridges to release the powder before loading their guns.[6] By 1858 the British Crown assumed control over the Indian subcontinent, but the rebellion was bloody and violent. Exceptional cruelty occurred on both sides of the conflict, but the Indian rebels and their supporters received the lion's share of this violence; whole villages were razed by British soldiers, and the Indian cities of Delhi and Lucknow were entirely decimated. The revolt led to much scrutiny of Britain's role in India and demands for modification of British rule; the British Parliament, anxious to please the British electorate and maintain this valuable colony, enacted reforms within a

CORNWALL's RIDING SCHOOL,
GLOUCESTER-STREET.

V. R.

GREAT NOVELTY for EASTER WEEK!

A most gorgeous and artistically painted
PANORAMA
OF
THE INDIAN WAR!!
Will be exhibited at the above place
ON EASTER MONDAY, APRIL 5, 1858.

MR. & MRS. HENRY BOX BROWN, proprietors of the Panorama of the WAR IN INDIA, respectfully inform the public that they have spared neither trouble nor expense in procuring the most truthful and thrilling information respecting the all-engrossing topic of the day. They hope that their friends, who so nobly patronized them on their recent visit to the Channel Islands with their Panorama of "Slave Life in America," will bestow the same favor on them on the present occasion.

Between the scenes, Mrs. Brown will give a description of all the incidents connected with the subjects of the paintings.

PROGRAMME.
PART I.
The commencement of the Indian Revolt, at Meerut—The fearful Massacre at Cawnpore—Repulse of the Sortie from Delhi, on July 14, 1837—Indians Blown from the Guns at Peshawar—General View of the City of Delhi, before the Siege—Destruction of the City of Delhi, and the Explosion of the Cashmere Gate—The Slaughter inside the City of Delhi—Fight in the Lines before Delhi—Engagement with the Mutineers at Baballee-Serai—Rout of the Mutineers, at Allahabad, by Colonel Neill.

PART II.
The Revolted Sepoys driven from a Walled Village, near Gusneede Nugger, by the 60th Rifles—The City of Calcutta, and Fort William, with the arrival of Reinforcements—A splendid View of the City of Lucknow—The Roomee Durwara Gate, and severe Battle at Lucknow—The Relief of Lucknow by the Scotch Highlanders, and the Screamings of Jessie Brown—The Mahomedan Festival of the Moharrim—Concluding with an exquisite Display and Illumination of Indian Fireworks, at Moorshedabad.

The Artist who has executed this Panorama is the celebrated Mr. Mills, of London, acknowledged to be one of the most faithful painters of the day. The public may rest assured that when they witness this Panorama they will not only appreciate it as a work of art, but will award it that approbation which all faithfully-executed paintings should command. The Panorama gives the whole of the military engagements that have taken place in India during the late war, up to the relief of Lucknow.

☞ Further particulars will shortly appear.

Figure 4.2. Full Listing of Contents of Indian War Panorama, as performed in Jersey on March 10, 1858; narrated in part by Jane Brown. *Jersey Independent and Daily Telegraph*, March 10, 1858 (BNA). Part I: The commencement of the Indian Revolt, at Meerut—The fearful Massacre at Cawnnore; Repulse of the Sortie from Delhi, on July 14, 1837—Indians Blown from the Guns at Peshawar—General View of the City of Delhi, before the Siege—Destruction of the City of Delhi, and the Explosion of the Cashmere Gate—the Slaughter inside the City of Delhi—Fight in the Lines before Delhi—Engagement with the Mutineers, at Allahabad, by Colonel Neill. Part II: The Revolted Sepoys driven from a Walled Village near Gusneede Nugger, by the 60th Rifles—The City of Calcutta, and Fort Williams, with the arrival of Reinforcements—A splendid View of the City of Lucknow—The Roomee Durwara Gate, and severe Battle at Lucknow—the Relief of Lucknow by the Scotch Highlanders, and the Screaming of Jessie Brown—the Mahomedan Festival of the Mohurrin—Concluding with an exquisite Display and Illumination of Indian Fireworks, at Moorshedabad.

year that allowed from more religious freedom and less interference within Indian society.

Brown's panorama vividly portrays the violence of this conflict. He includes scenes such as "The Fearful Massacre at Cawnpore," an event in which at least 120 British women and children captured by the Indian forces were killed in what came to be known as the Bibighar Massacre. Brown also took advantage of and perhaps performed ballads about the "screaming of Jessie Brown"—a popular story from this conflict about a young woman who heard bagpipes signaling the arrival of a Scottish regiment that would break the siege of a British fortress at Lucknow and save British citizens and soldiers there. Jessie Brown supposedly heard the bagpipes of the Scottish-allied army approaching long before anyone else and screamed the news to others.[7] Yet there also appears to be some compassion for the Indian rebels in scenes such as "Indians Blown from the Guns of Peshawar," "Destruction of the City of Delhi," and "The Slaughter Inside the City of Delhi." In other words, the panorama illuminates, as the description says, "the whole of the military engagements that have taken place in India during the late war."

Yet in concluding with "an exquisite Display and Illumination of Indian Fireworks at Moorshebad" (Murshidabad), the panorama highlights the festive aspects of the British victory celebration, rather than its gorier side; perhaps this decision connects to Brown's desire to reinforce his alliance with his (mainly) British audience. The panorama also deploys an ethnographic gaze at times, as in scenes such as "The Mahomeden Festival of the Mohurrim," probably a reference to the Mahomeden Festival of the Muhurrim, a ceremony of mourning for Hosain, the grandson of Mohammed, who fell at the battle of Karbala. Such scenes would no doubt be viewed as exotic by most of the British public.

Jane often narrated this panorama, and in doing so it seems that she might speak in several different voices or registers at once. On the one hand, as a British citizen, she might approve of the British Crown taking authority over this territory, while putting some reforms in place. Yet as a working-class woman married to an African American man (and a former slave), she might have some reservations about England's reinstatement in this geographical region of its political and social control, which would not end until 1947. For Brown, the irony of living in a nation that colonized and controlled people of another race would be evident; as we watch him move into this performance mode we must be attuned to how he performatively speaks or enacts such ironies. Perhaps the insistence on the panorama's giving the whole truth of the war—not only the triumphant reassertion of British dominance, but also the bloody and painful skirmishes that undergirded this control and the suppression of religious freedoms that engendered the revolt—represents a mode of doublespeak in

which both messages of dominance and resistance to English control could be heard.

In any case, the conflict was exciting to the British people, and the Browns had a good run with the Indian War panorama; it was performed (with other panoramas) from March 1858 to May of 1861 (just over three years), in locations such as Jersey (March–April 1858), Portsmouth (December 1858), Hammersmith (March 1859), Windsor and Uxbridge (March 1859), Maidenhead (April 1859),[8] Dawley (November 1859), Cheshire (March 1860), Burnley (April 1860), Newcastle and the Potteries (in Staffordshire; January–March of 1860), and again in Burnley (April–May of 1861). As discussed below, the Indian War panorama was reviewed positively and eventually attracted good crowds, and Jane Brown's narration was particularly admired.

The earliest version of this panorama—in Jersey—was advertised and reviewed in French-language newspapers such as the *Chronique de Jersey* and the *Nouvelle Chronique de Jersey*, which featured extraordinarily glowing accounts of the shows, published from March 10–April 17, 1858. An advertisement for one of Brown's shows in the *Nouvelle Chronique de Jersey* on April 10, 1858, was very successful in urging people to attend the show, as the Indian War panorama was extended to April 19–20, 1858 (see Figure 4.3).[9]

The advertisement reads in part: "Full Houses Every Evenings! Immense Success of the Panorama of the War of India! which will be exhibited for another week!!! . . . Panorama of Slavery in America!!! Diorama of the Holy Land!! Three Shows Every Night!" French was the official language of Jersey in this era, so it is not surprising that French-language newspapers would print advertisements for and reviews of the Browns' performances in Jersey. On the other hand, reviews demonstrate a vehement degree of enthusiasm and respect for Brown's art. For instance, an article in the *Nouvelle Chronique de Jersey* on April 7, 1858, describes the festivities of an Easter Monday celebration and remarks that they were greatly enhanced by "Mr. Box Brown," who "opened his superb Panorama of the War of India that same evening." According to this article, a "considerable crowd of people from the city and the countryside" visited the panorama "to contemplate the reproduction on canvas of the great incidents of the revolt." An article from the March 13, 1858, issue of the *Chronique de Jersey* refers to the panorama of slavery and of the Indian war as both artistic and true, and reviews in both newspapers mention large turnouts for these performances.[10]

After the Jersey shows, the Indian War panorama was shown more widely and received positive reviews for several years. By June of 1858, the Browns took their show on the road, performing in the Town Hall in Basingstoke in June, in Woolwich in July, in Lewes in November, and in Gosport in early December, where the Browns are described as exhibiting in the Town Hall their panoramas

CIRQUE DE M. CORNWALL,

GLOUCESTER-STREET.

Par permission de Jean Hammond, écr., Bailli.

V. R.

SALLE COMBLE TOUS LES SOIRS!

IMMENSE SUCCÈS

DU

PANORAMA DE LA GUERRE DE L'INDE!!!

QUI SERA EXHIBÉ

ENCORE UNE SEMAINE!

COMMENÇANT

LUNDI PROCHAIN, LE 12 AVRIL 1858,

SUIVI CHAQUE SOIR PAR LE

PANORAMA DE L'ESCLAVAGE A L'AMÉRIQUE!!!

ET LE

DIORAMA DE LA TERRE SAINTE!!

TROIS SPECTACLES CHAQUE SOIR.

PRIX D'ENTRÉE pour toute la représentation :—Premières Loges, deux chelins ; Loges latérales, un chelin ; Parterre, six pennys.

Un Corps de Musique sera présent.

Les portes ouvrent à sept heures et demie, et l'exhibition commence à huit heures.

☞ REPRÉSENTATION DE JOUR MERCREDI l'après-midi. Ouverture des portes à trois heures et demie ; commencement de l'exhibition à quatre heures.

MERCREDI SOIR, le 14 Avril, le Panorama sera patroné par le MAJOR SKIPWITH et les OFFICIERS du Bataillon de Dépôt.

Figure 4.3. Advertisement of panoramas at Cornwall's Circus in French-language newspaper *Nouvelle Chronique de Jersey*, April 10, 1858. Courtesy Valérie Noël, Librarian, Lord Coutanche Library, Saint Helier, Jersey, England.

of slavery and of the Indian Mutiny, as well as "the 'identical box' in which [Brown's] extraordinary and miraculous escape was effected."[11] The review of the show in Gosport notes that "the descriptive part of the entertainment is entrusted to Mrs. Brown; Mr. Brown singing a buffo nigger melody, the company joining in the *refrain*." Brown was described as singing a "buffo" or comic song, perhaps one of the ones he composed on his escape, but the fact that the writer feels free to call it a "nigger melody" speaks to his racist views. Attendance was small at this show. By late December of 1858, the Browns were exhibiting their panoramas at the Town Hall in Ryde, and in early 1859 they began performing in Ventnor.[12] These shows were more successful, and one newspaper describes good attendance for the panoramas and calls Brown the "best Negro speaker of the English language we have ever heard,"[13] strongly implying that he does not speak in dialect, but also that there is something surprising about Brown's good English.

At first Brown's status as a former enslaved man and the slavery panorama were the big attractions and eclipsed the Indian War panorama. The *West Sussex Gazette* reports on February 3, 1859, that a performance in Petersfield of all the panoramas was very successful, but mainly focuses on the slavery panorama and its ability to evoke pity for the abject enslaved; Box Brown's narration of the slave trade caused "many a circular drop to flow" for "those poor degraded Negroes."[14] After describing Jane Brown's "fluent and eloquent manner" of speaking and her "numerous and respectable hearers," the article circles back to Brown's slavery experiences: "Mr. Box Brown having been a slave himself, can enter into the spirit of his exhibition; and it was very affecting to hear of his method of escape, as well as his description of the various outrages perpetrated against his unfortunate fellow men." At this date, then, Brown as a survivor of slavery still seems to be the big draw, and he is viewed as entering "into the spirit of his exhibition," as being part of the spectacle of slavery's degradation and trauma.

Yet even in this early period, on occasion the Indian panorama—rather than the spectacle of Brown's enslavement—would be the headline. A review from the *West Surrey Times* just two days later, on February 5, 1859, of a performance in Godalming is even titled "Panoramas of India" and mentions that the Browns have been exhibiting their "Panorama of the Indian War, Holy Land, &c., at the Public Hall in this town"; the slavery panorama is not even referred to by name. According to this review "some of the scenes are very capitally painted, especially the view of Delhi, with the storming party, exhibiting the state of that fated city during the period of its memorable siege." The "accompanying entertainment" (about which the review is not specific) renders the performance "peculiarly attractive to the audience."[15]

By March of 1859, the panorama of India and Jane Brown's narration of it was attracting even more attention. An extraordinarily long review of an Odd Fellows[16] sponsored performance in early March of 1859, in Brentford, West London, notes that there were "crowds of spectators" for all of the panoramas, including the Indian War—so large, in fact that "hundreds were unable to gain admission." Jane Brown "gave the description of the war in India in a most vivid and able manner" and was "listened to with breathless interest, and loudly applauded." Mesmerism, magnetism, electro-biology, and legerdemain were also included in the evening's extravaganza, and the article terms this an "excellent evening's entertainment."[17] This show also was covered in the March 12, 1859, issue of the *Windsor and Eton Express*, which notes that "on Tuesday night the room was literally packed to overflowing, many having to go away without witnessing the entertainment, which decided Mr. Brown on stopping another night, when the room was again filled." The penultimate scene of the Indian War panorama, the representation of the "Mohommedan festival of the Mohurrin," is described as a "very brilliant one" and a fitting end to the performance.[18]

Just one week later—on March 19, 1859—the *West London Observer* describes a performance in Hammersmith in which Henry Box Brown exhibits his "large and excellently painted African and American Panoramas . . . to crowds of anxious listeners and spectators."[19] Yet at least half of this review focuses on Jane Brown, who on several nights narrates the Holy Land panorama "exceedingly well" and introduces the "panorama of the great Indian Mutiny" in a "manner highly creditable to her, and very charming in her audience." On these nights, too, the hall is said to be "filled to overflowing," and many were turned away.[20] The Browns performed in Dawley toward the end of 1859 with various panoramas, including the War in India, and were still "attracting large audiences," which would continue in Newcastle, in the Potteries (in Staffordshire), and in Hanley in January–March of 1860.[21] A short article about a performance in Cheshire in March of 1860 reports good attendance at all the panoramas, and especially pays attention to the Indian Panorama, narrated by Jane Brown in a "concise and truthful" manner that "elicited the applause of the audience"; the article goes on to state that "the representations of the massacre at Cawnpore,— view of the city of Delhi before and after the destruction by the blowing up of the Cashmere Gate, and all the frightful scenes of slaughter and destruction were well delineated."[22] In other words, it appears that the Browns were successful in speaking a double message: they show not only Britain's reinstatement of its dominance in this area but also what underlay this dominance: "frightful" slaughter and destruction.

A large poster for a performance from this era was located in 2008,[23] and I reproduce it here to give a sense of how the Browns presented their unique messages and of Box Brown's multifaceted performance persona (see Figure 4.4). As we can see by this time (1859), the Browns give less visual space on the poster to the Indian War panorama and more to panoramas that concern slavery and the Holy Land. Henry Box Brown's name is given prominence at the top of the poster, and he will be performing his "Mirror of Africa & America! Followed by the Diorama of the Holy Land!" It is also mentioned (in a much smaller font) that "Mrs. H. Box Brown will appear with the Great Diorama of the Indian War."

If we *watch* Brown's image move across this poster, we can see him traveling through time and space. Some of these scenes, for example, such as his presentation of the "Diorama of the Holy Land," have little to do with his time in enslavement and would represent Brown's present-tense identity as a free man living happily in England married to a British wife. However, Brown is also called the "celebrated American fugitive slave," and in the center of the poster we have a reproduction of Brown sitting in his box in Philadelphia, a past-tense self as ex–American slave that is still (evidently) with him visually and in other ways. Finally, at the bottom of the poster, there is a note that Brown "will appear in his Dress as a Native Prince." This would not be the first or last time that Brown would dress as an African prince, and he played one in *The Nubian Captive*, as discussed in the previous chapter. Yet the African prince persona is harder to pin down in time: was this his past (perhaps he believed himself to be descended from an African king) or his future (when he might be liberated from being an "ex-slave")? This may be a diasporic persona that ruptures time and space to show Brown existing outside of Anglo-British or Anglo-American construction of his identity. The poster is fascinating in presenting Brown's various temporal and geographic personae as coexisting in one medium, and in one (implied) performative space. Brown also produces geographical spaces via his engagement of the "native prince" persona, which is everywhere and nowhere.

It is evident that the Browns were successful with their panorama performances overall. Yet personal events would overtake them and mean that they would need to settle down for a time. Jane Brown took a hiatus from performance of the Indian panorama in the summer of 1860, perhaps because she was expecting her first child, Agnes Jane Floyd Brown, who was born on August 25, 1860, and christened on October 5 at St. Mary's Church in Stockport (in Cheshire, England), where the family was living.[24] At this time, Brown also lists his employment as "tobacco manufacturer." Based on newspaper articles it appears that Box Brown took some time off from performance in the summer and early fall of 1860 to spend time with his new child while working in a tobacco factory, a trade with which he was familiar from his days in slavery.[25]

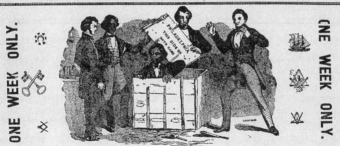

Figure 4.4. Poster from Henry Box Brown's performance in Shrewsbury, England, December 12–17, 1859. Used with permission of the Shropshire Archive.

By April of 1861, however, the family's busy performance schedule resumed, with Henry Brown performing his panoramas of *Negro Life in America* and Jane Brown performing panoramas of the Indian Mutiny and the Holy Land. At this time the couple worked with a "Juvenile band called the Rowland Family" and had a "successful run," as reported in the April 20 and May 4, 1861, issues of the *Burnley Advertiser*.[26] Burnley was close to their home in Stockport (about forty miles away) but bringing their infant child with them or leaving her with a caretaker would have been equally difficult choices. Sometime in April of 1861, the Browns stopped performing their Indian War panorama in favor of the Civil War panorama.

I must note that during this period (1858–1861) Brown was also staging his slavery panorama and still getting good reviews for it. In one extraordinary performance, Brown seems to have compared his time in his box to that of individuals who had undergone the harrowing Middle Passage onboard slave ships traveling between Africa, the Caribbean, and the US. During this 1859 show in Wellington, Brown describes the cruelties of the slave trade and then gets into his own original box:

> His description of the slave trade from experience, and the dealings of rich and influential men therein, were mostly cruelly severe. Slaves were often conveyed some thousands of miles by sea, fed only on bread and water, and packed close together side by side, chained down, and lying in one position until their journey's end, when many of them in being removed would lose portions of their flesh from their long confinement in the same position, and were then sold at half price. Mr. Brown persevered and got into the box in which he made his escape, which was only 3 ft. 1 in. long, 2 ft. wide, and 2ft. 6 in. high; in this he traveled 350 miles.[27]

Brown seems to be staging a parallel (though lesser) confinement for himself, as he first describes the horrors of the cramped slave ship holds of the Middle Passage and then gets into his small box. In so doing, Brown may imply that his past is not in fact past and that the Middle Passage of enslavement is still ongoing, either symbolically or literally. As Christina Sharpe might put it, Brown's past reappears here "to rupture the present" and perhaps to dramatize the fact that Brown still lives in the wake of slavery and in the "afterlife" of having once been property.[28]

Ironically, Brown evokes his (former) status as "property" in this performance and others to build up his status as a property owner, an owner of his own labor, and a man who has fashioned a lucrative career out of dramatizing his enslavement. Indeed, Brown could still make a good deal of money from the

slavery panorama, even when he performed it alone. A report in the *Hudders-field Chronicle* in December 1860, for instance, describes many "public amuse-ments" available during a Christmas fair—such as a Punch and Judy show, a "female wizard" who performed with her "temple of magic," a "caravan of wax work[s]," Chinese jugglers, a Kaffir chief, tightrope walkers, shooting galleries, an opera, and a concert. Out of all these shows, the article highlights that Brown performed in the Philosophical Hall with his "monster diorama of Africa and America" and "reaped a fair harvest."[29] Brown had good attendance at his stag-ing of his slavery panoramas well into early 1862 and received mainly positive reviews of these performances.[30]

Of course, Brown faced many challenges in this era, including racism, com-petition from other performers, and legal hurdles. Brown was sued in 1861 by the editor of the *Accrington Guardian*—John Boothman—because Boothman claimed that Brown paid him only three shillings instead of six for an advertise-ment for a show placed in his newspaper. Without a lawyer, Brown defended himself against this charge, saying he had paid the agreed-upon price, and pro-ducing in court two of his "servant-men" to corroborate his claims. Brown won this case and was also allotted railway expenses as he had traveled from Stock-port to Accrington to defend himself.[31] Yet, as we will see, not all his legal trou-bles were so easily resolved.

By early 1862, it also seems that the British public was looking for something new and different from Brown, which they found in his presentation of his Civil War panorama, staged from January 1862 to November 1863 and which was also positively reviewed in many newspapers of this era.[32] In the Civil War panorama there is, once again, an evident tension between ethnographic display and sym-pathy, entertainment and education. Again Brown would be speaking on several different frequencies, as a free man who had been living in England for twelve or more years, but who was also continually (via his performance work and the panoramas) being figured as a slave who must constantly revisit (in this case, quite literally) scenes of his own enslavement, especially as some of the Civil War events were set in or near Richmond.

The first Civil War panorama that I have located was staged on January 13 and 14 of 1862 in Leigh (Lancashire) and was called *Grand Moving Mirror of the AMERICAN WAR*.[33] In the January performance, Brown was described as giving excellent lectures and singing the following songs during his "entertainment": "Freedom's Song!," "Mr. Henry Box Brown's Escape!," and "Song of the Nubian Family by the North Star!" Apparently, then, scenes from the *Mirror of Slavery*, Box Brown's US slavery panorama, were reused in the Civil War panorama, such as the scenes of the Nubian family escaping slavery and of Box Brown's escape. In addition, Brown once again uses music to create a multisensory experience for

his audience that would encompass both sound and vision and perhaps function in a politically transformative manner by blending and blurring past and present and sonically substantiating the "everywhere" of slavery.

There were at least four performances of the Civil War panorama in Leigh in January of 1862, and several more in Atherton in this same month; they are described as "successful" in local newspapers.[34] Like other shows that Brown staged, the idea of the panorama being a "mirror" implies accuracy but perhaps also the audience's self-scrutiny, as an onstage mirror would (literally) reflect back to the audience their own image, but more symbolically ask them to cast a glance at their participation in the oppression of the enslaved. As will be discussed below, although Britain was officially neutral during the US Civil War, it still played a role in its continuation by allowing the sale of arms to the US South.

Advertisements for panorama exhibits from later in 1862 describe it in more detail and take account of later Civil War battles, such as the battle of Hampton Roads, which occurred on March 8–9 of 1862. A full listing of the Civil War panorama's contents appears in the *Jersey Independent and Daily Telegraph* on April 21, 1862 (see Figure 4.5). In this advertisement, enjoyable aspects of this visual spectacle are emphasized, perhaps to lure visitors in before presenting more graphic or controversial subjects. Brown describes the Civil War panorama as "A Great Treat for the Easter Holidays" and "Grand Day Entertainments" for "Public and Private Schools," and notes that a "splendid Band accompanies the Entertainment." Another clear focus is the scenery of the US, including views of New York and Washington, which would no doubt entertain British viewers, and may have been recycled or reused from earlier panoramas.

On a more educative level, heroic battles of the war already fought are referenced multiple times (such as "the Great Battle at Bull's Run!" and "the Great Battle at Richmountain"). The panorama also shows the "Great Battle of Springfield, Missouri, between the Federalists and Confederates, assisted by the Half bred Cherokee Indians." The panorama here refers to the second largest battle (up until this date) of the Civil War, which occurred on August 10, 1861, at Wilson's Creek in southwest Missouri. Brown's panorama highlights a little-known fact about this conflict, which was that it was one of the first in which Native Americans fought alongside Confederate troops and helped defeat the Union forces.[35] How would Brown have narrated this scene? He would no doubt side with the Union soldiers who were being killed (and who could, after all, free his family, still in slavery) but would he have any sympathy for the Native Americans, who were being dispossessed of their own land in this era by the US government? Brown would sometimes (as I explore below) adopt an "Indian costume"; he was also described as "a stalwart Indian" in one newspaper account (in 1867).[36]

Figure 4.5. Advertisement for Brown's Civil War Panorama published in the *Jersey Independent and Daily Telegraph*, April 21, 1862 (BNA). A full listing of the contents of the panorama reads as follows: Part 1: Distant Views of the City of New York—New York, Broadway—Departure of the Troops by Land from New York—Embarkation of Troops by Sea from New York—City of Washington—Campground near Washington City—Soldiers leaving the Camp for the Seat of War—Heights of Maryland Fortified by the Rebels, within sight of the Camp Ground—London [sic] Bridge across the Potomac; March of 15,000 Northern Troops to the Great Battle of Bull's Run. Part II: The Great Battle of Bull's Run—Commencing at the Fairfax Court-house with Masked Batteries—Prominent View—The Southern Commander Jeff. Davis with his two Generals, Johnson and Beauregard—Russell, the English Reporter of the London Times, to be seen in the distance on the Hill, taking his Sketches for the English Mail—The Grand Retreat from Bull's Run—The Great Battle of Richmountain—The Cotton Valley at Richmountain, with the Growth and Cultivation of Cotton—The Great Battle of Springfield, Missouri, between the Federalists and the Confederates, assisted by the Half bred Cherokee Indians. Concluding with the Grand Naval Engagement of the Monitor and Merrimac and the Illumination of Richmond City.

So it is worth pondering his investment in American Indian struggles. At this battle (white) Union forces were defeated (in part) by a race considered "primitive" and "savage," so this is a fascinating moment for Brown's panorama to highlight. And yet in the term "Half bred Cherokee Indians" we hear tones of disdain and racial superiority. It would appear, again, that Brown speaks on multiple frequencies: as a free man who might enjoy playing various roles, in disguises, and comically passing in "Redface" as an Indian; but also as a (formerly) subjugated individual who might have some sympathy for those who fought back against the dominating majority, regardless of the larger rationale.

We do not know whether Brown's panorama of the Civil War depicted any graphic scenes of enslavement or torture, but there are some hints that he entered controversies surrounding slavery in the US as well as the UK. As already mentioned, a scene of the panorama refers to the "Great Battle at Richmountain," one of the first battles in the Civil War (July 11, 1861). This dramatic battle took place in Randolph County, VA (which later became West Virginia), and in it, Union regiments defeated Confederate troops who had been defending an important mountain pass on the Staunton-Parkersburg Turnpike. This battle gave Union forces control over much of northwestern Virginia, so it makes sense for the panorama to highlight this triumph of the North.[37] But the panel after this one—"The Cotton Valley, at Richmountain, with the growth and cultivation of cotton"—is a bit more puzzling. Cotton does not seem to have been grown on Rich Mountain (in Virginia), although it was grown in some parts of Virginia.[38] Here the panorama would segue from a great battle that would interest the British public to an imaginary cotton landscape—but why?

As we have seen, other panoramas (such as Banvard's) featured cotton cultivation to gloss over the horror of slavery and present the US as a bucolic land. In contrast to this type of imagery, Brown's panorama may have featured graphic depictions of enslaved individuals cultivating cotton, perhaps under the lash. I suspect, however, that this imaginary planting of cotton on Rich Mountain was not a mistake on Brown's part, nor solely a reference to the anguish of slavery, but a shrewd way to work the scenes of the Civil War panorama into a controversy in England over cotton produced by slavery. Britain had declared neutrality in the Civil War in May of 1861. At this point, many cotton farmers in the South withdrew their cotton from the market to attempt to force Britain to side with the Confederates, and some farmers even burned their cotton to drive up prices. The strategy was unsuccessful; Britain found alternate suppliers for their cotton. But in an ironic twist, the South's Confederate government was able to leverage the financial power of cotton (via loans) to purchase, from British manufacturers, weapons, ammunition, and ships with which to fight the war. Moreover, to prevent the shipment of cotton to European powers, Abraham Lincoln

declared a naval blockade of the Confederacy in April of 1861, yet this only fueled a lucrative cotton trade in which blockade-runners would offload cotton on the British islands of Nassau and Bermuda off the Confederate coast in exchange for weapons. In alluding to the "Cotton Valley" and the "growth and cultivation of Cotton," then, Brown's panorama invokes a source of great conflict during the early days of the war and shrewdly alludes to Britain's hypocritical stance of attempting to maintain "neutrality" while allowing weapons to be sold to the Confederacy. If this scene included enslaved labor, Britain's culpability in prolonging US slavery would be even more evident and poignant.

The panorama also features scenes set near Richmond, where Brown had lived and worked, and that might resonate with his trauma of losing his wife and children. Two ending images depict the "Grand Naval Engagement of the Monitor and Merrimac" and the "Illumination of Richmond City." In these scenes, the panorama refers (first) to the Battle of Hampton Roads in Virginia (a location just one hundred miles from Richmond), also referred to as the Battle of the *Monitor* and the *Merrimack* (or *Virginia*), a crucial engagement between ironclad ships that had taken place just six weeks earlier, on March 8–9, 1862.[39] This spectacular battle was given worldwide attention and ultimately caused leading naval powers such as Britain and France to halt construction of wooden-hulled ships. There were many stunning illustrations of this battle in circulation, sketched by eyewitnesses, some of which were likely relied on in Brown's panorama and would have greatly interested his audience.

Perhaps a bit more puzzling, however, is the panorama ending with a scene from earlier in the Civil War, titled the "Illumination of Richmond City." The panorama here refers to an incident on April 12–13, 1861, when pro-Union sentiment in Virginia was significantly weakened after the success of the Confederate attack on Fort Sumter (in Charleston Harbor). The city of Richmond reacted to this victory for the South with large public demonstrations in support of the Confederacy. A Richmond newspaper described the scene on Main Street, when celebratory bonfires were lit "at nearly every corner of every principal street in the city, and the light of beacon fires could be seen burning on Union and Church Hills." The effect of this illumination was "grand and imposing" and supposed to reflect "the triumph of truth and justice over wrong and attempted insult."[40] This was a decisive moment in Virginia's turn toward secession, and it is a curious moment with which to end the panorama. Why not end with the illustration of the more recent and spectacular battle of the two ironclads, instead of "the Illumination of Richmond"? No doubt the "Illumination of Richmond" would be a vibrant visual spectacle to conclude with, and it seems that many panoramas ended with visual illuminations of various sorts; Brown (having lived in Richmond) could give a unique twist on the local setting. But did

Brown mean for his audience to read this more ironically: what looked like "illumination" (brightness, light) was a desire to keep the enslaved—indeed his own family—in slavery and darkness? As a trickster-like figure, Brown might have added sarcastic commentary to these types of "heroic" scenes of Southern "victory" and the "triumph of truth and justice over wrong and attempted insult."

Brown's Civil War panorama was well received in England and had good audiences.[41] The Leigh performances are described in January of 1862 as highly successful shows given to "delighted audiences."[42] A notice in the *Jersey Independent and Daily Telegraph* on April 21, 1862, encourages attendance by noting that the "Great Panoramas of the American War and Africa and America" had been very successful in other parts of the country. The newspaper then goes on to describe in some detail the Civil War panorama, saying it "fills the mind of the spectator with sadness" and that the "many rapid changes which are brought to notice in quick succession certainly makes it both interesting, instructive, and amusing."[43] Another Jersey review just a few days later notes that attendance has been good and that the panorama contains "faithful and artistic views of most of the towns, cities, and localities which have acquired an interest in consequence of the stirring events that have taken place in America since the commencement of the Civil War." This article particularly commends the scenes of the naval engagement between the *Monitor* and the *Merrimack*; it notes that "Mrs. Brown explained this part of the entertainment in an exceedingly lucid manner."[44] Another report in the *West Briton and Cornwall Advertiser* on November 14, 1862, remarks that Brown has been exhibiting his panorama of the American war in the Assembly-room, St. Austell,[45] and that it has been "numerously attended by the public"; a newspaper notice from February 14, 1862, in Falmouth also describes Brown exhibiting his Civil War panorama to "good houses" and "large audiences."[46] By midyear of 1863 (July) the Civil War panorama was still attracting good attendance in Exeter and other nearby towns.[47]

Ruggles accurately notes that at this point, Brown was not an authority on the Civil War, having been absent while it was taking place; moreover other speakers were more current with these events, such as Archibald MacKenzie, another former resident of Richmond who had recently arrived in the UK.[48] Ruggles contends that panoramas of the Civil War were themselves going out of fashion, eclipsed by more modern visual media such as photographs and *cartes de visite* of the war, which quickly made their way to England via steamship.[49] Nonetheless, Brown was able to perform his Civil War panorama for almost two full years (from early January 1862 to late November 1863), and during most of

this time he had respectable audiences. So perhaps it was not so much that the panorama went out of fashion but that Brown moved into new art forms that he could manipulate with greater freedom, and which could turn the audience into a spectacle. Either way, his narration of these panoramas as an "ex-slave" still seemed to be an enticing feature for his audience, once again pointing to Brown's enacting of the unfinished business of emancipation as an important aspect of his wake work.

I find no performances of the Civil War panorama after November 16–17, 1863.[50] Toward the end of the time in which Brown performed his Civil War panorama, he was also exhibiting his slavery panorama, and using both to comment on the nature of enslavement in the US. As the following article from March 26, 1863, evidences, Brown still could vivify the nature of slavery, even though he had not lived in the US for more than thirteen years. After noting that "Mr. H. Box Brown . . . escaped from slavery in 1849, and arrived in Liverpool in 1851," the reviewer goes on to state that he effectively shows "the various phases of slave life in the Confederate States of America, such as labour, amusements, punishments, and escapes."[51] Many years after his escape, Brown is still read as "a fair specimen of the slaves raised in the Southern states," and the author proudly notes that Brown now speaks "excellent English" in a "strong, clear voice."[52] Racist connotations about African Americans speaking only mangled dialect inhere in this statement, although the reviewer evidently means to be very positive toward the show and certainly reads Brown as representing (still) an excellent exhibition of enslaved identity.

But as time passed, Brown had more difficulty attracting a large audience to his panoramas; consequently, they grew more and more circus-like. Some panoramas were even accompanied by donkey races set up by Brown, as an advertisement for a panorama given on May 13, 1862, at Cornwall's Riding School makes clear (see Figure 4.6). Here the panorama of African and American slavery is mentioned, as well as the "Roars of Laughter at the Extraordinary Sayings and Doings of the Mesmeric Subjects!—More Novelties!—Donkey Races on the Road and in the Circus!—Silver Cups and other valuable Presents to be given away!" Mesmerism, as I explore below, appears to grant Brown a degree of power over his audience, and in some instances he seems to have convinced them that they were various types of animals. Yet the donkey races, which are described in detail, seem to be pure entertainment, a pure "hustle," so to speak, to draw the audience into the panorama. Donkey races, or donkey derbies, were and are a favorite form of "entertainment" in England, with riders trying to get the reluctant donkeys to run a straight distance, and often getting bucked off. It is also fascinating that Brown will be giving away three silver cups (and

CORNWALL'S RIDING SCHOOL
GLOUCESTER-STREET.

Continued Success of the Panorama of Africa and America !—Roars of Laughter at the Extraordinary Sayings and Doings of the Mesmeric Subjects !—More Novelties !—Donkey Races on the Road and in the Circus !—Silver Cups and other valuable Presents to be given away !

Mr. H. BOX BROWN will continue his Entertainment ONE WEEK LONGER—MONDAY, TUESDAY, WEDNESDAY, THURSDAY, FRIDAY & SATURDAY, May 12th, 13th, 14th, 15th, 16th and 17th. GRAND DAY ENTERTAINMENTS on WEDNESDAY and SATURDAY, at half-past Three o'clock.

SPORTING EXTRAORDINARY!

IN order to create outdoor as well as indoor amusement, Mr. Box Brown has determined to eclipse both the Derby and St. Leger Races. With this intention he will give away THREE SILVER CUPS, to be run for by Donkies, starting from the British Hotel, Beaumont, at half-past Six o'clock on Wednesday evening, proceeding along St. Aubin's-road to the Circus—the winning-post—where Mr. Brown will announce the winners in his Indian costume. The first Donkey in will be awarded the first prize; second do., second prize; third do., third prize. Precisely at Nine o'clock the losing Donkies will run in the Circus for a fourth prize. Owners of Donkies intending to compete for these valuable Presents are requested to make their entries at Mr. Church's White Horse, Peter-street, where the Silver Cups may be seen.

☞ As these will be the most interesting races that have ever taken place in Jersey, the public should not fail to see both races—the one on the road and the other in the arena of the building.

A splendid Band accompanies the Entertainment.

Admission :—Dress Circle, 2s.; Side Boxes, 1s.; Pit and Promenade, 6d. Doors open at half-past Seven. Commence at Eight o'clock.

Tickets and Places may be secured at MILNE's Music Warehouse, Halkett-place.

☞ The polite art of Riding taught as usual by Mr. Cornwall.

Figure 4.6.
Advertisement for
*Panorama of
African and
American Slavery,
Jersey Independent
and Daily
Telegraph*, May 13,
1862 (BNA).

an unnamed fourth prize), dressed in his "Indian costume," a term that implies that Brown has other costumes in his wardrobe. Brown perhaps goes into "Redface" here, as this would not seem to be a serious event, and as part of his act he may have mocked American Indians. As with Blackface, Redface performers often ridiculed Native Americans through their assumptions of stereotypical behaviors or physical characteristics thought to be associated with this group.[53]

The location of this show—Cornwall's Riding School—was a very large space that could hold panoramic shows, "theatrical circuses," and various sporting events, such as horse races.[54] Marcus Wood has suggested that Brown's performances melded aspects of the circus, beast show, and other stage spectacles, and Daphne Brooks has argued that Brown was a bold fugitive artist who leapt from art form to art form.[55] Cornwall's Riding School was a productive location for Brown, allowing him to stage many diverse kinds of shows and performances, and so it is not surprising that he would perform there for several months at a time.

We can watch Brown's persona leaping boldly from art form to art form in another advertisement for an 1862 show at Cornwall's Riding School that includes a great deal of visual spectacle, the giving away of presents, and the Civil War panorama (see Figure 4.7). Brown's advertisement drums up interest for the Civil War panorama by saying: "Go and see the Panorama! Go and see the Sea-Fight! Go and see the Illumination! Go and get a Prize!" Brown highlights the exciting and thrilling visual aspects of this show and (as he would often do) offers many presents, such as "elegant and costly articles, adapted for the gentleman's breakfast, dinner, tea and supper tables" and "magnificent . . . rings, brooches, lockets, portmonnaies, &c.," all of which have been placed on view in a local shop window. The first prize every evening is said to be worth three British pounds. The use of multiple exclamation marks and a variety of fonts and typefaces is meant to attract viewers and sharpen their craving for the event. Brown knew how to market his shows effectively, and the 1862 Jersey shows were extended several times, running for over three weeks, from April 21 to May 21. The poster presents a vivid *spectacle* of enslavement, although, as noted, Brown's audience might have been lured in by this only to be presented with more subversive content about the injustices of slavery and Britain's participation in the protraction of the Civil War via its sale of weapons to the South.

It also appears that in at least some of these shows in Jersey, Jane Brown performed panoramas by herself. A show advertised in the *Jersey Independent and Daily Telegraph* on May 17, 1862, under the "distinguished patronage of the Ladies of Jersey," features a race with twenty donkeys, live pigs given away in the ring as prizes, other presents, and ponies to be ridden by "ladies and gentlemen."

By Permission of John Hammond, Esq., Bailiff.

CORNWALL'S RIDING-SCHOOL,
GLOUCESTER STREET.

ONE WEEK MORE.

GRAND JUVENILE DAY ENTERTAINMENT THIS DAY, SATURDAY, at half-past Three o'clock for the Public and Private Schools.

☞ Several Magnificent Bibles, Portmonnaies, &c., will be given away.

UNHEARD-OF ATTRACTION!

PRESENTS! PRESENTS!! PRESENTS!!!

MR. H BOX BROWN begs to announce to his friends and the public that he has determined upon exhibiting his

PANORAMA OF THE
AMERICAN WAR.

One Week More, when 30 Presents will be GIVEN AWAY every Evening.

☞ The said Presents consists of most elegant and costly articles, adapted for the gentleman's breakfast, dinner, tea and supper tables, as well as magnificent and useful rings, brooches, lockets, portmonnaies, &c.; the whole of which will be on view at 55, King street, the proprietor of which has kindly placed one of his handsome windows at Mr. Brown's service for the exhibition of the costly articles which are

TO BE GIVEN AWAY!

☞ GO AND SEE THE PANORAMA!
☞ GO AND SEE THE SEA-FIGHT!
☞ GO AND SEE THE ILLUMINATION!
☞ GO AND GET A PRIZE!

NOTE PARTICULARLY!—The FIRST PRIZE that will be given every evening will be worth £5 BRITISH!—Other prizes in proportion!

☞ A splendid Band accompanies the Entertainment.

Admission:—Dress Circle, 2s.; Side Boxes, 1s.; Pit and Promenade, 6d. Doors open at Half-past Seven. Commence at Eight o'clock.

Tickets and Places may be secured at MILNE'S Music Warehouse, Halkett Place.

☞ The polite art of Riding taught as usual by Mr. Cornwall. (366

Figure 4.7. Advertisement for *Panorama of the American War, Jersey Independent and Daily Telegraph*, May 3, 1862 (BNA).

"Mrs. H. Box Brown" will appear with the *Panorama of Africa and America* (see Figure 4.8). It appears that Jane Brown presented panoramas without Henry Brown on May 19, and this certainly added to the novelty and popularity of the entertainment.

By the early to mid-1860s, Brown would sometimes walk the streets dressed in various costumes to drum up business. On May 4, 1861, in Burnley, in order to attract people to his panoramas he "paraded the streets, dressed as an African chief."[56] While we cannot know what this particular costume (in 1861) consisted of, later descriptions call it "Othello-like"; the *Bristol Daily Post* reports in October 1864 that Brown was habited "in a handsome Othello sort of dress, tunic robe and turban, with a comely pair of boots upon his nether extremities."[57] Brown's outfit is fetishized here, right down to his "comely pair of boots." A performance from March of 1864 (in Wales) mentions "Box Brown, the African Biologist" appearing before his shows in the streets richly dressed as an African prince and even accompanied by a footman.[58] The *Oxford Times* on October 12, 1867, references Brown performing mesmerism and magic "in the full dress of a native [American]."[59] Brown had (earlier in his career) been criticized for flamboyant outfits; as mentioned, an 1855 newspaper writer from Wales mocks Brown's showman-like clothing, which included a "gold-frogged and be-laced coat."[60] But it seems clear that Brown was willing to make a spectacle of himself to stimulate the public's hunger for his performances and garner an audience. On another level, Brown subversively blurs and conceals his identity through these multiple disguises, perhaps fracturing the audience's ability to know or visually control or contain him.

As we see in some performances of the panoramas—such as the donkey races or donkey derbies—Brown makes his audience part of the spectacle and incorporates them into his shows. Eventually, however, Brown seems to have decided to move toward performance modes that gave him an ability to make the audience even more of a spectacle through hypnosis, magic, and other audience-focused performance modes. Moreover, the market for mesmerism, "electro-biology," and (eventually) magic swelled in the 1860s and 1870s, fueled in part by the rising tide of interest in spiritualism. Turning to these later performance modes after 1863 was a logical business decision for Brown, but mesmerism, magic, clairvoyance, and even science may have allowed him to exercise surveillance over his audience, rather than only being watched. Brown's persona deploys, in these mesmeric shows, a powerful kind of dark sousveillance (looking from below and looking differently) and counter-visuality (looking back at his audience). Brown also draws upon a potentially transgressive visuality when he returns his viewer's gaze or makes them an object of spectacle, disrupting the politics of being looked at and (to borrow terms from Lisa Merrill)

By Permission of John Hammond, Esq., Bailiff.

CORNWALL'S RIDING SCHOOL,
GLOUCESTER-STREET.

THREE GRAND NIGHTS!

SPECIAL ENTERTAINMENTS, MAY 19, 1862,
For the BENEFIT of

MRS. H. BOX BROWN,
Under the Distinguished
PATRONAGE OF THE LADIES OF JERSEY

On which occasion Mrs. BROWN will appear with the
PANORAMA of AFRICA and AMERICA.

TUESDAY, MAY 20,
TWO LIVE PIGS to be GIVEN AWAY in the Ring,
With other PRESENTS.

WEDNESDAY, MAY 21, RACES! RACES! RACES

20 Donkeys to start from the Half-way House at
Half-past 6. Valuable Presents for the Winners. 8
Ponies in the Ring to be ridden by Ladies and Gentle-
men at 9 o'clock.

PRESENTS! PRESENTS!! PRESENTS!!!
For particulars see Programmes.

Figure 4.8. Advertisement for performance by Jane Brown, *Jersey Independent and Daily Telegraph*, May 17, 1862 (BNA).

transforming and reappropriating the audience's gaze in explicitly performative acts of self-determination.[61]

The Audience as Spectacle: Mesmerism and Electro-Biology, 1860–1875

As will be clear when I discuss Brown's shows, mesmerism (hypnosis), electro-biology, electro-magnetism, phrenology, science, and magic were closely inter-connected in the nineteenth century and in Brown's shows; separating them within this discussion of Brown's work has been difficult. However, I deal first here with mesmerism (which turned the audience into a spectacle) and later with Brown's magic and phrenology (which seemed to give him dominion over a world that his audience could not apprehend). I view Brown's movement into these modes as his most subversive performance of a kind of wake work that aesthetically ruptures social power and points toward freedom practices that might exist outside the visual and symbolic domain of slavery.

Turning to mesmerism and "electro-biology," we must note that the public was fascinated by the scientific and artistic aspects of shows that incorporated these fields. Brown's movement into this domain makes a great deal of business sense, beyond its evident ability to allow him to control or manipulate audiences. Mesmerism was considered an important medical specialty from roughly 1780–1860, and hundreds of books were written on the subject; moreover, well into the latter part of the nineteenth century it continued to have influence. Franz Mesmer, the founder of mesmerism, and a doctor himself, believed that an invisible force connected all living things (humans, animals, and vegetables) and that manipulation of this force could have physical effects, including heal-ing. His views were contested, but mesmerists in the first half of the nine-teenth century took up the task of hypnotizing people both to heal and to entertain them. Electro-biology—the phase of mesmerism or animal magne-tism which was purported to produce a form of electricity that leads to a mes-meric or hypnotic state—was another part of mesmeric shows, although it was highly disputed.

Claims about the purported healing power of mesmerism and electro-biology were controversial enough that they merited serious research by medical au-thorities. For example, in 1826 the Royal Academy of Medicine in Paris investi-gated mesmerism and magnetism. This commission concluded that "this state exists, when it gives rise to the development of new faculties, which have been designated by the names of *clairvoyance*; *intuition*; internal *prevision*; or when it produces great changes in the physical economy, such as insensibility; a sudden

and considerable increase of strength; and when these effects cannot be referred to any other cause." The members of the commission also attested that many people under hypnosis were completely insensible to pain; they could be pinched so hard that marks were left on their skin, pricked with pins under their nails, and even surgically operated on without showing any pain; moreover, individuals could be mesmerized while they were nearby or even through closed doors, with similar effects.[62] Mesmerism was connected in various ways to spiritualism and spiritual healing; some practitioners stressed that "spiritual rather than physical benefits [could] be gained from animal magnetism" and obtained a good clientele of spiritually inspired individuals.[63]

In the nineteenth century, mesmerism also had many branches and encompassed medicine, spiritualism, healing, unusual states of mind, out-of-body experiences, and even forms of mental clairvoyance (where, for example, an individual might seem to speak a language that she or he never learned or claim to play a musical instrument that she or he had never played before). Mesmeric shows also sometimes overlapped with magic shows and other modes of clairvoyance (such as "second sight"). For example, in 1858 a man named "Barnardo Eagle" was performing a show titled *Art Magique et Soiree Mysterieuses* in which he practiced "mesmerism, magnetism, and physiology," clairvoyance, and "spiritual visions of the mind."[64] Brown exploited such interconnections in his own shows, as we will see. Mesmerism was therefore the perfect art form for Brown, an autodidact and polymath, as well as a multifaceted performer who enjoyed smudging divisions between the "real world" and a more speculative, magical, or mysterious realm.

To begin with Brown's mesmerism, the first record of a performance by Brown that I have located took place in 1859 in Hammersmith and included several experiments in legerdemain (magic tricks involving sleight-of-hand), human magnetism, and electro-biology. The *West London Observer* on March 12 describes the overflowing "crowds of spectators" who came to view the panorama of slavery; the article goes on to state that "to conclude the evening's entertainments on Wednesday, Mr. Brown, together with Professor Chadwich . . . introduced several experiments in legerdemain, human magnetism, and electro-biology, which proved most successful, and afforded the crowded audience much pleasure and amusement." The article clarifies that "the mesmerism and biology by Mr. Brown, being his first experiments in public, was excellent and very successful."[65] From 1859–1862, however, Brown was not concentrating much on mesmerism perhaps because, as noted above, his panoramic shows were successful.

Yet by 1862, Brown had become accomplished at performing hypnosis and used it extensively in his shows. A show given at Cornwall's Riding School in

May of 1862 notes that Brown plans to "operate on the extraordinary and won-derful subject Mr. Cox Canary (from London). . . . This gentleman will sing, dance, play, and go through a variety of astounding feats while under Mr. Brown's influence." It also notes that "other subjects will be operated on"—in other words, audience members will also be mesmerized. The show is described as blending "art, science, and music."⁶⁶ An advertisement that appeared in the October 26, 1864, issue of the *Bristol Daily Post*"⁶⁷ also mentions Brown's "feats of dexterity and experiments in mesmerism and electro-biology." It appears that his hypno-sis was successful, and "provoke[d] great amusement among the audience."

We have seen racist overtones in some of the reviews of Brown's panoramas, but racism grows stronger as Brown advances into more subversive performance terrain in which white audience members become the spectacle and are "oper-ated on" by him. Three newspaper reports from 1864 highlight the racism Brown faced when he performed mesmerism and electro-biology. On January 2, 1864, the *Merthyr Telegraph, and General Advertiser* (from Glamorgan, Wales) con-tains a notice that "Henry Box Brown—'dis colo'd g'emman,' who, it will be re-membered, made a tour of the country some years ago with a panorama of *Uncle Tom's Cabin*, has turned up in the character of an electro-biologist, and on the first three nights of this week lectured on the above subject at the Temperance Hall."⁶⁸ The attendance on this occasion was small, and the writer seems to en-joy making fun of Brown's speech (or supposed speech) and his pretensions of being a gentleman. Later notices of this show indicate that Brown did have "tol-erable houses"⁶⁹ but still this review must have hurt his sense of pride; as we have seen, other newspaper accounts called his speech eloquent and remarked on his intelligence. A notice of another show in Wales just one month later (in Febru-ary 1864) is more glaring in its racism; published in the *Western Daily Press*, it reads: "MESMERISM—Every evening last week a 'darkey' calling himself 'Henry Box Brown' has been giving a mesmeric entertainment. The scene in the Temperance Hall on Thursday evening was ludicrous in the extreme, [with] numbers obeying Sambo's wonderful attractive power, and exhibiting them-selves on the platform in a variety of characters."⁷⁰ Clearly the reporter does not like his fellow countrymen and women "exhibiting themselves," and he goes out of his way, in the short space of five lines of text, to call Brown a "darkey" and "Sambo," and to imply that "Box Brown" might not even be his real name. He also notes "Sambo's wonderful attractive power," and the "ludicrous" effect it produces, harping on the stereotype of the sexually dominant African Ameri-can male; this idea was no doubt compounded by the fact that Brown hypno-tized both men and women.⁷¹

Rusert notes that we should think seriously about the implications of a for-mer slave controlling white bodies on the Victorian stage and the spectacle of

Brown taking "possession" of audience members.[72] Brown's challenge to regimes of social, visual, and racial power was comprehended and resented by *some* reviewers. One reporter in Ghent (Wales) in 1864 even describes Brown's performances as being "of a very disgusting order" and goes on to state that on "Tuesday evening last the most obscene, vulgar, and immoral acts were perpetrated by some low bred fellows, who feigned to be acting under the power of [Brown's] mesmerism—scenes which are unfit for publication, and calculated to outrage every sense of decency or humanity." This reviewer had not seen Brown's show (apparently) and Brown was given the opportunity to rebut such claims in a long letter published in this same newspaper. Taken together, this suggests that these imputations were untrue, but also that Brown's shows could elicit fear in white individuals who only heard about them.[73]

A strong disdain for Brown is evident in such reviews, and there is a clear implication (via racialized epithets) that the reporters see a power imbalance between whites and Blacks that they seek to correct via mockery.[74] Another review—this time from Newport (Wales) earlier in April of 1864—speaks more subtly to the racist overtones that Brown sometimes faced during mesmeric shows, in particular:

> MESMERISM—A tall, brawny, and good-tempered-looking son of the "sable race," whose cognomen is Box Brown, derived from the legend that he is the identical Brown who escaped from slavery in a box, commenced a session of seven nights mesmeric operations at the Town-hall, on Saturday evening. He designates himself "the king of mesmerisers," and here in Newport, where so much gullibility has been exhibited in respect to similar demonstrations, there is no doubt Box Brown will draw large houses, especially as he couples gifts of "costly value" with his mesmeric displays. There is some significance about the last "gift" to be awarded at last exhibition on Saturday night next—a splendid educated donkey![75]

This would not be the first or last time that Brown, ever the showman, would give away a donkey as a prize.[76] Yet something more insidious is at work in this review. While we cannot be sure of this, it seems that the reviewer means to pun on the phonetic and linguistic similarity of "donkey" and "darkey" (darky) and is (in effect) calling Brown a "splendid educated darkey." What is clear is that he reads Brown in racialized terms (he is "of the sable race" and "good-tempered-looking"—a "happy darky" type) and questions whether he is really the man who escaped by box (calling this a "legend"). The writer also finds it amusing that so many of his fellow countrymen and women would be lured in by his "costly" gifts.

Perhaps due to racism or other factors, such as competing performers, disruption of Brown's mesmeric shows also was common. A long descriptive piece about one of Brown's shows from 1867 depicts the carnivalesque atmosphere that sometimes prevailed:

> MESMERISM—Entertainments in mesmerism, electro-biology, and sleight of hand were given in the County Hall on Thursday, Friday, and Saturday . . . by a stalwart Indian named Henry Box Brown, attired in the full dress of a native, who escaped from slavery in a box, from which circumstance he received that appellation. There were extremely good audiences on each occasion, and the performances especially, while boys were under the mesmeric spell in which some of them appeared extremely ridiculous, were greeted with hearty applause and shouts of laughter. At the conclusion of the entertainment on the first night, a man rose in the body of the hall and began addressing the audience, informing that "Box" Brown was an imposter, and that he (the speaker) was the only person who could mesmerize, and that Brown, by his imposition, had nearly ruined him. His wife here joined in, and "added fuel to the fire," and Brown, who indignantly denied the insinuation of the worthy couple, who were met with shouting and hissing, stated to the audience that they had gained free admittance to the hall by false pretences and had only created a sensation to further their own ends. "Turn them out" was called for by the audience, and speedily, with loud applause, it was performed.[77]

Brown had good audiences all three nights who were entertained by his making his mesmeric subjects appear "extremely ridiculous." Brown performs "in the full dress of a native," which surely added to the entertainment. But the shows are interrupted twice—once by rival mesmerists, and once by a drunken man who had to be escorted out by the police. The overall atmosphere seems a challenging one in which to perform.

Another disruption of one of Brown's shows occurred in Margate, as reported in the *Thanet Advertiser* on February 20, 1869, and again tells us much about derogatory attitudes toward his mesmerism. The audience in general was pleased and entertained by Brown's mesmerism, and some "lads of the town were operated on with some success, or at least a *show of it*, for they tumbled about in a most absurd manner," reports the article skeptically. But then on Tuesday night a "lawyer" named Athelstan Boys ascends the platform to "test Mr. Brown's mesmeric powers." Brown fails to mesmerize Boys, and Boys leaves the stage, "laughing heartily and denouncing the whole affair as humbug, estimating that the boys [in previous shows] had been paid for their trouble."

Both Henry and Jane Brown protest this, and the performance concludes with a distribution of prizes given to the certain ticket holders. We cannot know why Boys (who was a clerk, not a lawyer) decided to disrupt the proceedings, but he was the editor of a humorous newspaper called the *Tickler*, and he may have been seeking fodder for a story.[78] Reputable scientific studies suggest that up to 25 percent of the population cannot be hypnotized, and that this likely has to do with brain structure and cognitive style.[79] Perhaps Boys had tried this type of stunt before, but Brown's failure to mesmerize him does not prove the show a sham.

We also see other reviews in the 1860s claiming, as Athelstan Boys had, that Brown is not a "real mesmerist" but someone practicing deceit and trickery. A newspaper report from 1866 tries to make this point by comparing another mesmerist—"Professor Morgan"—to Box Brown, and is worth examining carefully for what it reveals about attitudes toward both mesmerism and Brown:

MESMERIC PHRENOLOGY—Professor Morgan opened on Monday evening a series of mesmeric entertainments at the Stuart Hall. . . . Mesmerism is a peculiarly attractive subject with the working classes in most towns, and when illustrated by men of ability and education, draws, in spite of the feeling that the experiments must be impositions, a large portion of the thinking part of the community. The name of mesmerism has been often made the instrument of the vilest deceit, and trickery, which when exposed by a shrewd eye witness, leads to scenes by no means conducive of confidence in the science or respect for its professors. . . . Mr. Morgan belongs to the upper class of professors of mesmerism, and does not resort to the empty bombast of a "Box Brown." . . . His experiments are in every respect successful, and excite admiration of those who witness them. . . . Everything appears honest, straightforward, and, judging from the physiognomical and phrenological caste of the professor [Morgan], he does not appear one who lived by deceit.[80]

Although there is some debate in the review about whether this is true science, the article's main goal is to limit mesmerism to certain types of practitioners. Mr. Morgan is said to belong to the "upper class of professors of mesmerism" and "does not resort to the empty bombast of a 'Box Brown.'" Morgan is "evidently a firm believer in the science he endeavours to illustrate," unlike Brown who (it is implied) lives "by deceit." The comment about Morgan having a "physiognomical and phrenological caste" of honesty is clearly racialized. Phrenology, as discussed later, was often used in the service of racist science that attempted to prove the inferiority of African Americans. While this writer is a little bit on

the fence about the "science" of mesmerism, he is clearly *not* on the fence about Brown: he believes that Brown is not a true mesmerist, and he subscribes to many racist nineteenth-century ideas about African Americans.

Brown's turn to mesmerism was also read by some as merely a ruse to obtain money after shows about slavery had lost their "entertainment value," presumably in the post–Civil War era. A long and fascinating review of his "mesmeric entertainments" in the *Uxbridge & W. Drayton Gazette* on April 4, 1868, opines that because "negro difficulties have gone out as an auricular and ocular treat, mesmerism has come in."[81] By calling "negro difficulties" an "ocular treat" the author mocks the trauma of enslavement but also notes the visual appeal of spectating enslaved bodies. The article also pokes fun at Brown's "exceeding dimensions" and his appearance, claiming that he has been "attiring himself in a variety of remarkable articles supposed to be the exact costumes of a native of 'Afric's sunny shore,'" with the whole costume "surmounted by a prodigious head dress of feathers, so that he looked a most mysterious incarnate wizard." The writer derides Brown's claims to have cured a "rheumatic lady" via his electro-biology. In his show, Brown maintained that his electro-biology was "highly effective as a medical agent" and even invited his audience to write to the rheumatic woman who had been cured, which the reporter finds hilarious. The reporter also views Brown's sleight-of-hand tricks as "ordinary" and opines that the mesmeric illusions comprise "the usual laughable features," in this case including hypnotized audience members catching imaginary butterflies and eating turnip tops with incredible relish while "under the impression that that they had assumed the nature of the *ovis domesticus*" (domesticated sheep). Despite the reporter's evident disdain for Brown's skills, he reports that audiences were large for the "Ethiopian necromancer" and that the "the professor's visit must have been altogether very successful, from a pecuniary point of view." The reporter dislikes Brown's antics, doubts his claims of curing people, and makes fun of his fantastical costume; he even scoffs at his ability to make fellow Brits believe they are sheep, a point I discuss below.

Despite such obstacles, it appears that Brown became adept at mesmerizing his audience and that some of his shows were extraordinary. A March 1868 newspaper report in the *South London Chronicle* shows Brown turning the tables on his audience, making them the butt of the joke, and even animalizing them. Brown is described as a mesmerist and electro-biologist of "consideration pretensions" as well as a lecturer and a "'professor of magic,'" although the reporter notes that Brown's sleight-of-hand tricks are "old and commonplace."[82] On the other hand, the reporter remarks that the "power he exercises over the wills of those he operates upon, is, to say the least, astonishing." The reporter

then describes in detail the antics of *sixteen to eighteen young men* who are col-
lectively hypnotized by Brown during this show:

> First, they were seated round the platform with their heads bent forward,
> and after Mr. Brown had made a few motions with his hand, they succes-
> sively dropped off their seats in a profound sleep. Having been awakened
> by the mesmerizer, they were in succession given a fit of sneezing, a horri-
> ble fit of the toothache; made to march, dance, sing, frantically whirl their
> arms round, chase and catch imaginary insects, fancy themselves in the
> cold regions and commence skating and sliding in all directions across
> the platform, and, as the climax, to imagine themselves converted into
> sheep, going down on all-fours, imitating the peculiar noises of those ani-
> mals, and devouring with great avidity greens and cabbage cast to them.

The reporter also notes "the disgust and indignation manifested by the 'subjects'
on regaining possession of their proper."

Others (such as Ruggles and Britt Rusert) have argued that when a former
slave such as Brown (who had been forced to do the will of his enslaver) exercises
dominance over a white audience, there is a powerful subversion of accepted
norms, in which whites control Blacks and enslavers command the enslaved. Yet
something more is going on in shows where Brown turns people into animals,
or forces the mesmeric subjects to "march, sing, and dance." Brown compels
white individuals to taste some of the trauma of enslavement, when pain was
inflicted wantonly and individuals were routinely told to dance to show their
"happiness" and treated like animals. In his widely read 1845 autobiography,
Frederick Douglass describes falling at one point into a "beast-like stupor" and
being in a "degraded" condition, reduced to a mere chattel with little will of his
own. Douglass also famously relates how enslaved children were fed as if they
were animals with food that was dumped into a trough: "The children were then
called, like so many pigs, and like so many pigs they would come and devour the
mush."[83] For his own part, in his 1851 autobiography, Brown describes one par-
ticular enslaver who viewed his slaves as animals, calling them "'hogs,' 'dogs,'
'pigs,' &c., &c."[84] By having as the climax of his show a moment when individu-
als become sheep, going down on all fours, bleating, and devouring "with great
avidity greens and cabbage," Brown turns white British individuals into en-
slaved beasts; in so doing he enacts revenge on those who viewed the enslaved as
less than fully human, either in the US or in Britain, and those who would call
him "uncivilized," "Sambo," or "nigger."

This would not be the only time Brown deployed this trick of making people
behave like sheep. As we have seen, he did this during the show described in the

Uxbridge & W. Drayton Gazette on April 4, 1868, much to the reviewer's ire. Just a month later he performed a similar show at the Cooperative Hall in Sheerness (Kent), which was covered in the *Sheerness Times Guardian* on May 2, 1868.[85] The article notes that Brown is "a well-known negro professional sleight-of-hand performer and mesmerist" and that "a very good audience" witnessed "a number of clever [magic] tricks." Unlike the reviewer of the South London show, this reviewer finds Brown's magic skills strong. Brown mentions in this show that "he had cured various complaints by mesmerizing the afflicted parties"; Brown asserts that his mesmerism has medical properties, an idea that will return in later shows in the US. After Brown makes this claim, several young men and one girl agree to be "operated on," and they ascend the platform. From here things get a bit more frenzied, as one by one all the volunteers fall asleep, except for a man who, finding the "inexplicable influence stealing over him," exclaims, "Good morning, Mr. Boxer Brown, I've had enough" and jumps off the stage while the audience laughs. Brown hypnotizes the rest and puts them "through a variety of innocent antics, causing great merriment." But are these really "innocent antics"? The participants are "horrified at the thought of devouring a quantity of raw cabbage," so once again it appears that he turns the tables, enslaving his subjects to his will. Brown could not only convince people that they were sheep, but also "transport them to Australia and back in five minutes" and cause them to "imagine themselves on fire or in the ice regions"—he could place them in either heaven or hell, in this world or another, take them out of their human subjectivity and then place them back into it.[86] In other words, Brown exhibited profound control over his audience members' states of mind and made them into spectacles onstage.

We can also turn to H. M. Holbrook's reminiscences (in 1904) of a show he attended sometime in the 1860s for more glimpses of Brown's mesmeric style and the carnivalesque atmosphere in which he performed and trafficked. Holbrook recalls a show in Lowestoft that included "General Tom Thumb and suite— Wooden of Carpet Bag fame; the great Vance Thurston, the ventriloquist, with his Odd Folks; [and] Box Brown, the black mesmerist." Brown mesmerized many individuals onstage and "ordered" his subjects to eat from a can of paste. Holbrook goes on to claim that the subjects ate with "gusto," even licking the "can quite clean." A rhyme is made up on the spot: "Then the wags in the town / said that Box did them Brown, / And the pudding was properly cooked."[87]

But were all of these shows real? Or were Brown's subjects paid, as Boys alleges? Holbrook's reminiscences of Brown's mesmeric feats are tinged with humor and cynicism, and he implies that the hypnotized audience members ate rice pudding, believing it to be paste or at least pretending to do so. Some skeptics contend that hypnotists generally rely on plants in the audience, and as we

have seen, Brown was accused of this. Yet would Brown have the funds to pay up to eighteen people to perform onstage? If this were the case, the shows would be so expensive that he would not earn a profit. Moreover, scientists who have studied hypnosis believe that stage mesmerism is real to the extent that through careful selection of audience members, peer pressure, ordinary suggestibility, and some degree of stagecraft, a show is created in which individuals onstage appear to be in a hypnotic trance.[88] In this "trance" they may perform actions that make them look foolish, but the reality is that social compliance is at work here, along with some level of suggestibility. I tend to believe, then, that Brown's subjects were mostly real individuals who became part of his show, part of his spectacle, and were in fact hypnotized to some degree. Yet it is important to stress that either way, Brown was in charge, turning the tables on audience members who expected to be entertained by a spectacle, but became spectacles themselves.

In the period from 1860–1875, Brown's mesmeric performances were generally well attended and viewed as highly entertaining, yet they were sometimes controversial not only due to accusations of trickery, but also due to Brown's giving away of various prizes based on ticket numbers. In at least two instances it was alleged that Brown was conducting an illegal lottery. In 1870, Brown gave a mesmeric entertainment at the Public Hall in Rochdale and it was "alleged by the police that he had allowed a lottery in connection with his entertainment." It was also alleged that Brown was sent a summons for performing a lottery by police in Newark earlier in this same year.[89]

Regarding the incident in Rochdale, the *Rochdale Observer*, in a lengthy article from the Police Report section of the newspaper on February 12, 1870, reports that the lottery charges were dismissed, but not without disputation of them. A detective named Marshall attended the February 2, 1870, performance and described it as follows in his testimony before the court:

He (witness) paid 1s. at the door, and received a ticket, which was taken from him when he went to his seat. The first portion of the performance consisted of magic, and the second of mesmerism. At about half past nine o'clock Mr. Brown introduced a number of songs, which were sold at one penny each. On each of these songs was a number, and some 18 or 20 sales were effected. After the performance Mr. Brown called out certain numbers, and any person having a corresponding number received either a pipe, comb, knife, or walking-stick. Subsequently to that defendant [Brown] told the audience that he was determined to make the public of Rochdale patronize him if he remained in the town for years, and on the following night he said he should distribute a number of silver-plated articles.[90]

Marshall was then cross-examined by Brown's lawyer about whether Brown knew that the proceedings were "illegal or improper"; Marshall responds that he had no doubt that Brown knew this, as he had "been summoned for the same thing at Newark." Marshall also affirms that the show "was not such a good one of its class as he had seen elsewhere, but that there was nothing objectionable in it, and it was conducted respectably." Brown could have been fined or punished as a "rogue or vagabond," but his lawyer asserts that Brown is not one of the "ordinary itinerant performers" but instead "a resident and householder in Manchester, and a man of respectability."[91] Charges against Brown were dropped, but only after he paid the court costs and promised "not to repeat the offence." Brown did, however, continue to perform similar lotteries or "draws," so it appears that the incident in Rochdale was somewhat trumped up to create trouble for Brown.[92] When Brown and his lawyer resisted, the charges were dropped, but not until after some cost (of both time and money) for Brown.

In other words, by the 1860s we see a degree of "pushback" against Brown's controversial methods of performance on the part of the British public, press, and even legal authorities. There was also an implication in some reviews that Brown was more of a flim-flam man than a legitimate artist. In a review of an "electro-biological" or hypnosis performance in 1871, the reporter claimed that Brown was tricking the older inhabitants of Ashton out of a good portion of their money:

> THE SABLE HERO—Mr. Henry Box Brown, the renowned magician, has been astonishing the oldest inhabitants this week with his new "electro-biological" performances at the Educational Institute. On this first appearance he only met with a moderate reception, but his fame spread like wild-fire, and his later visits have proved a great success. *He has by his thousand and one devices managed to mesmerize the public and extract from their well-lined purses a good round sum*, and though he boasts of how much he can eat and drink, and the quantity of tobacco he can smoke in a week, he cleverly hides the fact that he is talking like most of his class do, "all for money."[93]

The tone here is far from respectable and the moniker "the sable hero" is meant to be ironic, while the references to his eating and drinking seem to shame Brown in some way (perhaps by implying that he was overweight). The overall import is that he is merely a con man committed to separating people from their hard-earned money.

Brown proved to be resilient even in the face of such disapproving commentary, however, and continued to perform mesmerism well into the early to

mid-1870s, with good audiences and many positive reviews.[94] Brown's hypnosis was generally combined with magic tricks, but in the last decade of his time in England he seemed to focus more on phrenology and magic. Brown may have foiled the surveillance of his identity and body by dissembling, distracting his audience, and utilizing magic tricks that made it seem as if he had supernatural powers of vision, sound, and hearing. He also extended his skills into another scientific domain—phrenology—a pseudoscientific belief that bumps on the human skull could be "read" to understand character. Indeed, phrenology and magic were often woven together to produce a stronger effect on individuals, as will be discussed below.

Brown the Phrenologist and Magician: 1865–1875

As Brown's skills in magic and phrenology became stronger, advertisements for his shows grew more grandiose. An announcement for a performance might be short but contain several different typefaces, with Box Brown's name and a few other details being in the largest font to attract a reader's attention (see Figure 4.9). Brown calls his show of magic, electro-biology, and phrenology *The Greatest Sensation of the Day!*" and uses both italics and exclamation points for emphasis. He names himself "the King of Biology and Animal Magnetism, and Professor of Magic," giving himself titular enfranchisement, and claims that "GREAT PRESENT[S]" of "every description" will be given away.

Brown's self-styling now includes the scientific domain; he is employing phrenology. As Rusert notes, science was a space for the inculcation of racial inferiority, as well as a realm of performance, and African American bodies were often physically showcased to support pseudo-scientific theories of racial inferiority. For example, Samuel George Morton's theories of racial inferiority were buttressed by exhibitions of his skull collection at the Academy of Natural Sciences in Philadelphia and by his friend George Gliddon's extremely popular mummy show and panorama (discussed in Chapter 2). During such shows Gliddon would use skull size and shape to "prove" that Blacks and whites were separate races, and "unwrap mummies ransacked from Egyptian tombs before a public audience" in the service of proving the purported Caucasian roots of advanced civilizations such as Egypt.[95] Brown himself had a scientific rival of his own race in England, an African or African American man who went by the moniker of the "Black Doctor" and who toured the country, giving lectures on "the colour of the skin; or why an Englishman has a white skin while the slave has a black."[96] It appears that this rival, who also went by the name John Brown

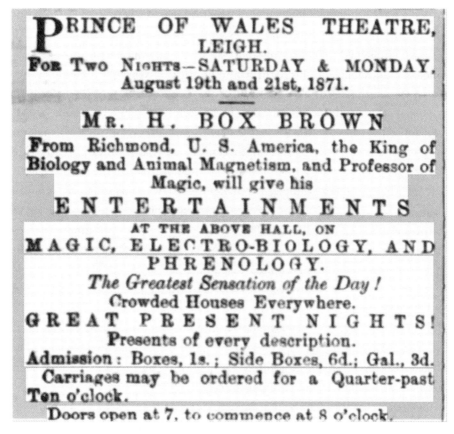

Figure 4.9. Advertisement for a show from the *Leigh Chronicle and Weekly District Advertiser*, August 19, 1871, at the Prince of Wales Theater in Leigh (BNA).

(and claimed to be an escaped slave) lectured on some sort of racial hierarchy or "scientific" basis for the idea of separate races.

As Rusert also argues, the history of racial science shares an important genealogy with the history of performance. Science, biology, phrenology, mesmerism, and stage shows of various sorts often went hand in hand in the late 1860s and early 1870s, and this certainly is the case in Brown's shows. For example, a show by Brown alluding to "biology and phrenology" appears in the *Dover Express* on March 5, 1869; a show by Brown on phrenology is listed in the May 29, 1870, issue of the *Era*; one on "phreno-mesmerism" and "animal mesmerism" appears in the November 5, 1870, issue of the *Bolton Evening News*; and one on "animal magnetism, mesmerism, electro-biology and phrenology" appears in the August 19, 1871, issue of the *Leigh Chronicle and Weekly District Advertiser* (see Figure 4.9 above).[97]

Why might Brown be interested in performing some version of the pseudo-science of phrenology? Phrenology was largely invented by Franz Josef Gall, a German physiologist who believed that bumps on the skull were caused by force exerted from the brain underneath the skull; therefore, people's character and ability could be read through an examination of skull shape and ridges. Gall did not believe that skull size or shape per se was indicative of intelligence or level of civilization, as some racist scientists did. However, phrenology quickly took on racist connotations in the nineteenth century, as many white phrenologists studied skull shape and (sometimes) size to attempt to prove the alleged inferiority of other races. For example, a French physician who was a follower of Gall's named François-Joseph-Victor Broussais gave an extremely popular series of lectures at his medical school in 1836 that endeavored to rank different races based on phrenological research. The dominant idea of phrenological racism that Broussais and others promoted was that in the so-called "civilized" races, parts of the mind that controlled intellect, higher thought, and rationality would be highly developed, whereas in the "lesser" races parts of the brain that facilitated instinct, violence, and irrationality would be amplified. These pronounced traits would lead to bumps on the skull that were visible and could be pressed to produce various emotions or abilities. His followers continued to promote such ideas into the latter half of the nineteenth century.[98]

As specious as these claims may seem to us today, they held great sway during much of the nineteenth century. Some doctors in this period even combined phrenology and mesmerism, calling this practice phrenomesmerism or phrenomagnetism. These phrenologists joined a mesmeric trance with the touching of certain parts of the skull; they believed this would allow a physician to better understand and manipulate a patient's characteristics and traits. A phrenology broadside by Doctor J. P. M'Lean from the 1870s claims to explain "how to read character scientifically; including the physical, social, moral, and intellectual development of the race," and it contains the adage: "Know Thyself!"[99] While it is not clear what M'Lean means by "the race," his offer to read or "examine" character "at the close of each lecture" was standard fare. In any case, the idea of phrenology as a reading of the character and ability of an individual based on skull size and shape quickly passed into the realm of the public's imagination and from there into the universe of performance.

It is no wonder, then, that Brown incorporated lectures and tricks based on "phrenological science" into his shows. A show by Brown advertised in the *Maidstone Telegraph* (Kent, England) on April 17, 1869, is fascinating, both in its reference to phrenological mesmerism (in practice with Jane) and in its reference to Brown's other magic tricks.[100] In this show, "phreno-mesmerism" appears to consist mainly of hypnotizing individuals in order to make them "Sing, Dance,

Laugh, Cry, imagine themselves on Fire or in the Ice Regions." While Brown never appears to have manipulated bumps on audience members' skulls, he did physically touch his mesmeric subjects to have them feel cold, heat, hunger, or a variety of other states, as an advertisement in the *Heywood Advertiser* from July 5, 1872, that will be discussed later makes clear.[101] Of course, there is great power in Brown co-opting an often racist discourse—phrenology—and combining it with his own tool (mesmerism) to take power over it. African American feminist theorist Audre Lorde has famously avowed that "the master's tools will never dismantle the master's house,"[102] but Brown took a tool of the master (phrenology) and changed it; if phrenology was a hammer used to hammer nails into the notion of racial inferiority, he turns the tool around, attempting to remove the nails, via his phreno-mesmerism.[103] As we watch Brown perform in this domain, it becomes evident that he is not controlled or contained via racist phrenological ideas; instead he subversively manipulates his subjects via phreno-mesmerism, making them feel cold, heat, or hunger, and making them sing, dance, or cry onstage. Brown uses phreno-mesmerism to turn his audience into a spectacle and to take power over them. He undermines the pseudoscientific racist underpinnings of phrenology via his own performance of it, and by his own mastery of this domain and his operations on white subjects within it.

Turning now more specifically to Brown's magic shows, we can see how they also turned spectacle around and showcased his own empowered subjectivity, in this case by creating a magical and even supernatural persona who exhibits a mode of dark sousveillance and counter-visuality (or seeing beyond the physical world via extrasensory powers) that exceeds white comprehension of the material or spiritual realm. To give a flavor for the types of magic Brown performed, I begin with a detailed advertisement in the *Maidstone Telegraph* on April 17, 1869 (see Figure 4.10).

We see references to magic tricks such as "Magnetic Apple Trees, Butterflies, and Infuriated Swarm of Bees," "Catching the Magnetic Fish," the "Great Ghost Illusion," and "Shower of Frogs." The references to magnetism may imply that Brown would hypnotize people and make them think they were near an apple tree, picking or eating apples, trying to catch butterflies or fish, and being attacked by an infuriated swarm of bees. However, since magnets were becoming widely used in magic tricks in this era to make objects move and the process of using electromagnetic or magnetic induction to create an electromotive force was becoming known, I suspect that Brown was using magnets (seen and unseen) and electromagnetic force to "mysteriously" cause various objects to seem to move on their own. Yet the reference above to "magnetic apple trees" suggests that Brown's magic tricks were more sophisticated than this; indeed, some may have been modeled on tricks performed by an earlier, famous pioneer of stage

CONCERT HALL,
CORN EXCHANGE, MAIDSTONE.
FOR FIVE NIGHTS.

WEDNESDAY, THURSDAY, FRIDAY, SATURDAY, and MONDAY, APRIL 21st, 22nd, 23rd, 24th, and 26th, 1869.

Mr H. BOX BROWN,

FROM Richmond, U.S. America, the King of all Mesmerists, and Professor of Magic will give his

ENTERTAINMENTS

At the above Hall on Magic, Animal Magnetism, Mesmerism, Electro-Biology, and Phrenology, assisted by

MADAME BROWN.

PHRENO-MESMERISM,

Producing the Magnetic Apple Trees, Butterflies, and Infuriated Swarm of Bees, Catching the Magnetic Fish, the Great Ghost Illusion, Shower of Frogs, &c.; many while under the operator's power will be made to Sing, Dance, Laugh, Cry, imagine themselves on Fire or in the Ice Regions. Concluding with the Great

AMERICAN TEA PARTY,

And the New York Barber's Shop. Mr B. will introduce the American Electric Drum and Bell, with many other Feats of Magic, changing his entertainment each night.

GREAT PRESENT NIGHTS!

Presents of every description.

Appropriate Music will be in attendance.

Stalls, 1s 6d; Unreserved Seats, 1s; Body of the Hall, 6d; Back Seats, 3d. Doors open each evening at 7.30, commence at 8. Carriages may be ordered for a quarter-past 10 o'clock.

Figure 4.10. *Maidstone Telegraph* (Kent, England), April 17, 1869 (BNA).

magic, Jean-Eugène Robert-Houdin (1805–1871), considered by many to be the father of modern conjuring techniques. Robert-Houdin was onstage in London in 1853, so Brown might even have attended one of his shows. Posters for this show refer to several of Robert-Houdin's tricks, such as the Marvelous Orange Tree, originally the Mysterious Apple Tree Trick[104]—a famous conjure in which an orange or apple tree seemed to bloom instantaneously onstage, producing real fruit that would be distributed to the audience, and then magical butterflies flutter out from it with a handkerchief that had been taken from an audience member. In this trick a concealed mechanism beneath the table that the magician or his assistant would manipulate cranked the tree so it appeared to burst into bloom; the tree would then bear "ripe fruit in less than a minute's time, which several of the company tasted of."[105]

The above advertisement in the *Maidstone Telegraph* strongly implies that Brown owned an automated apple tree of some sort. His use of automation is corroborated by a later magic poster from 1878 that refers to "the instantaneous growth of flowers" (see Figure 5.3, discussed in Chapter 5). Therefore, it appears that Brown's magic tricks encompassed cutting-edge science (such as electromagnets) as well as older techniques such as automation. They also might make the audience think of Brown as having authority, in a certain way, over life and death. If he could make an apple tree blossom and fruit appear on its branches in the space of a few seconds, he was creating an impressive spectacle onstage, one that gave him great power over an unseen world. No wonder several newspapers referred to him as "Box Brown, the wizard"[106] and as a "celebrated necromancer from Richmond, America"—someone who practiced black magic and (possibly) communication with the dead.[107]

The reference to the "Great Ghost Illusion" in the 1869 advertisement is a bit more mysterious; many magicians (including Brown) claimed to be able to produce ghosts onstage, and spiritualism played a strong role in some of Brown's shows, as discussed later. In any case, this magic trick seems to be modeled on one called "Pepper's ghost," named after English scientist John Henry Pepper (1821–1900), who popularized this illusion onstage in London in 1862. The effect of a spirit appearing onstage was produced by an actor disguised as a ghost lying on his or her side in a pit in front of the audience; a reflecting glass tilted at a 45-degree angle would project the actor's ghostly form onto the stage. Brown would seem to be mixing the realms of the seen and the unseen, the living and the dead. Moreover, he now had the power to place himself or his assistants in small box-like spaces which might be reminiscent of his own entombment, another way in which Brown symbolically makes the space of the "original" postal crate used during his escape a realm that represents not only slavery and death but new life and resurrection.

The sentence in the Maidstone advertisement that "Mr. B. will introduce the American Electric Drum and Bell, with many other Feats of Magic" is also quite revealing. This was likely a version of a "spirit bell" or "spirit drum" trick in which an ordinary bell or drum answers a series of questions posed by the audience, tells fortunes, guesses ages, and so on; the bell apparently can do this because it is haunted by a spiritual presence who knows the answers. The method generally involves a second bell in the table connected to an electric battery. What again might be most vital here is that Brown would seem to exercise dominance over a dark and unknown spirit world. We might read this as a mode of dark surveillance, of gazing back at audience members via knowledge they do not possess. Brown also was very good at performing a doll trick;[108] this likely involved a doll that would seem to move on its own, raising its arms by way of a "spirit" power. Again, this was probably done by automation or magnets, but the point is that Brown would seem to be controlling a world beyond material reality.

In addition, Brown played with a public fascination with ghosts, spirits, and the realm of the mystical. "Spirit rapping" was a huge phenomenon in Victorian England, and Brown manipulated this obsession with ventures into spiritualism and second sight. As mentioned previously, his famous resurrection by box already had spiritualistic overtones; the box was rapped on, and Brown called out from within it. He manifests in this instance as a voice that is not-yet-living but certainly not dead, one that emanates from a world in between the living realm of freedom and the socially dead realm of slavery. This rapping on the box, as we have seen, is repeated in the play that Brown acted in in 1857, *The Fugitive Free*. Moreover, Brown performed his resurrection during performances and lectures in the 1850s and as late as 1877, although it is unclear whether his box was ever rapped on in such performances.

By 1864, Brown was beginning to move more explicitly in the realm of spiritualism, "magic clairvoyance," and "second sight." In second-sight performances, one individual goes out into the audience to retrieve random objects from audience members, and the person onstage (who is blindfolded and turned away from the audience) guesses these objects. This trick can be performed because a code is developed between the magician and his assistant; in this code various innocuous questions the magician speaks (such as "what is this" or "what am I holding" or "guess what this is") are translated into numbers and letters, so the person onstage can decode the questions to tell what object is being held. Brown modeled some of his second-sight and magic shows not only on those of Robert-Houdin, but also on those of John Henry Anderson (1814–1874), a Scottish professional magician who is often said to have brought the art of magic from street performances into theaters. Known as the Wizard of the North,

Anderson's shows in the 1850s and 1860s in England were highly popular and often called *World of Magic* (a title Brown would later borrow),[109] and Anderson used second sight, including having his daughter (whom he called "the second-sighted sybil"[110]) perform with him. Anderson both debunked spirit rapping and deployed second sight (an act with spiritualistic overtones),[111] a practice that Brown also would (later in his life) employ. Anderson toured the world with his magic acts but was also performing in England and Scotland from 1850–1868,[112] so again it is possible Brown saw such shows; in any case, Brown certainly utilized some of Anderson's tricks. The British press was quick to note this similarity. One article from 1867, for example, opines that Brown's tricks are "exactly the same" as those "performed by Professor Anderson, the Wizard of the North," although "on a more limited and less clever a scale."[113] Despite this opinion, the report notes that Brown had "good audiences" for all his entertainments in Swindon.

Brown's repertoire (like Anderson's) contained a second-sight performance. For a time, Brown worked with a woman known as "Miss Pauline." Brown performed with this mysterious woman, who was also called "the Second-Sighted Sybil," from October 25, 1864, to March 24, 1865 (five months).[114] Brown would later perform second sight (in 1877) with his wife, Jane, but it is unlikely that "Miss Pauline" was Jane, because the couple's second child (Edward H. Brown) was born on October 28, 1864, at the couple's home on 25 Cumberland Street in Bristol.[115] Jane's delivery date of October 28 (in the middle of a performance run) makes her taking on the role of "Miss Pauline" unlikely.

During the five months that Miss Pauline worked with Brown, she became a strong part of Brown's second-sight shows and a practiced partner. She is described in advertisements as "Miss M. Pauline, the great wonder of the age, [performing] in her SECOND SIGHT; or MAGIC CLAIRVOYANCE."[116] She was given great prominence in advertisements for the shows, as one in the *Cheltenham Mercury* on November 19, 1864, makes evident (see Figure 4.11). Miss Pauline's name is in typography and spacing that makes it even larger than Brown's, and she is described as "THE GREAT WONDER OF THE AGE!" who will exhibit "the Astounding Marvels of Second Sight!" Brown once more appears in his "Native Costume," and now he is calling himself "the Great African Magician," suggesting perhaps an exoticism that his British audience might crave. The large typeface for Miss Pauline's name suggests that his audience desired something just a bit different than his usual show. Brown claims (at the end) to be giving "LESSONS . . . IN THE MAGIC ART." Was he now teaching magic privately? Or showing (onstage) how some of his magic tricks were done? There is a tradition of some magicians revealing parts of magic tricks onstage— or at least *pretending* to do this. So, Brown might seem to be regulating what

Figure 4.11. Advertisement for a second sight performance with "Miss Pauline," *Cheltenham Mercury,* November 19, 1864 (BNA).

knowledge could be known by his audience, and what would remain hidden. These shows were successful in drawing good audiences, according to newspaper reports.[117]

To engage in second-sight performances, Brown and his assistant (Miss Pauline) would have a coded mode of communication that the audience could not hear, a doublespeak practice that has overtones (perhaps) for Brown of his days in slavery. Spirituals sung by the enslaved, for example, often contained coded messages about escapes and resistance, and there is even a phrase known as "putting on old master" to describe the ways enslaved individuals communicated via subterfuge and disguised meanings that the enslaver failed to catch. In England, while Brown was performing second sight, his audience might not grasp such overtones. But Brown would appear to have mental telepathy with his assistant, and both would seem to possess higher (perhaps spiritual) powers

of clairvoyance (clear vision, clear sight). Second sight might penetrate beyond the material outlines of the everyday world, seeing past its physical barriers. Moreover, in at least one performance he is described as practiced in the art of ventriloquism, a mode he would employ later in his career, so he might also be seen as controlling voices and sounds from beyond, from a mystical or supernatural realm.[118] The enslaved man who had been a spectacle now deploys a powerful multimodal form of counter-visuality that encompasses sight, sound, and access to a nonmaterial world.

Brown's magic and mesmeric shows continued to be popular in England into the late 1860s and early 1870s; reviews for the later shows were generally good, and attendance seems to have been large. He often used humor in ways that were subversive, turning the tables on his viewers and making his audience laugh at the individuals he put onstage. A review in the *Thanet Advertiser* on February 13, 1869, describes Brown performing at St. George's Hall and notes that "Mr. H. Box Brown continues a great favorite with the sight-seers of Ramsgate, the hall being crowded nightly to witness his entertainments, comprising feats in magic, mesmerism, and electro-biology, which keep the audience in continuous roars of laughter."[119] It concludes that "the entertainment is certainly one of the liveliest we have seen for some time at Ramsgate." A newspaper report from the *Portsmouth Times and Naval Gazette* on September 11, 1869, similarly notes that Brown (described respectfully as a "gentleman of colour from America") has been attracting "large audiences at the Portland Hall, to witness his entertainments of magic, sleight of hand, &c, with mesmerism and electro-biology." This article goes on to say that "his feats in magic, &c, are very good, many of the tricks being quite new and far above the average."[120] Brown was also successful in Ventnor in early October; the *Hampshire Telegraph and Naval Chronicle* (of Portsmouth, Hampshire) reports on October 9, 1869, that he has been giving entertainments "this week to very large audiences."[121] In mid-October, Brown performed magic, animal magnetism, mesmerism, electro-biology, and phrenology for two weeks in the Volunteer Drill Hall, Newport, Isle of Wight; he "attracted a large audience" and "was warmly applauded."[122] By October 30 of 1869, Brown had moved on to Cowes, where the *Hampshire Advertiser* reports that Brown is giving a "series of discourses on Magic, Electricity, Mesmerism, &c, at the Foresters' Hall, to large audiences, who appeared highly delighted."[123] In July of 1870, one article claims that Brown, who was "once famous, but now almost forgotten, for his marvelous escape from slavery in a wooden box," has been performing in the Temperance Hall in Leeds his "Illusions in Magic and Mesmeric Science."[124] But it is unclear whether the escape-by-box could *ever* be forgotten; it was engrained in Brown's very name and seemed equally embedded into British public memory.

These performances were still popular into the early 1870s, a somewhat astounding feat given that he had been performing in Britain for more than two decades.[125] Perhaps the most flattering review from this period comes from the *Heywood Advertiser* on July 5, 1872, and is worth examining closely as it gives some sense of his strong reputation, even into the early 1870s:

> Mr. Box Brown, a gentleman of pure African lineage, once a slave on a Virginian plantation, from whence he escaped in a box, and now one of the best known and most accomplished of mesmerists, phrenologists, and magicians, commenced a series of entertainments on Saturday last, in the Mechanics' Institution, Heywood, concluding on Wednesday evening. His feats of legerdemain are many of them of startling excellence, marvels of patient study and skill. They evoked frequent bursts of applause from the admiring audience. His exposition of phrenology was clear and concise, and very interesting. His mesmeric illustrations of that science were a display of the most masterly skill, his perfect influence over the persons operated on being only equaled by the unique tact with which he directs it, making them by a few rapid touches, exhibit the feelings of cold, heat, hunger, &c., as easily as the keys of a piano would flow forth music at the touch of an accomplished pianist. The comical pranks he evoked from his mesmerized guests elicited a continued roar of laughter from the large audiences which crowded the hall on Wednesday evening.[126]

Brown is described as an excellent magician and mesmerist—one of the "best known and most accomplished." He is also conducting phreno-mesmerism, in which he touches people—a "few rapid touches" make his subjects feel heat, hunger, and so on; this would not be the only performance in which he would physically touch people onstage.[127] Enslaved individuals were of course physically touched on auction blocks by potential buyers, but I think the point to notice is Brown's manipulation of his audience as easily as a trained pianist plays a piano, exhibiting his complete mastery over their bodies and minds. He makes his audience laugh, and he fills the hall for at least four nights. Heywood is part of Greater Manchester, so its population most likely had access to many shows coming through the area. The fact that this performance generated so much enjoyment speaks to his still being a big draw into the early 1870s.

Still, some press reports indicate that Brown's shows were sometimes popular for a night or two but then audiences dwindled. For example, Brown performed something called *The Works of Wonder* (which seemed to include mainly works of magic and mesmerism) in the Town Hall in Hadfield on August 5, 8,

and 9 of 1871; the *Ashton Weekly Reporter: Stalybridge and Dukinfield Chronicle* reports that attendance on Saturday and Monday was "very good" but the attendance on Tuesday night was "thin," even though the "entertainment on the whole was very amusing, and won loud applause."[128] Similarly, a report from December 2, 1871, notes that Box Brown, who is now styling himself on placards as the "king of biology and animal magnetism, and professor of magic from Richmond, US," performed at the Public Hall on Saturday and Monday evenings; on Saturday he had "an attendance of two or three hundred people"; however by Monday the attendance was "somewhat less."[129] In this show, Brown pulled out all his tricks, including magic, electro-biology, and phrenology, and according to a review of this show the "phrenological portion" was "highly appreciated"; "several youths went through laughable antics whilst under mesmeric influence." That Brown could still attract *two or three hundred people* to a performance in 1871 is impressive, and he seems to have made a decent living from his performances through the early 1870s, despite some drawbacks.[130] Brown also gave several performances for charity organizations in this period.[131]

Yet perhaps the British public was growing a bit tired of Brown's shows, and he was vying against multiple modes of entertainment. During a show in Oldham, for example, on May 29, 1870, Brown competed against the female troupe of Christy Minstrels (assisted by the "New York Clipper Boy"), the Funny Cons ("Irish duettists, duologists, and dancers, who cause quite a furore"), Mr. J. F. Robins ("a capital versatile comic"), the Brothers Fritz (acrobats), Ben Ray and Sons (who have been "very successful in their delineation of Negro life"), Miss Emma Thornton ("serio-comic singing"), Miss Nelly Bradly ("characteristic and dancer"), Mr. Hugh Claremont ("a clever comic singer"), and others. *All* these acts appeared in Oldham during the same brief period that Brown was giving "a series of entertainments . . . comprising mesmerism, sleight of hand, and phrenology."[132] By the early 1870s Brown faced stiff rivalry within the field of performing arts, and also from those who chose to create "delineations of Negro life" such as Ben Ray and Sons or the Christy Minstrels.[133] When he performed in Macclesfield on the 14th and 16th of March, 1874, as a magician and conjurer, "owing to so many counter attractions Mr. Brown's entertainment has not been patronised so well as it deserves"; during this week in Macclesfield *alone* Brown was competing with dramas such as *The Tiger Slayer* and *Nick of the Woods*; concerts featuring "serio-comic and ballad vocalists"; and *Hamilton's Original and Delightful Excursion*, a large-scale artwork featuring scenes from "Charing-cross to Calcutta within two hours . . . via Paris, Mont Cenis, Brindisi, and the Suez Canal, a Journey of nearly 10,000 Miles."[134]

Therefore, he constantly needed to introduce new tricks or gimmicks into his show to maintain his audience, including ventriloquism, auctions,[135] and a

"dark séance." Ventriloquism is mentioned only twice in all the reports I have found, so it may be that Brown worked with a partner for this act who created voices offstage, and that Brown was not a true ventriloquist.[136] Still, if Brown could perform this trick, this might explain some of his success in magic, spiritualism, second-sight performances, and the dark séance. The ability to ventriloquize could make the appearance of ghosts (in his magic show) or spirits (in his séance) more convincing. Such a practice would also be conversant with the misdirection employed by Brown in many of his magic shows; ventriloquists do not actually throw their voices but instead employ the same misdirective technique as conjurers. By changing the tone of his or her voice while pointing in another direction, the performer convinces the viewers that a hat is speaking, a baby is crying from under a stage, or a trunk is filled with squealing pigs. Through ventriloquism and misdirection, then, Brown might deploy a mode of counter-visuality that makes the audience look *away from the performer*, again removing Brown from the eye of the beholder as an object of spectacle.

One performance by Brown in England highlights his further investment in modes of spiritualism and radical temporality that might place the performer *beyond* the viewer's surveillant gaze. An advertisement in the *Staffordshire Sentinel* in May of 1874 describes Brown as a "veteran coloured entertainer" who is giving "entertainments in the Town Hall" in Hanley, including magic and electro-biology. The shows were well received.[137] But then a cryptic sentence is added to the newspaper report: "To-night (Monday) it is expected that a dark *séance* will be held." "Dark séances" (in which individuals sit in a room with no light and the medium produces spirits and other psychic manifestations) had been a popular craze in Victorian England, a fertile space for fraud and extortion, as well as scientific study (as scientists tried to figure out how the "spirits" were produced). Spiritualism and séances were popular in England from the 1850s onward, due to the influence of mediums such as Daniel Dunglas Home, who was a clairvoyant and trance medium purported to be able to rise in the air, levitate, and float horizontally out of windows, as well as produce spirit hands that glowed in the dark. The craze for séances was also fed by the Davenport brothers, who toured England in 1864 and used a specially constructed cabinet (we might even say a "box") in which they securely tied themselves along with some musical instruments; when they were immobilized, ghostly hands appeared at the cabinet windows, the instruments played, and violins emerged and whirled through the air. Essentially these were all conjuring tricks, but it is fascinating to consider how the spectacle of a medium enchained in a cabinet might have resonated with Brown in terms of his escape-by-box when he performed his own séances in May of 1874.

Brown's performance of a séance would also resonate with other "dark séances" from this time conducted by magicians. For example, in April 1873 a man named "Herr Dobler," a "conjurer of the first order," gave a performance in Leeds.[138] He placed the room in total darkness, and then performed a series of escape tricks and spirit "manifestations," such as making a tambourine float around the room and a bell ring without anyone touching it. One eyewitness even reported that he felt hands passing through his whiskers and hair. Brown's performances of magic had included the appearance of mysterious objects (ghosts) and the ringing of spirit bells; moreover, his phrenology may have entailed touching people during performances. So, Brown's séance might have resembled that of Herr Dobler and would have incorporated some of Brown's earlier magic feats and tricks. He would also conduct at least one more séance (in the US, in 1880), as will be discussed in the next chapter.

The last performances by Box Brown in England that I have located occurred on February 6–9, 1875, in Rochdale, where he had once been prosecuted for running a lottery, and on March 1–3, 1875, in Stockport. Notices of these performances in the newspaper are short but respectful. The review of the Rochdale performance notes that "Mr. Henry Box Brown, the very popular coloured entertainer, gave his miscellaneous performances here on Saturday, Monday, and Tuesday." The account goes into no details about the nature of his performance or whether it was well attended. The Stockport performance notice is equally brief, stating only that Brown gave his "sleight-of-hand" entertainments in the Odd Fellows' Hall on March 1–3 to "fair houses."[139]

Brown had been involved in local politics in Cheltenham in October 1873, and in 1874 he sent a letter to the *Cardiff Times* complaining about the rigging of food prices by middlemen who bought produce from local farmers and then sold it at a much higher price. In 1874, the family was living in Cheetham, a suburb of Manchester. There appear to be signs that Brown and his family had settled into England and planned to stay, and Brown's performances throughout 1874 were still moderately successful. Moreover, Brown's role in the abolition movement continued to be a subject of great interest in the 1870s in the UK.[140]

It may be, however, that the press reports of Brown's continuing success into 1874–1875 were more polite than real; perhaps after twenty-five years, the British public had finally tired of Box Brown's presence, no matter how many times he reinvented himself as a magician, mesmerist, actor, ventriloquist, electro-biologist, phreno-mesmerist, and conductor of dark séances. And perhaps the tragic death of Henry and Jane Brown's fourteen-year-old daughter Agnes Jane Floyd Brown on October 20, 1874, of Bright's disease (a hereditary disease of the kidney) meant that the couple felt they needed a fresh start.[141] One of the Browns' daughters (a twin to Annie named Mary Emma Martha Brown) had died when she was only

two months old on June 13, 1870, and a son (John Floyd Brown) had died in 1872 when he was seven months old, so the Browns certainly knew the terrible bereavement and heartbreak of child loss.[142] In any case, whatever their reasons, the remaining family (Henry, Jane, Edward, who was now ten, and Annie, who was five) set sail for the US and landed in New York in July of 1875, where Brown would once again take up his itinerant life as a performer, now traveling back and forth between Canada and the US, and even (perhaps) back to England for at least one brief performance stint.

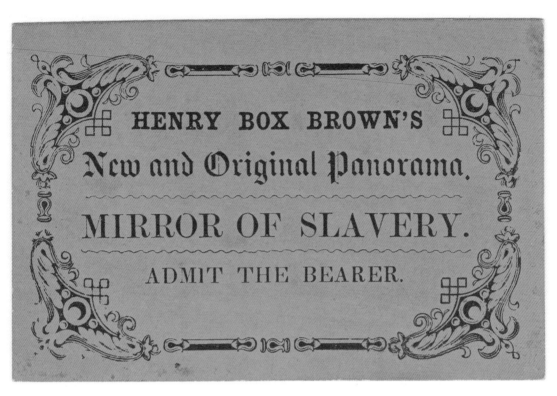

Plate 1. Front side of a ticket to Box Brown's *Mirror of Slavery*. Cornell University Archives, Digital Collection. https://digital.library.cornell.edu/catalog/ss:1312471. Also see Figure 2.7.

Plate 2. Back side of a ticket to Box Brown's *Mirror of Slavery*. Cornell University Archives, Digital Collection. https://digital.library.cornell.edu/catalog/ss:1312472. Also see Figure 2.8.

Plate 3. "Now We Lynch Ourselves," National Great Blacks in Wax Museum, Baltimore. Photograph by author, © 2018. Also see Figure 6.1.

Plate 4. Box Brown coming out of his box. National Great Blacks in Wax Museum, Baltimore. Photograph by author, © 2018. Also see Figure 6.2.

Plate 5. Replica of Box Brown at the National Underground Railroad Museum in Cincinnati. Photograph by author, © 2020. Also see Figure 6.5.

Plate 6. Metal replica of the postal crate that Henry Box Brown used to escape, Canal Walk in downtown Richmond (Box Brown Plaza). Photograph by author, © 2021. Also see Figure 6.6.

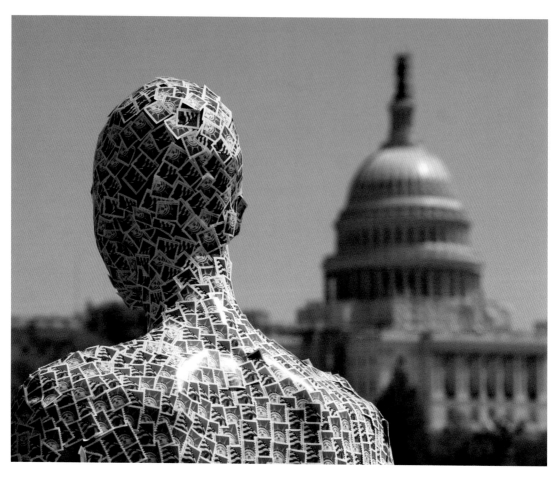

Plate 7. Day Three: Congress. Wilmer Wilson IV, *Henry "Box" Brown: Forever* (2012); Wilson visits location in the iconic tourist corridor of Washington, DC. Used with permission of Connersmith and Wilmer Wilson IV. Also see Figure 6.11.

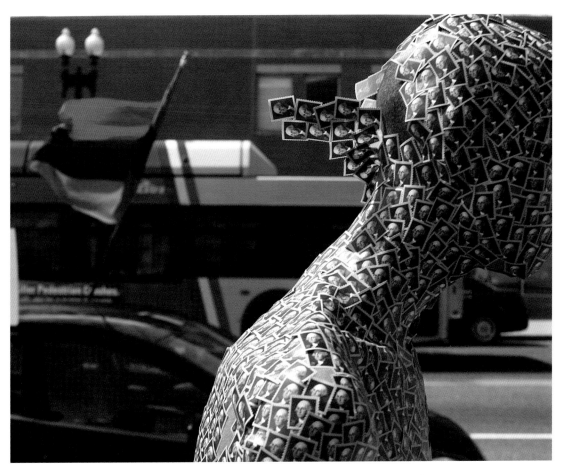

Plate 8. Stamps flake off Wilmer Wilson's body as he walks. *Henry "Box" Brown: Forever.* https://issuu.com/connersmith/docs/connersmith_wilsoniv_hbbforever. Used with permission of Bree Gant, photographer, and courtesy Connersmith and Wilmer Wilson IV. Also see Figure 6.12.

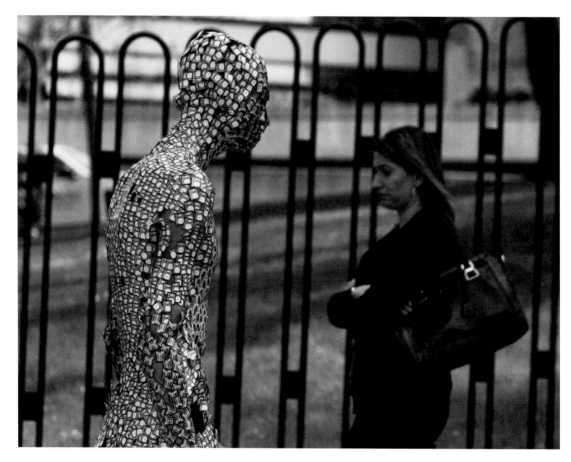

Plate 9. Wilmer Wilson looks back at an audience member. *Henry "Box" Brown: Forever.* https://issuu.com/connersmith/docs/connersmith_wilsoniv_hbbforever. Used with permission of Bree Gant, photographer, and courtesy Connersmith and Wilmer Wilson IV. Also see Figure 6.13.

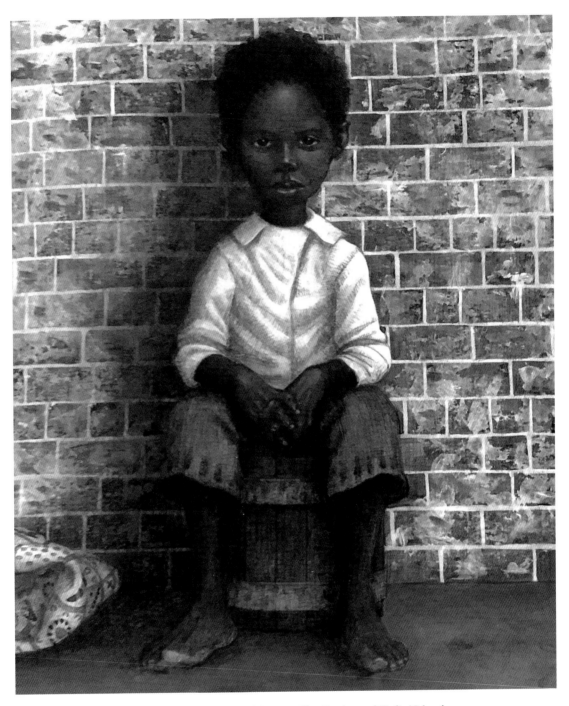

Plate 10. Henry Box Brown as a child. From Ellen Levine and Kadir Nelson's *Henry's Freedom Box: A True Story from the Underground Railroad* (New York: Scholastic Press, 2007). Used with permission. Also see Figure 7.1.

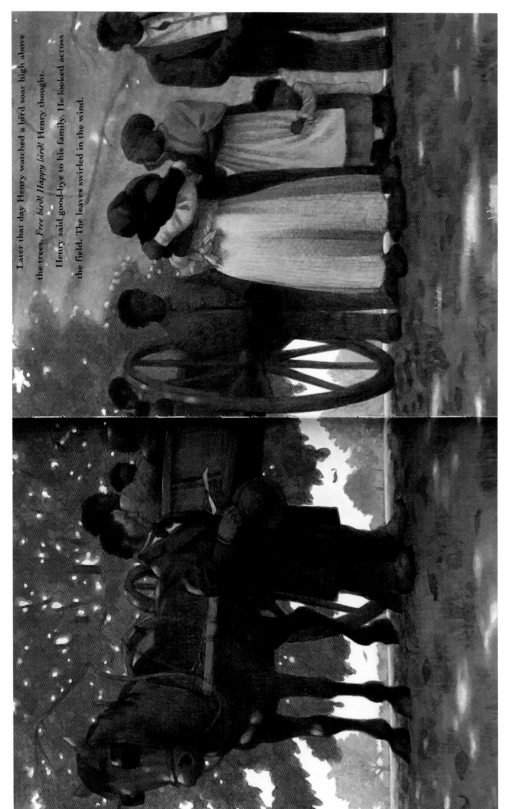

Later that day Henry watched a bird soar high above the trees. *Free bird! Happy bird!* Henry thought.

Henry said good-bye to his family. He looked across the field. The leaves swirled in the wind.

Plate 11. Family parting. From Ellen Levine and Kadir Nelson's *Henry's Freedom Box: A True Story from the Underground Railroad* (New York: Scholastic Press, 2007). Used with permission. Also see Figure 7.2.

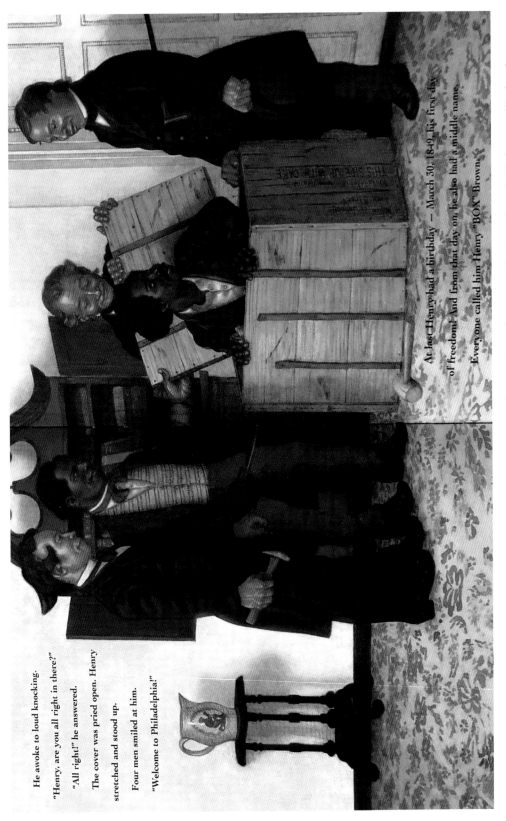

He awoke to loud knocking.

"Henry, are you all right in there?"

"All right!" he answered.

The cover was pried open. Henry stretched and stood up.

Four men smiled at him.

"Welcome to Philadelphia!"

At last Henry had a birthday — March 30, 1849, his first day of freedom! And from that day on, he also had a middle name.

Everyone called him Henry "BOX" Brown.

Plate 12. Henry Box Brown being unboxed. From Ellen Levine and Kadir Nelson's *Henry's Freedom Box: A True Story from the Underground Railroad* (New York: Scholastic Press, 2007). Used with permission. Also see Figure 7.4.

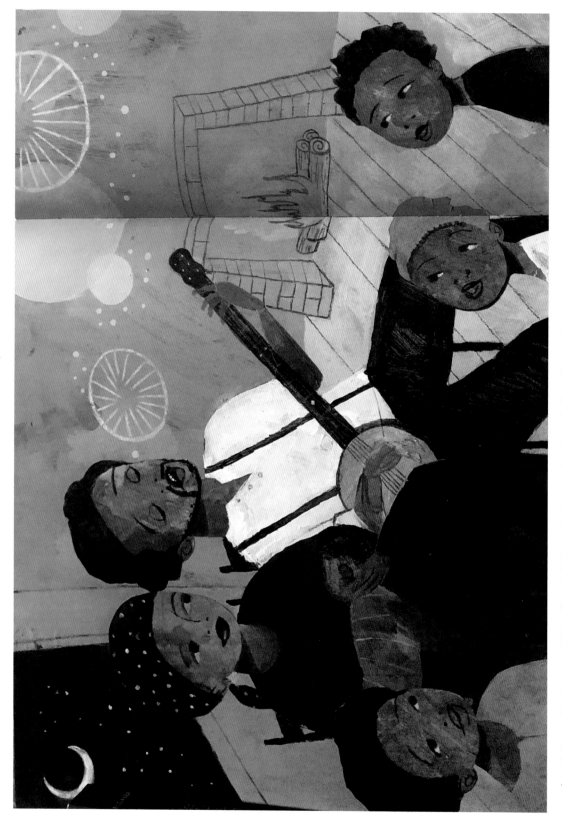

Plate 13. Henry Box Brown and his wife and children, singing together. From Sally Walker and Sean Qualls's *Freedom Song* (New York: HarperCollins, 2012). Used with permission. Also see Figure 7.5.

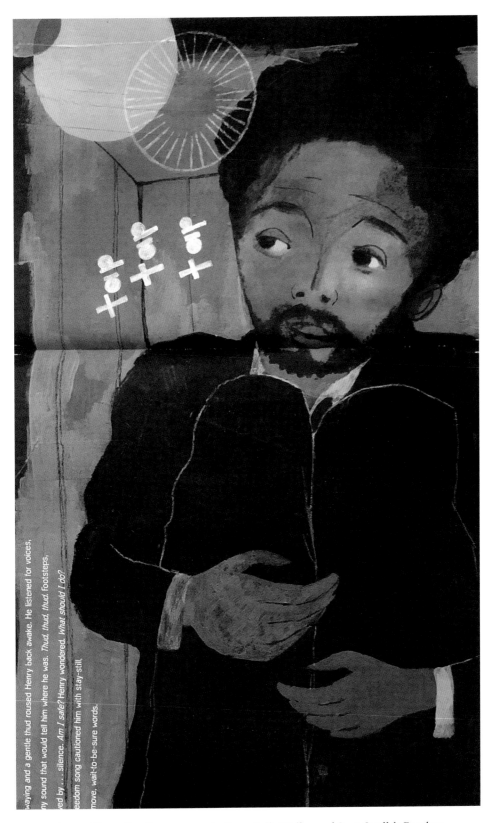

Plate 14. Henry Box Brown en route. From Sally Walker and Sean Qualls's *Freedom Song* (New York: HarperCollins, 2012). Used with permission. Also see Figure 7.6.

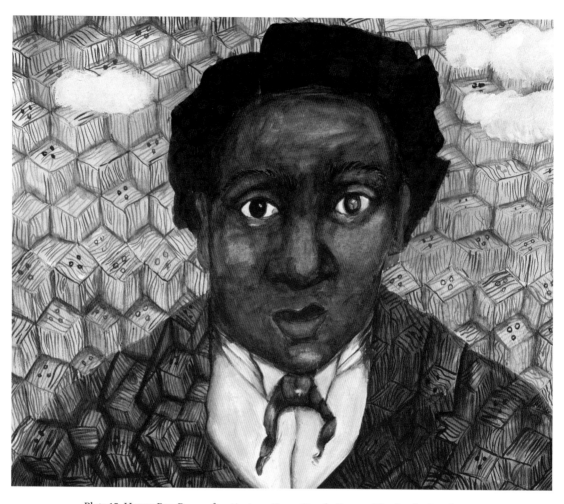

Plate 15. Henry Box Brown frontispiece. From Carole Boston Weatherford and Michele Wood's *BOX: Henry Brown Mails Himself to Freedom* (Somerville, MA: Candlewick, 2020). Used with permission. Also see Figure 7.9.

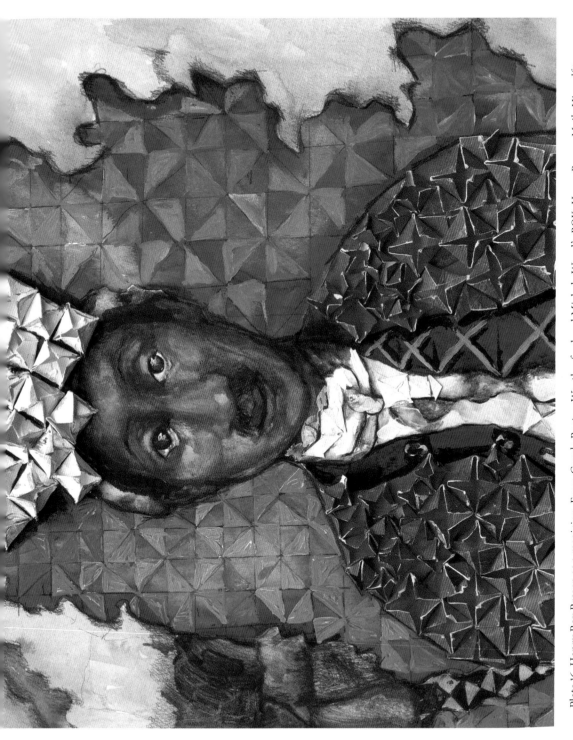

Plate 16. Henry Box Brown as a magician. From Carole Boston Weatherford and Michele Wood's *BOX: Henry Brown Mails Himself to Freedom* (Somerville, MA: Candlewick, 2020). Used with permission. Also see Figure 7.10.

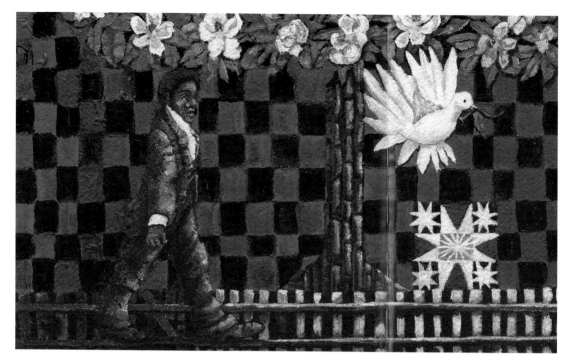

Plate 17. Henry Box Brown walks toward freedom. From Carole Boston Weatherford and Michele Wood's *BOX: Henry Brown Mails Himself to Freedom* (Somerville, MA: Candlewick, 2020). Used with permission. Also see Figure 7.11.

Canada, the United States, and Beyond

Performing Slavery and Freedom, 1875–1897

On July 14, 1875, Henry Box Brown, Jane Brown, and their two surviving children (Edward and Annie) landed at New York Harbor aboard a ship called the *Algeria* (arriving from Liverpool). The passenger manifest lists the following details: Henry H. Brown (50 years of age, professor); Jane Brown (44, wife); Edward Brown (10, child); and Annie Brown (5, child).[1] No doubt this was a somber arrival, in view of the recent tragic demise of their daughter Agnes, who had perished at age fourteen just seven months earlier, on October 20, 1874. As discussed in Chapter 4, two other children had died previously. Haunted by these losses and perhaps craving a fresh start in a new land, the remaining two children and their parents set sail for New York. When they arrived, the Browns—a theatrical and musical family who would go on to perform together—were perhaps inspired by the vibrancy of New York or intrigued by the hustle and bustle of Broadway, a street hectic with carriages and theaters even in this era, and which had been pictured in Brown's Civil War panorama.

Brown had left England, but perhaps not permanently. It is possible that he returned in 1890 as part of a minstrel show, as well as for a performance in 1896, just one year before his death. Returning to England makes some sense, especially given that, after 1875, Brown was gone but not forgotten. The British press made references to him in a lecture on the Underground Railroad in March of 1877. And in an 1879 discussion of the abolition of American slavery, Brown was compared favorably to Frederick Douglass. Even small details of his life, such as his owning and running a fully licensed tavern—The King's Arms Beerhouse— in Atherstone in the late 1860s, were mentioned as late as 1894.[2] Brown's fame would never be as great as it was in England in the 1850s and 1860s, but it is evident that the British public remained intrigued by his story after he departed in 1875.

Nor had the US forgotten about Box Brown's story during his twenty-five-year sojourn in England. During the Civil War he was referred to in a derogatory way as part of an army that might invade the South. And Brown's exploits abroad had been traced by the US press, including his reperformance of his resurrection from the famous box in front of a live audience in Leeds and the 1852 Wolverhampton trial, in which Brown won a successful judgment of libel after slanderous newspaper coverage. Moreover, Brown's successful performance of his life in plays in Liverpool in 1857 was noted by at least one Richmond newspaper. On June 9, 1870, Brown was lauded (in absentia) at a celebration in Philadelphia of the ratification of the Fifteenth Amendment; in speeches Brown was called a "man of invention as well as a hero." And his escape-by-box was still lionized by the press as late as 1871.[3]

Moreover, before Brown landed in the US, he had arrived by way of a refurbished visual presence in one extremely influential publication. In 1872, the famous activist William Still, who had helped countless individuals to freedom through his work on the Underground Railroad, published his memoir, which contained a new print of Brown and an extensive account of his 1849 escape. In this chronicling of events, Brown never faints upon his unboxing (as he was said to do in earlier accounts) but stands up boldly to sing his freedom song:

> Rising up in his box, [Brown] reached out his hand, saying, "How do you do, gentlemen?" . . . Very soon he remarked that, before leaving Richmond he had selected for his arrival-hymn (if he lived) the Psalm beginning with the words: "*I waited patiently for the Lord, and He heard my prayer.*" And most touchingly did he sing the psalm. . . . As he had been so long doubled up in the box he needed to promenade considerably in the fresh air . . . and while Brown promenaded the yard flushed with victory, great was the joy of his friends.[4]

This is a triumphant arising from the living death of slavery, one in which Brown (even a showman upon his exit from the box, in Still's recounting) promenades the yard, rosy with his triumph. Gone is the rising and falling motion (in and out of the living death of slavery) that other accounts put forward. Twenty-three years after his actual escape, Still creates remarkable suspense, giving Brown a dramatic entrance into the realm of freedom: "All was quiet," writes Still. "The door had been safely locked. The proceedings commenced. Mr. McKim rapped quietly on the lid of the box and called out, 'All right!' Instantly came the answer from within, 'All right, sir!'" And then, the scene of Brown's dramatic and miraculous resurrection from the death of slavery is enacted once again: "The witnesses

will never forget that moment. Saw and hatchet quickly had the five hickory hoops cut and the lid off, and the marvelous resurrection of Brown ensued."[5]

The 1872 lithograph in Still's book also encapsulates this sense of wonder and marvel that Brown's spectacular unboxing still engendered. The illustration in Still's book was certainly based on the January–February 1850 lithograph by Peter Kramer,[6] but there are some remarkable divergences (see Figure 5.1). In the 1872 print, Brown seems to be pushing himself up and out of the box; the position of his left arm suggests activity and mobility. The box is also turned at an angle, and Brown looks more like a jack-in-the-box beginning to pop up than an exhausted fugitive slave. Still's book was widely reviewed from 1872 onward, and reprints from it appeared in many newspapers, often featuring excerpts from Brown's story or drawings of his box, reintroducing Brown's heroic story to members of the US public three years before his arrival stateside.[7]

In short, although Brown had left the US twenty-five years earlier, there is good evidence that the US public was still intrigued by his tale and by his life abroad. Upon his arrival in the US, he rapidly began carving out a performance career. Archival data that I have located indicates that Brown lived and performed in the US (in New England and Michigan) until 1881 or 1882, at which point he migrated to Canada, living first in London, Ontario, and performing in

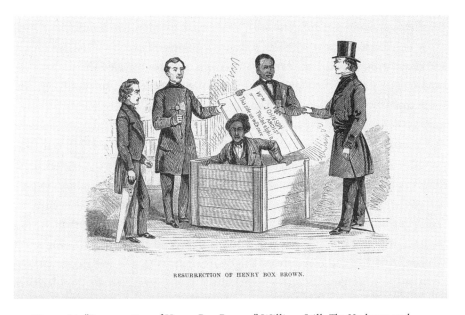

RESURRECTION OF HENRY BOX BROWN.

Figure 5.1. "Resurrection of Henry Box Brown." William Still, *The Underground Rail Road* (1872). Engravings by Bensell, Schell, and others. Image courtesy of Schomburg Center for Research in Black Culture, Manuscripts, Archives and Rare Books Division, New York Public Library. https://digitalcollections.nypl.org/items /510d47df-799a-a3d9-e040-e00a18064a99.

small towns, until settling in Toronto in 1886, where he lived until his death in
1897. Brown and his family were itinerant, always on the move, and even in the
last few years of Brown's life there is some indication that Box Brown and his
wife might have made their way back to England. Carving out a life as a per-
former was always arduous, and as Brown aged it became more difficult to inter-
est people in his shows. Once again he would multiply his performance modes,
invoking his story of enslavement (and his old standby, his box) as well as his
feats of magic, this time including Jane and one or even two of his children in
some of his acts. We can also watch Brown as he moves into new performance
modes, such as Jubilee singing and diverse varieties of healing, adding new skills
to his ever-expanding repertoire.

Revisiting New England Spaces (1875–1880): Mirth, Magic, and Mystery

In the first early years in New England, Brown struggled to make his perfor-
mances relevant to a changed US public. In 1870s New England Brown had stiff
competition; audiences could take their pick among plays, operas, lectures on
Africa, mesmerists, veteran phrenologists, comedy shows, jugglers, circuses,
pantomimes, and professional magicians.[8] Brown and his family were good
vocalists but could not compete with the likes of extraordinary musicians such
as the Fisk Jubilee singers, who first toured New England in early 1872. This highly
acclaimed group of African American college students traveled the US and Eu-
rope singing a cappella songs consisting mainly of traditional spirituals but also
some tunes by the well-known minstrel composer and lyricist Stephen Foster,
such as "Swanee River" (also known as "Old Folks at Home").[9] Ruggles contends
that Brown mainly functioned as a magician or conjurer in the US in this time
period,[10] but given the popularity of all these different art forms it makes sense
that he would move between different performance genres, again blurring his
identity and creating visual static about whether his audience was seeing the
"real" Box Brown. In this epoch, Brown continued to practice mesmerism, music,
healing, and mystical modes, both employing second sight and exposing spiri-
tualism. And like the Fisk Jubilee singers, it appears that he would sometimes
cross over into singing "plantation melodies," trying to access the popularity of
minstrel songs without succumbing to the genre's racist stereotypes and nostalgia
for the days of slavery.

The first US performance that I have located occurred in Providence, RI, on
August 21, 1875 (just five weeks after he had disembarked with his family in New
York), at Howard Hall, and the reviewer was not kind: "Professor Box Brown

gave his entertainments the past week to two-dollar houses, which was more than he deserved"; the author then adds a cryptic note: "Bill posters and all others look out for him."[11] Was the writer here implying that Brown would rip down posters of other presenters, as had been alleged in the past? Yet a performance just a few months later (October 18, 1875) in Salem, MA, appears to have been greeted with more enthusiasm (see Figure 5.2).

Brown is arranging for several entertainments in Salem that will occur in the following week, and the article notes that Brown visited Salem previously (presumably in 1849–1850) and garnered large audiences; therefore, he should be "cordially welcomed." Another newspaper notice of the Salem show—this time in the *Lowell Daily Citizen and News*—goes even further in trying to create enthusiasm for his show:

The Salem *Gazette* mentions that Mr. Henry Box Brown, whose middle name is a continual commemoration of his memorable escape from Virginia to Philadelphia in a box, is arranging for an entertainment in Salem. Mr. Brown was formerly a lecturer on slavery in this country, but for a number of years has been giving entertainments in England, which are referred to in the English papers in a very appreciative manner. Box Brown, though long absent, would be recognized by many Massachusetts people who in days of yore listened to his ready wit, shown in his comic style of narrating the manner of his escape, swimming rivers, lurking in cornfields by day and journeying, like Nocodemus, in the night.[12]

Figure 5.2. Performance by Brown in Salem, MA, 1875. *Salem Register* (Salem, MA), October 18, 1875 (EAN).

Like the report in the *Salem Register*, the Lowell newspaper notes that Brown's "middle name is a continual commemoration of his memorable escape from Virginia to Philadelphia in a box"—in other words, Brown is still defined by his box. The article also refers to his 1849–1850 performances: "Box Brown, though long absent, would be recognized by many Massachusetts people who in days of yore listened to his ready wit, shown in his comic style of narrating the manner of his escape, swimming rivers, lurking in cornfields by day and journeying, like Nocodemus [sic], in the night." In comparing Brown to Nikodemus (spelled incorrectly as Nocodemus), a leader of the Jews who in John 3:1–21 journeyed to visit Jesus in the night to learn about resurrection into eternal life, the writer alludes to the notion of Brown's much earlier rebirth as a free man, from the living death of slavery. It is intriguing that the reporter recalls Brown's description of swimming rivers and lurking in cornfields—events that never happened to Box Brown, but that he might have incorporated into his performances to create drama and excitement.

Brown also performed in Chelsea, MA, in early 1876, as reported in the local section of the *Boston Globe* on January 3: "Mr. 'Box Brown' is announced to give drawing room entertainments at Broadway Hall, this and tomorrow evenings."[13] Few details, unfortunately, are given about the content of any of these early shows, and they may have been brief because Brown was testing out his New England audience and trying to determine what performance modes they might relish.[14] However, the next performances that make their way into US newspapers are given slightly more detailed coverage. These are shows in which Brown, sometimes alone, sometimes with Annie, and sometimes with Jane, resumes his performance of magic. Edward is not listed, but he may have been working behind the scenes to make the magic tricks function properly, a common practice in the creation of illusions. Yet even with his family in tow, and after twenty-five years of absence, Brown is still legible only in terms of his former fugitive self, and he had to constantly evoke this prior persona. For example, on January 10, 1877, Brown gave a magic show in Mechanics' Hall, Portland, ME, that was given a very favorable notice:

> PROF. HENRY BOX BROWN—This genius, who gave entertainments in Old City Hall twenty-six years ago, appeared at Mechanics' Hall last evening in his novel entertainment. There were but few present, but the tricks performed were very cleverly done. This evening he will give the history of his escape from slavery in 1849, in a box, and he carries the box with him and has it on the stage. His little daughter will also assist, and perform several feats of sleight of hand.[15]

Referring to Brown as a "genius" who gave "entertainments" in Old City Hall twenty-six years ago, the reviewer calls his new show "novel" and states that the "tricks performed were very cleverly done," even though audiences were small. This article mentions Brown giving another show on January 11 in which his daughter, Annie (now seven years old), will "perform several feats of sleight of hand." As mentioned in Chapter 4, it was not unusual for magicians—such as Robert-Houdin and Robert Anderson—to perform with their sons and daughters, but the Portland public might also be titillated by the fact that Annie was a mixed-race child. Moreover, the reviewer notes that Brown "carries the box [in which he escaped] with him and has it on the stage."[16] Brown's box—or rather a reproduction of it, for surely this could not be the same postal crate from 1850, twenty-seven years later—is a prime feature of the spectacle he enacts onstage. In narrating "his escape from slavery" he may once again climb into and out of his "original" box, as he had done several times in England.

Brown appeared to enjoy performing in Maine and he gave several other shows there: one on May 23, 1877, in Emery Hall in Bucksport and another in July of the same year in Paris, ME. It was reported that Brown left without paying his bills, however: "Box Brown who exhibited on Paris Hill Saturday night, and cut out the temperance meeting, forgot to pay his bills. A writ followed him quite closely. It is harder to escape from one of these little documents than from slavery," quips the *Oxford Democrat* on July 24, 1877, both trivializing the horror of enslavement and insulting Brown in one breath.[17] Brown would perform again in the next few years in diverse parts of Maine (Bangor and Portland), so despite the writ following him from Paris, it seems he enjoyed performing there.[18]

By fall of 1877, Brown was in Vermont, where he appears to have performed for several months (September to November). Brown had some influential friends in this part of New England, as reported in the *Argus and Patriot* on September 5; while in Bradford, Brown was seen strolling "arm in arm" with a prominent judge. However, audiences in Vermont were disappointing. The *Argus and Patriot* on September 19, 1877, reports that "Prof. Box Brown" performed in White River Junction to small audiences, but those "who attended were well pleased."[19] Brown's shows in Vermont involved magic, but also the debunking of spiritualism, as we see in a long description and critique of one of his shows performed in Vermont in late October or early November of 1877. The account was published in a prominent American spiritualistic journal—the *Religio-Philosophical Journal* (on November 3, 1877). Because the writer (W. H. Wilkins) of the article gives Brown's show a detailed and fascinating description, I reproduce it in full:

Spiritualism Exposed!

A Colored Gentleman and Former Slave Explains the Whole Thing.

W. H. Wilkins, of South Woodstock, VT, writes: "Mr. Henry Box Brown gave an entertainment at the town hall here. The first part of the performance consisted of a number of very *fair* tricks in legerdemain, and were performed in a manner which was satisfactory. We now come to the next announcement on the bills, which is set in heavy capitals, and reads thus: 'Prof. H. Box Brown in an entirely new entertainment! SPIRITUALISM EXPOSED! Mr. Brown will introduce and expose the mediumistic Spiritualism as given by the Davenport Brothers and the Eddy Brothers. Rope-tying, instrument playing, tambourine floating, ringing of bells, etc.' Next comes the 'wonderful sack feat' by Miss Annie Brown, to conclude with the mysterious Second Sight performance by Madame Brown.' But I cannot help thinking that according to the professor's reasoning, the statement on his bills must be the *truthful part of a lie*, and the professor himself an exposer of his own ignorance. Yet, no doubt, there were many who went away that night thinking that Spiritualism was exploded in a grand manner. But what authority must a person be who distinctly affirms in his performance that there is no such thing as Spiritualism, and who, at the close, states that he is a believer? If I wanted to add new converts to Spiritualism, I would get this colored professor to go before the people, and go through with his (as the gentleman said) "darn [?] slim [?] performance."[20]

I take Wilkins's observation with a grain of salt due to his evident spiritualist leanings. But it is interesting that Brown engages in performances that entail mystical communication between individuals (such as second sight) while also debunking spiritualistic practices, such as communication with the dead via spirit bells. So, Brown plays both sides of a spiritualist coin, so to speak.

Previous notices have shown Brown performing with his daughter Annie, but here we have a specific reference to one of her magic tricks—the "wonderful sack feat." This trick might reference a popular nursery rhyme for children—"The Wonderful Sack" by John Townsend Trowbridge. In this story, a mysterious stranger produces magical items from a small sack, including a lighted fire, a sofa, pitchers of milk, and a fully cooked meal that includes soup, two plates of fish, bread for twenty, and a roasted goose, to say nothing of utensils, tables, chairs, and even a small waiter to serve the sumptuous repast.[21] Annie's stunt might entail a mysterious provision of numerous items from a simple everyday

entity, a small sack (and Edward might sit below the sack, under a table covered by a long tablecloth, handing up these multiple items to his sister).[22] Annie's trick within Brown's act perhaps had religious or spiritualistic overtones via a veiled reference to Christ's ability to turn two fish and five loaves of bread into enough food to feed a multitude. This trick might also echo Brown's own endowment (during his escape) of a simple everyday item—a postal crate—with miraculous overtones of escape and rebirth, of finding the plentitude of freedom within the sordid daily drudgery and trauma of enslavement, represented by the wood of the crate. Brown's shows in this period often trafficked in implied metaphors of enslavement and freedom, over which Brown might now seem to have extraordinary control. For example, in a performance in Danvers, MA, in Gothic Hall in May of 1878 he gave an "exposé of spiritualism," or more specifically of the "rope-tying part" of this act.[23] Spiritualists would be tied up in ropes and locks and then appear miraculously free later in the show; Brown's reenactment of this trick of being fettered and then escaping his bonds would no doubt resonate with his original "magical" resurrection from slavery.

As mentioned previously, Brown had performed a second-sight act in England for five months (from October 1864 to March 1865) with a woman named Miss Pauline. In the US, we find Jane, as early as November 1877, taking on the role of the psychic in second-sight performances. In such performances, Jane would be blindfolded with her back turned to the spectators, while Brown would go out into the audience and they would (silently) proffer specific objects to him, which Jane would then guess without seeing them. The trick entails a code that both partners must carefully memorize, so that a question by Brown to Jane such as "What do I hold in my hand?" (instead of, for example, "My, what an interesting object. What is it, Jane?") would be decoded alphabetically or alphanumerically to spell out the object. Yet this was all done in a flash with innocuous questions, so that it might seem as if Jane and Brown had some sort of telepathic communication with each other, or that Jane could see past the physical world into a second (hidden or invisible) one. Both Annie's and Jane's acts—second sight and the "wonderful sack feat"—therefore had mysterious and supernatural overtones, as well as spiritual ones. About a performance in Leominster, MA, on November 10, one newspaper notes: "Prof. H. Box Brown, who escaped from slavery in 1849 in a box, gave a very good entertainment in the town hall, last Saturday. He will give another, this (Wednesday) evening, in the same hall, where mirth, magic, and mystery will be shown."[24] Although Brown's history of enslavement is mentioned, the focus on "mirth, magic, and mystery" implies that mesmerism and magic, atemporal planes of performance with mystic overtones, are the main acts being showcased.

Brown gave several more performances in Massachusetts at the end of 1877: in the Millbury Town Hall, Brown and his family had only a small audience for a show that entailed exposing spiritualism and miscellaneous other entertainments; Brown would "exhibit the box he escaped in and get into it before the audience." As late as 1877, then, Brown was still climbing into and out of his box.[25] Ruggles postulates that over the twenty-five years during which Brown performed in Britain, from 1850–1875, he appears to have "emancipated himself, in a sense, from his personal history of enslavement."[26] Yet I would argue that, rather than releasing him from his history of enslavement, performance, magic, and mesmerism gave Brown a type of dominion over this history, transforming it into art while not abandoning its essential political content. Brown's climbing back into his box, for example, delineates the afterlives of slavery, of living in the wake of being property, of being a thing, and his invocation of the slave-as-thing implies that the larger sociopolitical logic that undergirds not only slavery, but also racial debasement and discrimination, remains intact. Brown symbolically illustrates the paradoxes of Black identity; his act implies that slavery is still an unfinished tale and freedom remains elusive. In turning these facts into art, Brown creates a radical content for this imaging, a radical form of fugitivity. In a more atemporal and nonmaterial register, magic and mesmerism, which appeared to give Brown authority over an unseen world beyond the audience's comprehension, might also shift power away from the audience and into the figuration of enslaved and formerly enslaved subjectivity. Brown turns his box into a metaphor for the fact that slavery existed everywhere and anywhere, in the past and present. He places this material artifact into a present tense moment while asserting his management over trauma and the horror of enslavement via magic, mesmerism, and other modes of atemporal performance.

Another avenue through which Brown managed and stage-managed the trauma of enslavement was (once again) through the creation of various personae. From 1878–1880 Brown had multiple performances in New England, in towns in Massachusetts (Worcester, Danvers, Brookline), Maine (Portland and Bangor), Rhode Island (Woonsocket), Vermont (Guildhall, Montpelier, and others); while it cannot be said that he ever had large audiences in New England in this era, he continued to multiply the identities he manifested onstage.[27] His multiple personae are showcased in posters from this time used to advertise his shows (see Figure 5.3). The inscription at the top of this poster—Town Hall Brookline, May 2, 1878—gives the time and location of the performance. Brown and his family (Annie and Jane) have a family magic show, but Brown is also exposing spiritualism and performing as "Prof. H. Box Brown."

If we watch Brown carefully as he "moves" across this poster, we can see that he has at least three distinct temporal identities that will be brought into being

PRICES OF ADMISSION TO SUIT THE TIMES.

PROF. H. B. BROWN,

Whose escape from slavery in 1849, in a box 3 feet 1 inch long, 2 feet wide, 2 feet 6 inches high, caused such a sensation in the New England States, he having traveled from Richmond, Va., to Philadelphia, a journey of 350 miles, packed as luggage in a box. He has very recently returned to this country after a lengthened tour of 25 years in England, where he has traveled extensively in various entertainments; among these are the Panorama of American Slavery, the Holy Land, the great Indian Mutiny, the great war between the North and South, Mesmeric Entertainments, and, lastly, the

AFRICAN PRINCE'S

Drawing-Room Entertainment.

The Programme will consist of the following:

Destroying and restoring a Handkerchief, astounding feat with the Sword and Cards, the wonderful Flying Card and Box Feat, Burning Cards and Restoring them again, the most Wonderful and Mysterious Doll, the Inexhaustible Hats, the wonderful experiment of passing a Watch through a number of Boxes, the extraordinary feat of Flying Money, the Inexhaustible Pan, the instantaneous Growth of Flowers, the Enchanted Glass, etc., etc.

Mr. Brown, having only just returned to this country from England, will give a first-class European Entertainment.

Letter from Ex-Mayor Buffum, of Lynn.

To WHOM IT MAY CONCERN. I would say that the bearer of this note in the original Box Brown. I knew him when he was first taken from the box in Philadelphia, and he has in nowise changed except by age.
LYNN, Nov. 7, 1875. JAMES N. BUFFUM.

PROF. H. BOX BROWN,
In an entirely new entertainment.

SPIRITUALISM EXPOSED.

Mr. BROWN will introduct and expose the Mediumistic Spiritualism, as given by the Davenport Brothers, the Eddy Brothers; rope tying, instruments playing, tamborines floating, ringing of bells, &c.

TO CONCLUDE WITH THE MOST

WONDERFUL SACK FEAT BY MISS ANNIE BROWN,
Such as was never performed before by any child.

THE WONDERFUL

Mysterious Second-Sight Performance,
Will also be introduced by

MADAME BROWN.

Admission 10c. Body of the Hall 15c. Reserved Seats 25c.
Doors open at 7.30. To commence at 8.

Chas. Hamilton, Printer, 311 Main St., Central Exchange, Worcester.

Figure 5.3. Broadside advertising a performance by Henry Box Brown with his family in Brookline, MA, May 2, 1878. Used with permission of Mike Caveney and the Egyptian Hall Museum, Pasadena, CA. Note handwriting at the top.

as he performs: Box Brown (the escaped slave of the past); Professor H. B. Brown (perhaps a present-tense version of himself); and the "African prince" (perhaps an allusion to his presumed royal past in Africa or to an imagined future in which he has transcended the legacy of enslavement). These three identities—or temporal planes—signal the larger psychic problem of slavery, of the ex-slave, continually haunted by the trauma of slavery, and who has multiple identities as (for example) the individual undergoing this trauma (a past-tense subjectivity), the individual writing about it or performing it (in the present-tense moment), and a future self who still may not be free from this legacy. Across the space of the poster Brown floats chronologically and geographically via these shifting personae. These multisided personae enable Brown's supervision of the visual spectacle of slavery through a radical reimagining of time and even space, as he produces new identities across disparate eras and locations.

In a discussion of memory and slavery, W. J. T. Mitchell writes that although the public and verbal recounting of a sequence of events may provide an autobiographer with a sense of dominion over the material of his or her life, such a practice is fraught with danger, especially when visual materials are involved, because it may activate "an uncontrollable technology" as memories threaten to come alive, to be re-membered and resurrected "as ghosts who act upon the material world and the body of the narrator." This recalling of events may be so traumatic that it threatens identity, causing a "strategic amnesia, a selective remembering, and thus a selective *dis*(re)membering of experience."[28] It is, of course, possible that Brown's repeated reenactments of his boxing and unboxing are a dis-remembering of the trauma of this experience. It may also be, however, that Brown has learned to mediate the memory of the trauma of enslavement via performance ("restored behavior"). Perhaps the embodied incarnation in the box ("Box Brown") wears the trauma, while his other identities (as Professor Brown and as an African prince) embody a retelling and manipulation of traumatic experiences. Brown's performance of multiple personae may allow him to stage-manage the traumatic memory of enslavement, and to force it into a language and representations that he could control.

It is also fascinating, given Brown's history of his escape via a miraculous crate that was both womb and tomb to him, that his magic act involves playing with specific symbolism involving boxes; as the poster above states, Brown will perform "the wonderful Flying Card and Box Feat," as well as "passing a Watch through a number of Boxes." Once again Brown is in touch with mysterious and unseen forces—as a magician he can make money and cards fly, pass material objects through each other, and make flowers bloom instantaneously. The single, solid object of the postal crate symbolically expresses the plurality inherent in it via Brown's magic; a box will appear and disappear in his act, and become

multiple, as he passes a watch through several boxes. Time itself seems to be referenced in this trick—as the watch, used to measure time, is passed through boxes (physical spaces). Brown could be here referencing his own history of passing through multiple boxes, in many spaces and temporal phases of his life. Once again, a box has mystical and marvelous overtones, as it represents not just a physical object but something that Brown could play with, resurrect, and reinvent.

No doubt this poster—printed first in Worcester, most likely in 1875 as it contains an endorsement by the mayor of Lynn from November 7, 1875—was used by Brown to advertise many of his shows, over a three- to five-year period. A scholar's ticket from this era indicates that Brown's show was widely exhibited in Massachusetts, Maine, and possibly New Hampshire (Manchester and Concord are towns in both Massachusetts and New Hampshire; see Figure 5.4). The ticket states that "All the Schools from Boston, Lynn, Salem, Marblehead, Biddeford, Saco, Portland, Bath, Lewiston, Bangor, Belfast, Franklin, Fisherville, Concord, Manchester, Grafton, Leominster, Fitchburg, Clinton, and many other places, have recently attended this Entertainment in large numbers." This list, while perhaps a bit hyperbolic on Brown's part, does lead me to believe that Brown was earning decent revenue performing the African prince's Drawing-Room

Figure 5.4. Scholar's Ticket to a Show by Box Brown, ca. 1875–1878, with handwritten lettering, "Town Hall Quincy May 8th." American Antiquarian Society Archives. Used with permission.

Entertainment in schools all over New England, as well as some venues meant specifically for adults.

The Browns continued to perform in New England—in Maine and Vermont—until 1880; they then moved on to Michigan and Ontario, Canada. The last performance notices I have located from the years in New England indicate, however, that although their act was well done, it did not receive large attendance. On August 20, 1878, the *Portland Daily Press* (Maine) notes that "the well known sleight-of-hand performer, Prof. H. B. Brown, better known as Box Brown" will be giving an entertainment at Lancaster Hall for three days, assisted by Mrs. Brown. "They give a very interesting performance," the reviewer notes vaguely. The *Bangor Daily Whig and Courier*, on October 17, 1878, also lists two performances by Brown, but no details are given.[29]

After a summer and fall spent in Maine, the Browns moved on to Vermont, where they were less than well received: "Not a very large audience attended the entertainment given by Box Brown in Association Hall last week," notes the *Essex County Herald* (from Island Pond, VT) on December 5, 1879; "our people seem to want something better and of a higher nature than shows of this kind, and we are glad to note the fact."[30] It seems that Brown was still performing magic—perhaps the reviewer wanted something more uplifting. During March, April, and May of 1880, the Browns continued to try to eke out a living through their shows, with limited success. The *Rutland Weekly Herald and Globe* (Vermont) reports on March 12, 1880, that "Prof. Brown, a colored man, better known as 'Box Brown,' gave a sleight-of-hand performance and lecture at school house hall, Proctorville" on the previous Saturday, but says nothing of the attendance. Just a few days later, the *Rutland Daily Herald* reports that Box Brown is "advertised to give an entertainment in the town hall this evening, consisting of legerdemain, ventriloquism, and a spiritual séance" and notes that Mr. Brown is "the person who escaped from slavery many years ago in a box." Brown performs ventriloquism and séances at this point, as he had done in England, perhaps to gain a stronger audience. Yet he is unsuccessful, as the same newspaper (the *Rutland Daily Herald*) reports just a day later, on April 2, 1880: "'Box' Brown performs some clever sleight-of-hand feats at the town hall last evening. The audience was small." On April 30, 1880, the *Enterprise and Vermonter* (Vergennes, VT) notes that "The entertainment by 'Box Brown' at the School House Hall, Wednesday evening, though slimly attended was very good."[31] Other reports are positive but fail to suggest large audiences, such as one from a show by the Brown family at the Village Hall, Montpelier, for several nights, in the *Argus and Patriot* in May of 1880: "The head of the family, H. Box Brown, is a colored gentleman of courtly manners, *debonair* deportment, and *distangue* appearance, while the other members conducted themselves all as good citizens should and gave a

show that had merit in it."[32] As we have seen in previous chapters, Brown could dress up like a showman, but I take the reporter's point here to be a compliment: Brown is dressed tastefully and he and his family comport themselves in a "respectable" manner. Still and all, this does not seem to mean that his audience increased. "'Box Brown' and family have been in town," notes the *Argus and Patriot* (Montpelier) about a show in Plainfield a few days earlier; however, they "drew a light house."[33]

In the past, New England was a sort of refuge and home to Brown—the place in 1849 where he began his speaking and performing career, had many successful shows, and found sympathetic friends among abolitionist speakers and supporters. But by 1880, it was clear that the people of New England had grown weary of Box Brown. Ever the opportunist and pragmatist, Brown made the decision to leave New England, sometime after May 28, 1880, perhaps never to return, to try his luck in other parts of the US and even outside the US, where he might once again be viewed in a fresh light.

Parts Unknown: Michigan and Canada, 1880–1887

After 1880, Brown's story gets less detailed and harder to trace, unfortunately. This is due in part to the fact that many nineteenth-century Canadian newspapers remain undigitized to this day, and therefore difficult to search. At this point Brown was also older—perhaps 64 or 65—although he was passing for a man in his early 50s.[34] He may have had some physical difficulties performing, as at least one newspaper report from 1887 (discussed below) suggests, or he may have simply been unable to attract much of an audience. In any case, the performance record becomes fragmentary and in parts of the chapter I can only offer surmises about what Brown was doing during his shows.

In 1881 Brown moved to Canada—and more specifically to London, Ontario—where he lived and performed until at least 1883, although in this era he also continued to perform in the US (mainly in Michigan). The *London Advertiser* on November 29, 1881, lists Brown as a "promising candidate for aldermanic honors in No. 3 Ward." In Canada, the term "alderman" was used for persons elected or sometimes (in the case of aldermanic honors being conferred) appointed to a municipal council to represent the wards; for Brown to be appointed to an office in Ward 3 of London, Ontario, he would have to be living there. Brown's son, Edward, also lists (on his marriage certificate from October 30, 1883) London, Ontario, as his place of residence.[35] Brown also performed frequently in London, including on July 19 and November 29, 1881; on November 16, 1882; and on February 22 and March 1, 1883.

Most importantly for establishing the Brown family's residency in London, Ontario, the London City Directory for 1883 lists Mr. H. B. Brown as a proprietor of the Victoria Restaurant at 88 Dundas Street and a professor of phrenology, residing at 326 Hill Street. The 1883 London City Directory also lists Brown's son, Edward Brown, as the manager of the Victoria Restaurant (Edward Brown is also listed as boarding at 326 Hill Street).[36] According to Arthur G. W. McClelland, Ivey Family London Room Librarian at the London Public Library, Hill Street and the area around it was a place where many of the early Black settlers of London resided.[37] Taken together, these pieces of information document that the family was living in London, Ontario, from July 1881 until at least late October 1883, after which they appear to have lived in Kingston for a few years before moving to Toronto in 1886.

Fascinatingly, in the early 1880s many shows by Brown alone or with his family also occurred in a somewhat unusual place: Cheboygan, MI. Brown had never performed in Michigan before, so perhaps he had some relatives with whom he lived for short periods of time. In any case, from 1881–1883, Brown crossed back and forth over the US-Canadian border (between London, Ontario, and Cheboygan, MI) with some degree of ease. The distance between London and Cheboygan is 350 miles—not an easy voyage in the early 1880s. But Cheboygan could be reached by train or boat; passenger boat service to Cheboygan began in 1869, and the Michigan Central Railroad opened a branch that connected the city to the Midwest and the nation in 1881.[38]

Brown put on a magic show on February 21, 1882, in Indian River (near Cheboygan, MI), as the *Northern Tribune* notes: "Our opera house (school house) was opened Wednesday evening to the first show for Indian River. The great Prof. Box Brown, Prestidigitatuer [sic] &c. gave a very interesting entertainment, and distributed some very unique if not valuable presents. He was well patronized and no doubt has visited Cheboygan before this."[39] The term "prestidigitator" is used here—"sleight of hand magic"—but more intriguing is the idea that Brown had been in the Cheboygan area before. Another article in the same newspaper just a few days later, on February 25, comments that Prof. H. Box Brown gave a "slight-of-hand [sic], legerdemain, animal magnetism, and electro biology, etc. entertainment at the Town Hall last night to a pretty good sized crowd" in Cheboygan. The tone here seems to be one of boredom, although the reporter does note that Brown will move on to perform in St. Ignace. It appears that the February 25 performance did not go well, however, as Brown filed a complaint with the Cheboygan village council against a night watchman named O'Brien; O'Brien had already been removed, so Brown's complaint was unsuccessful.[40] All of these performances appear to involve Brown performing magic

and mesmerism by himself—unlike earlier performances in which both Jane and Annie participated.

Despite these setbacks—harassment by a night watchman and mediocre crowds—Brown would return to perform in the Cheboygan area in 1883 with a "troupe of Jubilee singers" who likely included members of Brown's family. In late 1883 Brown appears to have retooled himself once again, this time via music, taking advantage of interest in Jubilee singing generated by the Fisk Singers. Due to the popularity of the Fisk Singers, as Adrienne Shadd has documented, several African American and African Canadian groups such as the Ball Family Jubilee Singers and the O'Banyoun Jubilee Singers performed in this mode, often singing songs from the days of enslavement and spirituals.[41] In 1883, Brown and his family appear to have joined the rising tide of interest in jubilee singing, as they would also do as late as 1889 in Canada.

On August 16, 1883, the *Weekly Expositor* (from Brockway Centre, MI) comments that "Henry Box Brown with his troupe of jubilee singers visited this place and gave an entertainment in Duffle's Hall last Friday evening." Unfortunately, the newspaper goes on to report negatively on the performance: "A very large crowd witnessed a very thin entertainment."[42] It seems that the "troupe" as such likely consisted of Brown, Annie, Jane, and Edward, and these shows may represent one of the rare occasions in which we see Edward performing onstage with his family. The *Northern Tribune* lists a performance on December 1, 1883, "under the formidable name of 'Professor Box Brown's Troubadour Jubilee Singers'":

The AuSable Saturday Night thus sketches a familiar subject: A week ago Friday an antiquated antiquity in the shape of an aged "cullud" man struck town. He was accompanied by three younger members of the human family. Saturday and Sunday evening, they held forth at [the] Opera Hall under the formidable name of "Professor Box Brown's Troubadour Jubilee Singers."[43]

The reference here to Brown as not only aged but also an "antiquated antiquity in the shape of an aged 'cullud' man" manages to be both racist and ageist at once. What is more remarkable is the phrase that Brown is "accompanied by three younger members of the human family"; although the writer stops short of saying that all the individuals onstage are direct family members, he or she very strongly implies this, and it seems possible that these three "younger members of the human family" would be Annie, Jane, and Edward. Box Brown is listed as singing with his family at other times (in Brantford, Canada, in 1889, for example,

as I will discuss), and we know they had performed magic onstage with him in 1878, so it seems likely that the "Troubadour Jubilee Singers" are composed of Brown and his family. Edward Brown would marry a woman from Richmond, VA, named Jane Price on October 30, 1883, so perhaps he stopped performing with his family after his marriage.[44]

Yet, as mentioned above, Box Brown was also living and performing in Ontario during the early 1880s and listed as running a restaurant there in 1883. Perhaps Edward, who was eighteen years old in 1883, helped run the Victoria Restaurant while Box Brown was on the road, at least until he married. In terms of performances in London, the *London Daily Advertiser* lists one by Box Brown in a jocular way on July 19, 1881. This is the first performance record for Brown in Canada that I have found, and its colloquial tone implies that members of the town were very familiar with his unusual character and mode of performance, and that he had been on site there previously: "The three mile walking match in the Tecumseh Park last night, in connection with the Box Brown entertainment, resulted in a victory for O'Higgins, who was awarded Box Brown's six dollar silver cup. The other two contestants, Mutehart and Fawcett, were ties, but owing to a foul they were not awarded the second cup."[45] This performance appears to entail a classic marketing ploy by Brown, like ones he orchestrated in England involving donkey races that were exploited to encourage people to attend his shows (see Chapter 4). Here, a valuable prize is given away—a six-dollar silver cup—to the person who wins the "three mile walking match in Tecumseh Park." Most likely, runners or walkers paid a fee to enter the match, or perhaps to see Brown's entertainment, and the winner and runner-up got valuable prizes, although in this case no runner-up prize is awarded. The tone of this article evinces familiarity with Brown: the writer seems to feel no need to explain the nature of this entertainment—as if everyone already knows about it and indeed about Brown.

Brown performed many times in London, Ontario, and in nearby towns from 1881–1886. The *Guelph Daily Mercury and Advertiser* on October 18, 1881, describes "Henry Box Brown, a coloured magician" giving an "entertainment in the old City Hall last night before a good audience, mostly composed of children." The article also calls Brown a "first-class sleight-of-hand performer" and notes that he keeps his audience's interest for a full two hours, at the end of which he conducted a lottery for a butter dish.[46] The *Markdale Standard* (September 28, 1882) lists an upcoming performance of "a dramatic entertainment" on October 10, 1882.[47] The article is not specific about the nature of this performance but it seems to have entailed magic and mesmerism, which Brown performed when he was alone in this era, rather than singing (which Brown performed with his family).

It is also clear that Brown was (once again) multiplying the modes in which he performed, moving into some early forms of medical treatment, as he had in England. In November of this same year, Brown was granted permission for a performance in London, Ontario. The *London Advertiser* describes the planned performance as follows:

> Professor Box Brown appeared in the Town Hall last night, and obtained leave to address the Council. He related the thrilling scenes and incidents connected with his escape from slavery, and how he was packed away in a box three feet one inch in length by two feet in width; that he wanted the use of the hall for one of these lectures, and if so granted would expose conjuring, give an exhibition of legerdemain, and would lecture on animal magnetism, biology, sociology, tricology, and micology. The use of the hall was granted, the Professor to pay all expenses.[48]

Brown relates his enslavement to the town council. In the show itself, he will "expose conjuring," as well as doing some of his own magic tricks ("legerdemain"). But he also plans to lecture to his audience on a variety of scientific subjects including biology, sociology, tricology (presumably trichology, the study of hair loss and diseases of the scalp), and micology (presumably mycology, a branch of science concerned with the healing properties of mushrooms). In the performance, Brown will play the role of both a scientist and a type of healer or doctor. As discussed in Chapter 4, Brown claimed to have used hypnosis and electrobiology to cure disease, yet the planned performance in London goes further. Brown will lecture on treatments for hair loss, most likely using information he obtained in England where the formal study of "baldness, greyness, [and] deficiency of hair" began in the late 1870s.[49] As we saw, in England Brown physically touched his audience members during his performance of phrenological mesmerism, and it is fascinating to consider whether his treatment of hair loss might involve physical touch or laying on of hands (scalp massage); some clinical studies indicate that hypnotherapy might be a treatment for hair loss.[50] Brown also plans to lecture on the healing qualities of fungi—a subject long studied by scientists, shamans, and lay healers; mushrooms were believed by some to cure diseases such as anxiety, arthritis, and even cancer.[51] Brown's potential connection with mycology is also fascinating, given that some magicians had been known to create medicinal teas using mushrooms in order to psychedelically enhance their audience's experiences during performances, or to use other psychedelic substances to cure and cause disease, and to even seem to produce a resurrection in a dead person.[52] In light of Brown's long history of symbolic resurrection, and the fact that some sort of medicinal beverage induces a (temporary)

death-like state in one of the characters in *The Fugitive Free*, it is intriguing to ponder whether Brown ever used such substances in his performance work. That is speculative, of course, but what is clear is that Brown once again would be marshaling the authority of science in his performance work, and that he felt himself to be proficient to lecture on many scientific topics, in his persona of "Professor Box Brown."

Of all the roles that Brown played and all the performances he gave, it appears that magic and mesmerism, when operated in tandem with his box, gave him one of his most subversive and radical performance modes. Combining these modes with his own form of boxology, Brown turned slavery into a type of spectacle that he could manipulate through the proliferation of visual and tactile imagery. By repeatedly employing physical symbols of bondage (such as his box, and fetters that he might miraculously slip out of) in acts of conjure and mesmerism, Brown was able to reshape and refigure his traumatic experiences via representation. As we have seen, Brown staged his own boxing and unboxing on many occasions; there are also reports that he even had himself shackled and swaddled in a large canvas sack as part of his magic acts, and that he would escape from these bonds in a Houdini-like fashion.[53] Brown's performances represent forms of witnessing and testifying to the trauma that was enslavement; yet by accessing nonmaterial worlds and even extrasensory ones through magic and mesmerism, he was able to restage his story in a manner that gave him dominance over its outcome and meaning.

Perhaps this explains why Brown continued to perform as a mesmerist and magician in London, Ontario, and other towns in the area for at least four more years before moving to Toronto in 1886. The *London Advertiser* reports on March 1, 1883, that "Prof. Box Brown applied for the use of the [City] Hall for a lecture on mesmerism, and a free 'invite' to the members of the Council, whom he would undertake to mesmerize individually or collectively. His application was favorably received." Here Brown daringly offers to mesmerize members of the Town Council to prove his skills in this field. The members of the Town Council, perhaps having heard of how Brown could reduce people to fools, wisely decline this offer but grant Brown the use of the hall.

But Brown was struggling to attract an audience; as mentioned, he was running a restaurant in London, Ontario, in 1883, suggesting that his shows (alone) were not supporting the family. In 1884, Brown performed magic in Watford but had low attendance, and a show in Iona Sparks with his wife and daughter was poorly received. His shows were "highly appreciated" in West Lorne on October 16, 1884, and in Comber on November 6, 1884.[54] Two years later, the *Daily British Whig* (a Kingston, Ontario, newspaper) reports on April 30, 1886,

that on May 1, "'Box' Brown is advertised to exhibit his feats of magic in the town hall" in Portsmouth. However, Brown's show was unsuccessful: "'Box' Brown, who has been giving exhibitions in sleight-of-hand for the past two nights, was to have given a lecture and concert last night, but failing to draw an audience turned down the lights at 8:30 o'clock." Brown once again endeavored to use his fallback—Jubilee singing—but even there he struggled. The *Daily British Whig* reports just one day later that "Box Brown wants to get the City Hall at reduced rates for a troupe of jubilee singers. As an inducement to get this favor he offers free tickets to the mayor and council."[55] Because his shows were not doing well, Brown asks for a discount on rental of the hall and offers free tickets to the mayor and council. Whether he ever performed again in Kingston is unclear.

Just a few years later, however, in 1889, Brown is still engaging in multiple modes of performance—oral (his narrative), aural (singing), and visual (his magic). One effect of his multimodal performances is to capture the radical atemporal moment of slavery—the fact that it was not past, but part of his present and future. A long report in another Ontario newspaper—the *Brantford Evening Telegram* of February 27, 1889—makes clear the ways in which Brown accessed his own past, a more universal history of slavery, and a speculative future world of liberation via magic and spectacle:

> Last evening, Professor Brown and Family gave one of their unique entertainments in Wycliffe Hall (YMCA location) to a fair audience. First, Professor Brown told us about slavery and his escape from the slave scouts to Philadelphia in a box from which incident he was for many years called "Box Brown." He then proceeded to give a number of feats of legerdemain (tricks of a stage magician) of the usual order and after which the Company rendered a number of plantation songs which were well appreciated by those present. The ladies were very good singers and there was more of plantation energy than usual in such entertainment. The Professor stated at the close that a number of gentlemen in the city were anxious to have him give a lecture on slavery and to do so in about two weeks.[56]

In this report, we can watch Brown circle back to his original escape-by-box in the past and give tricks of magic which gesture to his present-tense identity as a magician and conjurer. But then the family sings "a number of plantation songs" with "more of plantation energy than usual in such entertainments." The songs, which gesture to a past of slavery, are sung in the late 1880s by Annie and Jane,

neither of whom ever experienced slavery. Where does this "plantation energy" come from then? Gwen Bergner has recently argued that "the afterlives of slavery" in the US constitute a historical legacy of race relations that "continue to be structured by the plantation form." The "plantation form" can be said to subsume diverse time periods, from plantation slavery property through the failure of Reconstruction and the imposition of Jim Crow, but also up to our present moment via the prison industrial complex.[57] Perhaps in having Jane (who was a white, British citizen) and Annie (who was born legally free in England) musically inhabit the traumatic temporal moment of slavery and the antebellum past, Brown implies that anyone could have been a slave—regardless of their race, nationality, or specific historical era. So Brown here aesthetically ruptures the formulation that the "afterlife" of enslavement impacts only African Americans or formerly enslaved individuals. "The plantation" becomes a carceral moment that floats free from time, and even from space (this plantation energy emanates from Brantford, Ontario, not Richmond, VA, or any other part of the South). The "plantation energy" appears limitless and all-engulfing; it is past, present, and future, all wrapped up into one. Brown and family gesture to this concept by the modality of music, which also floats in time and space, into the ears of the hearers, perhaps alerting them to a radical political soundscape within Brown's art: slavery is an *eternal now* from which no one—Black, white, Canadian citizen, or inhabitant of the US—is ever precisely liberated.

Of course, white minstrels also sang "plantation songs" that were explicitly nostalgic for the days of slavery. But I have little reason to believe that Brown was (here) engaging in a musical minstrelization of slavery—mocking or glorifying it. Minstrel shows were commercial successes in this time, in both the US and Canada. These acts mocked and stereotyped African Americans and glorified slavery. Such a mode of performance is evident, for example, in the 1894 production at the Canadian National Exhibition titled "In Days of Slavery." Archival posters for "In Days of Slavery" describe it as a "Grand Afro-American Production" that featured "fun, mirth and melody, introducing Cotton-Picking Scenes, Old-Fashioned Melodies, Southern Plantation Songs, Buck and Wing Dancing, Cake Walks, etc., by the world famous Eclipse Quartette" (see Figure 5.5).

It seems that Brown's singing of plantation songs with his family did not entail "fun" or "mirth" and perhaps this is what the writer in the *Brantford Evening Telegram* means when he or she states that the Brown family entertainment had more of the "usual" plantation energy—perhaps their performance caught the pathos and trauma of slavery. What is most important about the Brantford show, however, is the way that Brown's art engages with slavery as he attempts to manage it through the activation of multisensory artistic forms that might mediate its trauma but also suggest that slavery occurs in an eternal now that im-

Figure 5.5. Promotional poster for "In Days of Slavery," an 1894 production at the Canadian National Exhibition. Courtesy Linda Cobon, Manager, Records & Archives, Exhibition Place, Toronto, ON.

pacts everyone. Brown negotiates this radical temporality via his multimedia performance, but he does not evade it.

1886–1897: The Toronto Years

It appears that Brown and his family moved to Toronto in 1886, if not earlier, given that the last towns he performs in above—Kingston and Brantford—are closer to Toronto than they are to London, Ontario, and given that Brown appears to have had a relative living in Hamilton, a town near Toronto, in 1888.[58] Perhaps Brown found better opportunities to perform in this large and well-populated city, or perhaps the Browns as a family found other modes of employment; as I document below, both Annie Brown and Henry Brown were proficient at teaching music and did so for periods of time while living in Toronto.

In any case, I date Brown's residency in Toronto to one source in particular: a full legal file obtained from Archives of Ontario that documents Brown's lawsuit

against Toronto General Hospital (TGH) in 1892–1893.[59] In 1892 Brown sued TGH for failure to repair some stairs in a property that they owned and rented to him; he fell through these stairs and was badly injured, but he did not obtain any legal redress, as I discuss later. Neither Brown, nor Annie nor Jane, appear in any other documents from Toronto—street directories or tax rolls—until 1888. But the full file of the lawsuit against TGH contains this information, on what would be page 13 of an unnumbered legal file:

> On or about the first of November, 1886, the plaintiff [Henry Box Brown] rented from one Butland and became the tenant of all and singular the lands and premises then No. 40, now known as 42 Bright Street, in the City of Toronto, at the price or sum of $8.00 per month; the said Butland then undertaking to put the said premises in repair and to keep the same in repair during the plaintiff's tenancy, and a short time after the said date the defendants [TGH] became the owners of the said lands and premises and notified the plaintiff thereof and that all rents were to be paid to the defendants, and the defendants then agreed with the plaintiff to ratify and confirm the said tenancy or lease entered into by the plaintiff with the said Butland, and certain repairs were then done to the said premises by the defendants.

Curiously, Toronto City Tax Rolls from 1886 list Butland as the owner of the property, but Brown is not listed as living there. In 1886 there is a widower named Josephine Reardon living at 42 Bright Street (but her name appears to be crossed out), and in 1887 Toronto City Tax Rolls list a man named John Daly (aged 30, a groom). Still, I take the legal file to be more definitive than the tax rolls; the legal file also contains as an exhibit a "receipt dated November 4th, 1886 by R. B. Butland," presumably for rent that Box Brown paid. The property known as "40 Bright Street" became reclassified as "42 Bright Street" in 1890, but it appears that Brown lived there from 1886–1893, renting first from Butland and then from TGH.

Moreover, R. B. Butland (1830–1886) was a well-known music store owner and amateur thespian, and even after his death in 1886 his store was a vibrant space for musicians and other artists to congregate and advertise their shows. In an 1890 photograph of the store (see Figure 5.6), the windows of Butland's music store are crammed with posters advertising different kinds of performances, and I like to imagine Brown and his daughter Annie putting their own posters or signs there. In any case, it makes sense that Brown (who seems to have gravitated to circles of other artists) would find his way to Butland's store and become his tenant, if only briefly.

Figure 5.6. R. B. Butland's music store, Toronto, King St. West or W. in 1890. The figure is George Marshall Verrall (1864–1959), manager of the shop and nephew of Butland's widow. Courtesy of Toronto Public Library.

It also appears that Brown was still performing while he lived in Toronto from 1886 well into the early 1890s. In Toronto Street Directories and the City of Toronto Tax Rolls from the 1880s and 1890s, he lists his employment as "Professor of Animal Magnetism," "Lecturer," "Concert Conductor," "musician," and "music teacher." Moreover, Annie Brown (who lived with Henry and Jane Brown at 42 Bright Street until her marriage in 1890) lists her occupation as "music teacher" and "musician" (see Table 5.1 and 5.2). The tax rolls for 1888 and 1889 in

Table 5.1. Henry Box Brown Residences in Toronto, 1888–1897 (from City of Toronto Tax Rolls)

Year	Name Listed	Prop. Address	Age Listed	Occupation Listed	Landlord	Number of Residents	Residents under age 18	Rent Paid
1888	Henry B. Brown	40 Bright Street	61	Professor of Animal Magnetism	Toronto Hospital Trust	3	1	$9
1889	Henry B. Brown	40 Bright Street	62	Professor	Toronto Hospital Trust	3	1	$10
1890	Henry B. Brown	42 Bright Street	64	Concert Conductor	Toronto Hospital Trust	4	0	$15
1891	Henry B. Brown	42 Bright Street	64	Concert Conductor	Toronto Hospital Trust	4	0	$15
1892	Henry B. Brown	42 Bright Street	65	None Listed	Hospital Trust	4	0	$15
1893	Brown, Henry B.	42 Bright Street	66	Concert Conductor	Hospital Trust	2	0	$15
1894	Brown, Henry B.	42 Duke Street	68	Professor	Henry Lewis	2	0	$20
1895	Brown, Henry B.	42 Duke Street	69	Professor	Henry Lewis	2	0	$25
1895 (for 1896)	Brown, Henry B.	38 Ontario Street	69	Professor	Henry Lewis	2	0	$25
1896 (for 1897)	Brown, Henry B.	38 Ontario Street	69	Professor	Henry Lewis	2	0	$20

Table 5.1 list the Browns living with one child under 18 in these years; therefore, Annie (born in 1870) lived with her father and mother at 42 Bright Street until at least 1890 (and the notation "bds. 40 Bright" in the Street Directory indicates that she was a boarder there, perhaps paying some rent to her father). Annie married Charles William Jefferson (1865–1953) in 1890, when she was nineteen, and moved to Kane, PA, where she would live until her death in 1971.[60] In the street directory for 1889 and 1890, there also appears to be another boarder—Nettie Moorhead, listed as a nurse in 1889 but a musician in 1890; perhaps Nettie Moorhead sometimes performed with the Browns. The notation in 1893 of a "Brown, Mrs. James" living at 42 Bright Street is also quite fascinating; it

Table 5.2. Street Addresses for Henry Box Brown, 1888–1897 (from Toronto City Street Directories)

Year	Street Address	Occupants	Occupation	Comments
1888	40 Bright Street	Brown, Henry	Teacher	h
1889	40 Bright Street	Brown, Henry R.	Teacher	h
1889	40 Bright Street	Brown, Annie H.	Music teacher	Bds 40 Bright
1889	40 Bright Street	Nettie Moorhead	Nurse	Bds 40 Bright
1890	42 Bright Street	Brown, Henry B.	Musician	h
1890	42 Bright Street	Moorhead, Miss Nettie	Musician	
1890	42 Bright Street	Brown, Miss Annie H.	Musician	b
1891	42 Bright Street	Henry Brown	traveler	h
1892	42 Bright Street	Brown, Henry B.	traveler	h
1893	42 Bright Street	Brown, Mrs. James [Jane?] wks Meredith & Davis		h
1893	42 Bright Street	Brown, Prof Henry B	Lecturer	h
1894	42 Ontario Street	Brown, Henry	Music teacher	h same
1895	42 Ontario Street	Brown, Henry	None listed	
1896	38 Ontario Street	Brown, Henry	Music teacher	

Note: h = home; b or Bds = boards; wks = works for.

is possible that Brown had reunited with some of his relatives. However, I believe this could be a typographical error and is supposed to read, "Brown, Mrs. Jane."

In this era, Brown was making his living in Toronto through his performance skills, again using multimodal methods: animal magnetism (hypnosis), music, lectures, and teaching. I have also located one performance description for Brown in Toronto, on October 28, 1887, when he performed with his family and others in St. Lawrence Hall—a hall with a thousand-seat amphitheater. The performance in St. Lawrence Hall is extraordinarily detailed and deserves careful attention as the only full (if biased in tone) review of a performance by the Brown family—or by Brown—in Toronto. I therefore quote from it in detail:

A Dark Gathering at the Old Market Hall: Captain G. W. Carter and the Brown Family Give a Unique Entertainment.

St. Lawrence Hall was in full blast last night . . . This, as per ticket, was the inducement thereto:

GRAND BENEFIT CONCERT

to be given by

THE BROWN FAMILY

tendered to

CAPT. G. W. CARTER

On Friday Evening, October 28th, 1887

Tickets, 25 Cents

Concert Commences at 8 PM

. . . . The feminine part of the Brown family, two young ladies of hand-some appearance and brunette complexion, emitted a couple of planta-tion songs. Professor Henry Box Brown, to which effect he explained his full name to be, emerged and stated that he was pleased to see officers of city regiments present. Said he, "England! With all thy faults I love thee still!" He further said that he had been a slave and had escaped in a three-foot one inch box. . . . Then the Professor called upon a couple of the few boys in the audience and went through some tricks, which he said were of the legerdemain order. Perhaps they were. Anyway, the audience was pleased. Some of the tricks were good of their kind, but they would have been better if the gas was not burning. The Professor produced a battered white plug, which he said was given to him by Horace Greeley, "A man who had overexerted himself by wanting to be President of the United States" . . . The Brown Family sang, "Didn't My Lord Deliver Daniel?" At 9.10, more people came in and Prof. Brown, who wore a black fez with a long tassel, explained that because he had once been hurt in an accident he always had a pain in his side. He requested that there should be no encores.[61]

The event seems chaotic, and it was poorly attended. The reporter is racist and de-rogatory toward Brown and his family. For example, he states that they "emitted" a couple of plantation songs, as if they were sheep bleating out a tune, and he says that

both ladies have "brunette complexions," when in fact Jane was white. His "review" of the performance must therefore be understood as far from factual.

Yet this article can give traces of the ways Brown was reinventing himself in Canada. First, Horace Greeley had died in 1872 after an unsuccessful presidential run, so it is unlikely that Brown had a "battered white plug" from him unless he had carried it all the way to England and back in 1875. This could be an example of Brown's own mythmaking, like his embellishment of the "Providence Incident" in 1850 when Brown claimed to be hunted as a fugitive slave but was (more likely) the victim in a simple drunken brawl. We also glimpse hyperbolic sartorial self-styling in this show; Brown is said to wear a "black fez with a long tassel," perhaps in an endeavor to make himself exotic to his audience. But more importantly, the show's evocation of several of the Browns' performance modes rings true with other performance materials found in more neutral reviews. Brown performs magic tricks, and sings with Annie and Jane several songs, including the haunting spiritual from the days of enslavement about escape, "Didn't My Lord Deliver Daniel?" with its famous lines promising Christian redemption and freedom for all:

> Didn't my Lord deliver Daniel, deliver Daniel, deliver Daniel
> Didn't my Lord deliver Daniel, then why not every man
> He delivered Daniel from the lion's den
> Jonah from the belly of the whale
> And the Hebrew children from the fiery furnace
> Then why not every man.

For a man who had been delivered from slavery through a postal crate, the song of being delivered out of other types of enclosures (a den of lions or the belly of a whale) would be particularly resonant; and the promise of freedom for "every man" is compelling, even today. While the attitude of the reporter toward this show is sarcastic, such a song still may have resonated with the audience, as similar songs would in Brantford.

By 1890 it also appears that Brown was earning his living by conducting concerts or leading some sort of vocal entertainments, a point I will return to in discussing a trip that Brown might have made to England in 1896. A newspaper article in the *Toronto World* in 1892 describes Brown as a "well-known concert singer."[62] But in the early 1890s Brown is also listed in Toronto street directories as a "traveler"—perhaps a euphemism for someone who has no stated occupation. This term is intriguing, however, considering Brown's possible later voyage(s) to England and his itinerant life as whole, where it appears that he never stayed in one geographical terrain, or in one performance mode, for very long. Brown was always crossing borders and refashioning his identity.

As previously mentioned, in May of 1892 Brown was severely injured when he fell through the front stairs of the house that he was renting from TGH at 42 Bright Street. His lawyer claimed that due to grave injuries Brown could no longer perform: "By the shock and fall the plaintiff was hurled to the ground, a distance of some four feet, causing him great injury to the spine and back bone and dislocating his right foot, and otherwise sustaining permanent injuries, which entirely incapacitated the plaintiff from his former and usual occupation, and by reason of the same the plaintiff has suffered great loss and damage and has been put to great expense for medicine and other attendance, loss of time and otherwise." The legal file also states that due to the fall Brown has "been unable to fulfill his engagements and appointments made prior thereto, thereby suffering great loss of profits."[63] The phrase "appointments" perhaps refers to his teaching of music, but "engagements" implies that Brown was still performing as late as 1892 and making some profit by both occupations.

Brown's lawyer argued that 42 Bright Street needed repair as early as 1889, and that in April of this year Brown notified TGH that the premises were in a dilapidated state and threatened to move out unless they made repairs. Indeed, photos of the property from forty years later show a sad line of narrow and shabby houses that need much renovation (see Figure 5.7). Bright Street was in a rundown area of Toronto known as "Corktown," perhaps because famine-fleeing Irish immigrants had moved there to work in nearby breweries. The area was

Figure 5.7. 38–44 Bright Street, 1936. City of Toronto Archives. Fonds 200, Series 372, subseries 33, Item 79. Used with permission.

full of slum housing, and many photographs of it were taken by the city's public health department to document the poor conditions.

Brown's lawyer stated that "the defendant [TGH] then promised and agreed to do all repairs that were then required and to keep the said lands and premises in repair during the tenancy of the plaintiff." However, there do not appear to be exhibits in the file to buttress these claims, and TGH was able to argue that because Brown *knew* the stairs were faulty and continued to use them instead of the back stairs, he had no legal redress against them for his injuries. As specious as these claims sound to us today, the case was argued in various courts and in front of at least one jury[64] over two years and finally decided against Brown, leaving him with serious injuries and in need of a new place to live.

Brown was successful in many lawsuits throughout his life and was (apparently) a credible and competent witness, and a person who knew enough about the law to keep on hand important documents, as we saw in his lawsuit against the Adelphi Casino described in Chapter 2. The failure of TGH to redress any of Brown's claims or help pay his medical expenses is troubling. It also seems (see Table 5.1) that TGH had raised his rent several times in these years (from $9, to $10, to $15), and that they could have been legally compelled to fix the dilapidated front stairs. But Brown, in claiming injuries after the fact, may have seemed to be exploiting the situation, or perhaps Toronto courts in this period generally sided with landlords, not tenants. After the failure of the lawsuit, Brown moved to 42 Ontario Street in 1894, after having lived in the same house on Bright Street for seven years (1886–1893). The two charts above also give credence to his claim that injuries he suffered in this fall meant that he was unable to perform for a time. After 1894 his occupation is listed as "music teacher" or "professor" rather than "Concert Conductor" or "musician," although documents that I refer to below complicate the claims that Brown could not perform at all after this fall.

The tax rolls for this period from 1893 onward list just two residents in the Brown household—Jane and Henry Box Brown. As we have seen, Brown's son Edward had married in 1883, so never lived with him in Toronto. In 1894 Edward appears to be residing near Boston with his Richmond-born wife Jane Price; he shows up at an Odd Fellows organization known as Richmond Patriarchie No. 6 that had traveled from Richmond to Boston, arriving on October 20, 1894; the group met with many "colored Citizens of Boston" who were formerly Virginians or children of Virginians, including "Mr. A. E. Brown, the son of the historic box Brown."[65] By 1890 Annie Brown too had married and was living with her husband in Kane, PA. Perhaps the Browns felt that with the children married and living elsewhere it might be a good time to travel. Brown had not been forgotten in England and he may have returned there to perform in the

1890s.[66] If so, these performances would be the *last* known performances by Box Brown, and they are as fantastical in some ways as the rest of his amazing life.

Return Voyages? Fantastical Box Brown Sightings in England, 1890–1896

In late November of 1890, a newspaper in Yorkshire contained a long review of an entertaining fundraiser for the Shade Church of England Schools. Attendance was very good, and the room was full of an appreciative audience eager to see the show. The three-part program consisted of songs, serious and comic; then a ventriloquist act by Mr. Chas. Steele ("Mr. Voaks and his funny. . . . little folks, Darby and Joan"); and finally, a "Christy Minstrel entertainment" in which Box Brown is listed as appearing:

> Two choruses were sung by the troupe, conundrums were freely asked and answered in true nigger fashion, and the following songs were also introduced: "I'll take you home again Kathleen," Mr. Box Brown; "Remember your turn on the mill" and "Rock me to sleep mother," Mr. Dan Snow; "Sailing," Mr. A. Tarr; "The vacant chair," Mr. Julius Caesar; and another by Jem Johnson.

The entertainment concluded with a musical farce called "The hungry army."[67]

As we have seen in Chapter 2, some of Brown's earliest performances in England were embedded within minstrel shows, and he may have been a leader of a troupe that performed some minstrel songs. It is evident that the benefit concert for Shade Church of England Schools in 1890 mixes comic songs, racist discourse, and some melancholy content, as was common within the genre. Indeed, the song Brown is reputed to sing here—"I'll take you home again Kathleen"— was a dark folk tune written in 1875 by Thomas Westendorf, a public school music teacher in Plainfield, IL, about the death of a girlfriend, wife, or daughter.[68] "I'll take you home again Kathleen" was incredibly popular in the US in 1875– 1876 and if this is indeed Box Brown he may have first heard or sung it there; in England in the era of the 1890s it had frequently been featured in other minstrel shows,[69] although it was not a minstrel tune per se.

Yet was this Box Brown, singing in England in 1890? I have found no other performances by Brown in England in this year, so it seems unlikely that he would make an entire transatlantic voyage to perform just once. There is the possibility that Brown performed in minstrel shows under assumed names or

other personae in this era. As we have seen, he had several alter egos (the "African prince" and "Prof. H. B. Brown") and performed in Redface. It is also conceivable that someone was *playing the character of Box Brown* or pretending to be him within a minstrel format, which would demonstrate the lasting impact of his persona. By the 1890s, did he retain fame to the degree that he might be impersonated in such shows in England?

I have found one other notice of a performance in England in this decade that seems to feature Brown. In Wales in March of 1896 there was a musical benefit for the Varteg School, and Brown's name is mentioned twice in the context of an organ recital:

> The Varteg Board School was close to overflowing on Thursday evening, when one of the grandest of entertainment was given on behalf of Mr. George Selby. . . . The programme was as follows:—Pianoforte solo, Miss Jessie Pope; duet, Misses Esse Short and A. Brace; dialogue, "Mrs. Pert and visitors," by nine friends; organ recital, Professor Box Brown. . . . The organ recital by Prof. Box Brown has left a marked impression on the minds and ears of the people.[70]

As we have seen, Brown had performed many times in Wales earlier in his career and may have lived there for a time. It was also reported that Brown knew how to play piano, so playing an organ might have been in his skill set.[71] The advertisement mentions *twice* that Box Brown was giving an organ recital and singles out his recital as especially moving, which might indicate that this is an actual performance by Box Brown.[72] Although I have not found passenger records that transport Brown to England in this time period, I have found one passenger manifest that suggests a return of the Browns (Jane and Henry) to Canada in November of 1896 on board the ship *Halifax City*, which traveled from London to Halifax.[73] This information is not definitive, however, because passenger records in this period of ships returning to Canada contain few specific details about their occupants beyond first and last name and gender. Yet if this is the Browns' return voyage, it would mean the couple spent some time in England in 1896, perhaps visiting friends and relatives, while Henry Brown performed. If the performance by Brown at the Varteg School is valid, this would be the last known performance by Brown, because he died just one year later. However, without further documentation of this point (which I have searched extensively for but not found), the idea of Brown visiting England during 1896 remains tantalizing, but insubstantial. Overall, these notices speak to the idea of Brown's larger-than-life personality living on in England, if not in actuality then certainly in the minds of the public.

The End of It All: 1897

Henry and Jane Brown's official residence in 1896 was Duke Street in Toronto, but this does not mean that the amazing adventures of Box Brown had been forgotten in the US. In the years before his death in 1897, several magical resurrections of Brown were present in US newspapers. For example, on January 9, 1889, the *Boston Weekly Globe* published a long essay on the Underground Railroad and some of its more astounding escapes, and Box Brown's tale was narrated once again, this time with a different picture of his unboxing (see Figure 5.8). This drawing appears to be based on an illustration first published in *The Liberty Almanac* for 1851. In this one, as in the 1851 version, Brown looks frail and weak—like an infant getting ready to kiss his beneficent saviors, all of whom appear to be white in this imaging, unlike in other "resurrection" prints. His box is narrow, and his frail form emerges from its coffin-like space without any visual energy. Perhaps this is the last pictorial representation of Brown created during his long life, and as such it is disappointing.

So, I would like to end this history of Brown with an alternative image, which is not *drawn* but imagined, and once again may be more fantastical than

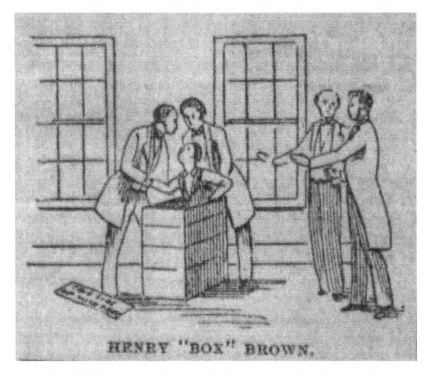

Figure 5.8. Drawing of Box Brown in *Boston Weekly Globe* (Boston, MA), January 9, 1889 (newspapers.com).

real. In "A Prosperous Colony of Former Southern Slaves," a letter from Montreal republished in the *Chicago Tribune* on December 29, 1888, Brown's story is retold by one of his relatives in highly visual language:[74]

> One of the most remarkable of these stories [of escape from slavery] is that of a fugitive named Henry Brown, who was shipped per Adams Express from Virginia to Philadelphia in a box two feet eight inches deep, two feet wide, and three feet long. The story of his escape, as told by a relative of his who resides on a farm in Hamilton [Ontario], is to the effect that, becoming tired of being knocked down to the highest bidder at public auctions, Brown resolved to escape, and how to do it puzzled him. Finally, he resolved to have himself boxed and shipped to somebody in a free state. . . . In due time the box arrived at its destination, but by a preconceived plan it was delivered to the Vigilance Committee of the "underground railroad," where it was duly opened. Everybody had supposed that Brown was dead, but when the lid of the box was raised Brown leaped out like a "Jack-in-the-box," and no doubt would have made a desperate break for further liberation, but finding himself in the hands of his friends he gave vent to his feelings in a song. He was christened "Box Brown" and sent to Canada.

In this oddly truncated version of Brown's history, told (in theory) by "a relative of his who resides on a farm in Hamilton," he goes directly to Canada after his escape (bypassing the twenty-five years spent in England and the additional five years spent in the US). And one of his primary reasons for escape is not the sale of Nancy and his children, as was true in real life, but his being "knocked down to the highest bidder at public auctions." As we have seen, Brown was never put onto an auction block to be sold, but this does happen in the play he acted in about his life, *The Fugitive Free* (1857). So, fiction becomes fact, or rather the two (once again) are intermingled creatively in this version of Brown's escape. Moreover, I wonder if this is a true relative of Brown, or Brown himself telling this story, again inventing another identity for himself?[75] What fascinates me most is the story of Brown "leaping" out of his crate like a "jack-in-the-box," and then giving vent to a song. It is a powerful image of a man making a miraculous jump into freedom and turning his escape into a spectacular musical performance. Brown here becomes an almost fantastical (mythical) creature—a jack-in-the-box who cannot in fact be contained by the box: he is always escaping it, while still tethered by invisible strings to its legacy and history.

Brown died on June 15, 1897, and was buried in Toronto's Necropolis Cemetery, as I documented in 2015.[76] The death certificate lists Brown's age as 67, but

if he was born in 1815 or 1816 as he states in his first two narratives, he was closer to 81. Necropolis Cemetery records indicate that Annie (Brown) Jefferson was the owner of his cemetery plot, and it is my belief that Annie (who lived to be 101 and died in 1971) returned to Toronto to put up a new headstone sometime after her father's death; the gravestone looks too fresh to have been in place since 1897 (see Figure 5.9). This is a small and modest stone with a simple engraving: "Husband" and "In Memory of Henry Brown, Died June 15, 1897."

Brown's death certificate from Necropolis lists his cause of death as "locomotor ataxia," an inability to control bodily movements which is often a symptom of tabes dorsalis, caused by late-stage syphilis. On the death certificate from Necropolis Cemetery, the following information is also given: "Name: Brown, Henry; Age: 67; Where Born: United States; Where Died: Toronto; When Died: 15 June 1897; What Disease: Locomotor Ataxia; Where Interred: J-15, Adult Single Grave; Ground Property of: Mrs. Annie Jefferson; Medical Attendant: R. J. Coatsworth; Officiating Minister [Blank]; Undertaker: B. D. Humphrey." In the nineteenth century there was no cure for syphilis, and the disease's last stages were marked by extreme mental and physical decline. I therefore doubt the veracity of this cause of death because Brown appears to have continued to support himself in some fashion in Toronto right up until his death. "Locomotor ataxia" may have been a catchall phrase applied to numerous older men who had some degree of difficulty with physical movement, which could have been caused by a variety of ailments not known in the nineteenth century, such as multiple sclerosis or Parkinson's disease.

Figure 5.9. Box Brown Burial Stone in Necropolis Cemetery, Toronto. Photograph © Peter Linehan, 2015. Used with permission.

Yet as I examine in the next chapter, Brown's performance legacy continued to grow after he died. Why? Even though very little was known about his escape (beyond the box itself) and his life afterward, many contemporary artists, writers, poets, and musicians have continued to be drawn to him, and we might briefly ponder this before moving on. Brown was bound to his box but also (always) escaping it. The enslaved man who was considered property materialized himself as a "thing" (a box) and was ever defined by this item. But the box perhaps became a space of magical transformation for him, as he used it to gain power over the trauma of his enslavement through representation and to multiply (via this symbol) his performative incarnations so that he could never be exactly captured by his audience's gaze. I have elsewhere hypothesized that Brown's box may have been repurposed (in some symbolic way, if not an actual one) as part of his magic act, and become the box that a magician disappears into, only to reappear elsewhere in the room. In other words, the box may come to represent a space not only of stasis and place, but also of displacement and transfiguration.[77] Perhaps the protean box is the metaphor *and* the thing that draws us to Brown. It is a dark and fathomless space, but a fertile one for the imagination, and for the reimagining of trauma and horror, but also modes of empowerment. Is Brown, like that cat in Schrödinger's famous box, both alive and dead, in the box and not in the box? In Schrödinger's thought experiment, a cat is in a box with a radioactive isotype that might cause its death, but because the box is unopened, we do not know the cat's fate, so it exists as *both* alive and dead at once, a state that is known as superimposition. Brown is overlaid across several worlds: in one space he is a thing, in another a man; in one location he is living, in another dead; in one temporality he is the past, and in another he is the present and future. He *produces* for a viewer these multiple geographies and temporalities via the protean object of the box itself.

What is clear is that Brown—a formerly enslaved man who started with nothing but his mind, his box, and a story—was able to craft a performative life for himself in which he was an adventurer, magician, actor, ventriloquist, musician, concert conductor, healer, professor, doctor, and panoramatist. Black powerlessness is still today a facet of African American existence, but Brown took power over his history, turning it into a spectacle in which he played many roles, but was always the leading man, the hero. Brown's life is a fascinating chronicle of a man who was both demarcated by the box (and its "thingness") and continually redefining and unmaking it. So, he lives on in art that is as mysterious and intriguing as the man himself.

Box Brown and his fantastic escape were remembered briefly throughout the late nineteenth and early twentieth century. Mentions of his story in newspapers and books, especially during Black History Month, kept it alive in cultural

memory in England and the US, but never fleshed it out.[78] His story was not fleshed out in the first half of the twentieth century, when much scholarly recovery work was done, perhaps because the lives of heroes such as Frederick Douglass, Sojourner Truth, and Harriet Tubman were considered more important as early icons of resistance for the civil rights struggle. Yet in a surprising twist of fate—one that Box Brown would himself certainly appreciate—he has become something of a fixture in late twentieth-century and early twenty-first-century art, literature, performance work, film, and a variety of other media, as I show in the next two chapters of this book and in the Appendix. Perhaps, on the one hand, it is the mystery of Brown's story that fascinates artists today; the fragmentary quality of what has been known about Brown begs for elaboration but also re-creation and remaking. But second, Brown fits a modern and postmodern era in which identity (both in real life and on the internet) is always being performed, always being produced and re-produced. He is a hero for our era because of the plasticity of the forms he used and his innovative performative repertoire, his constant re-creation of self, and the very mystery that lies at the heart of a story: what kind of imaginative leap did it take to literalize the logic of the enslaver—that you were a thing—ship yourself as "dry goods" to freedom in a postal crate, and then make this very box your own unique performance stage? The "real" Box Brown remains something of a mystery, but his story is nonetheless enthralling for its elusive quality; in fact, this may be precisely why it appeals to artists today. Brown's story gives contemporary artists a chance to play in the archive of the past and create new and innovative designs that have implications for our own era and for the future, as I elaborate in the next chapters.

Epilogue: Annie, Jane, Edward, and Others of the Brown Family Line

Brown's family line continues today, although it is in some ways as mysterious as the man himself. As mentioned, Edward married Jane Price and appeared to be living near Boston in 1894, but I have been unable to trace his record any further, even with the help of a trained genealogist.[79] Annie's story is clearer, however. She married Charles William Jefferson (1865–1953) in 1890.[80] Charles William Jefferson was twenty-four years old, and Annie Amelia Helena Brown was nineteen, and their union lasted sixty-three years and eight months. Jane Brown lived with the couple until her death—at age ninety—on June 6, 1924.[81]

Annie (Brown) Jefferson and Charles Jefferson lived in Kane, PA, all their lives (after the marriage) and had three children: Charles Henry Jefferson (born in late 1890), Manley Lawrence Jefferson (born 1892), and Gertrude Mae (May) Jefferson

(also known as Mae G. Jefferson, born in 1899). Gertrude Mae Jefferson appears to have been an artist; census reports list her occupation as musician in the theater industry and a piano player;[82] she may have carried on her grandfather's and mother's performance legacy. Gertrude Mae Jefferson married Wilson Oliver Holly on April 20, 1915 (when she was only sixteen), a marriage that ended in divorce in 1923.[83] On April 15, 1929, she married for a second time (to Charles Maxfield) but died (with no children) just one month later on May 31, 1929.[84] Manley Lawrence Jefferson married Bertha W. Wright, fought in both World War I and II, worked as a barber, lived in Ohio and New York, and died in September 1963.[85]

Of Annie's three children, it appears that *only* Charles Henry Jefferson (who married Hazel Brooks in 1911 in New York) had children—but the couple had seven children (in other words, Box Brown had at least seven great-grandchildren from Annie Brown Jefferson's son).[86] Brown has living relatives, but to date they wish to remain anonymous. As to Brown's first wife, Nancy, and the couple's four children, even the talented genealogist Kenyatta Berry has been unable to trace this branch of the family. Perhaps in the future genetic research could be used to locate some members from this line.

Annie Box Brown Jefferson—who lived to be 101—outlived all her children except for Charles. Her obituary gives testament to her vital and glowing life. When she died, Annie had been residing in Buffalo, NY, with her son Charles Henry Jefferson, and she left behind one son, nine grandchildren, thirteen great-grandchildren, and eight great-great-grandchildren. While the obituary is incorrect in stating that she came to reside in Kane when she was 12 years of age, it is correct in many other details.[87]

I turn in the next two chapters to the artistic legacy of Box Brown, as I watch him being resurrected in contemporary memorials, performance work, poetry, and children's books that remake the spectacle of his miraculous boxing and unboxing, of the womb-tomb that was the platform for his revivification and resurgence from the living death of slavery. In true revenant fashion, Box Brown returns in the imagination of contemporary artists, as they gesture toward his mysterious, spectral agency and his status as an icon of the enslaved persona who lives in the wake of the cataclysmic event of slavery yet continually recreates his spectacular life and history.

The Absent Presence

Henry Box Brown in Contemporary Museums, Memorials, and Visual Art

A visitor to the National Great Blacks in Wax Museum in Baltimore, MD, will be greeted by a host of historical figures frozen not only in time but also in the amber-like substance of the wax. Wax figures appear grotesque because of the unbending nature of the art form, but the models here (some of which are in wax and some of which are store mannequins) are particularly macabre: a man on a slave ship with a metal tube pushed down his esophagus so that his captors can force-feed him to prevent suicide; a lynched pregnant woman with her bloody child lying on the ground below her; a tortured man whose genitals have been torn off prior to his hanging by the KKK and are now being eaten by two cats. There are also the historical figures in wax that one would expect—Harriet Tubman, Sojourner Truth, Frederick Douglass, Martin Luther King, Jr., Malcolm X, and more recently Barack and Michelle Obama, as well as John Lewis. But even the contemporary individuals seem immobile, more dead than alive. An explicit purpose of the museum (according to its founding directors) is to frighten young visitors into an understanding of the sacrifices prior generations had undergone to secure their present liberty (as such). So, the overall atmosphere of the museum is one of horror at the maiming and torture, respect for the ancestors, and a lesson on what not to do. The lynching of a pregnant Mary Turner (with her child ripped out of her uterus first) and other lynchings are followed by the "Boulevard of Broken Dreams" where figures of contemporary Black youth shoot drugs and (presumably) destroy their lives. The message is clear: "Now we lynch ourselves" (see Figure 6.1).

Figure 6.1. "Now We Lynch Ourselves," National Great Blacks in Wax Museum, Baltimore. Photograph by author, © 2018. Also see color inset, Plate 3.

A handout describing the museum that is given to visitors is even clearer in its delineation of the relationships between past knowledge and present action: "A message from the ancestors. . . . We did not struggle to keep our minds from being shackled, only to have you turn away from learning and the wise ways of the elders. We did not endure bondage for you to become a slave to drugs and alcohol. We did not die by the millions for you to kill each other by the thousands. . . . We withstood their slaughterhouse slave ships, their seasoning and breaking for you to walk in unity and live with dignity." The past informs the present in a very explicit manner, and the message is didactic and transparent.[1]

Tucked away among all the stasis of these immobile forms from the past, however, is an odd figure, the only one that moves at all: an imaginative duplication of Henry Box Brown coming out of his box (see Figure 6.2). Although Brown wears a straw hat (an unlikely accoutrement in a box), he seems more animated than the other wax figures—he is rising out of the box, his hands open as if to grasp his freedom, and his eyes are alive; they seem to follow you as you navigate the tight spaces of the room. There is also something humorous about his figure—he seems almost ready to break into a laugh. The most astonishing aspect of Brown's wax form, however, is that his right hand, motorized by unseen wires, waves *ever so slightly* as visitors pass. The museum is mainly static and humorless, but he is one of the few figures imbued not only with vivacity but also with actual movement and humor. There is even a long-standing and

oft-repeated story that for some period Brown's wax form *popped up out of the box*, or rose ethereally from it, but that this scared too many viewers and had to be curtailed.[2] This story appears to be untrue, according to the museum's current directors, but it has been told over the years so frequently that many Baltimore schoolchildren who visited the museum claim they saw this. So, the story of Brown "popping up" out of his box becomes part of his legend, and yet another telling example of how the man's larger-than-life persona grew long after his physical death.

This chapter examines Box Brown's presence in contemporary memorials and museums, and in the visual art of Pat Ward Williams, Glenn Ligon, and Wilmer Wilson IV. Yet it is always attentive to what I call "boxology"—a combination of mythology and mixology surrounding the magical box. How do artists in the present create new versions of his story from the slim facts they do know: that he was a man who boxed himself up, shipped himself to freedom, and survived? I analyze methods contemporary boxologists employ to sample and remix his legacy into formats that speak to present-day concerns but also reflect on the historical past and what can and cannot be known; these artists also consider how our interpretations of this past impel the freedoms we can imagine into the future. In other words, many of these boxologists *watch* Brown as he moves through time and space, not only physically but also imaginatively.

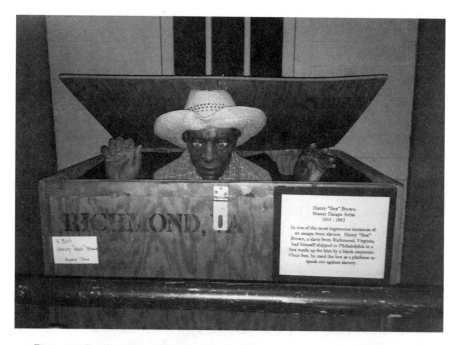

Figure 6.2. Box Brown coming out of his box. National Great Blacks in Wax Museum, Baltimore. Photograph by author, © 2018. Also see color inset, Plate 4.

Alan Rice argues that memorials and museum exhibits need to engage with complexities of history and perform a certain kind of memory work that turns memory into a project (rather than a product) or perhaps even a *process*. At their most effective, memorials "speak to their future contexts as much as to the past they commemorate, to a future-oriented responsibility, rather than a guilt-charged retrieval of the past." Rice develops the idea of "guerilla memorialization" not only with respect to Brown (see Chapter 2) but also in his analysis of contemporary memorials and museum exhibits about slavery and the slave trade. Guerilla memorials resist cultural amnesia about these subjects by creating "new imaginative forms" that summon "the ghosts of Black presence" and reveal the gap between past events and the remembrance of these events.[3] Each of the three visual artists I discuss here creates memorials that counter national amnesia about the history of slavery and bring the ghost of Box Brown's body into the present-tense moment. Museums and memorials sometimes materialize a configuration of a past that is understood as past, over and done. Yet the larger question raised by more provocative memorials is how to memorialize a past that is still ongoing and unfolding.[4]

I am particularly interested in this chapter in representations of Box Brown's body, because the body of a Black person is often represented as a space of captivity, and in many memorials and museums about the slave trade such bodies seem frozen in time and in the past, like the bodies at the Great Blacks in Wax Museum. In Rice's terms these bodies therefore may speak to the past rather than to a future-oriented responsibility, and a central struggle of many memorials and artworks about slavery is bringing this pastness into the present. As Dionne Brand writes, it is as "if those leaping bodies, those prostrate bodies, those bodies made to dance and then to work, those bodies curling under the singing of whips, those bodies cursed, those bodies valued, those bodies remain curved in attitudes. They remain fixed in the ether of history."[5] Some boxologists leave the body of Box Brown fixed in the ether of history, while others struggle to liberate him from his box, from captivity, and from history. They also struggle to integrate the viewer into this body and identity. If contemporary individuals enter the body of Box Brown, will they find a mode of liberation, a mode of further confinement, or both?

This chapter contends that boxologists generally move back and forth between two modes of watching and representation: ecstatic-ekphrastic and faithful-ekphrastic. As discussed in other chapters, the visual presence of African Americans has always been shaped by competing logics: first, the visual surveillance and control of African American bodies within both antislavery discourse and the minstrel show; and second, a more resistant mode of "looking back" or counter-visuality found within *some* illustrations, photography,

panoramas, and visual modes of performance (such as plays). And yet, even within resistant forms created by African American artists in the nineteenth century, there is often a semblance of reality engrained in the visual formations—there may be some symbolic play via objects (for example) within the photographs of Frederick Douglass and Sojourner Truth, and blurring of their images via visual static, yet the image remains something the audience accepts as a respectful replication of the person, if not the person himself or herself. When it comes to Box Brown, however, perhaps because his life is so hidden, and there are so few extant images of him, some artists *play* freely with his imagining and his legacy, inventing new histories for him that are flexible, ambiguous, and transformative. This mode I call ecstatic-ekphrastic. The word ekphrastic refers to a vivid depiction of a picture within another work of art (such as a poem or song), and it comes from Greek words meaning to "out" and "speak." Ecstatic-ekphrastic modes of boxology meditate on the famous picture of Brown coming up out of his box (see Figure I.1) in ways that are more creative than factual.

I use "ecstatic" not in the sense of joyful, but in an older sense of ecstasy invoking an experience of mystic transcendence; in their new myth of Box Brown, some of these artists leap over the linear or factual events of Brown's life. A faithful-ekphrastic representative mode of meditation on Brown, on the other hand, tries to be true to the known facts to some degree, imbuing them with new meaning within a contemporary historical context. But with Brown, it is almost impossible to stay within a faithful-ekphrastic mode. For instance, even reshaping the materials of Brown's well-known postal crate (from wood to steel) can have a profound impact on how we understand the history being enacted. The division between faithful and ecstatic modes of representation is not fixed, and even realistic works of art can slip over into ecstatic imagining of Brown's life and legacy. Overall, I am interested in this chapter in how artists (some with care, and some with abandon) cross back and forth between ecstatic (nonrealistic) and faithful representations of Brown's life, in their attempt not to capture the man or his legacy, but to utilize it for a new generation of viewers and to partially release the Black body from the ether of history while still delineating what it means to live in the wake of slavery, and in the unfinished project of emancipation.

"I Rose a Free Man": Memorialization and the Limits of Ecstatic History

For most of history, memorials were meant to be representative and realistic; they were considered public art commemorating the past and giving inspiration to future generations. Public memorials that do not follow this paradigm were

subject to additional scrutiny and various modes of revision or censorship, as was evident in Maya Lin's controversial 1982 nonrepresentational black granite wall meant to remember the veterans of the war in Vietnam, called by some "a monument to defeat" and a "black gash of shame."[6] More recently, memorials such as the 9/11 Memorial & Museum (opened in 2011) have been abstract and minimalistic without attracting too much controversy.

Still, when it comes to figures in African American history—such as Martin Luther King, Jr., who was honored in 2011 in the *Stone of Hope* monument in Washington, DC—or the history of slavery—dealt with extensively in the National Museum of African American History and Culture, opened in 2016— realism seems to be the mode of choice, and memorials to Box Brown mainly fit this paradigm. The first of these memorials is a simple signpost—known as a "historical highway marker"—placed on Route 33 in Cuckoo, a small unincorporated community in Louisa County, VA, near the plantation on which Brown was born (known as the Hermitage) and near the First African Baptist in Richmond where he worshipped and sang in the choir, an activity that was fundamental to his (eventual) freedom (see Figure 6.3).

As far as the details of Brown's life go, the historical marker is mainly accurate. However, his life seems reduced and encapsulated by the brief narrative. For example, the sentence that "Brown moved to Great Britain where he toured as an entertainer" ignores the fact that he was also (for the first year in England) an antislavery activist and that he continued to lecture on slavery for most of his time there, even though there would appear to be space on the sign for additional wording. Of course, this is the nature of historical markers; they flatten the meaning of a place or event. But we can contrast this to more evocative symbols of enslavement, such as the Toni Morrison Society's homage to the Underground Railroad in the form of simple—yet also somewhat mysterious—benches placed by the side of the road, an idea taken from Morrison's remarks in a 1989 interview: "There is no place you or I can go, to think about or not think about, to summon the presences of, or recollect the absences of slaves. . . . There is no suitable memorial, or plaque, or wreath, or wall, or park, or skyscraper lobby. There's no 300-foot tower, there's no small bench by the road. There is not even a tree scored, an initial that I can visit or you can visit in Charleston or Savannah or New York or Providence or better still on the banks of the Mississippi."[7] A bench is a space for reflection, rest, or pause, but it also acknowledges the absent presences of African American history—what is disremembered and unaccounted for, as well as factually "known" (see Figure 6.4).

These are iron benches created with vertical slats, with spaces between them; these spaces representationally mark what is unknown, as well as the bare linear facts of the dominant narrative of African American history. Yet an undulating,

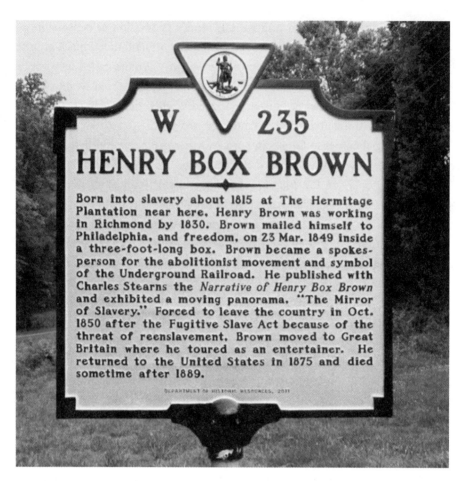

Figure 6.3. Historical marker on Rt. 33 in Cuckoo, VA. Erected in 2012. Photograph by author, © 2021.

serpentine line weaves through the center of the back of the bench, perhaps representing the spirit that transcends this forgotten history, that (like a backbone) somehow holds people together. These benches honor specific individuals who fought to end slavery (whether in the US or elsewhere), and as such they are memorials both to people as well as to a more general erasure or perhaps amnesia about the worldwide history of slavery. Perhaps a simple box by the side of the road would be a better homage to Brown than the reductive historical marker on Route 33 in Cuckoo, at least in notating what is *not known* about Brown's life—the facts the historical record fails to disclose.

The point I am making is that memorials can transcend the limits of "factual" representation and gesture toward the unknown history when they are thoughtfully designed. The exhibit on Brown at the National Underground Railroad Freedom Center in Cincinnati, OH (opened in 2004), would seem to be one

Figure 6.4. Bench by the side of the road, Oberlin, OH. Photograph by Hilary Solan. In tribute to memory of Louis Delgrès—insurgent, revolutionary, and freedom fighter in Guadeloupe, https://www.tonimorrisonsociety.org/bench.html. Used with permission.

place for such a thoughtful meditation on the past, and yet the museum is confusing and chaotic, crammed with facts and artifacts that seem to want to give exhaustive *information* about the Underground Railroad while eliding its true emotional or psychic legacy. The Box Brown exhibit is difficult to find and confusing in layout. A replica of Box Brown stands in front of his box in a suit of some sort, with a label affixed to his body (see Figure 6.5). Brown looks like a disheveled mannequin, wearing a shirt that is half blue and half white, and the exhibit overall feels cluttered—there are several boxes scattered around and educational material often lies on top of them. The focus here seems to be on a factual (or even artifactual) presentation of Brown, but much is lost in this imaging of him. I am reminded of James Young's critique of archives and museums—that they can disable what he calls "memory work": a creative relationship with the past that encourages us to rethink it and meditate on it. Some museums, Young argues, document the past through claims of material evidence and proof but give us little sense of what this past meant; in this way the archivist or museum curator may "confuse proof that something existed with proof that it existed in a particular way."[8] The physical Box Brown exhibit seems

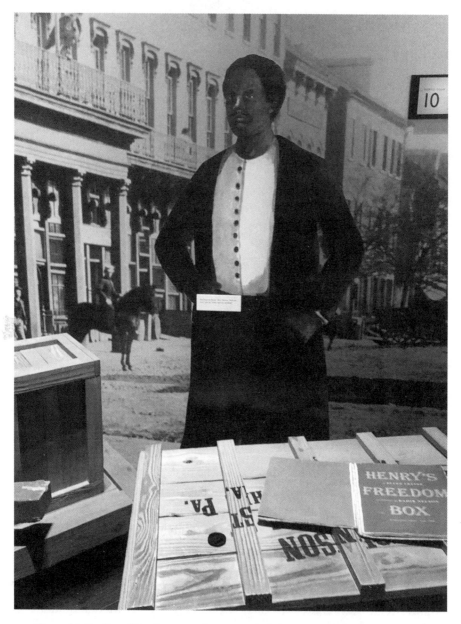

Figure 6.5. Replica of Box Brown at the National Underground Railroad Museum in Cincinnati. Photograph by author, © 2020. Also see color inset, Plate 5.

to show he *existed* but gives few hints of what his life signified in the past or could signify to viewers now.

On a more positive note, the narrative description of Brown's history on the placard near his box at the Underground Railroad Freedom Center has some noteworthy features, including a focus on Brown's ingenuity in devising and executing the scheme for his escape, and his standing up to shake hands with

the members of the Philadelphia Vigilance Committee when he is unboxed. The placard also mentions his career speaking "all over the United States and Europe about his escape." The placard is titled "From Richmond to Philadelphia" and it reads as follows:

> Brown, enslaved in Richmond, Va., convinced Samuel A. Smith to nail a box shut around him, then wrap five hickory hoops around the box and ship it to a member of the Vigilance Committee in Philadelphia. The box was 2 feet 8 inches wide, 2 feet deep and 3 feet long—just the size of this crate. At 5 feet 10 inches and more than 200 pounds, Brown had very little room. Even though the box was marked "This side up with care," he spent some of the time upside down. He couldn't shift his position because that might attract attention. Brown took only a little water (to drink and splash on his face if he got too warm) and some biscuits. He had made some tiny holes in the box so he could breathe. In all, the trip took 27 loooong hours. When the box finally arrived at the Philadelphia Anti-Slavery office, four people locked the door behind them, knocked on the box, and opened it up. Henry stood up and reached out to shake their hands. He was a free man! Henry "Box" Brown went on to speak all over the United States and Europe about his escape. Samuel A. Smith tried to help another slave escape in the same way but was caught and sent to prison in Richmond for more than seven years.

Perhaps because the museum primarily has in mind an audience of children, there is a pedantic tone to its narration: "In all, the trip took 27 loooong hours." It also mentions the white man who helped Brown—Samuel A. Smith—but not the Black man (James C. A. Smith) who was instrumental in his escape. Even more strangely, it ends with Samuel A. Smith's being sent "to prison in Richmond for more than seven years," making the focus white (rather than Black) heroism. This is a factual account of Brown's history, but one that subtly shifts the focus *away from* African American courageousness.

Some public memorials seem content to live with the ambiguity and mystery surrounding Brown. Is Brown in his box or outside of it? Has he escaped or is he still encapsulated within the material artifact? Like Schrödinger's cat, Brown may be alive and dead at the same moment, because we just do not know *where* he is—in the box or out. In 2001 a metal replica of Brown's box was installed at Canal Walk in downtown Richmond, in what is now called Box Brown Plaza. It would be easy to miss this installation, as it is tucked under a bridge and seems nondescript (see Figure 6.6). The memorial is realistic in some ways; it contains a paving stone, for example, that states: "In a wooden crate similar to this one,

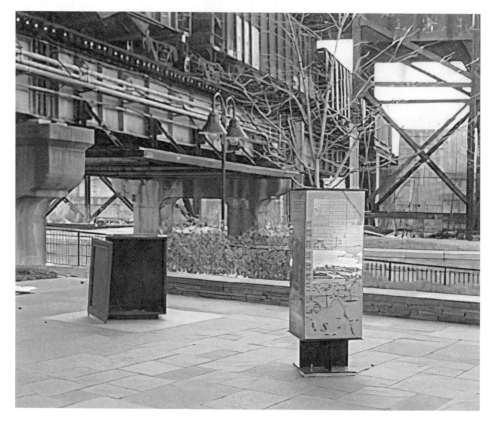

Figure 6.6. Metal replica of the postal crate that Henry Box Brown used to escape, Canal Walk in downtown Richmond (Box Brown Plaza). Photograph by author, © 2021. Also see color inset, Plate 6.

Henry Brown, Richmond tobacco worker, made the journey from slavery to freedom in 1849." Yet the installation captures some of the opacity of Brown's life and story. The box stands open, and Brown does not appear to be in it when it is viewed from far away.

When we approach the box, we see that there is a tracing of his body in it. Is Brown still in the box? Or has his body merely left some sort of imprint, whether real, symbolic, or imagined? The tracing of Brown's body within the box is meant to invite the viewer to participate in the exhibit—to place their hands on this outline, to touch it, or even (as many visitors have done) to try to fit themselves into Brown's box (see Figure 6.7). By tracing Brown's body in the empty space of the box, the exhibit encourages a viewer to enter the reality that Brown lived in for a time, to share his voyage. The exhibit therefore aims to create intersubjectivity—a sharing of imaginative and physical space between the viewer and the viewed, the object of the artwork and the subject who looks at it. The huddled figure with his head down and his knees clasped is also reminiscent of

Figure 6.7. Outline of Brown's body within the metal replica of his postal crate. Canal Walk in downtown Richmond (Box Brown Plaza). Photograph by author, © 2021.

bodies of enslaved people during the Middle Passage, depicted in multiple art forms; the viewer may be invited to share not only the space of Brown's story, but the lengthier chronicle of the Middle Passage in which, as Morrison notes in *Beloved*, somebody is always dying but these bodies cannot be called or recalled because "nobody knew [their] name."[9] The metal box embodies not only Brown's story, but the longer chronicle of transatlantic slavery.

The installation also has slightly rewritten quotes from Brown's 1849 and 1851 narratives placed strategically on different sides of the box. The various sides read:

> The idea flashed across my mind of shutting myself up in a box & getting myself conveyed to a free state.
> I laid me down in my darkened home of three feet deep by two
> My friends managed to break open the box & then came my resurrection from the grave of slavery
> I rose a free man.

These quotations encourage viewers to piece together Brown's history, but this requires some work on the part of the viewer to walk around the box and re-create the story. The quotations could also be read in different orders, depending on whether a viewer walks around the box clockwise or counterclockwise. As the viewer moves in space he or she also moves in time, back to the past of Brown's escape and forward to the contemporary moment, where we might imagine him rising "a free man" in a "free state."

There is also a placard that mentions Samuel Smith, yet (unlike the sign in the Underground Railroad Freedom Center) ends with Brown's heroism and his words. The sign has a variety of different fonts and typefaces:

> Samuel Smith was arrested after attempting to box up two more fugitives from slavery.
>
> "Buoyed up by the prospect of **freedom** . . . I was willing to **dare** even death itself."
> HENRY "BOX" BROWN

The word "freedom" is huge and bold, and the word "dare" is larger than many other words. The memorial foregrounds Brown's willingness to risk even death to obtain freedom. The monument here perhaps gestures to those who never escaped, or who tried to escape but failed. It also leaves Brown's

accomplishment a bit mysterious and open-ended, focusing instead on the *daring* act of escape.

Overall, the Canal Walk homage to Brown is evocative and fosters intersubjectivity—a sharing of emotional states—with the viewer. Brown's story is mobile and moves with the viewers as they explore the exhibit. The absent presence of Brown is figured, as he remains in the box, but also outside of it, in his words and narrative. Most importantly, the viewer's circumnavigation of Brown's box means that his attainment of freedom is emphasized as an ongoing process or story rather than a finite or finished historical fact.

Always in the Box: Pat Ward Williams and the Impossibility of Escape

Unlike the creators of memorials and museums, who are often held to some degree of truthfulness, visual artists have a higher degree of creative license to play with the materials of Brown's life and story. At first glance, however, Pat Ward Williams's homage to Brown would seem to be a realistic treatment of the past: the installation contains a transparent box with a figure of a man trapped inside (see Figure 6.8). From 1987, the installation *32 Hours in a Box . . . Still Counting* is composed of four wood pillars, cyanotype prints in two window frames, photocopies, and narrative. Like Brown's own art, it is three-dimensional and multimedia (composed of text and images, as well as material items such as columns). The figure of a man huddles with his head down and his hands supporting him; he is in a fetal position, and although the panes of glass are window-like he does not look out. The four sides of the box contain snippets of Brown's story, and in this sense the sculpture is realistic and representational.

However, there are aspects of this installation that can be understood as forms of what Alan Rice has called guerilla memorialization, because they are dialogical, interventionist, and create startling juxtapositions between past and present.[10] For example, the four columns around the box are more abstract than the box itself, and they hold pictures that bear no direct connection to Brown's story: a violin, a doll's eye, a skyscraper, and a rose. Moreover, the columns are roped together with barbed wire, and there is narrative text on the ground about contemporary instances of violence against African Americans. Huey Copeland writes that Williams's homage to Brown collapses the historical frames that constitute slavery to create a generative metaphor that "engages the present through recourse to an irrefutably tragic past."[11] For Copeland, Williams weaves Brown and his latter-day incarnation (the man in the box) into a narrative in

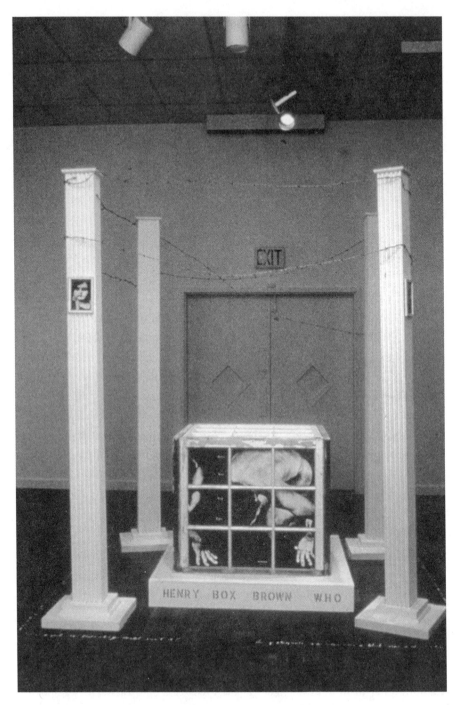

Figure 6.8. Pat Ward Williams, *32 Hours in a Box . . . Still Counting*, 1987. Cyanotype prints in window frame, photocopies, and wood pillars. © Artist. Collection of Peter Norton. Used with permission.

which fugitivity illustrates only the promise of future subjugation. The date of the piece parallels the height of the mass incarceration of Black men in the prison industrial complex, so it speaks to the "degradation of black life and the production of black masculinity as abject, dishonored, and inherently criminal."[12] Yet beyond the (apparently) evident fact that there seems to be no escape from captivity—either for Brown or for African Americans today—what does Williams's exhibit signify?

As Daphne Brooks has mentioned, in many of his shows Brown demonstrated that "excruciating confinement could be recycled into a symbol of corporeal subversion,"[13] and as we will see with Ligon and Wilson, in contemporary artistic exhibits about Brown there often is a great deal of play about where Brown's body is: in his box, or outside it; everywhere or nowhere? Williams's rendering of Brown certainly speaks more to a contemporary context of continual fugitivity and of neo-slavery, a context in which Black bodies are never free and thus can be read as demonstrating the unending nature of slavery and its long afterlife. Sharpe argues that as "we go about wake work, we must think through containment, regulation, punishment, capture, and captivity and the ways the manifold representations of blackness become the symbol, par excellence, for the less-than-human being condemned to death. These are questions of temporality, the *longue durée*, the residence and hold time of the wake."[14] However, I read Williams's work not only as a dramatization that enslavement is ongoing as a long durée but also as a type of "running up" against fugitivity or rupturing of it. I therefore want to look at the places within the exhibit where the man does slip free from his box, if only momentarily.

First, who is in the box? Is this Brown, or someone else? In fact, nothing real is in the box. A simulacrum of Brown is in the box, but even this is not real—it is a photographed figure, tugged into a fetal position, and the race of this figure is not clear. Of course, Williams means to comment on the ongoing incarceration/imprisonment of African Americans (and especially of African American men) via this exhibit, but the cyanotype printing process she employs creates the image of a body that is lightly tinged with blue, as if to suggest its "blue blood." Perhaps Williams means for the viewer to intersubjectively enter the body in the box, to consider becoming this body in some way. Rice argues that "Williams's installation interrupts the playful, joyous resurrection of Brown that the prints had depicted to take us back to Brown en-route and endangered, but also to take us forward to the problematics of a limited freedom because of the operations of racism and discrimination both for Brown and for the black men and women that will follow him."[15] However, ambiguity about whether this is really the body of Brown (and not a representation of another body, anybody, or any/body) is evident in a blurring of what body is being viewed.

Intersubjectivity is also created by a single sentence that wraps around the box, with a single line on each of its sides. As with the Richmond Canal Walk exhibit, this forces the viewer to circumnavigate the exhibit, and to walk not only in space but also in time:

Henry Box Brown who
escaped slavery en
closed in a box 3
feet wide and 2 long

The most powerful aspect of the phrases written on each side of the box is the enjambment of the second and third lines, on the second and third sides of the box ("en" and "closed" are broken apart). The viewer must hold the "en" in his/her mind and get to "closed." More symbolically, the viewer would stop and pause after "en" in a degree of puzzlement: what does "escaped slavery en" mean? Halfway through the stanzas, there is a pause for reflection, puzzlement, or confusion that perhaps is meant to put the viewer into a state of uncertainty as she or he ponders Brown's story. The sentence ends with the phrase "2 long," alluding to the long and painful history of white violence against Black bodies, which has gone on too long. The sentence describing Brown's journey by box connects to others that Williams has inscribed on the floor that narrate contemporary instances of racism and discrimination, connecting Brown's voyage to the 1987 moment. A slippage is encouraged between past and present, and the exhibit fosters the creation of a radical temporal instant that is ongoing between slavery of the past and present; "all of it is now," as one of Morrison's characters says in *Beloved*.[16]

The columns and the objects they contain also enable connection between past and present and a radical temporal framing of the exhibit. Some of these objects are timeless—the rose, for example (roses have been grown for over five thousand years). Others are harder to pin down—such as the image of a violin or a doll. Yet others are wholly contemporary—such as the picture of a skyscraper. Through incorporating modern items such as these, Williams encourages a viewer not to separate his or her own moment from Brown's boxing story. We are also meant to consider the "advancement" as such of society via the four pillars, which surely evoke the "pillars of progress" of Western civilization. Yet they also resemble a house without a roof, one which might allow the spirit of Brown (if not his actual form) to escape upward into the heavens. The roofless columns might be a moment of ecstatic release, perhaps utopian in impulse, that comes from meditation on this picturing of Brown. As discussed in the previous chapter, Audre Lorde has famously stated that the master's tools will never

dismantle the master's house; discrimination against another person cannot be used to end oppression. The master's house must be disassembled, and Williams strives to illustrate the necessity of keeping the roof open, of keeping alive the idea of always pushing up against the limits of the master's house. In discussing this work, Williams states that "As black people we have to find different solutions to overcome the obstacles that are in our lives politically and also personally. This is a piece about Henry Box Brown and problem solving."[17] It is an artwork, in other words, about the creative and powerful ways that Black people engage in "*problem solving.*"

The open columns also create a space for the viewer to walk around the box. The box is in our world, now, and it is up to us to decide what to do with it. Should we ignore the box, become part of the story, or look upward to the space in which Brown might find his release? Jacques Derrida has written that the historical archive is not "a concept dealing with the past that might already be at our disposal" but rather "a question of the future itself, the question of a response, of a promise and of a responsibility for tomorrow."[18] Through intersubjectivity and keeping the exhibit open to the sky, Williams asks that viewers engage in problem solving, as we wander around the exhibit, consider our response to the material archive of the past, and ponder our responsibility to the possible futures into which we all might walk.

Glenn Ligon and Schrödinger's Cat

I turn now to Glenn Ligon's recreation of Box Brown from 1993, titled *To Disembark* (see Figure 6.9).[19] Literally, this exhibit is ekphrastic as it meditates on a picture; Ligon notes in an interview that he learned of Brown's story through the nineteenth-century lithograph of Brown emerging from his crate.[20] In an analysis of this exhibit, Hartman writes, "The wooden boxes secrete the escaped slave and render him invisible. The body disappears into the darkness of the crate."[21] Yet because the boxes are closed, we do not know if Brown is in them or outside of them, dead or alive. Moreover, it is unclear if these boxes represent the past-tense moment of Brown's journey-by-box, the present-tense moment of stasis within the box, or a future-tense (perhaps ecstatic) moment in which he has exited the box.

Like Schrödinger's famous thought experiment about an imaginary cat—who (as previously mentioned) is in a box with a radioactive isotype that might decay and cause the cat's death—because the boxes are closed we do not know if Brown is dead in the box (from suffocation or some other cause) or has escaped it and is alive. Schrödinger's experiment can be interpreted to mean that while

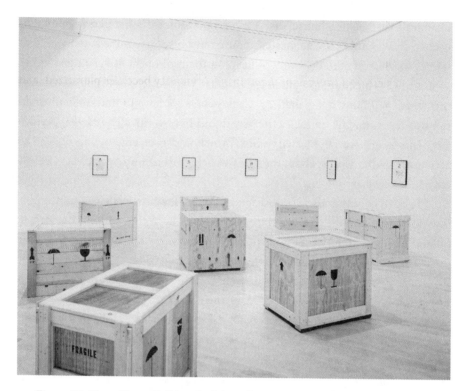

Figure 6.9. Glenn Ligon, *To Disembark* (installation view), 1993–1994. Works depicted: *Runaways*, 1993, Suite of 10 lithographs, 16×12 inches (40.7×30.5 cm); Untitled (To Disembark), 1993, 9 wood crates with synthetic polymer, acrylic paint, and 9 audio recordings, 31.25×38.25×25.25 inches (79.38×97.16×64.14 cm). Image courtesy Hirshhorn Museum and Sculpture Garden, Smithsonian Institution, Washington, DC. Photography by Lee Stalsworth. © Glenn Ligon; Courtesy of the artist, Hauser & Wirth, New York, Regen Projects, Los Angeles, Thomas Dane Gallery, London, and Chantal Crousel, Paris.

the box is closed, the system simultaneously exists in a superimposition of the states "decayed nucleus/dead cat" and "undecayed nucleus/living cat"; the situation collapses into one of the two states only when we open the box and perform an observation. In Ligon's exhibit, Brown might be alive and dead at once in the viewer's imagination, in the box and outside of it. Superimposition is the action of placing or layering one thing over another, typically so that both are still evident, and Ligon clearly positions Brown's past meanings over a present-tense moment.

Hartman avers that Brown's escape from slavery confirms the logic of human as property, as does Ligon's exhibit about him: "Just as Henry Box Brown escaped slavery by absolutely submitting to the terms of the chattel principle . . . so, too, does Ligon's work inhabit and replicate the dominant antebellum predications of subjectivity and identity (blackness) to reveal the tenacity of their

hold on the present and to estrange them."[22] However, it is vital to note that in Ligon's exhibit there are as many as nine different boxes (or "audio sculpture crates"[23]), but all of them are closed. We do not know if Brown is in any *one of them* or has *escaped from all of them*. Brown's identity becomes pluralized, and his status as a type of trickster figure is emphasized. The ambiguity is added to by the fact that the boxes are all slightly different sizes (and larger than the actual box in which Brown escaped) and arranged in diverse positions. The boxes are a kind of second skin, but they are multiplied. Or, as Copeland puts it, the crates function as "a kind of corporeal armor, a bodily cladding that both secures the opacity of its contents and solicits the viewer's phantasmatic projections only to expose the arbitrariness of their moorings."[24] We may project ourselves into these boxes, guess at what they contain, but never really know. The impenetrability is deliberate and ongoing; Ligon forces the viewer to reside within ambiguity.

The boxes have text on them ("fragile" and "handle with care") and representations of material items, such as a wineglass (broken and whole) that represents the delicateness of the contents; this reflects the international logistics of shipping (of people and of things) that Ligon accesses in his exhibit. Ligon's boxes also allude to human trafficking today, as well as to how the image of the slave ship, the hold of the slave ship, the "box" of the Middle Passage, repeats and reverberates from the past into the present. As Christina Sharpe writes, even though the holds of the slave ships "multiply" into the present, so does "resistance to them, the survivance of them."[25] Specific to Ligon's exhibit, some boxes have an open umbrella next to a broken or whole wineglass; the umbrella is an icon indicating that the contents should be stored in a cool, dry place. However, on one box, the umbrella floats in space, devoid of context, but pointing upward, reminding us of Williams's upward-facing columns with no roof. Perhaps this is a symbol of the survival of Brown's spirit, which floats free from the box via whimsical, curious, or mythical means, even if the box remains closed.

The layering of past and present—superimposition—is also created by the music and sound that emanate from these audio crates. There is a voiceover of Ligon reading from Brown's narrative as well as songs from different eras: plantation work songs, Paul Robeson's "Didn't My Lord Deliver Daniel" (sung by the Browns in Toronto in 1887), Billie Holiday's anti-lynching song "Strange Fruit," Bob Marley's "Redemption Song," and a song by the rapper KRS-One ("Sound of da Police"). "We always talk about slavery as an event in the past, and I wanted to contemporize it someway, to bring it forward," Ligon comments; KRS-One singing "Sound of da Police" makes a connection between police control and overseers (one lyric reads: "Be a officer? You wicked overseer!").[26] Music, as we

have seen, was vital to Brown's escape and career, and the sonic landscape of Ligon's exhibit, as Christina Knight remarks, moves us from the nineteenth century into the late twentieth, asking us "to make connections between the horrors of slave ships and the other kinds of racial violence that the songs evoke."[27] Rice puts this differently when he states, "these multiple soundscapes speak to survival after the horror of slavery, promoting voiced African Atlantic figures in opposition to the silencing of commodification."[28] The music not only connects past and present but also gestures to a continuing state of unfreedom in contemporary culture for Black people as well as their political resistance via sound and music.

Fred Moten has discussed music as a revolutionary soundscape for the oppressed, and elsewhere I have discussed it as a freedom practice with politically transformative purposes. In this regard, it is particularly interesting to consider Ligon's use of Marley's "Redemption Song," which asks its listeners:

Won't you help to sing
These songs of freedom?
'Cause all I ever have
Redemption songs
Redemption songs.

In his song, Marley famously suggests that his listeners emancipate themselves from "mental slavery," as Box Brown did when he decided to escape; as Marley comments and as Brown intuited, "none but our self can free our minds." This does not mean that material freedom is only mental, but it may imply that psychic freedom (the desire to say, for example, I am not a thing, a piece of property, or subhuman, despite the enslaver's logic) sometimes is a condition for an escape from slavery or neo-slavery. Marley asks the listeners to contribute to freedom practices by helping him to sing "these songs of freedom" and these "redemption songs"—so freedom and redemption become a practice shared between people, similar to the way that Brown shared his own "freedom" song not only with James "Boxer" Smith and other abolitionists, but also, later, with the world. Ligon turns Brown's box into a dynamic "freedom song"—a way for viewers to intersubjectively emancipate themselves not only by viewing a material artifact, but also by engaging in a sonic or aural practice (hearing, if not singing, the songs). As the music floats into a listener's ears, she or he may become part of the exhibit, as we understand that freedom is an unfinished project, for Brown or for a contemporary person. The "afterlives" of slavery live on, an idea that Brown demonstrated via his box and his music when he sang "plantation songs"; but various musical freedom practices also endure.

Marley's song is also a telling inclusion because it references the Middle Passage ("Old pirates, yes, they rob I / Sold I to the merchant ships / Minutes after they took I / From the bottomless pit") as does the title of Ligon's exhibit: *To Disembark*. Ligon points to the long history of the Middle Passage and the slave trade; captive Africans on slave ships would disembark into a new world, teeming with violence and trauma. As a minimalistic artwork, however, the piece insists that viewers construct meanings for the boxes. Knight argues that this minimalism suggests a kind of "culpability" in museumgoers "not just in helping to constitute art objects through their interactions with them, but in similarly creating black artists."[29] She references how Brown was encouraged repeatedly to jump out of his box as a performance of his racial pain for the spectator. But Ligon deliberately chooses to *avoid showing* Brown jumping out of his box, or even letting us know if Brown is in the box. Minimalism is therefore an aspect of intersubjectivity because viewers may imaginatively project themselves into the boxes, or imaginatively use visuality as a type of redress if they *mentally* see Brown free from his box. The private space inside the box may offer a moment for confrontation with an "other" who both is and is not there, one whom we must imagine obtaining meaning from the artwork.

Ligon models this imaginative engagement with the racialized self of the past with another aspect of his exhibit—lithographed posters that hang on the wall. In some of these posters Ligon figures himself as a (contemporary) runaway slave, with a knapsack over his shoulder. Like Brown, Ligon has multiple personae that he manipulates via his artwork. In discussing this exhibit, Ligon states, "I was interested in the idea of invention and self-invention in autobiography as it speaks to counteracting essentialist notions of black identity. The 'one' that I am is composed of narratives that overlap, run parallel to, and often contradict one another."[30] There is no single Glenn Ligon, just as there was no one persona for Box Brown.

Ligon also directly figures himself as Box Brown, placing his own persona into the frontispiece of Brown and Stearns's 1849 narrative (see Figure 6.10). Of course, this frontispiece was present only in the 1849 edition and Brown never used it again. Perhaps he disliked it. So, it is vital that Ligon creates his own interpretation of this frontispiece through narrative text on the poster. In the poster's narrative text, there is a great deal of emphasis on eyesight; two of the sentences on the poster read: "When he [Ligon] talks . . . he faces you from a slightly different angle. He looks at you from the corner of his eyes." Slavery functioned, as discussed previously, through physical surveillance and the removal of "the right to look." However, enslaved and formerly enslaved individuals (such as those discussed in Chapter 1) did find ways to look back, to use counter-visuality and assert the right to look. Brown/Ligon does in fact look *at*

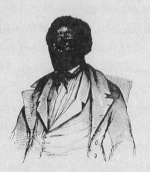

R AN AWAY, Glenn. He is black. He has very short hair and eye glasses. He has quite light skin tone (faded bronze). Not tall. No noticeable accent. Wearing a plum-colored shirt, long-sleeved, and shorts. Very casual and stylish in appearance. He is wearing a bead bracelet (stones – a mixture of black-and-white). He has big hands and fingers. When he walks his feet cross each other a little bit. When he talks, he usually has a big smile towards you, yet he faces you from a slightly different angle. He looks at you from the corner of his eyes. His voice is very calm.

Figure 6.10. Poster on the wall of the Glenn Ligon exhibit, *To Disembark* (installation view), 1993–1994. Works depicted: *Runaways*, 1993, Suite of 10 lithographs, 16 × 12 inches (40.7 × 30.5 cm); Untitled (To Disembark), 1993, 9 wood crates with synthetic polymer, acrylic paint, and 9 audio recordings, 31.25 × 38.25 × 25.25 inches (79.38 × 97.16 × 64.14 cm). Image courtesy Hirshhorn Museum and Sculpture Garden, Smithsonian Institution, Washington, DC. Photography by Lee Stalsworth. © Glenn Ligon; Courtesy of the artist, Hauser & Wirth, New York, Regen Projects, Los Angeles, Thomas Dane Gallery, London, and Chantal Crousel, Paris.

you in this lithograph, if only from the corners of his eyes. Ligon inhabits the persona of Brown here, but this persona asserts his own I-sight/site/cite, like Brown. Ligon is also a trickster, wearing multiple guises and disguises, and playing multiple roles, like Brown. His imaginative inhabiting of Brown models a way that viewers can see in Brown the legacy of the past (of enslavement proper) but also a (possible) future in which empowered visuality floats between viewer and viewed, the subject and the object, the self and the other. Ligon/Brown faces a viewer from "a slightly different angle"; the Brown incarnation here has a slightly unusual perspective of vision, but he does see (face) the viewer.

Hartman views the exhibit as suggesting that "freedom is the endlessly deferred and never-arrived-at destination." Copeland, on the other hand, sees the art exhibit more expansively, writing that in Ligon's piece "blackness, slavery, and its aftermaths are not simply agencies of oppression or marks of foreclosure, but expansive openings through which we might see the modern, the aesthetic and ourselves differently."[31] Ultimately, though, this interpretation depends in part on the viewer: do we see Brown crouched in his box, enslaved? Or do we imagine him out of it, somewhere in the world? Or are we able to see both? What is most at stake for Ligon in his Box Brown homage is that viewers carefully meditate on the past in an open-ended rather than closed manner, and that they infuse themselves via intersubjectivity into the exhibit. We do not come away with a lesson about what Box Brown meant in the past, or what he might mean to us in the present or future. Instead, we may break away from the exhibit with a type of freedom practice—a way of psychically reconstructing our worlds via an engagement with an "other," who turns out to be our own self.

The Object Looks Back via Its Own Flesh: Wilmer Wilson IV's *Henry "Box" Brown: Forever*

In a trenchant discussion of Josephine Baker's performances, Anne Anlin Cheng postulates that Baker often made models of herself in her performance, models that she wore like a second skin.[32] Perhaps the same could be said of Box Brown because, as we have seen, he had numerous personae that he wore onstage for the public, skins that Brown could peel on and off as needed. It seems apropos, then, that Wilmer Wilson IV, who staged a Box Brown performance piece in 2012, literally plays with the idea of the artist having second skins that he can remove at will. Wilson generally deploys a form of body art in which he creates different representations of himself by encasing his body in different materials, such as bandages, brown bags, or even "I voted" stickers. For his 2012 Box Brown homage, he covered his body in three different "skins" of postage stamps as he

walked through various parts of Washington, DC, asking to be mailed to freedom; at the end of each walk he peeled off his postage stamps, creating an illusion of shedding skin. Hannah McShea argues that Wilson "ends up looping the object continually between the embodied subject, the first skin, and the second."[33] In other words, the "real person" that is Wilson (the embodied subject) flows between his first skin (flesh) and his symbolic personae (the second skins), obfuscating whether we are seeing or knowing the "real" individual that is Wilson. Wilson becomes a walking mode of what Rice terms "guerilla memorialisation" that not only challenges past knowledge about Brown but also stages interventionist confrontations in which the viewer might come to question his or her ability to "know," scrutinize, or contain the racialized body being viewed.

Leaving aside the intriguing symbolism of the postage-stamp skins for a moment, I would note that like Box Brown, Wilson deliberately makes himself a spectacle via multiple media: Wilson's voyage through DC is videoed, people take pictures, and later it is documented in a book and short film.[34] Wilson's art exists (now) in material artifacts (films, pictures, and books) but also in immaterial ones: audience reactions documented via photographs but also in written encounters of the event. Perhaps, then, there is power in this objecthood, and specifically in the moments when audience members engage with Wilson and become part of his art. Although we do not always expect this, the object can look back. I want to use this idea of the "object" looking back—or even talking back—to consider the ways that Wilson incorporates Brown's legacy and demands viewers become part of the artwork, which like Brown's own artwork is liberated from one performance space and roves, moves, and circumnavigates the physical spaces of the world. In meditating quite directly on Brown's somewhat vexed legacy of never being performatively liberated from his box, Wilson (like the other artists discussed) also means to invoke neo-slavery, a state in which Black individuals today face ongoing forms of incarceration, dehumanization, and brutality, and viewers certainly recognized this connection, as we will see.

The Box Brown exhibit that Wilson created took place on April 5, 9, and 13, 2012.[35] He was followed by photographers, curators, and spectators as he entered a post office, peeled back a few stamps from his mouth, and asked to be mailed. One postal clerk responded, "I can't [mail you]. . . . Because you're a body," and Wilson then retreated to the post office lobby and removed his stamp skin, leaving it crumpled on the floor.[36] The process was repeated on three separate days with (first) four-, five-, and ten-cent stamps with arts and crafts motifs, then (on the second day) twenty-cent George Washington stamps, then finally forty-five-cent Forever stamps. The neighborhoods that Wilson walked through were deliberately chosen with the curator (Laura Roulet) and included Cleveland Park, a rich white neighborhood, the historically Black Shaw neighborhood, and the

National Mall. Each performance began with Wilson spending several hours applying postage stamps to his body (in front of an audience), then engaging with the public on his walk through DC and in post offices, and then ending with a conclusion during which he peeled off the layer of stamps, also in front of viewers.

Numerous photographs were taken of Wilson during this performance and at iconic tourist locations in DC's core on Capitol Hill. In one photograph (see Figure 6.11), Wilson faces away from the camera, which could be viewed as a form of invisibility that grants him privacy within his stamp suit, or as his enactment of the enslaver's removal of the right to look from the enslaved. But the deliberateness of this photograph's staging makes me think something else is going on. In the right part of the picture sits the Capitol building, but it is blurred, while Wilson's figure is crisp and clear. This photograph reminds me of numerous slave narratives that describe the enslaved person being held in prison in Washington, DC, while this building is being constructed or while Congress is in session.[37] Such an image invokes a particular irony: a country with a foundational principle that all men have the inalienable right to life, liberty, and the pursuit of happiness simultaneously enslaves humans in pens around the corner

Figure 6.11. Day Three: Congress. Wilmer Wilson IV, *Henry "Box" Brown: Forever* (2012); Wilson visits location in the iconic tourist corridor of Washington, DC. Used with permission of Connersmith and Wilmer Wilson IV. Also see color inset, Plate 7.

from its seat of power. But in this photograph, Wilson means to imply that his own creative ingenuity will outlast this paradox. This is day three and he wears the "Forever" stamp skin, which could imply that he will be forever encased in a box, in a skin that does not allow freedom. On the other hand, the word "forever" when applied to the title of the exhibit, implies that the Box Brown story—one of continual (ingenious) escape and performative reinvention—will go on forever and survive this unfreedoming. Wilson is here in the space of fugitivity—he is running up against captivity, engaging in a creative freedom practice, as we saw with Brown in the plays in which he acted and in much of his performance work.

However, it must be noted that Wilson engages in a kind of bodily performance art, and therein lies not an escape from fugitivity but a new embodied mode of finding continual (self) transformation and intersubjectivity. Unlike the still photo in Figure 6.11, during the actual performances Wilson's body constantly transforms itself—it is always in flux—and in this flux he finds a degree of freedom. He walks. He moves. He removes stamps. He is mainly silent, but from time to time he will speak to an audience member. The stamps flake off his body, creating a sense of a shedding skin, but also the possibility of renovation or revelation (see Figure 6.12). As the stamps flake off, his skin color seems to be revealed, which has several resonances. Perhaps we are meant to understand that underneath the spectacle lies a real person, with a real race and a real body. But how do we know this is the "real body"? If the audience had not witnessed the performance from the start (when Wilson applied the stamps), this might seem like just another covering, another layer or costume. In short, the body remains a mysterious, mutating entity within this artwork.

Transformation also occurs via audience engagement with the artwork. Because this was a public performance piece, one goal was to create intersubjectivity by engaging viewers. The postal clerks who responded to Wilson, for instance, became part of the exhibit. As mentioned, one postal clerk said, "I can't [mail you], you're a body"; perhaps Wilson's identity as human (rather than cargo) is recognized via this exchange. Even more interestingly, while removing the third set of stamp skins, Wilson overheard another postal clerk say, "I would have mailed him, if he came to my counter,"[38] which does suggest that viewers engaged with the more radical implications of his performance piece. If Wilson desired to be mailed somewhere, either for his art, freedom, or identity, this postal clerk would have been willing to recognize this desire. Brand notes that the "body is the place of captivity" for African Americans, a domesticated space (at times); yet it is also a "wild space"—a sign of "transgression, opposition, resistance, and desire."[39] Perhaps these two responses—"I can't mail you" and "I would have mailed you"—embody the idea of Black corporeality simultaneously representing two different sides of the same coin: captivity and freedom.

Figure 6.12. Stamps flake off Wilmer Wilson's body as he walks. *Henry "Box" Brown: Forever.* https://issuu.com/connersmith/docs/connersmith_wilsoniv _hbbforever. Used with permission of Bree Gant, photographer, and courtesy Connersmith and Wilmer Wilson IV. Also see color inset, Plate 8.

Like Brown, Wilson made a spectacle of himself, and his artwork elicited reactions from viewers outside the post office, some of whom became part of the performance (in other words, the spectator becomes part of the spectacle). Some people took photographs, turning him into something to be viewed. However, these individuals now appear in photographs of the performance event. Other audience members tried to dialogue with Wilson, asking him questions about the performance. Yet others were upset by the spectacle he was creating and clearly saw its connections to enslavement. During his second performance, when he was covered in George Washington stamps, one woman seemed to view this as a form of neo-slavery, fuming "Don't let them do this to you" and "George Washington had slaves! Lincoln freed the slaves!" Wilson broke his silence, removed a few stamps from his mouth and assured this woman that he was fine and acting under his own volition, but she was not calmed.[40] Wilson's performance viscerally evoked the reality of slavery over the long history of the US. This viewer references an ongoing violation that occurs through not only slavery, but also the body, spectacle, and visuality.

Normally, art is centered around things—paintings, sculptures, photographs, and so on. People look at these things as observers. Body art, on the other hand, makes a person into a thing (an object) in a certain way, but it also puts human identity into this "thing," as we can see in this woman's reaction to Wilson's art.[41] Wilson's art blurs the divide between subject and object, person and thing, viewer and viewed, as Box Brown did when he mailed himself or even passed for a box. In many photographs taken of the event, Wilson gazes at his viewers as they look at him; he looks back, in other words (see Figure 6.13). Wilson's performative embodiment (the stamp skin he wears) grants both invisibility (we cannot see his face) but also empowered visibility: he is a spectacle as he walks through the streets of DC, but one who looks back and even speaks to viewers when necessary. He is not silent or passive, but interactive and engaging.

Performative personae can showcase objecthood but also deploy a degree of agency. Box Brown and Wilson find power not by evading the dynamics of the spectacle, but by manipulating them, by creating an open performance terrain that they can traverse and remake and into which the audience can enter. They

Figure 6.13. Wilmer Wilson looks back at an audience member. *Henry "Box" Brown: Forever.* https://issuu.com/connersmith/docs/connersmith_wilsoniv_hbbforever. Used with permission of Bree Gant, photographer, and courtesy Connersmith and Wilmer Wilson IV. Also see color inset, Plate 9.

incorporate the viewer into their performances in ways that challenge who is being gazed at and who is doing the gazing; they turn the tables (at times) on viewers by making them part of the performance. As we have seen, Brown hypnotized some of his audience members onstage and made them think they were sheep (or at least pretend to be sheep); either way, they became the object of the gaze and part of the performance. Such performances leave open the question of who, in the end, has power—the viewer or the viewed. They create multiplicity and flux via their performative icons, rather than stasis and a single meaning. In discussing his performance of Brown's story, Wilson hopes that it will be open to "deconstruction, reassembly, and multiplicity."[42] Neither Brown's nor Wilson's legacy is to remain fixed, but to be interpreted and remade by others.

In the nineteenth century, slaves were reduced to property, to thingness, but both Wilson and Brown continually evoke their objectification to undermine the binary between thing and person, object and subject, human chattel and human being, and to embody a degree of self-control that performatively runs up against enslavement in the past and the present. As Wilson comments, "The forever project was also an attempt to embody agency. The stamp skin was intended to be the experimental vehicle, skin-as-box, its mutability wherein lay its freedom."[43] The comment that "I would have mailed him, if he came to my counter" does suggest that skin-as-box *might* have become a possibility for freedom, in the same way that Brown might have found, via performance and continual reinvention of his escape-by-box, a measure of control over his trauma through the multiplication of his personae.

Brown's and Wilson's performance work are radical in the ways they attempt to integrate the audience and (in the case of Wilson) engage in forms of intersubjectivity. Unlike traditional art, performance body art requires a different role for the spectator. The art object becomes an embodied subject, forcing the viewer to engage with it in a different way; a space of intersubjectivity and revolution might open into which participants can step. While it is not clear that this usually happened with Box Brown, Wilson, as the most ecstatic and playful boxologist I have discussed so far, does work hard to open a space of exchange between the viewer and the viewed, so that there is a renovation of and understanding about the conditions of the body, enslavement, and freedom within our contemporary moment.

Conclusion: A Box of No Return?

In *A Map to the Door of No Return*, Brand explores intergenerational trauma and post-memory and develops a concept of "The Door of No Return." The Door

is the space in which the history of Black people is lost, specifically when slaves from Africa were transported during the Atlantic slave trade: it is "that place where our ancestors departed one world for another; the Old World for the New. The place where all names were forgotten and all beginnings recast."[44] It is a place that is as metaphorical as it is psychological, as imaginary as it is real. The Door symbolizes how much ancestry and history have been lost or forgotten, left in the amnesia of the past.

The artists in this chapter are interested in meditating on Brown's box as (to some extent) a space into which the past has disappeared, in part because so little was known about Brown's life. Yet all these artists imaginatively recreate this box, filling it with innovative and modern content to show that Brown and his legacy cannot be lost but must be retrieved and revivified for a new generation. As discussed in the next chapter, this process continues in contemporary literature written for children and visual poetry. Ecstatically and realistically, the artists analyzed in this chapter invoke Box Brown to signify the necessity of re-creating the past, of intersubjectively engaging with it in ways that allow for a degree of freedom in the moment of looking *at* a picture of something or someone and remaking it. Slavery perhaps has not ever, and cannot ever, be fully represented, as William Wells Brown notes. But the creative solutions to the problems of the afterlife of slavery discussed in this chapter reveal that representing and even rupturing the past—and its modes of not only captivity but also performative freedom—is an ongoing process in which both artists and viewers must actively engage.

Playing in the Archives

Box Brown in Contemporary Children's Literature and Visual Poetry

Ta-Nehisi Coates's novel *The Water Dancer* (2019) plays fast and loose with history, creating in its heroine Harriet Tubman a larger-than-life figure who can bend time and space to transport fugitives to freedom on the Underground Railroad via a magical process of conduction. Yet when the novel turns to Henry Box Brown, it sticks to the dominant historical script about his escape inculcated by Frederick Douglass in 1855. In *My Bondage and My Freedom* Douglass writes, "Had not Henry Box Brown attracted slaveholding attention to the manner of his escape, we might have had a thousand *Box Browns* per annum." Douglass also goes on to chastise "the very public manner" in which some individuals have conducted the Underground Railroad, which for Douglass instead might better be called the "Upper-ground Railroad."[1] Picking up on this thread more than 160 years later, Coates's Tubman, when asked about how she liberates people from slavery, says, "My methods are not for the offering. It's the Underground, not the Overground. This ain't no show. I don't advertise like Box Brown."[2] Coates transforms the historical archive of what is known about Tubman, giving her supernatural powers, but in Tubman's voice he confines Brown to his box, leaving him flat on the page, and scolds him for not keeping his escape a secret.

As we have seen in the last chapter, some visual artists liberate Brown from his material box; others utilize the box as a metaphor for the afterlives of slavery, implying that African Americans exist still within the "box" of racial inscription, stereotype, and various continuing modes of enslavement such as the prison industrial complex. The most intriguing artists play with the concept of Brown being both in his box and outside of it, thereby implying that slavery continues

today, but so do various freedom practices that aesthetically rupture racial stereo-typing and inscription and point to the survivance of African Americans.

In contemporary literature, drama, musicals, and film, there have been a va-riety of resurrections of Box Brown. However, the most innovative work has been in children's literature and contemporary poetry for adults, some of which is visual and literally attempts to move Brown off the page into three-dimensional space. This chapter first examines children's literature written about Brown to see in what ways it transfigures Brown. These works continue the project of watching Box Brown move not only through time and history, but also through space by way of innovative visual layouts. I then scrutinize poetic treatments of Brown's escape by contemporary African American poets Elizabeth Alexander, Joshua Bennett, and especially Tyehimba Jess. I spend the most time on Jess's stunning poetic remaking of Brown's story in his Pulitzer–winning collection *Olio* (2016). Some of these treatments of Brown are more fantastical than others, but the goal is creating an interlocutor who can interrogate both history and contemporary African American struggle. Jess in particular encourages a new reading practice that spatially runs up against enslavement, creating a freedom practice that cannot be contained within one geography, time, or history.

This chapter also analyzes how the authors discussed engage with Brown's legacy and the archival facts known about him. Some scholars of African Amer-ican literature have asked us to reimagine what constitutes an archive of the past and how we as readers employ it. Jeanne Scheper discusses a practice of creatively "playing in the archive" of the past to complicate "official accounts" of history and to understand contemporary practices of art that seek to reembody the past.[3] In this vein, the scholar Wendy Walters contends that "where the archive records people as slave, coolie, and arsonist, black international creative writers set these languages mobile, aspirational, and open to the subjunctive, asking: what if they were rebel, lover, leader?"[4] In these contemporary texts, does Brown become a rebel, a trickster, a hero? Or does he, instead, remain flat on the page? In many of these works, Brown's story deliberately incorporates contemporary readers so that they become part of the process of re-creating the historical past and liberat-ing themselves from restrictive and flat archives of American history.

A Child's Guide to Box Brown: Henry Brown in Twenty-First-Century Children's Literature

There have been at least three books for children published since 2007 about Henry Box Brown: the lushly illustrated *Henry's Freedom Box: A True Story from the Underground Railroad* (a Caldecott Medal honoree) written by Ellen Levine

and illustrated by Kadir Nelson (2007); the musically infused *Freedom Song: The Story of Henry "Box" Brown* (2012), written by Sally Walker and illustrated by Sean Qualls; and the more poetic interpretation *BOX: Henry Brown Mails Himself to Freedom* (2020), written by Carole Boston Weatherford and illustrated by Michele Wood.[5] These books may have been influenced by Jeffrey Ruggles's publication, in 2003, of the only book-length treatment of Brown's life, *The Unboxing of Henry Brown*; Ruggles's volume fleshed out much of Brown's life to 1889, giving authors of children's literature more details with which to work. Brown had an early presence in children's literature. In *Cousin Ann's Stories for Children* (1849), Ann Preston briefly retold the narrative of his escape; she used as a visual hook a drawing of Brown standing up and shaking hands with members of the Philadelphia Underground Railroad Committee.[6] After this there appear to be no children's books that take him as subject for about 150 years. What has fueled twenty-first-century interest in his story?

As we have seen in the previous chapter, boxologists meditate on the picture of Brown emerging from his box with a degree of care (Pat Ward Williams), ambiguity (Glenn Ligon), or even abandon (Wilmer Wilson IV). Creators of children's literature, perhaps because they have pedagogical and educative goals for their audience, are wary of embellishing too much of the historical record. There is some room for creativity vis-à-vis certain aspects of the story, including Brown as a focalizer (seeing the world from his point of view); the symbolism of the box; Brown's music; and the ending of his chronicle. Yet the unfinished history of Brown's life may limit such experiments to some degree; for example, it was unknown where Brown died until 2015. Some books betray unease with their closure or an unwillingness to "write beyond the ending" of Brown's escape-by-box.

The most well-known book for children on Box Brown—one frequently taught in schools and read by children—is Levine and Nelson's *Henry's Freedom Box: A True Story from the Underground Railroad*, meant for ages four to eight. From a narrative point of view, this book is the most straightforward in recounting Brown's life, and while it does play in the archive of the past via key symbolic items, this play is limited. Even so Levine and Nelson's book was faulted for not sticking to the "known" details; Catherine Threadgill claims that some of the "'facts' related in [Levine's] text are unnecessarily dubious."[7] This critique is not entirely accurate because, as we have seen, many of the details of Brown's life were unstable, such as the exact date of his escape; Levine and Nelson use March 29 instead of March 23, but there is (as noted in my Introduction) scholarly dissensus on this point. But Levine and Nelson do not necessarily want to stay entirely factual in their telling of Brown's story. They include an author's note that gives information, but from the start the focus of the story and the

stunning graphics are creating empathy for Brown as the focalizer. In many works of literature, but especially those for children, a character focalizer is "selected and developed as the prominent fictional world sensory perceiver, emoter, and thinker,"[8] and Brown is certainly this in Levine and Nelson's volume.

Brown's role as focalizer is made clear from the book's start. He is a child who does not even know his birthday: "Henry Brown wasn't sure how old he was. Henry was a slave. And slaves weren't allowed to know their birthdays."[9] This lettering is in small print by itself on the first page of the book, and the facing page contains a large image of Henry looking out at the reader or listener with huge, luminous eyes as he sits quietly on a stool against a brick wall (see Figure 7.1). The colors—rust, brown, white, and tan—are subdued and somber, and match Henry's sorrowful expression. The stunning full splash page with little text focuses on the boy, and his sadness and confusion leap off the paper. For many children, birthdays are days of celebration and excitement, and (as we will see) the book ends with Henry "learning" his birthday. The authors create a kind of narrative circle through this motif, one which subtly connects to the themes of Brown's rebirth as a free man that inhere in his story from the first lithograph of him, known as the "resurrection" print.

When Levine and Nelson deviate from Henry's focalization, they do so skillfully through organizing shots that make clear that the story is still being told from his point of view. The book includes the perspective of Henry's mother but prefaces it with these words: "Henry's master had been good to Henry and his family. But Henry's mother knew things could change." Some readers have criticized the description of Henry's enslaver as "good,"[10] but these lines are undercut by the illustration on the right-hand page, and by the inclusion of the words of Henry's mother. The author and illustrator weave words from Brown's 1851 narrative into the book when Brown's mother, looking out at the beautiful colors of fall leaves, tells her son (sitting on her lap), "Do you see those leaves blowing in the wind? They are torn from the trees like slave children are torn from their families." Levine gives Brown's mother a direct voice, and Nelson's illustration renders this as a sacred and mournful moment. Brown is tucked in his mother's protective arms, and they face away from the viewer, so they are granted a degree of privacy for this melancholy reflection. Still, the focus remains on Henry's response to his mother's words more than on his mother.

Henry's Freedom Box also presents creative moments that do not occur in the 1851 text but foreshadow Henry's future escape and speak to his strong spirit and desire for freedom; this makes him a focalizer with whom children might empathize and more of what Walters calls a "rebel, lover, [or] leader." At one point, a slightly older Henry is being separated from his parents and family to go to Richmond and work in a tobacco factory; Levine writes, "Later that day Henry

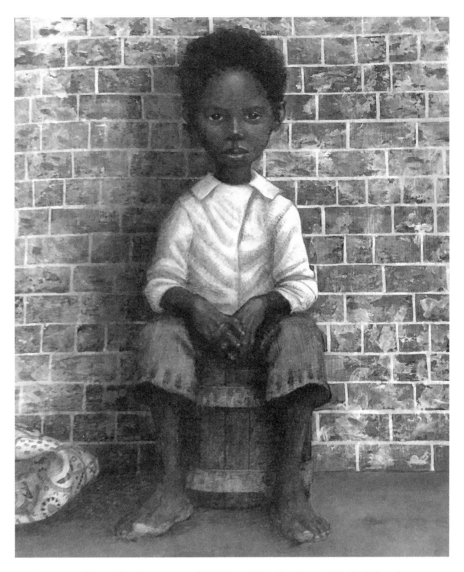

Figure 7.1. Henry Box Brown as a child. From Ellen Levine and Kadir Nelson's *Henry's Freedom Box: A True Story from the Underground Railroad* (New York: Scholastic Press, 2007). Used with permission. Also see color inset, Plate 10.

watched a bird soar high above the trees. *Free bird! Happy bird!* Henry thought. Henry said goodbye to his family." The full two-page graphic of this scene does not show a bird anywhere, but it does show a brilliant red tree that bleeds from the left page to the right, suggesting the way that slavery bleeds across the generations, separating parents from children and husbands from wives, and savagely fracturing familial bonds (Figure 7.2; see Plate 11 for color). The line of the book's spine cuts across not only the blazing red tree, but also the wagon and the

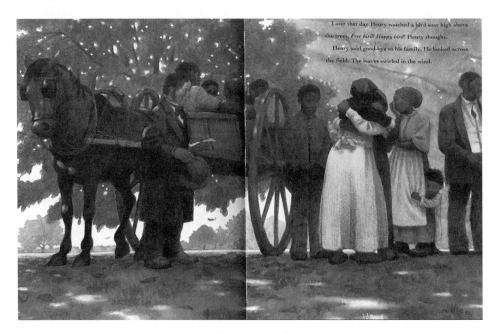

Figure 7.2. Family parting. From Ellen Levine and Kadir Nelson's *Henry's Freedom Box: A True Story from the Underground Railroad* (New York: Scholastic Press, 2007). Used with permission. Also see color inset, Plate 11.

family. Despite the wounding cut of the spine, families mourn in a quiet and dignified manner. Again, we see the muted, somber colors of rust, brown, and brick red.

Bleeds across the spine of the book are frequently used in an almost abstract way, especially when it comes to the traumatic breakup of Brown's family, making the images visually gripping and all-encompassing, again increasing empathy. As Brown learns how to work in a tobacco factory, grows into an adult, meets his wife, Nancy, and has children, the narrative maintains a tidy visual distinction between left- and right-facing pages, and there are no bleeds across the center of the book. In the book's center pages, then, Brown becomes (momentarily) happy and even "felt like singing"; he hums "all the way home." But after Nancy warns Brown that she and his children might be sold, the bleeds return and we see a visually astonishing close-up of a side view of his face split across two pages, with only these simple words on the left-hand page: "Henry worked hard all morning. He tried to forget what Nancy had said." Of course, Brown cannot get these words out of his head, as the large picture of his skull makes clear. When Brown is separated from his wife and children, a dark sky roils the landscape, and the backward glance of his son on the right-facing page is agonizing, yet the focal perspective is still Brown's: "Henry watched his

children disappear down the road." On the next page, Brown sits alone in his empty room, facing away from the viewer, weeping into his hands.

But Brown has not lost hope entirely. The bird symbolism returns, as Brown as focalizer again dreams of freedom and formulates his plan of escape: "Henry heard singing. A little bird flew out of a tree into the open sky. And Henry thought about being free. But how? As he lifted a crate, he knew the answer." The emphasis becomes Brown's box as akin to the bird and the bird's song—a symbol not of slavery, confinement, or death, but of escape. The symbols of the box and music are cleverly conjoined via the bird imagery; the bird's singing is a symbol of Brown's desire for freedom, and it leads him directly to the idea of the box as a mode of liberation. Indeed, the very next page in *Henry's Freedom Box* is a full two-page spread of Samuel Smith (the white carpenter who helped Brown escape) writing on the box: "Pennsylvania: This Side Up with Care." In this abstract representation of the box, the words are skewed, and the box takes up two full pages. We see the white hand of Samuel Smith lettering words onto the box, but the fingers of a Black hand in the upper right corner also touch it—presumably, this is Brown's hand (see Figure 7.3).

As users of books (rather than only readers), children often touch them, and this is a tactile picture that might encourage a child to place his or her hands

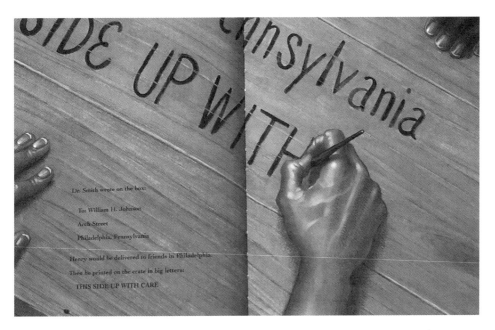

Figure 7.3. Henry Box Brown's postal crate. From Ellen Levine and Kadir Nelson's *Henry's Freedom Box: A True Story from the Underground Railroad* (New York: Scholastic Press, 2007). Used with permission.

directly on the box. Here, even to turn this page one would have to touch the box—that is, touch a symbol of enslavement that is being transformed into a symbol of freedom, a turning page, a new life; a reader intersubjectively shares Henry Brown's story of freedom. Brown's unboxing in Philadelphia further emphasizes the notion of box-as-freedom; after a harrowing journey, the men outside the box ask Brown if he is all right, and he responds, "All right!" The authors manipulate the archive of the past by intertwining the box with the bird and turning both into a symbol of Brown's transgression of his enslavement and enduring spirit. Through this symbolism, Brown becomes a hero with whom young children could identify.

However, since Brown's history after 1850 was mainly unknown until Ruggles's study in 2007, it appears that Levine and Nelson struggle to create a sense of closure beyond the escape-by-box. They fashion a circle in that Brown begins the book not knowing his birthday but creates one by text's end, when he escapes: "At last Henry had a birthday—March 30, 1849, his first day of freedom." This point is debatable: there is no evidence that Brown viewed his first day in the North as his "true" birthday. Levine and Nelson give Brown's story an ending which is "happy" to a certain degree—he is free, gets his middle name, and has a birthday. The detail of Brown having a "birthday" is perhaps meant to suture over some of the trauma of the history, but it feels a bit anticlimactic and abrupt.

On the other hand, Levine and Nelson play in the archive of the past through ambivalent symbolic items that are inserted into the book's closing pages, when Brown's "birthday" is created. In the final drawing, Brown is on his knees, gazing at the man to his left. Brown looks content with his freedom and satisfied to be coming out of this box; he even seems to be smiling. But he is not springing out of his box or standing up (as he does in *Cousin Ann's Stories*; see Figure 7.4). This appears to be a "happy ending," but on the left-hand side of the final two pages of the book, on a table to the left of Brown's box, there is a decorative water pitcher with the image of the supplicant slave on it. The position of the supplicant slave parallels that of Brown, as they both look to the right, presumably into the faces of their rescuers, who smile down on them with benevolence. This pitcher signals that the assembled men are abolitionists, of course, dedicated to helping the enslaved. Yet the image of the supplicant slave is problematic, as discussed in Chapter 1; it gestures to the usage of a pitiful and passive, static Black body as a symbol of abolition but not necessarily of agency or freedom. This icon suggests a future in which people, even after their escape, are always configured as ex-slaves, supplicants for freedom, but never quite free. This figure also embodies those rendered psychically or symbolically enchained by the visual realm specifically through pictorial representation.

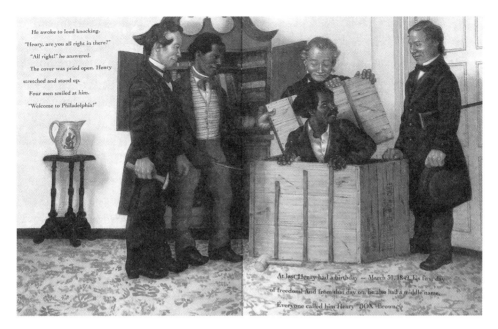

He awoke to loud knocking.
"Henry, are you all right in there?"
"All right!" he answered.
The cover was pried open. Henry stretched and stood up.
Four men smiled at him.
"Welcome to Philadelphia!"

At last Henry had a birthday — March 30, 1849, his first day of freedom! And from that day on, he also had a middle name. Everyone called him Henry "BOX" Brown.

Figure 7.4. Henry Box Brown being unboxed. From Ellen Levine and Kadir Nelson's *Henry's Freedom Box: A True Story from the Underground Railroad* (New York: Scholastic Press, 2007). Used with permission. Also see color inset, Plate 12.

As we have seen, individuals such as Box Brown, as well as Wells Brown, the Crafts, Douglass, and Truth, manipulated the visual realm, delineating the way white abolitionists used it (at times) to keep the enslaved or formerly enslaved person in a permanent position of abjection and dependency, but also resisting this configuration. Levine and Nelson's ending gestures to such concerns. Perhaps this ironic detail leaves questions in a child's or adult's mind, pushing them to think or read further. Or perhaps Nelson's illustration is meant to pull against Levine's words here—contradicting the somewhat happy ending of Brown creating a birthday on his first day in "freedom," which of course was really the beginning of his story and not its end. The tension between the cheerful narrative ending and the ironic graphic might lead to further meditation on the status of what freedom means, and who is really truly free, in the past or the present, and in the afterlives of enslavement.

The ending of Brown's story is difficult for many children's book writers because little was known of Brown's life beyond his escape-by-box. Some ambiguity or irony is introduced in the other texts by the symbolism of the box, and through the pivotal role that music plays; perhaps these symbols are meant to linger in the audience's minds, beyond the specific factual conclusion. These symbolic motifs—music and the box—will come to have even greater resonance in later books about Brown.

Walker and Qualls's *Freedom Song* in fact makes music a central and repeating motif, as Brown is continually given voice through it. As we have seen, Levine and Nelson create empathy from the start of their text by making Box Brown the focalizing presence. *Freedom Song* (also intended for ages four to eight years) gives more of a prehistory to the story and creates a community around Box Brown, so he is not exactly the focalizer. We do from time to time hear (in italics) the words in his head, but for the most part the narrator tells Brown's story, which includes a prequel in which an infant is held aloft in a beautiful lapis blue two-page spread with bright hints of yellow as his family joys in his birth: "When Henry Brown came into this world, his family sang. Mama blew kisses on his soft, brown belly. Papa named him Henry, held him high to the sky. Sisters and brothers tickled his toes." The visual style of this book is less dramatic than Levine and Nelson's; it uses a collage form, and the illustrations are in a folk-art tradition. There are fewer full-page bleeds, and the sequence of images is easy to follow for a young child.

Perhaps the more subdued visual style makes Brown more of an everyman (or everychild) type of figure rather than a hero; in any case, the goal seems to be to embed him in a family network in advance of his escape. In fact, a reader does not know until the next page that Brown is enslaved: "Mama's cooking grew Henry tall. Papa's stories grew Henry smart. The whole family's love grew Henry strong. Even though they were slaves on the Master's plantation." Some readers complain that this has the effect of whitewashing slavery, and of making the enslaver seem good, but the goal is to delineate a family history for Brown *before* he is introduced as an enslaved child.[11]

In Walker and Qualls's *Freedom Song*, Brown's story is mainly narrated by an omniscient third-person narrator. However, at times the narrative shifts to a limited third-person mode of narration that gives Brown a degree of focalization and, interestingly, uses music to create a focalization effect. When Brown meets Nancy, for example, we are told that "her smiles made his heart thump. His love songs made her cheeks glow. Finally, their masters gave them permission to marry. Henry and Nancy sang with joy." On the next page Brown is shown singing with Nancy and his family: "Henry was papa proud when his first child was born. . . . At night, Henry sang him a cradle song. Its low, restful, close-your-eyes words rocked the baby to sleep." After he has more children, we are told that "family songs hushed Henry's freedom song. And Henry's heart was full." Most of the above sentiments could be attributed to Brown's consciousness, suggesting that he is the focalizer here, but more importantly music articulates his complex emotions.

The illustration in which Brown sings to his family is beautifully drawn by Qualls, using a peaceful blue with tints of yellow and orange. This two-page

spread shows a crescent moon in the sky and abstract drawings of light beams and suns on the walls of the house. Brown plays a banjo and sings to his family in a picture of domestic happiness (see Figure 7.5). The family looks peaceful and cozy, in part because they are visually organized on the page as a family circle. However, a conflict exists between Brown's freedom song and his songs of love for his family: "family songs hushed Henry's freedom song." Perhaps freedom songs are meant to be individualistic odes to escape, whereas "family songs" are community-oriented. In any case, a tension between freedom and family will be repeated later in the story.

Music is threaded throughout the narrative as a mode of voice for Brown, yet his "freedom song" is a soundless one. He sings workday songs that help him pick cotton, gather-up songs for harvesting peas, hide-and-seek songs when he plays with his siblings, and (as mentioned) family songs when his children are born. But we are told that his favorite song is silent: "At sleep time when his candle blew dark, Henry sang his freedom song. But silently, inside his head." Henry also *stops* singing this silent freedom song when he sings his family song. One wonders: if his family had not been sold, would he ever sing a freedom song again?

As might be expected, then, after Henry's family is taken away the grave trauma leads to stronger focus on the freedom song: "For weeks, silence filled Henry's house. 'Poor Henry. No songs left in his heart,' said a neighbor, shaking her head. But she was wrong. Henry *did* still have a song. His freedom song. And its think, plan, take-yourself-to freedom-land words were getting stronger every

Figure 7.5. Henry Box Brown and his wife and children, singing together. From Sally Walker and Sean Qualls's *Freedom Song* (New York: HarperCollins, 2012). Used with permission. Also see color inset, Plate 13.

day." The "freedom song" that Brown sings now leads directly to the idea of the box ("*Samuel ships boxes to freedom-land*, Henry thought. *Why couldn't he ship me, too?*"), and he even builds the box himself.

The symbolism surrounding the box in Walker and Qualls's *Freedom Song* is, however, quite dense. As in Brown's own narrative, the box is the place both where he could be reborn as a free man or where he could die—a womb and tomb. In other words, it is a symbol of the problematics of freedom in this era, and perhaps even in ours. At one point during his voyage, Brown feels as if the box is closing in on him and wonders, "Could he bear the squeeze much longer?" This imaging suggests both death (suffocation) and rebirth (the squeeze of the birth canal). The illustrator here places Brown in a fetal position, and he looks like a frightened infant. Brown also has a symbolic death and rebirth when his box falls out of the wagon and he faints. He awakens, and the visual image makes clear the womb/tomb symbolism of the box, again. Brown lies sideways in a coffin-like box, his body spread across the spine of the book, hands folded in a corpse-like pose, but his eyes are open, and he is being resurrected in a manner that has spiritualistic overtones: "*Tap, tap. Tap.* The secret code knock! *Tap.* Henry knocked back in reply" (see Figure 7.6). *Freedom Song* builds up the death/rebirth motifs of Brown's box to suggest that the process of birthing oneself into freedom and away from various forms of enslavement is ongoing; the struggle for freedom is never "finished." Brown will continue to live in what Sharpe terms the wake of slavery.

Figure 7.6. Henry Box Brown en route. From Sally Walker and Sean Qualls's *Freedom Song* (New York: HarperCollins, 2012). Used with permission. Also see color inset, Plate 14.

By building up symbolism around the box, Walker and Qualls gesture not only to the heroism of Brown's escape but to the many-sided quality of his story: its ambivalence, for example, as to what freedom might have meant to Henry Brown (who constantly climbed back into his box as part of his performance), or what it might mean in 1849 for Blacks, or today for African Americans. As mentioned in Chapter 6, for some visual artists the box that Brown escaped in becomes a type of freedom song. Glenn Ligon imbues his Box Brown crates with music (including Bob Marley's "Redemption Song," with its famous line, "Won't you help to sing / these songs of freedom"). In Walker and Qualls's text, the box is also a resonant musical symbol that vocalizes Henry's freedom. In the final illustration, he stands up and sings his "freedom-land" song, at first silently but then out loud; the hero sings the actual words that Box Brown was reported to have sung in 1849 when he first got out of his box:

I waited patiently for the Lord
And he inclined unto me, and heard my calling:
And he has put a new song in my mouth
Even a thanksgiving, even a thanksgiving unto our God

The narrative has posited a tension between freedom songs and family songs, so it seems that here the author and illustrator opt for a freedom song that covers over this tension. Ending with this song and his standing up out of the box suggests a movement into freedom, rather than the limited vision of Brown sitting in the box and smiling at his rescuers that we saw in Levine and Nelson's book.

Yet it appears that the creators of *Freedom Song* still have some difficulty with closure; although the story ends here, the book does not. Paratextual elements at the end include an author's note explaining that Brown was a real person who escaped in 1849 and moved to England in 1850, and that his trail eventually "disappear[ed] into history." The book also includes excerpts from an archival letter from J. M. McKim, one of the members of the Underground Railroad who received Brown; McKim details Brown's arrival to Philadelphia. There is even a footnote urging readers to peruse McKim's letter on the New York Historical Society's website. Such information authenticates the narrative as "true" but also has the strange effect of giving McKim the last word, perhaps suggesting the idea that freedom for the formerly enslaved exists only if a white man's words validate it.

Even so, there is a certain amount of play with this archival document. McKim's final words in his letter are that Brown's story *remains unpublished* because to publish it might prevent "all others from escaping in the same way." Yet the version of the story we are reading was made possible only because

Brown refused to keep silent about his miraculous escape-by-box and *did publish* his narrative. So, in effect, the archival (factual) document is transgressed, first by Brown (when he wrote his narrative) and then later by Walker and Qualls when they flesh out Brown's complex story. In the end, it is unclear in *Freedom Song* who gets the "last word," but Brown's story, song, and voice survive.

The endurance of Brown's story over time and its many-sided quality are also gestured to in the visually and formally dense work by Weatherford and Wood, which plays in the archive of the past much more than any of the other works. *BOX: Henry Brown Mails Himself to Freedom* is geared to a slightly older age group (ages ten and beyond), and yet some of the visuals in this text would appeal to a younger audience and might be shared with them, with careful explanation. The narrative is told in what the author refers to as "sixtains"— short poems composed of six lines. There are usually two to three of these short poems stacked like boxes on each page. Some of these short poems go into detail about topics that are only indirectly related to Brown's story, such as Nat Turner, David Walker, or the laws of slavery. The book moves beyond a narrow focus on Brown into the larger landscape of enslavement and modes of freedom.

BOX allows for a degree of abstraction in the story from its very start via a pretextual element, an abstract visual and linguistic poem named "Geometry," composed of a six-word poem with a very unusual layout, which is on the first page of the book before any other information is presented (see Figure 7.7). The words must be puzzled out, yet the shape contains its own answer: "How Many Sides to a Box?" The words are arranged in the shape of a six and this is the correct answer: in a three-dimensional world, a box or cube has six sides. This facet of Brown's story symbolically gives rise to the sixtains of the poems but also from the start asks us to think beyond the flattened version of Brown normally found in the archive: that he was an enslaved man who escaped by box. The central question of Brown's story (how to escape) is figured symbolically and visually as its own answer (by box), but it requires work on the part of the reader or listener to understand this paradox and to see the already complex symbolism woven into the box; when is a box a symbol of freedom rather than of slavery or death? Moreover, images of multisided cubes recur as a distinct visual pattern throughout the narrative, but do they allow the protagonist to escape from his fame as Henry "Box" Brown and to find an identity as a "freeman"?

Because Weatherford and Wood's book is more formally complex than the others discussed, I analyze the visual style before discussing focalization, the symbolic motifs centered on music and the box, and the ending. The palette mainly includes blue, green, pink, red, and neutral, and subdued shading is used throughout. Stylistically, Wood's artistic proclivity as someone often inspired by

Figure 7.7. Title page ("Geometry"). From Carole Boston Weatherford and Michele Wood's *BOX: Henry Brown Mails Himself to Freedom* (Somerville, MA: Candlewick, 2020). Used with permission.

quilts is reflected, and many of the pages contain quilting motifs; the book therefore ties into a longer tradition of African American artistry and voice in material objects that are also works of art.

The author and illustrator use word-poems, thereby creating some powerful set pieces, such as "Split," which delineates the moment when a young Brown must leave his family:

Split
I am fifteen when my master dies
And wills my family to his four sons
My parents, brothers, sisters, and I
Flung apart as if dandelion puffs.
I land in the young master's Richmond tobacco factory
He warns the overseer to never whip me.

The poem uses the powerful metaphor of the delicate dandelion puffs being "flung apart"—a beautiful image but one which also suggests the latent violence of enslavement, which pays no regard to family ties. However, the picture that faces this poem is quiet, as Brown and his family huddle together, and it offers a sort of calming contrast to the traumatic word-poem. The next poem (on the same page) continues to show the violence of slavery, but also the brutal commercialism that underlies this economic system:

Richmond
A sea of red brick rises from the James River,
Slavery the cornerstone of it all.
See the slave pens, whipping posts, auction houses.
Storefronts, tobacco factories, and gristmills—all busy.
Folks in packets and boats with cargo
Float along canals. People. Everywhere.

"Richmond" is persuasive in notating the way that "slavery [is] the cornerstone of it all"—of wealth, but also of the cruelty of the "slave pens, whipping posts, [and] auction houses." Here as elsewhere, *BOX* gestures to the viciousness of slavery, yet there is a subtlety to the final concluding lines, with the enjambment: "boats with cargo / Float along canals. People. Everywhere." Is this cargo enslaved? Clearly the phrase "People. Everywhere" is meant to encompass both the enslaved and the non-enslaved population, and the caesura between the two words emphasizes this—there are *people*, not slaves, "Everywhere."

The verses of the poems are rather ragged, but many contain nine syllables—perhaps because nine is six turned upside down, again emphasizing the many sides of Brown's complex history and escape. Like Levine and Nelson, Weatherford and Wood include powerful bleeds across pages, especially when they depict family separation or even thoughts of this. On one page, for example, we see a tree spreading across two pages; in the poem accompanying this illustration, "Wind," Brown's mother muses, "*Slavery is a cruel wind . . . / Sweeping child away from parents, / Scattering families far and wide. / She shivers and holds me close.*" Trees are powerful symbols of families (both their creation and their destruction) in the book, as we see when Brown marries and creates his own family tree, in the poem "Anchored":

Anchored
The good Lord anchored me and Nancy in the Word
And has given us three children and, then, blessed news:
Another babe on its way in a matter of months.

Our family tree, my treasure, bears precious fruit.
Our harvest, though bountiful, yields a bitter truth:
We have less power to stay than weeds with shallow roots.

The slant rhyming of "precious fruit," "bitter truth," and "shallow roots" makes clear that the precious family (the fruit) is subject to destruction. The illustration on the facing page shows Henry Brown and a pregnant Nancy Brown leaning on a large tree in full bloom, but it appears to have no roots; the blue background contains strange crosshatched drawings of ominous vague shapes, perhaps representing the looming forces that will destroy the family, who has "less power to stay than weeds with shallow roots."

Weatherford and Wood also have illustration and text in their book that are very abstract, moving away from the visual and narrative realism that mainly dominates the other two books. For example, when Samuel Smith (the white man who helped Brown) writes to a member of the Underground Railroad (presumably McKim) to gain help for Brown, there is a two-page spread containing (on the left), a poem about this letter, Brown's excuse for getting time off from work so his escape would not be noticed, and then another poem:

Manifest
Inside
One
Box
To
Flee
Another

The six-word poem "Manifest" complicates the official archive of the past, in which white men free Brown, by limning out some of the more abstract qualities of freedom: can it be found in a box? Where does it exist? How many sides does freedom have, in 1849 or today? Is it "manifest" or hidden? The facing-page illustration makes this abstract symbolism clearer, as it shows McKim holding up and reading a letter that has been folded out into three-dimensional, almost origami-like boxes (or rather cubes; see Figure 7.8). The letter expands into sixteen or seventeen boxes, suggesting that freedom is multifaceted and multidimensional—will Brown ever be considered as fully human, rather than cargo? McKim hides behind the boxes/letter, suggesting that he may not yet have embraced the idea of Brown's movement into an identity as a free man.

BOX is stylistically lush and complex, and it gives readers or listeners much to ponder; in this way it also plays with the archive of the past. Yet despite all

Figure 7.8. A member of the Underground Railroad Committee reads a letter requesting his help in Box Brown's escape. From Carole Boston Weatherford and Michele Wood's BOX: *Henry Brown Mails Himself to Freedom* (Somerville, MA: Candlewick, 2020). Used with permission.

this abstraction, it still makes Henry Brown the main focalizing presence, the hero, on both a visual and a narrative level. It accomplishes this from the start by including a frontispiece portrait (before the title page) of Brown looking directly at the viewer, his eyes wide, with a backdrop of boxes and cubes behind him (see Figure 7.9). Next to this page, the title page lists (in large letters) **BOX** and then "Henry Brown Mails Himself to Freedom." The background to Brown's face on the frontispiece page is a series of small boxes, some blue, some tan, with his face superimposed over these boxes. His left eye even has a box *in* it, suggesting just how much this symbol defines him. He looks out at the viewer, making clear that this is *his* story and that we should identify with him.

The title page layout evidences that Henry Brown is the heart of the story, but to further emphasize this idea the following two pages contain a full-page illustration of Brown with a pen in hand, in front of a nice house, with a small child (presumably his daughter Annie) to his left, and a quote from his 1851 narrative that starts with a classic feature of narratives of the formerly enslaved: "I

Figure 7.9. Henry Box Brown frontispiece. From Carole Boston Weatherford and Michele Wood's *BOX: Henry Brown Mails Himself to Freedom* (Somerville, MA: Candlewick, 2020). Used with permission. Also see color inset, Plate 15.

was born." Both the picture and the quote from Brown's narrative emphasize his authoring of the text. Since Box Brown (within the narrative of the 1851 text) never depicts himself achieving authorship, the opening illustration gestures forward in time to the moment when he will do so. This is the most radical way in which *BOX* plays with the archive of the past—it shows Brown authoring his own story *within* its narrative parameters. Moreover, there is scholarly debate about whether Brown physically wrote his 1851 memoir, even though it has the subtitle *Written by Himself*. In settling this debate in favor of Brown (he has the pen in hand), Weatherford and Wood substantially alter the historical archive, turning him into a writer who is shown in the act of authoring his own story.

The text uses first-person narration to give Brown voice, not only in the "I was born" phrase but also in other places, such as the poems "Split" and "Wind" (described above). A reader is also encouraged to see Brown as heroic via his resistance, especially in poems such as "Courage":

Courage
What have I to fear?
My master broke every promise to me.
I lost my beloved wife and our dear children.
All sold south. Neither my time nor my body is mine.
The breath of life is all I have to lose.
And bondage is suffocating me.

At this point, Brown has nothing left to lose except "the breath of life," which he might lose anyway since "bondage is suffocating me." He has freed his mind from enslavement, in other words, and he formulates his escape-by-box.

The box symbolism is complex in this book, and perhaps for this reason, music is downplayed as a symbol. We do see Brown stepping out of his box "a free man" and "burst[ing] into song." But the book is a bit cynical about the role music plays in Brown's life, as we see in the poem "Box":

Box
At the New England Anti-Slavery Convention, I sing the hymn
That was on my lips when I first breathed liberty.
Touring anti-slavery gatherings, I tell my story
And hawk my song lyrics and new book.
For abolitionists, I am tangible proof that the enslaved
Crave freedom. I earn the nickname "Box."

The reference to Brown's having to "hawk" his song lyrics and book implies that he must use his story and song for commercial purposes. Indeed, he is trying to raise money to "buy my family's freedom"—so Brown's book and song become part of a trade in human flesh. The facing page illustrates his confusion, as he stares out at the viewer, looking sad and perplexed; he is flanked on all sides by haunting images of Nancy and his children.

As we see in the above poem, the box that Brown escapes in is part of this traffic in human and nonhuman goods. Yet in this story the box's symbolism cannot be contained so easily as Brown's song. After he is closed into his box, he hopes that he "can pass as dry goods"; the authors explicitly note the way he must pass as a nonhuman, non-free item to become free. As elsewhere, the box is both tomb ("I pray this crate will not be my coffin") and womb ("I step out a free man"). Weatherford and Wood take advantage of some of the most current research on Brown and show his evolution (in England) into a "Showman" and "Magician" in two of the penultimate poems in the book, but they also notate the way he may not escape from his box:

Showman

Just as my escape transformed me into a freeman,
I reinvent myself onstage. For my one-man show,
I cast a new character, a well-dressed African prince.
Later, I spice up my act with hypnotism.
Audiences laugh at volunteers under my spell.
I crown myself "King of all Mesmerisers."

Magician

My new life brings a second chance for happiness.
I remarry and we have a daughter. I take them home.
In the United States, I call myself Professor H. Box Brown.
I perform magic tricks, but still portray the African prince
And climb from the box that delivered me to freedom.
After all, my escape was my finest illusion.

In these poems, Brown is a mesmerist, magician, professor, and African prince, yet he is still climbing back into the box that delivered him "to freedom"; this fact teases at the question of whether he is free. The phrase "After all, my escape was my finest illusion" is double-voiced, to say the least: was his escape his greatest trick to achieve freedom (a wonderful illusion), or is the escape (into freedom) only an "illusion," something insubstantial, unreal? The facing illustration makes this ambiguity evident; it mirrors the illustration of Brown on the frontispiece, with his large, teary eyes, but here Brown is dressed as an African prince with a turban made of interlocking boxes on his head. His jacket and the background of the illustration also feature a myriad of boxes, indicating that he is still using his box as the backdrop of his life (see Figure 7.10). As the book's penultimate page, this graphic makes the point that freedom is convoluted, especially for a fugitive whose identity has been defined precisely via the symbol of his enslavement—the box—and who now must live in the afterlife of being property, a thing, baggage.

The symbolism of the box appears again in the final illustration, which bleeds from left to right facing pages, across the spine, with this simple six-word poem:

Axiom

Freedom
Is
Fragile.
Handle
With
Care.

Figure 7.10. Henry Box Brown as a magician. From Carole Boston Weatherford and Michele Wood's *BOX: Henry Brown Mails Himself to Freedom* (Somerville, MA: Candlewick, 2020). Used with permission. Also see color inset, Plate 16.

This six-word poem makes clear that *if* Brown found a type of freedom, it would need to be handled with care because it is "fragile." But what does the accompanying drawing suggest? Here the archive is again complicated via abstract symbolism. The facing illustration contains a picture of Brown walking down railway tracks, perhaps still making his way to freedom. There is a tree alongside the tracks, perhaps connecting to his new family tree (in England) or the loss of his prior family tree. He follows a white dove, a symbol of peace, suggesting that he still seeks tranquility (see Figure 7.11). The drawing also contains a series of stars of different sizes, but all of them have eight points. These stars could symbolize resurrection or salvation, because within Judeo-Christian traditions the number eight often represents a new beginning. For example, a Jewish boy enters God's Covenant on the eighth day of his life through circumcision, and eight people were reportedly saved in Noah's ark (connecting to the symbolism of the dove). In a more strictly Christian context the eight-pointed star refers to redemption or regeneration; many baptismal fonts have an octagonal base. So, it seems that the unusual symbol of the eight-pointed stars in the final illustration,

Figure 7.11. Henry Box Brown walks toward freedom. From Carole Boston Weatherford and Michele Wood's *BOX: Henry Brown Mails Himself to Freedom* (Somerville, MA: Candlewick, 2020). Used with permission. Also see color inset, Plate 17.

which Brown is moving *toward,* suggests that Brown still seeks redemption or regeneration as he heads toward the final axiom about freedom.

But the most curious symbol in the final illustration is that the three-dimensional boxes have become flattened out, in a checkerboard pattern of blue and black boxes. Perhaps the author and illustrator mean to point to the way that enslaved people were moved around (bought and sold) like pawns on a chessboard. Yet I think the point is that our understanding of Brown's life became flattened out over time (one-dimensional), as defined by a flat box. The poem "Axiom," on the other hand, points toward the book's overarching concern, that freedom is an ongoing process and must always be handled with care. This is an allusive, illusive, and elusive ending to his story, in other words, one that clearly attempts to *watch* Brown as he moves across time and space.

In *BOX*, Weatherford and Wood complicate the archive of Brown's history by way of multifaceted images and poems that the reader must unfold and ponder. They also substantially extend the ending of Brown's story, covering his years in England and his return to the US.[12] But still, this ending leaves open much of the mystery of Box Brown's life that fascinates visual artists today: not only whether he ever found a type of freedom, but what is the final "message" of his story? As we will see in the poetry next discussed, the ability to reinvent

Brown, to create new lives for him, is vital to the types of freedom he is seen as obtaining. Brown is transfigured into an enduring mystery to be pondered and watched over time, or even a song to be performed in multiple geographical spaces—rather than only a man boxed into a specific historical and artifactual moment.

Moving Through Time and Space: Journeys Beyond the Box in Contemporary African American Visual Poetry

As discussed in Chapter 6, it appears that some artists feel free to play with the picture of Box Brown's "resurrection" in ecstatic ways—liberating him from visual connection to his box so that he is free to roam (for example) the streets of Washington, DC (in the case of Wilmer Wilson's performance pieces), and inventing new stories for him. Because the archive of known facts about Brown was slim until recently, some writers of contemporary poetry similarly design innovative narratives for him, knowing that history is, in the words of one of these poets, Elizabeth Alexander, "more than what happened" and that one must consider who "forgets more, denies more, and what it is to be salvaged, in whose name?"[13] History is not a neutral record of what happened. Therefore, history needs to be "salvaged"—ripped apart but also redesigned—to come alive in the present moment.

In many ways Alexander's poetry collection *Body of Life* (1993) seeks to play in and with the archive of history. While some of the poems are personal (or embed the personal within the political), the volume also contains reimaginings of key African American historical figures from the past, such as Josephine Baker, Yolande Du Bois (W. E. B. Du Bois's only daughter), Minnesota Fats, Betty Shabazz (wife of Malcolm X), and Henry Box Brown. At times, she recreates the stories of these individuals entirely. Regarding Box Brown, for example, her poem "Passage" is very far from Brown's life, and a reader might struggle to recognize Brown in this poem. For one thing, he is renamed as "Henry Porter," and for another, he says goodbye to his wife and daughter *before* getting into his box (in real life, Brown decided to escape only *after* his wife, Nancy, and his children were sold away). Other details are changed: his wife's name in Alexander's poem is Clothilde (not Nancy) and his daughter is named Eliza (the names of his children born in enslavement are not known). So the Henry Porter of the poem, who undergoes a "passage," may not in fact be Brown; it may be a Brown alter ego of some sort, portering or portaging or porting himself

to "freedom" via some sort of "passage." Yet, like Henry Brown, he loses his family and experiences a journey in a tomb-like space; furthermore, the character in Alexander's poem is mailed by box from slavery in Richmond to freedom in Philadelphia.

In 1993, when this poem was published, little of Brown's history had been recovered; Alexander therefore might have felt freer to invent a new persona for Brown. Yet I think there is a deliberate transgressing of the archive, especially in the representation of the tomb/womb and Brown's unboxing:

> Too tired to weep, too tired to look through
> the peephole and see what freedom looked like,
> he waited for the man to whom he'd shipped
> himself: Mister William Still, Undertaker,
> Philadelphia. . . . [14]

In this poem, Brown fouls himself in his box and is ashamed, and when he arrives his "suit was chalky / with his salt, and soiled, the shoes waxy with blood."[15] In other words, Brown's entrance to freedom is no glorious resurrection, and he is too tired to "see what freedom looked like." William Still is not the conductor of the Underground Railroad but an "undertaker"—one who delivers him to a sort of living death. We do not even see Brown exiting the box, and his final thoughts are not of liberation but of people he left behind: "goodbye wife Clothilde, daughter Eliza, best friend Luke. Goodbye, everyone, goodbye."[16] Alexander builds Henry Porter/Brown into a repository of all that has been lost in slavery and the historical past; although he tries to "remember everyone's name who had ever been taken away," he finds his memory fading.

In the face of an historical archive which knows very little about Brown's first wife (Nancy), Alexander attempts to turn her into a flesh-and-blood woman who makes her husband's clothing and packs a meal of salt pork and cornbread for him to take in his box. In the poem, we never know why Brown's persona decides to flee slavery, leaving his wife and child behind, but he plans to come back and liberate them. At the poem's end, he recalls his promise to his wife and child: "When I can, I'll come for you. I swear. / I'll come for you."[17] But the words "I'll come for you" stand by themselves on a single line, making this idea feel hopeless rather than feasible. Nancy/Clothilde is still abandoned in the past, in this empty-sounding promise.

While in the box Henry Porter/Brown finds that "Freedom was near but un- / imaginable."[18] Alexander's line break here (between "un-" and "imaginable") speaks to the paradox at the heart of Box Brown's real life—his status as always

"Brown of the Box," a man defined by a history of familial loss and enslavement, rather than "imaginable" freedom. The salient fact of his leave-taking in this version of his life is that we never see him entering a space beyond enslavement, and that he is trapped not by physical slavery but by emotional trauma—by his memories of the past—and by "everyone . . . who had ever / been taken away." Alexander imagines Brown not as a rebel but only a simple human man, trapped by past losses.

Joshua Bennett, in his poetry collection *The Sobbing School* (2016), also meditates on the losses of Brown's life, especially in terms of his first family, but Bennett focuses more on Brown's art as a possible venue for liberation. Like Alexander, Bennett is interested in the archive and what it leaves out, and his poems reconsider historical figures such as Malcolm X, Zora Neale Hurston, Richard Wright, and Ella Fitzgerald, as well as contemporary individuals like VonDerrit Myers, an eighteen-year-old who was shot seventeen times and killed by an off-duty police officer in St. Louis in 2014. Bennett also mentions "gaps in the archive"[19] and tries to fill in or remake these gaps. For example, his poem "12 Absolutely True Facts About Richard Wright" contains twelve stanzas with at least one clear fabrication about Wright, including that he was "born in a hornet's nest," that he could fly, that he "built the White House," and that he was "a soda can." In other words, these "absolutely true facts" are the opposite of facts, but the truths of this poem lie metaphorically in what Wright represents in African American history more broadly.

Perhaps, then, it is no surprise that Bennett begins his collection *The Sobbing School* with a poem that recreates Brown, called "In Defense of Henry Box Brown." It is a one-page poem in thirty-one right-justified lines; in it the narrator (perhaps Bennett) explicitly compares himself to Box Brown, saying: "Not every trauma has a price / point. You & I are special / that way."[20] The narrator compares selling his trauma and pain to Box Brown's: "No doubt, there is good / money to be made in the rehearsal of / a father's rage, an empty crate, / whatever instrument ushered us into lives of impure repetition." By using the word "us" in these lines the narrator parallels his "impure repetition" of pain in his art (presumably poetry) to Brown's continual exhibition of his rage as a father and his display of the "empty crate." Bennett also notes that Brown for "years on end" replayed his "infamous / escape for hundreds / of tearful devoted, sold out / shows an ocean away from the place / that made you possible, made you / parcel." The recycling of pain guarantees "sold out shows" but does not remake Brown's status as "parcel." Brown is still a contraband human being—someone smuggled to England but who has not found a type of genuine liberation.

In addition, Bennett ponders not only the commercialism of Brown and his story, but what his art may have cost him:

> If they had only known the weight
> of what passed before them.
> The wait you waded through.
> Twenty-seven hours spent inside
> a three-by-two-foot jail of splinter & rust.

Punning on the weight of Brown's trauma, which is on display, and his wait in a jail of "splinter & rust," Bennett makes the point that Brown's audiences never fully comprehend his story, what "passed before them." Bennett continues his comparison of his own persona to Brown, in a first-person voice in the final lines:

> I too
> have signed over the rights to all my
> best wounds. I know the stage
> is a leviathan with no proper name
> to curtail its breadth. I know
> the respectable man enjoys a dark
> body best when it comes with a good
> cry thrown in. I know all the code
> words, Henry. Why you nicknamed
> the violence. Why all your nightmares
> end in vermilion.

The persona has signed over his suffering, presumably to produce art that is crowd-pleasing, because the "respectable man" enjoys "a dark / body best when it comes with a good / cry thrown in." In beginning his collection with a poem about Box Brown, Bennett asks readers to ponder the status of African American art today—the way many "respectable" viewers want to see or read about African American trauma or pain, to cry over dark bodies, rather than engage in activism or hear about African American achievements. Bennett also claims to know "all the code words"—all the ways in which pain becomes a second skin that renames the violence but also simultaneously reiterates and repeats it.

Bennett is sometimes faithful to the historical record about Brown; he even notes Brown's trip to England. But there is an unusual twist at the end of the poem when Bennett writes: "I know. . . . / Why all your nightmares / end in vermilion." There is no way, of course, that Bennett can know Brown's dreams, so there is a genuine reimagining of Brown's history. Vermilion also is a brilliant scarlet color, so Bennett implies that Brown dreams of blood, of sadness—perhaps

the blood of whippings, or the "blood kin" he has lost. But vermilion, made from
the powdered mineral cinnabar, has many other significant connotations that
connect to Brown's story. Vermilion was used in illuminated manuscripts dur-
ing the Middle Ages, and perhaps Bennett means to illuminate Brown's story,
but also turn it into an illuminated story—one that sheds light not only on the
past but on the present. The word comes from an Old French word meaning
"worm" (*vermis*); do all of Brown's nightmares end with a specific worm-in-his-
apple, the fact that he could never liberate his family? Moreover, vermilion is
made when mercury and sulfur are mixed and a black compound is created;
when this compound is heated and then ground up, the brilliant red colors of
vermilion manifest. Vermilion, then, embodies something black that is ground
to create brilliant reds (perhaps pain or suffering that is illuminated onstage).
Brown's Blackness, his rage and trauma, were ground into something brilliantly
red (his art) which fills all his nightmares and yet is still his (Black) trauma
and art, underneath. With the resonant final image, Bennett plays in the archive
of the past to connect Brown's story to the ways in which, even today, African
American art must be suffused with trauma and suffering to be successful
commercially.

And yet, Brown is not precisely liberated from enslavement, nor does Ben-
nett turn him into a hero. In this regard, Tyehimba Jess's *Olio* pushes even
harder against the archive, turning Brown into a trickster artist who might leap
off the pages of the book, and moving him (quite literally) through time and
space.[21] Even by title (*Olio*), the collection engages questions of African Ameri-
can art, history, and voice, and the relationship between past and present; the
"olio" was the second part of a minstrel show and it often featured a variety of
performance acts, but the term also refers to a hodgepodge. *Olio* acknowledges a
formal connection to the minstrel tradition, but also makes of this hodge-
podge something entirely new, pushing back against the deformation of African
American art enacted by these shows. Jess's collection also renovates the histori-
cal past via its multimedia nature, which ultimately allows the reader to perform
this text in a different manner. The collection has songs, duets, photographs,
drawings, poems, dialogues, and interviews. Jess explicitly acknowledges that
Olio "is a performance in the memory of and in conversation with those de-
picted throughout the manuscript."[22] Diana Taylor has made a distinction be-
tween "archive" (fixed, static texts) and "repertoire" (performances of texts such
as songs, which can be sung in different ways).[23] For Jess, history is not a static
archive, but a performative repertoire—songs and poems that can be staged and
reperformed by the audience.

Olio fashions a mode of history that can leap off the page and engage the
reader not only visually but tactilely, via the reader's own hands. There are mul-

tiple spatial ways of reading the poems and a formal and thematic challenge to how history might be understood or created; in this way the book itself becomes a type of "guerilla" or kinetic memorial to Brown's legacy. As Jess explains in his Appendix, there are columns of poetry that can be read either straight across the page (to create one meaning) or down the columns (to create another). But many of the poems can be read in other directions: "diagonally down" and then "interstitially" or "antigravitationally up." Jess encourages readers to "strike your own path through their lines" and to "circle round their stories to burrow through time."[24] Some of the poems are even perforated along the book's spine, and Jess gives directions to the reader about how to fold them into diverse shapes—a cylinder, a torus, or a Möbius strip. As the poems go from being flat on the page into a three-dimensional space (like the three-dimensional boxes in Weatherford and Wood's *BOX*), separate words will "flow into the other's and back again, and on and on like an ever-bending act, a joke that never (ever?) never ends."[25] The poems demonstrate how "separate" histories from the archive of the past can be swirled into each other and reperformed, in a continuously changing and dynamic repertoire that moves through time and space.

As Brian Reed observes, Jess intends to give readers the agency to read in whatever direction they would like to go; we may experience an unexpected and energizing form of freedom.[26] In an interview Jess states, "while we're dealing with very, very serious subjects, I have the desire to provide a different kind of amusement in the form of mental exercise for the reader. It becomes a puzzle, it becomes a kind of exercise, it becomes a liberation, and it requires your engagement. It provides you the opportunity to deconstruct the actual text so that you can reconstruct the history of the people in the book in a way that is different from or in conversation with the way history is usually constructed."[27] History often has been constructed by the dominant society in a way that deprivileges minoritized voices, so the reconstruction of history in *Olio* must be playful, open, creative, ever bending, and never-ending.

In the poems about Box Brown, however, Jess accesses a unique mode of renovation of the historical past. Jess invokes the famous American poet John Berryman and rewrites (from within Box Brown's voice) poems from Berryman's *77 Dream Songs* (1964), which won the Pulitzer Prize for poetry in 1965 and was later collected with other poems as *Dream Songs* (1969). In 1969, Berryman appended a note to the new edition of *Dream Songs*: "The poem then . . . is essentially about an imaginary character (not the poet, not me) named Henry, a white American in early middle age sometimes in blackface, who has suffered an irreversible loss."[28] Berryman, in other words, profits off Black art via his deployment of minstrelsy. As Kevin Young has commented, Berryman's use of this tradition of "black dialect" is offensive; the poems are about an "American light

that is not as pure as we may wish."[29] The light of American artistic genius may rely on a cannibalization of "minority" literary traditions and voices. It is vital to remember that the minstrel show was first enacted by white people who wore Blackface and profited from the derogatory shows they created; only later did Black minstrel groups and actors such as Bert Williams gain any revenue from such shows.

In Jess's version of Berryman's *Dream Songs*, the process of literary appropriation is reversed: the Black character Henry Box Brown appropriates the white poet Berryman's Henry. There are ten Dream Songs spoken by Box Brown, plus an overview called "Mirror of Slavery/Mirror Chicanery" and a Pre/face called "Berryman/Brown." In the introductory piece we are told that these poems are the "Freed Songs of Berryman/Brown"—in other words, they are songs of freedom or perhaps songs about dreams of freedom, rather than only songs of inscription or appropriation. In these poems "the escaped slave and traveling mesmerist Mr. Henry 'Box' Brown blackens the voice of poet Mr. John Berryman's Henry" and thereby "liberates him(self) from literary bondage!"[30] There is a focus from the start on modes of liberation, on appropriating a voice so that symbolic bondage starts to come undone.

While there are many topics that could be broached regarding Jess's use of Berryman to reenact Box Brown, I focus on three: the symbolism of Brown's box; the renovation of history made possible by the Berryman/Brown/Jess dialogues; and the effect the spatial/visual reading practices have on the reader. To begin with the box: this section of the book commences with a freehand line drawing of Brown's box, but the box is standing up and Brown has already escaped it.[31] The box is a vehicle for escape but also, in Jess's text, a reminder of past enslavement. Brown is out of his box, and while the cover is off, a large X on its cover seems to mark the spot, suggesting the limits of ever being able (either symbolically or literally) to escape history, which always marks or brands people in certain ways.

In Jess's collection the box comes to symbolize this paradoxical relationship to history—that one is both inside and outside the box of it, marked by it but always fleeing it. In the prefatory poem Brown's persona says words to this effect (when the poem is read down the page):

> Let me say
> despite loss . . . I won my life. This story—
> how a slave steals back his own skin:
> smuggles loose like I did. It lives on,
> but through words—and
> free.[32]

In short, staccato lines the poem enunciates Brown's story as one of a resistant individual who stole back his "own skin" through words and so achieved a type of freedom. Jess (via Brown) also enunciates Berryman's inability to talk for all those Brown "left behind," for all those he still loves and aches for:

I'm
"Box" Brown. Ain't
Masking my truth: one day,
I delivered myself.
I ache
my
love for
. . . those left behind.
. . . Berryman can't talk for them,
can't tell my tale at all.[33]

Jess seems to be revising Berryman's ability to co-opt Black stories when he has Brown say, "Berryman can't talk for them" (all those "left behind"). In this reading the box becomes a symbol of a kind of liberation despite loss, of how a slave "steals back his own skin" and "smuggles loose" from enslavement.

Yet if the poem is read across the page, a more dialogic meaning emerges. The left column (in italics) is taken up by Berryman's remarks about speaking in Blackface and the right side with Brown's voice. Thus, we find lines like this:

This poem then	Let me say
whatever its wide cast of characters,	despite loss . . . I won my life.
	This story—
is essentially about	how a slave steals back his skin:
an imaginary character	smuggles loose like I did. It
	lives on,
(not the poet,	but through words—and
not me)	free. I'm
named Henry	"Box" Brown.[34]

In this iteration Brown/Jess and Berryman join, and we find words indicating that the story is liberated, while the persona remains enchained: the story "lives on, / (not the poet, but through words—and / not me) free. I'm / named Henry 'Box' Brown." These lines might demarcate the status of the enslaved as never free; the poet/singer/performer is "not me / free." If Brown's own box is for some artists a freedom song of sorts, then it still does not make the persona free—the

box is not Brown, and nor does the box represent Brown "free." Overall, we may unearth a *story of freedom* rather than a person who is liberated.

The complicated symbolism of the box is further developed in the third Dream Song by Jess, "Freedsong: So Long! (Duet) Henry 'Box' Brown facing/ evading Slave Catchers." This is a foldout, double-sized poem that encompasses pages 76–77 and shows two speakers (one Box Brown, one a slave catcher) thinking what seem to be separate thoughts; on the page we also see two large outlines of heads, facing each other so that the speakers seem to be speaking *to* each other (see Figure 7.12). Henry's thoughts (on the left) center on his box and, if we read downward, would be arranged like this:

> Coffined up in this here box. That's me. Henry:
> Postage-paid freeman. I tell myself that I ain't
> scared beyond death. Tell myself, *don't get baffled*
> in a moment of truth. All my muffled prayers have
> beaten beyond fear. I declare salvation of myself,
> all hope-filled with flight.[35]

Brown's box is configured as a coffin, but he also declares that through it he finds "salvation of myself"—he is using it to gain "all hope-filled" flight. In other words, the very instrument of his death becomes his salvation, as he transitions into a "postage-paid freeman."

However, the words on the facing page—those of the slave catcher—seem to undercut this declaration of rebirth by box, of Brown's becoming a free man:

Figure 7.12. Foldout poem. Tyehimba Jess, *Olio* (New York: Wave Press, 2016), pp. 77–78. Used with permission of the author and Wave Books.

Tremblin' like a whip-torn waif! He'll arrive
caught: sealed in slave chains again. He's a
runaway. Just you wait. We will get him in time:
just got to be patient . . .
. . . Henry, he's now
Special delivery. Into our nets he'll surely come.[36]

In this iteration, Brown is always a *runaway*, never free, always a slave in chains, and the box is a symbol of his enslavement: "Into our nets he'll surely come."

There are other ways of reading these two facing pages—not down the page but across, which would produce an entirely different reading of history, one which the reader can be active in creating, depending on how or she chooses to read these facing poems. Moreover, this is one of only four poems in the volume that have a perforation along the spine and that Jess encourages his readers to tear out and fold into different shapes. Depending on how we fold these poems we get different dominant stories—not only a different dialogue between Brown and the slave catcher but also a dialogue between Brown and abolitionist history. For example, the back side of these two pages has a quote from Samuel May (one of the white abolitionists who received the box in Philadelphia in 1849) that was included in Brown's 1851 autobiography. May testifies to the truthfulness of Brown's escape-by-box, calling Brown a "remarkable man" who "deserves his liberty," and recommending that individuals read and buy the narrative. May is supportive of Brown but is it a bit strange that he (not Brown) gets the last word of the "Freedsong: So Long!" poem.

Yet if a reader follows Jess's instructions to cut the poem out of the book, a different meaning will emerge. "As said before, let your scissors rend paper to illuminate this argument,"[37] writes Jess, and he even includes a picture to show how the poems might be folded in different ways, set above a figure of Brown emerging from his famous box (see Figure 7.13). It is possible to fold the poems in such a way that Brown's story covers over the stories of May and the slave catcher; in this iteration Brown's history is dominant and he gets the final word. Of course, other folds are possible. Still, as Jess notes, "we know how it ends in the end, audience"; how "Philly awaits Henry when he struggles out of his box of smuggle and strife to sing his hardest won act—his self-liberated life."[38] The reader is encouraged to manipulate the poem, to play (quite literally) in the archive as we fold it in diverse ways to create altered dialogues or stories. But we must always be aware of Brown's singing (in the background) his song of self-liberation, whether his actual freedom was entirely achieved.

As we can see, Jess encourages a creative performing of history but also intersubjectivity with Brown—he urges readers to become part of the duet being sung via the tactile movement of their own hands. In the two final poems about

But we know how it ends in the end, audience—how Philly awaits Henry when he struggles out of his box of smuggle and strife to sing his hardest won act—his self-liberated life.

Figure 7.13. Instructions. Tyehimba Jess, *Olio* (New York: Wave Press, 2016), p. 219. Used with permission of the author and Wave Books.

Brown—"Freedsong: of 1876" and "Freedsong: Dream Song"—we find reiteration of this theme of liberation via the reader's involvement with Brown's story. "Freedsong: of 1876" (a rewriting of Berryman's "Dream Song 22") concerns Brown's return to the US and his performances there:

> It is the Fourth of July
> The debt? One century's span.
> all spawned by the Designers, who'd forbid
> me from grasping Thomas Jefferson's gifts
> in vain, in vain, in vain . . .
> I am Henry, a free black. My bliss is wry.[39]

From the founding of the US in 1776 to 1876 (when Brown speaks this poem) is "one century's span," and the Fourth of July marks the ironic fact that Jefferson's words about all men being created equal were forbidden to individuals like Brown (or others who were female, nonwhite, or non-propertied). But Jefferson's gifts were forbidden to Box Brown "in vain," as he reiterates three times. In meditating on history in this poem, and what the Declaration of Independence might have meant to individuals such as Brown, Jess again asks the reader to take a creative approach to how we watch and understand history, especially in the last line, when Henry Brown comments: "My bliss is wry." Wry can mean grimly humorous, cleverly ironic, but also twisted or bent. Brown's bliss—his liberation—is ironic, perhaps because it was denied to him, or perhaps because in 1876 in the US freedom for many African Americans was extraordinarily limited, as it remains today. Yet Brown's freedom is also bent, twisted into unusual shapes—he had to crush himself into a box to obtain it, and later contort his persona into diverse forms to please his audience and earn his living. Jess asks the reader not to see a flat rendition of Brown, but to dynamically *watch* the multiple, vexed, twisted, contorted meanings of his life and his "liberty."

In the final dream song about Brown, "Freedsong: Dream Song," readers are again encouraged to become part of the poem. Brown's last dream song is a remodeling of Berryman's first poem, but Jess's lines center on Henry Brown, not Berryman's Henry, and deform Berryman's poem to do so. Jess's poem reads:

> Let us see how Box Henry, pried
> open for all to see, survives.[40]

Brown's box was pried open, and his life also was subjected to intense scrutiny. Still, he survives and continues to make art. Berryman's own lines, conversely, focus on Henry's depression and potential inability to survive after some never-explained "great loss" (generally understood as the suicide of Berryman's father, who shot himself when Berryman was twelve). The poetic persona in Berryman's poem wonders if Henry survived:

> I don't know how Henry, pried
> open for all the world to see, survived.[41]

The narrator of Berryman's poem uses past tense here, making us ponder if, after the creation of the poem, Henry did in fact survive. Jess's version of this poem, on the other hand, focuses on the fact that "Box Henry" "survives" (present tense)—in other words, on his resilience, despite great losses.

Moreover, Jess encourages readers to carry Box Brown's song of survival and resistance in their own heads: to sing, no matter the cost, of freedom and survival, rather than only darkness and death. Jess's final stanza of "Freedsong: Dream Song" reads:

What he has now to say is a long
Wonder the world can bear and see.
Once, with his black-face worn, John [Berryman] was glad
all at the top. And he sang.
Here in this land where some strong be,
Let Box Henry grow in every head.[42]

Like Berryman's Henry, Henry Box Brown is sad, and he wonders how the world can "bear and see" so much pain. Yet still Box Brown sings on. Moreover, Jess encourages the reader to "let Box Henry grow in every head"; in other words, the song must grow in this land where some (but not all) are strong, perhaps from sea to shining sea.

Jess (via Brown) revises the message of Berryman's first dream song, which ends with this stanza:

What he has now to say is a long
wonder the world can bear & be
Once in a sycamore I was glad
all at the top, and I sang.
Hard on the land wears the strong sea
and empty grows every bed.[43]

As we see in the above verse, one focus of Berryman's first Dream Song is sadness and sterility, as is evident in the final line, "empty grows every bed." Berryman's Henry is depressed and can only sing a song of wonder about how the "world can bear & be." But Jess's Henry has a different perspective; some are strong in this land and will sing a song of witnessing: they will "bear and *see*" (emphasis added). Readers might bear the story forward, witness it, and inventively revise it, so that Henry Box Brown will "grow in every head." The focus is on productivity and song, rather than sterility and death. Jess also means to place the story of Box Brown back into the reader's hands, to make and remake, as we intersubjectively touch and fold the poems, as we flow into them to formulate new realities about the historical past.

Throughout the collection, Jess, like many of the other writers discussed in this chapter, places Brown into a history of African American activism and

struggle, and Jess even has a timeline at the end that aids us in this process. But Jess is also concerned with Brown's place within a history of artists. If Brown *could* sing a Dream Song, co-opting Berryman in this way (especially given that Berryman co-opted Black art), what would the nature of this Dream Song be? We witness a resonant dialogue with history proper but also literary history and art, one that makes Brown not a flat character, but (with the reader's help) one who can leap off the page and across time. I have referred elsewhere to the idea that African Americans in the past and in the present are in a perpetual state of bondage through old and new forms of slavery. Jess's radical re-creation of Brown is a form of wake work that allows us to understand this but also creatively remake this idea; if we fold the pages in a certain way, will Brown find a type of liberation? And will we? Whether actual freedom is obtained is less relevant than that we try to see how this freedsong might be fashioned and hear Brown's song of self-liberation.

Of the three poets discussed, Jess is the most innovative in how he teases the archive to renovate Brown's history. He grants Brown a radical temporality in which he moves in time (into, for example, Berryman's poetry collection) and space (into, for example, a third dimension). Jess also more actively demands the reader's participation in Brown's story and in the recreation of history, as we burrow through time, reading in circles and off the page, back and forth across poems, down them, across them, and between them. Jess shares Alexander's and Bennett's concerns with the weight of the historical past, then. And yet in Jess's hands this past becomes not a static archive but a repertoire of mobile and mutating freedom songs—songs that readers can transform and reperform as we burrow through time and history.

Conclusion: Freedom Time?

Some writers of children's literature and some poets play with the known archival facts of Brown's life, complicating them so that we receive a three-dimensional picture of Brown, one that exists in time and space. In so doing, we come to a greater understanding not only of Brown's story, but perhaps of our abilities to create a new repertoire of stories through imaginative forays into a past that is alive and constantly evolving. Also at stake in most contemporary artists' recreations of Brown is attention to the modes by which time itself can be rethought (and so history and the past). What might a "freedom time" look like for Brown— or for contemporary African American artists or other individuals today? The critic Anthony Reed has urged us to think about time as circular and mobile, rather than static and linear (moving forward simply from point to point).[44]

New forms of politics and new social orders are possible only when minoritized people are given the ability to circle back to the past and be free of the dominant reading of history in which (for example) in 1776 the country really did institute the idea that "all men are created equal."

Creatively and formally spinning back to the past via experimental art may bring into being a freedom time that claims a vision of a liberated future. Box Brown, pried open for all the world to see, clearly survives in the minds of the poets and writers discussed in this chapter. But perhaps he survives in large part because his story, mysterious, tantalizing, and partial, does enable (formally and thematically) a freedom time: a moment when we circle back to the past not to repeat it, but to create a glimpse of future (if still unrealized) liberation. If we do indeed "let Box Henry grow in every head," we may sight revelations of an unshackled future, as we ponder the various repertoires we can create and struggle to sing Brown's freedom song.

Coda

The Resilience of Box Brown and the Afterlives of Slavery

In 2018, writer and director Wanjiru M. Njendu created a short dramatic film about the escape of Henry Box Brown. Although it is only six minutes, it features an intriguing dramatic scenario: it is filmed entirely from within the confines of the box and there is no dialogue, only jarring sounds from outside. Literally the "fourth" wall of theater (the line separating the audience from characters) is broken so that viewers feel as if they are *in* the box with Brown for the length of the film, a disturbing experience.[1] The film also features graphic visuals in which Black people are again in slavery and in rags (see Figure C.1). What would inspire an African American filmmaker in the year 2018 to dramatize and reenact Brown's story, specifically from within the confines of his box? And what does it mean that slavery (and Brown's story) still fascinates the US's cultural imagination? As I document in my Appendix, Njendu joins a long list of contemporary artists who work in a multitude of forms such as film, performance art, puppetry, music, poetry, comics, novels, plays, podcasts, musicals, and crankies (small hand-cranked panoramas) to refashion Brown's story.

I believe that for artists today it is the performative and ambiguous aspects of Brown's story that compel them to remake it. Even to consider literalizing the metaphor of the slave as thing (human chattel) via a box (Brown passes as property, cargo, within his box) can be understood as a subversive type of performance art; Brown seems to succumb to the enslaver's logic that the slave is a thing, but he does so precisely to escape this logic through a daylong performance in a box. In keeping with Daphne Brooks, Jessica Bell sees Brown's original escape as performative and writes, "reclaiming his body as a source of agency, despite his oppressed status, Henry Box Brown engaged in bodily spectacle as resistance"; in turn he began the work of dismantling "the fixity of power

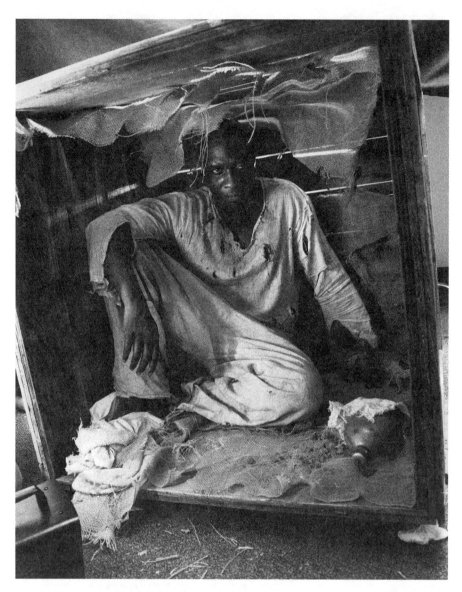

Figure C.1. Actor Adetokumboh M'Cormack in *Boxed* (2018), a short film written, produced, and directed by Wanjiru M. Njendu. See https://www.boxedthefilm.com. Used with permission. Photo credit: Birdie Thompson. © 2018 Wanjiru M. Njendu. All rights reserved.

affecting his own assertion of personhood." Bell also considers Brown's escape as "a multi-dimensional performance of self, wrought with contradiction and spectacularization."[2] Of course, the work of dismantling the power that turned him into an ex-slave or a thing was *never* complete, but what draws artists into his story, art, and life is his ongoing efforts toward this end. As we have seen, Christina Sharpe insists on the importance of being *in* the wake of slavery—of

understanding slavery's unresolved ending and living in this knowledge.[3] Yet she also maintains a focus on the ways African Americans artistically and physically challenge structures of domination. Many artists and writers have been drawn to Brown because his story speaks creatively and performatively about freedom practices that illustrate but also start to *challenge* the condition of literal or psychic bondage.

I began tracing the life of Henry Box Brown in 2014, when I was working on my book, *The Illustrated Slave*. At that time, I was writing a chapter on the frenzy of visual representations surrounding Harriet Beecher Stowe's blockbuster novel, *Uncle Tom's Cabin*. Brown seemed to be the perfect foil to the patient, loyal, steadfast enslaved man of the title—an individual who stayed in his place no matter what it cost him, right down to his very life. Of course, the character of Uncle Tom is more complicated than this, as he is willing to die rather than torture other slaves, but I was fascinated as to why the fictional Uncle Tom's image as a faithful slave endured, while Box Brown's story as the man who escaped by box became strangely truncated and stifled within the history of abolition, performance studies, visual studies, music, and theater in the nineteenth century.

But Brown surprised me, even back then. Over time, I discovered that Brown had his own panoramic version of *Uncle Tom's Cabin* and that he sang alongside of, if not exactly in, minstrel shows. Yet Brown's larger-than-life persona continued to intrigue me, as I discovered his movement into acting, magic, Jubilee singing, second sight, hypnosis, phrenology, spiritualism and the debunking of spiritualism, séances, healing, and even ventriloquism. Brown was known for his escape-by-box, but the box became an open performance terrain on which he enacted different versions of his identity: as an African prince, an Indian, a Wizard, and the King of all Mesmerists. I was engrossed by an individual who could turn his own enslavement into a spectacle (not only through the box but also by playing his enslaved self onstage) and who seemed to create, out of one of the gravest traumas a person can know (bondage and loss of family), a resilient and spectacular performance art.

Brown is fascinating in terms of nineteenth-century history and nineteenth-century studies of both slavery and visuality. He played with the visuality of slavery—its appearance in his shows—as if it were a toy, and he deserves serious study not as an abolitionist precisely but as a radical nineteenth-century performance artist. One goal of this book has been to flesh out the contours and directions of Brown's performance art and to uncover the many different roles he performed over the course of his *whole* life, from his time (perhaps) conjuring while enslaved, to his last performance, which may have been in England in 1896. By focusing this book on how he turned his life into a series of roving per-

formance acts, I substantially expand the archive of what is known not only about Brown, but also about nineteenth-century Black modes of art and entertainment. I also have highlighted those moments when Brown becomes a radical fugitive artist, one who reperforms his trauma to run up against it, to gain a mode of freedom from it within the space of performance. I have watched Brown as he moves across and between diverse temporalities and geographies, from the 1850s into our present moment, and from the US, to England, to Canada, and finally into a three-dimensional space embodied in art installations, performance art, visual poetry, and illustrated children's books. I have highlighted works that rupture the flat characterization of Brown often found in sanctioned archives about his life and release him back to us a mobile, living, transfigured entity. I have also focused on works that allow us to *hear* Brown's freedom song and to consider the ways in which not only visuality, but also sound, can become a type of wake work with transfigurative political content.

Brown's performance work—which allowed him to be a hero and a rebel (to borrow Wendy Walters's phrasing)—has political and social content, although not in the way that other abolitionists might have wanted. As a trickster figure who changed identities, hypnotized his audience onstage and made them do *his* bidding, and seemed to have supernatural powers of sight, sound, and vision, he complicates how nineteenth-century audience members might read Black bodies onstage, might seek to contain and control them via processes of visuality. Audience members might think that they would be able to know Brown, to capture him in their gaze, but what they would capture would not, in fact, be IRL (in-real-life) Brown. They would see, instead, his persona, someone who *represented* Box Brown but was only one adaptation of the real man. There is power in this, because the IRL man is always fleeing from the audience's gaze, reinventing himself, and in the process implying that he cannot ever be entirely apprehended. Brown's radical performance art strives to show the audience that the real Box Brown evades their scrutiny and grasp. There is power in the ways he runs up against slavery, against audience expectations of Blackness, and against abolitionists' staid representation of enslaved or formerly enslaved identity. Perhaps his audiences learned that the "Wizard" Box Brown—whoever he was— could never be completely comprehended. Perhaps to these audiences, as to many scholars and artists, he has remained a mystery for this exact reason: the "real" man was never entirely divulged.

As Chapter 1 documents, individuals such as Wells Brown, the Crafts, Douglass, and Truth used diverse visual modes (photographs, portraits, and panoramas) to create an image of African Americans that dignified them but also (from within the folds of various visual incarnations) kept their identity partially protected from view through a type of visual static. A seriousness and

poise are evident in their work in these visual modes. Brown's own work had political and social content via its message of an enslaved man who *refused* to stay in one place, who transgressed slavery through spectacle, yet there is a comic and even ludic feel to many of his performances. Brown could turn his own life—and the lives of other people who were enslaved—into comic art, into shows and spectacles that were edgy, funny, and bizarre, and that sometimes crossed over into foolishness, crass commercialism, or stereotype.

Brown was able to make humorous but subversive art about slavery for most of his life. Some of his shows elicited roars of laughter. In some ways, he seems like the comedian Dave Chappelle, whose edgy comedy shows went so far that he felt he became a stereotype; did people laugh ironically at Chappelle's shows about (for example) a minstrelized Black pixie (played by Chappelle in Blackface) who embodied racial stereotypes, or chortle because they endorsed (to take another example) his configuration of African Americans as prostitutes, crack addicts, and thieves?[4] Chappelle also made radical and humorous art about slavery. But one skit in which he traveled back in time to shoot a slave owner elicited so much horror when taped in front of a live audience that it never became part of the finished show.[5] Brown speaks to the survival of a comic African American art that runs the risk of becoming not edgy but stereotypical, and of a strand of performative work where the trauma of slavery becomes the central thing performed and yet humor is permitted. However, it seems that Anglo-American and Anglo-British cultures desire that their abolitionists and formerly enslaved people be serious and staid; their life should not become a circus. Even today, authors and filmmakers who use humor in their treatment of enslavement run the risk of offending many viewers, readers, and critics, as we see in responses to movies such as Quentin Tarantino's *Django Unchained* (2012) or novels such as James McBride's *The Good Lord Bird* (2013) and Paul Beatty's *The Sellout* (2015).[6] These works have been critiqued by some for mixing too much comedy into their portrayal of slavery.

Brown was funny, but he also made money from his shows, and he engaged in undignified pursuits, orchestrating donkey and foot races, giving out "valuable" prizes, conducting auctions and lotteries, singing and dancing onstage in ways that might have echoed the minstrel show, and sometimes turning his audience into part of the spectacle. In a sense, he could have been a Black P. T. Barnum, and for some time I was fascinated by the idea that Brown was running a circus in England, an idea I eventually stopped researching. Brown was more of a one-man show, and though he worked with others (as I document) at various points in his life, his "circus" as such was his own life, and it was a full one, containing as it did many oral and aural modes (speaking, singing, ventriloquism, and acting) as well as many visual ones (dancing, magic, and séances).

Barnum claimed to put on the "Greatest Show on Earth," but he exhibited African Americans in his entertainments in ways that mocked them and turned them into spectacles. Brown, on the other hand, turned his own life into a spectacle. There was power in this turning of the self into a spectacle, as I hope to have shown in this book, for Brown is always moving, never in stasis, caught and yet never quite caught in every performance.

Brown also speaks to twenty-first-century debates about the status of African Americans and the afterlives of slavery. Afro-pessimists like Frank B. Wilderson III contend that race impacts every feature of our moral, economic, and political world, and that a perpetual cycle of slavery continues to define the Black experience, both in the US and around the world.[7] Isabel Wilkerson argues that race in the US is a caste system—and that Blacks, like so-called untouchables in India or Jews in Nazi Germany, occupy a space of abjection, sanctioned state violence, socially enforced economic poverty, and governmentally regulated disempowerment on all levels that is difficult, if not impossible, to escape.[8] I agree with such claims. But based on my study of Box Brown, I believe that there are various "freedom practices" that *begin* the aesthetic and cognitive work of eroding the status of African Americans as socially or politically "dead" (powerless) within Anglo-American culture. And there are moments of running up against slavery and neo-slavery that dramatize the *struggle* for freedom, and of temporary escape, that might hint at the larger possibilities for liberation. I am reminded of the ending of Jordan Peele's film *Get Out* (2017), which depicts the main character, Chris, fleeing from the white Armitage estate, which he has burned down, and being rescued by his friend Rod, a TSA agent, in Rod's car. Where are Chris and Rod going? Will they escape? We are never told, and an alternative ending shows Chris in jail.[9] But the ending that *was filmed* after the 2016 election shows flight, escape, running up against enslavement and neo-slavery, being in *the wake of slavery*, but not succumbing to it. Brown's art also dramatizes this moment of escape, running, and struggle, even though freedom as such may not be achieved.

Today, Black Lives Matter has become for many an accepted slogan (finally) after the deaths of Daunte Wright, George Floyd, Breonna Taylor, Daniel Prude, Sandra Bland, and countless others, yet many still ignore the reality that Black people live in "the wake": the afterlives of slavery. As Sharpe argues, to be *in* the wake "is to be inhabited by the continuous present of slavery's unresolved endings, its lost histories."[10] Brown knew that he would always be in the wake of slavery, in its afterlife, and he literalized this condition by incorporating within his performance work the very symbol of the wake of slavery: his box, or a reproduction of it. He was a subversive comic performance artist who was able to see that the past was not past and that he had to turn it into a show or spectacle

that he controlled, that he could rehearse, repeat, and reperform. I have dug into the archives, then, to show how Brown's insubordinate performative repertoire might give us courage for the future. As noted, Derrida recommends that we conceptualize the historical archive as concerned not with the past but with the promise of the future and an obligation for tomorrow.[11] If we attend to Brown's unruly performative repertoire—the many modes of art he engaged in—we may find evidence of the ongoing struggle for freedom that animates Black life, both in the past and in the present.

A repertoire—rather than a stable archive—of Brown's art forms was the mode of performance that he deployed, as he constantly changed and multiplied his shows, performing and reperforming his work and adding different genres over time, such as science, healing, and phrenology. This has made Brown's art difficult to study, as there is no stable archive of his work anywhere—no one place we can go to find materials. Documents about Brown's life and art are scattered throughout databases, books on magic, spiritualist newspapers, abolitionist histories, and just a few physical locations. Yet because Brown does not exist in an archive, contemporary artists can create not so much a stable version of his life, but an evolving performative repertoire into which they invite the reader or viewer. In the poems of Tyehimba Jess, for example, we are encouraged to "strike [our] own path through" Brown's life and art and to "circle round [his] stories to burrow through time."[12] Although Brown does not give us explicit instructions (as Jess does) on how to fold and refold his life, to make of it different chronicles, his performative repertoire encourages the viewer to see his life as not "finished" but ongoing and constantly in transition. I also believe, as I said at the start of this book, that there are fascinating lives and afterlives still to be discovered for Box Brown. Perhaps he had other personae that we have not discovered, or he worked under other names than "Box Brown."

Brown's whole life can be read as a long-duration performance piece, fraught with contradictions and spectacle, and a freedom practice, a redemption song that allows him to showcase the modes of control that he took over the raw materials of his life and enslavement. By being multimodal and by engaging the audience, he demands that his audience become part of the show, and that we understand that slavery exists everywhere and in every time zone. He also insists that we become part of the process of understanding the contours of the afterlives of slavery and making inroads toward freedom and redemption within this terrain. Brown looks back at his audience; he puts the viewer onstage; he breaks the fourth wall between audience and performer; and he refuses to remain in one place, as one thing, for any length of time. He is always escaping, and he remains elusive, illusive, and allusive to the end. And that is why he continues to fascinate today. Brown had many resurrections, and he is still being

resurrected. I have not captured Brown in this book, of course, nor was that my intention. But I hope I have revealed him to be a dissident and insurgent performance artist who recognized the limits of freedom in his own time and place, but who also points to a future world in which these limits have been transgressed, if not transformed.

Appendix

Selected Contemporary Creative Works About
Henry Box Brown

Art

Pat Ward Williams, *32 Hours in a Box . . . Still Counting* (1987).

Glenn Ligon, *To Disembark, Sheldon* Collins/Whitney Museum of American Art, Smithsonian Hirshhorn, November 11, 1993, to February 20, 1994.

Wilmer Wilson IV, *Henry "Box" Brown: Forever* (site-specific performance art, April 5, 9, and 13, 2012, Washington, DC).

Torkwase Dyson, *I Can't Breathe (Water Table)* (2018), acrylic paint on canvas with wood and wire, National Museum of African American History and Culture. Also see *Dear Henry* series at https://www.artsy.net/show/davidson-dear-henry?sort=partner_show_position.

Children's Books

Virginia Hamilton, Leo Dillon (Illustrator), Diane Dillon (Illustrator), "All Right, Sir" in *Many Thousand Gone: African Americans from Slavery to Freedom* (1993).

Ellen Levine and Kadir Nelson, *Henry's Freedom Box: A True Story from the Underground Railroad* (2007).

Sally M. Walker and Sean Qualls, *Freedom Song: The Story of Henry "Box" Brown* (2012).

Susan Buckley, *Escape to Freedom: The Story of Henry Box Brown* (2013).

Carole Boston Weatherford and Michele Wood, *BOX: Henry Brown Mails Himself to Freedom* (2020).

Crankie (Hand-Cranked Mini Panorama)

Sue Truman and Richard Twomey, "Tribute to Henry 'Box' Brown," http://www
.thecrankiefactory.com/115034636.

Films, Documentary, Television

Karyn Parsons, dir., *The Journey of Henry Box Brown* (2005), Alfre Woodard
(Actor), https://vimeo.com/channels/638130/107764894.
Rob Underhill, dir., *Box Brown*, postproduction (2013).
Children's Theatre Company, *Henry Box Brown* (2017), excerpt at https://vimeo
.com/249884899.
Kevin Hart, *Kevin Hart's Guide to Black History* (Henry Box Brown and his
story are featured on the 2019 Episode, Chapter 3), Netflix, https://www
.youtube.com/watch?v=NdYQm1qoS2w.
Lorenzo Dickerson, dir., *The Story of Henry Box Brown*, Maupintown original
documentary film (forthcoming, 2022).

Museums and Memorials

Baltimore's National Great Blacks in Wax Museum (1983).
Monument to Henry Box Brown located along the Canal Walk in Richmond,
VA (2001).
National Underground Railroad Freedom Center in Cincinnati, OH (Exhibit on
Box Brown) (2004).
Louisa County (Richmond) historical marker honoring Henry Box Brown and
his escape from slavery (2012).

Music

Brandon Coffer, "Henry Box Brown Biography Rap Song for Kids with Sequence
of Events Worksheets," *Rap Opera for Kids*, https://www.youtube.com/watch
?v=Nhr_UgLidaw.
Liam Gerner, "The Henry Box Brown Story," on the album *Land of No Roads*,
https://www.youtube.com/watch?v=3k8P19pI2O0.

Musicals

Ballad of Henry Box Brown, by Milton Polsky, see article about this performance
in *Philadelphia Inquirer*, June 9, 1975, https://www.newspapers.com.

Henry Box Brown: A Musical Journey, written and directed by Mehr Mansuri, with music and lyrics by Frank Sanchez and Mehr Mansuri (2018–2019), https://www.henryboxbrownthemusical.com/about.

Henry Box Brown: A Hip Hop Musical, starring Karl "Dice Raw" Jenkins (2019), written and directed by Phill Brown, https://www.facebook.com/Boxthe musical/.

Novels, Poetry, Comics

Elizabeth Alexander, "Passage," in *Body of Life* (1996).

A. Van Jordan, *Rise* (2001).

Doug Peterson, *The Disappearing Man* (2011).

Joel Christian Gill, "Out of the Box Thinking: Henry Box Brown," *Strange Fruit,* Vol. I: *Uncelebrated Narratives from Black History* (2014).

Joshua Bennett, "In Defense of Henry Box Brown," in *The Sobbing School* (2016).

Tyehimba Jess, *Olio* (2016).

Performance Art and Reenactments

Anthony Cohen shipped himself along the same route as Henry Box Brown; see article about this performance in *Victoria Advocate* (Texas), February 11, 2000, https://www.newspapers.com.

Keith Henley portrays Henry Box Brown, https://www.youtube.com/watch?v =hVcLzbEfQnA, https://www.ahtheatre.org/characters/henry-box-brown.

Rory Rennick has a magic act and show that reenacts Brown's story, "The Henry 'Box' Brown Show," https://www.facebook.com/HenryBoxBrownShow/.

Plays

Valerie Harris, *Henry Box Brown* (2004).

Tony Kushner, *Henry Box Brown* (2010).

Mike Wiley, *One Noble Journey* (2022), http://mikewileyproductions.com/event/ one-noble-journey-a-box-marked-freedom-22/.

Podcasts

Steve Gilly, "Henry Box Brown," *Untold History Podcast*, March 24, 2018, https:// podcast.app/the-untold-history-p611991/.

Holly Frey and Tracy Wilson, "The Life and Magic of Henry 'Box' Brown," *Stuff You Missed in History Class Podcast*, April 9, 2018, https://www.listennotes.com/podcasts/stuff-you-missed/the-life-and-magic-of-henry-FY512J3oRsk/.

Puppet Show

Helene van Rossum, *The Story of Henry Box Brown* (2020), narrated by Davie-Lyn Jones-Evans, https://www.youtube.com/watch?v=-SjYNGNetus.

Notes

Introduction

1. Scholars such as Jeffrey Ruggles (*The Unboxing of Henry Brown*, Richmond: Library of Virginia, 2003); John Ernest ("Outside the Box: Henry Box Brown and the Politics of Anti-slavery Agency," *Arizona Quarterly* 63, no. 4 [2007]: 1–24); and Suzette Spencer ("An International Fugitive: Henry Box Brown, Anti-Imperialism, Resistance, and Slavery," *Social Identities* 12, no. 2 [2006]: 227–48) date Brown's escape to March 23, 1849. But in the 1851 narrative, Brown gives the date of his escape as March 29, 1849. I use the March 23 date because other documents (such as letters) that Ruggles has unearthed corroborate it. My thanks to Laura A. Wright for drawing my attention to this discrepancy.

2. Because Brown signed documents as Henry Box Brown and considered this his name, I do not use quotation marks around the word "Box" in it.

3. Mesmerism is a form of hypnosis. This will be discussed more in the following chapters.

4. "From the N.Y. Evangelist." Emphasis in original text. This quote is from the Reverend Furniss's speech in 1850 at the American Anti-Slavery Society meeting in Rochester, NY. Originally published in the *New York Evangelist* and reprinted in the *North Star*, May 16, 1850 (AAN).

5. Ariella Azoulay, *The Civil Contract of Photography* (New York: Zone, 2008), 15.

6. See Christina Sharpe, *In the Wake: On Blackness and Being* (Durham, NC: Duke University Press, 2016), 5, 8, and 13.

7. Ta-Nehisi Coates, "The Case for Reparations," *Atlantic* (June 2014), https://www.theatlantic.com/magazine/archive/2014/06/the-case-for-reparations/361631.

8. Toni Morrison, *Beloved* (New York: Vintage, 1987), 321.

9. William Wells Brown, "A Lecture Before the Female Anti-Slavery Society of Salem, Massachusetts" (1847), in *William Wells Brown: Clotel and Other Writings*, ed. William Wells Brown and Ezra Greenspan (New York: Library of America, 2014), 855–72 at 859.

10. On the idea of trauma as irretrievable, see Pierre Janet, who makes a distinction between traumatic memory (which in fact exists outside of language and narrative) and normal memory, *Psychological Healing: A Historical and Clinical Study*, trans. Eden Paul and Cedar Paul (New York: Macmillan 1976 [1919]), 661–3; also see Cathy Caruth, *Unclaimed Experience: Trauma, Narrative and History* (Baltimore: Johns Hopkins University Press, 1996). On the other hand, various theorists have argued for a model that investigates new relationships between experience, language, and knowledge and foregrounds the social and cultural significance of accounts of trauma. In this regard, see especially Naomi Mandel,

Against the Unspeakable: Complicity, the Holocaust, and Slavery in America (Charlottesville: University of Virginia Press, 2006).

11. Daphne Brooks, *Bodies in Dissent: Spectacular Performances of Race and Freedom, 1850–1910* (Durham, NC: Duke University Press, 2006), 69.

12. Janet Neary, *Fugitive Testimony: On the Visual Logic of Slave Narratives* (New York: Fordham University Press, 2016), 135.

13. Kathleen Chater, *Henry Box Brown: From Slavery to Show Business* (Jefferson, NC: McFarland, 2020).

14. Other than Ruggles, no critic has analyzed Brown's entire repertoire of performance work, but for important scholarship analyzing different art forms, see Ernest, "Outside the Box" and "Traumatic Theology in the *Narrative of the Life of Henry Box Brown, Written by Himself*," *African American Review* 41, no. 1 (2007): 19–31; Michael Chaney, *Fugitive Vision: Slave Image and Black Identity in Antebellum Narrative* (Bloomington: Indiana University Press, 2007); Teresa A. Goddu, *Selling Antislavery: Abolition and Mass Media in Antebellum America* (Philadelphia: University of Pennsylvania Press, 2020); Brooks, *Bodies in Dissent*; Marcus Wood, "'All Right!': The *Narrative of Henry Box Brown* as a Test Case for the Racial Prescription of Rhetoric and Semiotics," *Proceedings of the American Antiquarian Society* 107, no. 1 (1997): 65–104, and *Blind Memory: Visual Representation of Slavery in England and America, 1780–1865* (New York: Routledge, 2000); Cynthia Griffin Wolff, "Passing Beyond the Middle Passage: Henry 'Box' Brown's Translations of Slavery," *Massachusetts Review* 37, no. 1 (1996): 23–44; Spencer, "International Fugitive"; Neary, *Fugitive Testimony*; Aston Gonzalez, *Visualizing Equality: African American Rights and Visual Culture in the Nineteenth Century* (Chapel Hill: University of North Carolina Press, 2020); and Britt Rusert, *Fugitive Science: Empiricism and Freedom in Early African American Culture* (New York: New York University Press, 2017). Hollis Robbins discusses the specifics of Brown's use of Adams Express to escape; see "Fugitive Mail: The Deliverance of Henry 'Box' Brown and Antebellum Postal Politics," *American Studies* 50, no. 1/2 (2009): 5–25.

15. Alexis L. Boylan, *Visual Culture* (Cambridge, MA: MIT Press, 2020), 80.

16. Saidiya Hartman, *Wayward Lives, Beautiful Experiments: Intimate Histories of Social Upheaval* (New York: Norton, 2019), xii.

17. Nicholas Mirzoeff, *The Right to Look: A Counterhistory of Visuality* (Durham, NC: Duke University Press, 2011), 24.

18. See, for example, Dennis Childs, *Slaves of the State: Black Incarceration from the Chain Gang to the Penitentiary* (Minneapolis: University of Minnesota Press, 2015).

19. Sharpe, *In the Wake*, 12.

20. Ibid., 14.

21. Ibid., 50.

22. Much has been written on how the genre of the slave narrative attempted to control enslaved subjectivity and on white abolitionist "authentication" of Black voices; the topic of how formerly enslaved narrators negotiated these restrictions has also received careful attention. See James Olney, "'I Was Born a Slave': Slave Narratives, Their Status as Autobiography and as Literature," *Callaloo* 7, no. 1 (1984): 46–73; John Sekora, "Black Message/White Envelope: Genre, Authenticity, and Authority in the Antebellum Slave Narrative," *Callaloo* 10, no. 3 (1987): 482–515; and Robert Stepto, "I Rose and Found My Voice: Narration, Authentication, and Authorial Control in Four Slave Narratives," in *The Slave's Narrative*, ed. Charles T. Davis and Henry Louis Gates, Jr. (New York: Oxford University Press, 1985), 225–41. Sekora famously calls these narratives Black messages "sealed within a white envelope" (502). For more recent interventions, see Neary, *Fugitive Testimony*, who summarizes the conundrum as follows: "Before the black subject could speak, he or she must be legitimated by white authority. . . . Thus, to enter into the slave narrative is to enter a site of racial

constraint; the ex-slave narrator must explicitly engage the logic of racial slavery while implicitly critiquing its philosophical presumptions, specifically, the presumption that the black subject at the center is less than human" (14).

23. Tina Campt, *Image Matters: Archive, Photography, and the African Diaspora in Europe* (Durham, NC: Duke University Press, 2012), 6.

24. For critics who have read Brown as a performance artist, see Wood, who suggests that we can best understand Brown's art via the rubrics of "installation and performance art" (*Blind Memory*, 116); Brooks, who considers how Brown uses "performative strategies to transcend the corporeal as well as the discursive restrictions laid upon him as a fugitive slave" (*Bodies in Dissent*, 126); and Neary, who is attentive to how his narratives and his panoramas together destabilize "the very terms of the visible" and undermine "the evidentiary epistemology of abolition" (*Fugitive Testimony*, 133).

Chapter 1

1. On the concept of "fugitive performance," see Janet Neary, *Fugitive Testimony: On the Visual Logic of Slave Narratives* (New York: Fordham University Press, 2016), 23–34 and 131.

2. I am also influenced by Anne Anlin Cheng's argument that Josephine Baker made models of herself in her performances that she wears "like second skin." See *Second Skin: Josephine Baker and the Modern Surface* (New York: Oxford University Press, 2013), 66.

3. Neary, *Fugitive Testimony*, 5–7.

4. See Christopher Schankin and Peter J. Goadsby, "Visual Snow—Persistent Positive Visual Phenomenon Distinct from Migraine Aura," *Current Pain and Headache Reports* 19, no. 6 (2015), https://doi.org/10.1007/s11916-015-0497-9.

5. See Martha J. Cutter, *The Illustrated Slave: Empathy, Graphic Narrative, and the Visual Culture of the Transatlantic Abolition Movement, 1800–1852* (Athens: University of Georgia Press, 2017); Marcus Wood, *Blind Memory: Visual Representation of Slavery in England and America, 1780–1865* (New York: Routledge, 2000); Simon Gikandi, *Slavery and the Culture of Taste* (Princeton, NJ: Princeton University Press, 2011); and Jasmine Nichole Cobb, *Picture Freedom: Remaking Black Visuality in the Early Nineteenth Century* (New York: New York University Press, 2015).

6. Michel Foucault, *Discipline and Punish*, trans. Alan Sheridan (New York: Vintage, 1995), 200.

7. Nicholas Mirzoeff, *The Right to Look: A Counterhistory of Visuality* (Durham: Duke University Press, 2011).

8. Judith Butler, "Critically Queer," *GLQ: A Journal of Lesbian and Gay Studies* 1, no. 1 (1993), 17–32 at 22.

9. See Cutter, *Illustrated Slave*, 1–10 and 29–31.

10. For an articulation of the reasons behind the refusal to verbally describe scenes of violence, see Saidiya Hartman, *Scenes of Subjection: Terror, Slavery, and Self-Making in Nineteenth-Century America* (New York: Oxford University Press, 1997), 3–4. For a rebuttal, see Fred Moten, *In the Break: The Aesthetics of the Black Radical Tradition* (Minneapolis: University of Minnesota Press, 2003), 1–24.

11. See Cutter, *Illustrated Slave*, 1–13 and 53–56.

12. Matthew Fox-Amato, *Exposing Slavery: Photography, Human Bondage, and the Birth of Modern Visual Politics in America* (New York: Oxford University Press, 2019), 2.

13. See *Harper's Weekly*, July 4, 1863, https://www.loc.gov/resource/cph.3b44593.

14. "Mostly About a Slave's Back," *National Anti-Slavery Standard*, August 22, 1863, 4. Quoted in Fox-Amato, *Exposing Slavery*, 287n72. Some have argued that abolitionists

conflated the histories of different men to create the triptych; see David Silkenat, "'A Typical Negro': Gordon, Peter, Vincent Coyler, and the Story Behind Slavery's Most Famous Photograph," *American Nineteenth Century History* 15, no. 2 (2014), 169–186.

15. Fox-Amato, *Exposing Slavery*, 173.

16. Ariella Azoulay, *The Civil Contract of Photography* (New York: Zone, 2008), 175.

17. See *Harper's Weekly*, January 30, 1864, https://archive.org/details/harpersweeklyv-8bonn/page/68/mode/2up; and "Learning Is Wealth," photograph, https://www.loc.gov/item/2010647859. In both, Wilson is well dressed.

18. Laura Wexler, *Tender Violence: Domestic Visions in an Age of U.S. Imperialism* (Chapel Hill: University of North Carolina Press, 2000), 133 and 167.

19. Tina Campt, *Listening to Images* (Durham, NC: Duke University Press, 2017), 59.

20. Fox-Amato, *Exposing Slavery*, 14.

21. As the historian Ken Padgett notes, during the 1850s, ten theaters in New York City were devoted almost solely to minstrel entertainment. After 1870, the fashion for minstrelsy abated somewhat. See *Blackface! The History of Racist Blackface Stereotypes*, https://www.black-face.com.

22. See Eric Lott, *Love & Theft: Blackface Minstrelsy and the American Working Class* (New York: Oxford University Press, 1993), 115–21. Lott contends that Blackface presented the African American male body as "a powerful cultural sign of sexuality as well as a sign of the dangerous guilt-inducing physical reality of slavery" (118).

23. See Frederick Douglass, "The Hutchinson Family," *North Star*, October 27, 1848 (AAN).

24. For discussion of the differences between minstrel shows in the US and England, see Michael Pickering, *Blackface Minstrelsy in Britain* (Farnham: Ashgate, 2008); and Sarah Meer, *Uncle Tom Mania: Slavery, Minstrelsy and Transatlantic Culture in the 1850s* (Athens: University of Georgia Press, 2005).

25. See Meer, *Uncle Tom Mania*, 153.

26. Robert Nowatzki, *Representing African Americans in Transatlantic Abolitionism and Blackface Minstrelsy* (Baton Rouge: Louisiana State University Press, 2010), 64.

27. See Cutter, "'As White as Most White Women': Racial Passing in Advertisements for Runaway Slaves and the Origins of a Multivalent Term," *American Studies* 54, no. 4 (2016): 73–97, and "Why Passing Is (Still) Not Passé After 250 Years: Sources from the Past and Present," in *Neo-Passing: Performing Identity after Jim Crow*, ed. Mollie Godfrey and Vershawn Young (Champaign: University of Illinois Press, 2018), 49–67.

28. See P. Gabrielle Foreman, "Who's Your Mama? 'White' Mulatta Genealogies, Early Photography, and Anti-Passing Narratives of Slavery and Freedom," *American Literary History* 14, no. 3 (2002): 506–8. See also Neary's persuasive reading of how narrative text works in tandem with the portrait to keep "multiple interpretations of Ellen's body in view" (*Fugitive Testimony*, 84).

29. Ellen Samuels, "'A Complication of Complaints': Untangling Disability, Race, and Gender in William and Ellen Craft's *Running a Thousand Miles for Freedom*," *MELUS* 31, no. 3 (2006): 15–47.

30. Keith Byerman, "We Wear the Mask: Deceit as Theme and Style in Slave Narratives," in *The Art of Slave Narrative: Original Essays in Criticism and Theory*, ed. John Sekora and Darwin T. Turner (Macomb: Western Illinois University Press, 1982), 74.

31. Samuels, "A Complication," 20.

32. William and Ellen Craft, *Running a Thousand Miles for Freedom: The Escape of William and Ellen Craft from Slavery* (1860), ed. Barbara McCaskill (Athens: University of Georgia Press, 1999), 12.

33. Lindon Barrett, "Hand-Writing: Legibility and the White Body in *Running a Thousand Miles for Freedom*," *American Literature* 69, no. 2 (1997): 315.

34. William and Ellen Craft, *Running a Thousand Miles*, 23–24.

35. Ibid., 35.

36. Sterling Bland, *Voices of the Fugitives: Runaway Slave Stories and Their Fictions of Self- Creation* (Westport, CT: Greenwood Press, 2000), 150.

37. Dawn Keetley, "Racial Conviction, Racial Confusion: Indeterminate Identities in Women's Slave Narratives and Southern Courts," *a/b: Auto/Biography Studies* 10, no. 2 (1995): 14.

38. See also Barbara McCaskill's argument that "Ellen's frontispiece portrait articulates the death of herself as a captive commodity and her resurrection as a wily, liberated subject"; "'Yours Very Truly': Ellen Craft—The Fugitive as Text and Artifact," *African American Review* 28, no. 4 (1994): 516.

39. I am summarizing Neary's argument; see *Fugitive Testimony*, 28 and 89. See also Michael Chaney's argument that the portrait of Ellen in disguise achieves only a "form of looking that abjures decidability"; *Fugitive Vision: Slave Image and Black Identity in Antebellum Narrative* (Bloomington: Indiana University Press, 2007), 109.

40. Samira Kawash, "Fugitive Properties," in *The New Economic Criticism: Studies at the Interface of Literature and Economics*, ed. Mark Osteen and Martha Woodmansee (New York: Routledge, 2005), 279.

41. William Wells Brown, *The Escape; or A Leap for Freedom* (Boston: P. F. Wallcut, 1858) was not published until 1858. However, Wells Brown performed it in a public reading in Salem, OH, on February 4, 1847; see Leo Hamalian and James V. Hatch, eds., *The Roots of African American Drama: An Anthology of Early Plays* (Detroit: Wayne State University Press, 1991), 39. Also see Ezra Greenspan, who describes Wells Brown reading two plays in 1858 in *William Wells Brown: An African American Life* (New York: Norton, 2014).

42. The Great Exhibition of the Works of Industry of All Nations (also known as the Crystal Palace Exhibition) took place in London, from May 1 to October 15, 1851. Wells Brown and the Crafts staged their walking protest on June 21. See Greenspan, *William Wells Brown*, 252–5, and Lisa Merrill, "Exhibiting Race," *Slavery & Abolition* 33, no. 2 (2012): 321–36.

43. Merrill, "Exhibiting Race," 333–4.

44. Greenspan, *William Wells Brown*, 244–50.

45. Sergio Costola, "William Wells Brown's Panoramic Views," *Journal of American Drama and Theatre* 24, no. 2 (2012): 14. See also John Ernest's important argument that in many works Wells Brown seeks not to write linear and stable history, but to interrupt official narratives of US history and make a new bricolage history out what has been ignored; *Liberation Historiography: African American Writers and the Challenge of History, 1794–1861* (Chapel Hill: University of North Carolina Press, 2004), 340.

46. See Costola, "William Wells Brown's Panoramic Views"; Greenspan, *William Wells Brown*, 239–49; Chaney, *Fugitive Vision*, 49–79; and Aston Gonzalez, *Visualizing Equality: African American Rights and Visual Culture in the Nineteenth Century* (Chapel Hill: University of North Carolina Press, 2020), 120–33.

47. William Wells Brown, *A Description of William Wells Brown's Original Panoramic Views of the Scenes in the Life of an American Slave* (London: Charles Gilpin, 1849), *Cornell University Library Digital Collections*, https://digital.library.cornell.edu/catalog/may865211.

48. See Orlando Patterson, *Slavery and Social Death: A Comparative Study* (Cambridge, MA: Harvard University Press), 1982.

49. For one extension of Patterson's argument into contemporary times, see Frank Wilderson III, *Afropessimism* (New York: Liveright, 2020).

50. Wells Brown, *A Description*, 23.

51. Ibid., 29.

52. Ibid., 37.

53. Azoulay, *Civil Contract*, 18 and 22.

54. See Erkki Huhtamo, *Illusions in Motion: Media Archaeology of the Moving Panorama and Related Spectacles* (Cambridge, MA: MIT Press, 2013).

55. See William Wells Brown, *Narrative of William W. Brown, a Fugitive Slave. Written by Himself* (Boston: American Anti-Slavery Society, 1847), https://docsouth.unc.edu/neh/brown47/menu.html; and William Wells Brown, *Narrative of William W. Brown, an American Slave. Written by Himself* (London: C. Gilpin, 1849), https://docsouth.unc.edu/fpn/brownw/menu.html.

56. See *Montrose, Arbroath and Brechin Review; and Forfar and Kincardineshire Advertiser* (Angus, Scotland), April 23, 1852, which reports that Wells Brown's "lecture and panorama combined appeal most powerfully to the feelings of the audience, and are well fitted for stirring up every right minded person to assisting in bringing to a speedy termination the accursed traffic in human beings." Also see reviews in the *Aberdeen Herald and General Advertiser* on February 15, 1851, and in the *Stamford Mercury* (Lincolnshire, England) on October 3, 1851. All in BNA.

57. Wells Brown, *A Description*, 32.

58. Ibid., 34.

59. A scene in Wells Brown's 1849 *Narrative* does however correspond to this scene in the panorama; see page 72.

60. Wells Brown, *A Description*, 19–20.

61. Chaney, *Fugitive Vision*, 132–4.

62. Costola, "William Wells Brown's Panoramic Views," 14.

63. Ernest, *Liberation Historiography*, 39–40.

64. Frederick Douglass, review of *A Tribute to the Negro*, *North Star*, April 7, 1849 (AAN).

65. Elin Diamond, Introduction, in *Performance and Cultural Politics*, ed. Diamond (London: Routledge, 1996), 1 and 5.

66. See Roland Barthes, *Camera Lucida: Reflections on Photography*, trans. Richard Howard (New York: Hill and Wang, 1981), 32; and Herbert Blau, "Flat-Out Vision," in *Performance and Cultural Politics*, ed. Diamond, 188–9.

67. "The Negro as a Man," unpublished manuscript, ca. mid-1850s, Frederick Douglass Papers, Library of Congress, manuscript page 23, https://www.loc.gov/item/mfd.31025.

68. Douglass, "Pictures and Progress," in *Picturing Frederick Douglass: An Illustrated Biography of the Nineteenth Century's Most Photographed Man*, ed. John Stauffer, Zoe Trodd, and Celeste-Marie Bernier (New York: Liveright, 2015), 165.

69. Stauffer, Trodd, and Bernier, Introduction to *Picturing Frederick Douglass*, i–xxviii.

70. Fox-Amato, *Exposing Slavery*, 2 and 21.

71. Ibid., 58.

72. See David W. Blight, *Frederick Douglass: Prophet of Freedom* (New York: Simon and Schuster, 2018), 376.

73. For analysis of these daguerreotypes, see Brian Wallis, "Black Bodies, White Science: Louis Agassiz's Slave Daguerreotypes," *American Art* 9, no. 2 (1995): 38–61; and Azoulay, *Civil Contract*, 176–86.

74. Azoulay, *Civil Contract*, 176.

75. Christina Sharpe, *In the Wake: On Blackness and Being* (Durham: Duke University Press, 2016), 43. Sharpe argues that the gazes of the two women—Delia and Drana—look "past the white people who claimed power over them and the instrument by which they are being further subjected in ways they could never have imagined or anticipated" (118).

76. See, for example, Stauffer, Trodd, and Bernier, *Picturing Frederick Douglass*; also see the essays collected in *Pictures and Power: Imaging and Imagining Frederick Douglass (1818–2018)*, ed. Celeste-Marie Bernier and Bill E. Lawson (Liverpool: Liverpool University Press, 2017). Two excellent essays on Douglass and photography appear in *Pictures and Progress: Early Photography and the Making of African American Identity*, ed. Maurice O. Wallace and Shawn Michelle Smith (Durham, NC: Duke University Press, 2012): Laura Wexler's "'A More Perfect Likeness': Frederick Douglass and the Image of the Nation" (18–39), and Ginger

Hill's "'Rightly Viewed': Theorization of Self in Frederick Douglass's Lectures on Pictures" (41–80).

77. Wexler, "'A More Perfect Likeness,'" 18–39.

78. As Nell Irvin Painter notes, in the nineteenth century many people believed that photographs were, in the words of Henry David Thoreau, "an exact and accurate description of facts." Yet because portrait photography was commercialized, with set poses and formulaic presentations, any manipulation of it could be noteworthy. Therefore, as Painter notes, photography "is a sign system and has its own rhetorics of representation"; it could be manipulated like any other sign system. See "Representing Truth: Sojourner Truth's Knowing and Becoming Known," *Journal of American History* 81, no. 2 (1994): 486.

79. Campt, *Image Matters: Archive, Photography, and the African Diaspora in Europe* (Durham: Duke University Press, 2012), 17.

80. Neary, *Fugitive Testimony*, 27.

81. See, for example, a quarter-plate daguerreotype, circa 1848, of Douglass presented by him to Susan B. Anthony in the Albert Cook Myers Collection, Chester County Historical Society, West Chester, PA.

82. See the photographs in Stauffer, Trodd, and Bernier, eds. *Picturing Frederick Douglass*, 13, 14, 15, 16, 17, 22, and 23.

83. Donna Wells, "Pictures and Progress: Frederick Douglass and the Beginnings of an African American Aesthetic in Photography," *Pictures and Power*, ed. Bernier and Lawson, 48.

84. Bernier and Lawson, Introduction, *Pictures and Power*, 31.

85. Azoulay, *Civil Contract*, 86.

86. Sharon Sliwinski, *Human Rights in Camera* (Chicago: University of Chicago Press, 2011), 5.

87. Douglass helped many individuals achieve freedom. See Blight, *Frederick Douglass*, 243–5.

88. Frederick Douglass, "The Meaning of July Fourth for the Negro. A speech given at Rochester, New York, July 5, 1852," https://masshumanities.org/wp-content/uploads/2019/10/speech_complete.pdf.

89. Frederick Douglass, "Pictures and Progress," in *Picturing Frederick Douglass*, ed. Stauffer, Trodd, and Bernier, 166.

90. Ibid., 171.

91. See image in Stauffer, Trodd, and Bernier, eds., *Picturing Frederick Douglass*, 16.

92. Ibid., 19.

93. Henri Cartier-Bresson, *The Mind's Eye: Writings on Photography and Photographers* (New York: Aperture, 1999), 29.

94. Azoulay, *Civil Contract*, 14.

95. Designed and sculpted by Thomas Ball and erected in 1876, this monument today stands in Lincoln Park in DC and is known as "The Freedman's Memorial" or "Emancipation Monument."

96. All three quotes from Frederick Douglass, "Oration in Memory of Abraham Lincoln," April 14, 1876, in *Lift Every Voice: African American Oratory, 1787–1900*, ed. Philip Sheldon Foner and Robert J. Branham (Tuscaloosa: University of Alabama Press, 1998), 570.

97. See "Eulogy on Abraham Lincoln, June 1, 1865," holograph document, Frederick Douglass Papers, Manuscript Division, Library of Congress, Digital ID # al0177, https://www.loc.gov/exhibits/lincoln/lincoln-and-frederick-douglass.html.

98. Douglass, "Oration in Memory," 570–1.

99. Barthes, *Camera Lucida*, 32.

100. Shawn Michelle Smith, *At the Edge of Sight: Photography and the Unseen* (Durham, NC: Duke University Press, 2013), 190.

101. Sharpe, *In the Wake*, 22.

102. Frederick Douglass, "Age of Pictures," 1862, in *Picturing Frederick Douglass*, ed. Stauffer, Trodd, and Bernier, 142.

103. See image in Stauffer, Trodd, and Bernier, eds., *Picturing Frederick Douglass*, 65.

104. Azoulay, *Civil Contract*, 312.

105. Darcy Grimaldo Grigsby, *Enduring Truths: Sojourner's Shadows and Substance* (Chicago: University of Chicago Press, 2015), 28.

106. Sojourner Truth, *Narrative of Sojourner Truth; a Bondswoman of Olden Time, Emancipated by the New York Legislature in the Early Part of the Present Century; with a History of Her Labors and Correspondence, Drawn from Her "Book of Life"* (Boston: 1875), 140–41, Internet Archive, https://archive.org/details/narrativeofsojou7231gilb.

107. Grigsby, *Enduring Truths*, 29.

108. Painter, "Representing Truth," 483. Painter also argues that Truth's photographic portraits do not convey "authentic being" or a simple truth; in her *cartes de visite*, as in other photographs, "the sense of reality is enigmatic" (487).

109. Ibid., 482. According to Painter, in the US, photographic portraiture spread as soon as photography was invented in 1839. Daguerreotypes were the main form of portraiture in the 1840s, but they were expensive and only a single image could be printed from each plate. *Cartes de visite*, on the other hand, invented in the mid-1850s, used a camera with four to twelve lenses exposing different portions of a single large plate; when the lenses were opened simultaneously, several photos of the same pose were created. The photographic lenses could also be opened sequentially while the person adjusted his or her pose, creating slightly different images. Because *cartes de visite* were cheap to produce, they became the most popular form of portrait in the early 1860s.

110. Ibid., 483.

111. See Campt, *Listening to Images*, 60.

112. Azoulay, *Civil Contract*, 18 and 22.

113. Campt, *Image Matters*, 9.

114. Azoulay, *Civil Contract*, 143.

115. Painter, "Representing Truth," 485.

116. Campt, *Image Matters*, 79.

117. See, for example, the 1864 photograph of Truth on the Metropolitan Museum of Art's website, https://www.metmuseum.org/art/collection/search/301989.

118. See, for example, the 1882 captioned cabinet photographs of Truth by Croydon C. Randall found in Grigsby, *Enduring Truths*, 181.

119. Letter from Sojourner Truth (transcribed by Euphemia Cochrane) to Mary K. Gale, February 25, 1864; Sojourner Truth Collection, Library of Congress, Manuscript Division, https://www.loc.gov/exhibits/african-american-odyssey/images/04/0413001r.jpg.

120. Thierry Groensteen, *The System of Comics*, trans. Bart Beaty and Nick Nguyen (Jackson: University of Mississippi Press, 2007 [1999]), 128.

121. Painter seems to take this as the overt meaning of this motto; she argues that the motto "explains the photograph's fund-raising function"; see "Representing Truth," 485.

122. Augusta Rohrbach, "Shadow and Substance: Sojourner Truth in Black and White," in *Pictures and Progress*, ed. Wallace and Smith, 96.

123. Painter, "Representing Truth," 462.

124. Moten, *In the Break*, 210 and 205.

125. Anne Anlin Cheng, *Second Skin: Josephine Baker and the Modern Surface* (New York: Oxford University Press, 2010), 175.

126. Neary, *Fugitive Testimony*, 28.

Chapter 2

1. Henry Box Brown, *Narrative of the Life of Henry Box Brown, Written by Himself* (Manchester: Lee and Glynn, 1851), 53, *Documenting the American South*, https://docsouth.unc .edu/neh/brownbox/brownbox.html.

2. Christina Sharpe, *In the Wake: On Blackness and Being* (Durham: Duke University Press, 2016), 14–15.

3. Daphne Brooks, *Bodies in Dissent: Spectacular Performances of Race and Freedom, 1850–1910* (Durham: Duke University Press, 2006), 68. Brooks is not alone in seeing *Mirror of Slavery* as liberating for Brown; Cynthia Griffin Wolff, for example, claims that it allowed Brown to craft "an entirely new kind of African American narrative, one that was radically different from the standard slave's story," "Passing Beyond the Middle Passage: Henry 'Box' Brown's Translations of Slavery," *Massachusetts Review* 37, no. 1 (1996): 30–1.

4. For a discussion of the term "visual static," see the Introduction.

5. See *Merriam-Webster* definition of *spectacle*: "1a: something exhibited to view as unusual, notable, or entertaining, especially an eye-catching or dramatic public display; 1b: an object of curiosity or contempt; made a spectacle of herself"; https://www.merriam-webster .com/dictionary/spectacle.

6. Amy Hughes, *Spectacles of Reform: Theater and Activism in Nineteenth-Century America* (Ann Arbor: University of Michigan Press, 2012), 15.

7. Ibid., 16.

8. Jeffrey Ruggles believes that Brown did not actually put the words on paper. See *The Unboxing of Henry Brown* (Richmond: Library of Virginia, 2003), 129.

9. See John Ernest, "Outside the Box: Henry Box Brown and the Politics of Antislavery Agency," *Arizona Quarterly* 63, no. 4 (2007): 3 and 15.

10. For analyses of Brown's narrative, see Ruggles, *Unboxing of Henry Brown* (128–31); John Ernest, "Outside the Box" and "Traumatic Theology in the *Narrative of the Life of Henry Box Brown, Written by Himself*," *African American Review* 41, no. 1 (2007): 19–31; Marcus Wood, "'All Right!': The *Narrative of Henry Box Brown* as a Test Case for the Racial Prescription of Rhetoric and Semiotics," *Proceedings of the American Antiquarian Society* 107, no. 1 (1997): 65–104 and *Blind Memory: Visual Representation of Slavery in England and America, 1780–1865* (New York: Routledge, 2000); Janet Neary, *Fugitive Testimony: On the Visual Logic of Slave Narratives* (New York: Fordham University Press, 2016), 141–9; and Wolff, "Passing Beyond the Middle Passage." According to Ruggles, the 1851 text appears to have been popular, selling out its first edition of eight thousand copies in two months (*Unboxing*, 65). Moreover, as I document in the next chapter, it was still being reprinted as late as 1860.

11. Brown, *Narrative of the Life* (1851), 9 and 21.

12. Ibid., 16.

13. Ibid., 16–7.

14. Ibid., 16.

15. Ibid., 17.

16. Ibid.

17. Ibid., 46.

18. Ibid.

19. Ibid., 44–7.

20. Henry Brown and Charles Stearns, *Narrative of Henry Box Brown, Who Escaped from Slavery Enclosed in a Box 3 Feet Long and 2 Wide. Written from a Statement of Facts Made by Himself. With Remarks Upon the Remedy for Slavery. By Charles Stearns* (Boston: Brown and Stearns, 1849), 55, *Documenting the American South,* https://docsouth.unc.edu /neh/boxbrown/boxbrown.html.

21. Brown, *Narrative of the Life* (1851), 47.

22. Hughes, *Spectacles of Reform*, 16.

23. Saidiya Hartman, *Scenes of Subjection: Terror, Slavery, and Self-Making in Nineteenth-Century America* (New York: Oxford University Press, 1997), 53, 54, 68, and 51.

24. Ginger Hill, "'Rightly Viewed': Theorization of Self in Frederick Douglass's Lectures on Pictures," in *Pictures and Progress: Early Photography and the Making of African American* Identity, ed. Maurice O. Wallace and Shawn Michelle Smith (Durham: Duke University Press, 2012), 42.

25. Frederick Douglass, "Pictures and Progress," Frederick Douglass Papers at the Library of Congress: Speech, Article, and Book File, 1846–1894, ca. 1864–1865, 18, https://www.loc.gov/resource/mfd.28009/?sp=18.

26. Brown, *Narrative of the Life* (1851), 48. Because it was illegal for African Americans to preach in Richmond in this period, senior ministers were white; the first senior minister, Robert Rylan, served from 1841 until 1865, owned slaves, and believed that slavery was the best way to convert Africans to Christianity. See Lois Leveen, "The North of the South," *New York Times*, January 24, 2011.

27. Brown, *Narrative of the Life* (1851), 51.

28. Ibid., 52.

29. Ibid., 54.

30. Ibid., 56–7.

31. Ibid., iii–iv.

32. Jim Magus, *Magical Heroes: The Lives and Legends of Great African American Magicians* (Marietta, GA: Magus Enterprises, 1995), 32.

33. Ibid., 37.

34. Brown, *Narrative of the Life* (1851), 57.

35. *King James Bible* Online, https://www.kingjamesbibleonline.org/Psalms-Chapter-40.

36. "Engraving of the Box in which Henry Box Brown escaped from slavery in Richmond, Va. Song, Sung by Mr. Brown on being removed from the box," Boston Laing's Steam Press, 1-1-2 Water Street, ca. 1849, Library of Congress, https://www.loc.gov/resource/rbpe.06501600/?sp=1.

37. Ruggles dates this song sheet to June 1849 or thereabouts because it appears to have been sung at an abolitionist gathering on August 3, 1849. He believes it is the "first visual representation of Brown's escape" and that it predates his first autobiography, written by Charles Stearns and published in early September 1849 (*Unboxing*, 55 and 61).

38. Brown, *Narrative of the Life* (1851), 60.

39. Ruggles, *Unboxing*, 86.

40. For analysis of the hymn and of music in general in Brown's narrative, see Brooks, *Bodies in Dissent*, 102–4; Wood, "'All Right!,'" 81; Ruggles, *Unboxing*, 14–22; and Ernest, "Outside the Box," 15–7.

41. Hartman, *Scenes of Subjection*, 66.

42. Brown, *Narrative of the Life* (1851), 24.

43. See Arthur Schrader, "Singing SHEAR History: A Commentary and Music Sampler," *Journal of the Early Republic* 21, no. 4 (2001): 667–90.

44. There are minor changes in wording in later printings. Therefore, as Ruggles notes, "Brown had taken control of his songs. . . . At the second printing Brown was in a position to assert his authorship of the song" (*Unboxing*, 86).

45. Brooks, *Bodies in Dissent*, 74.

46. The most comprehensive analysis of images of Brown is given in Wood's "'All Right!'" Also see Martha J. Cutter, *The Illustrated Slave: Empathy, Graphic Narrative, and the Visual*

Culture of the Transatlantic Abolition Movement, 1800–1852 (Athens: University of Georgia Press, 2017), 198–206.

47. Ruggles, *Unboxing,* 83.

48. Cutter, *Illustrated Slave*, 197–206.

49. "The Running of Slaves"; article originally published in the *New York Evening Post* and republished on June 12, 1849, in the *Richmond Inquirer* (newspapers.com).

50. Ruggles, *Unboxing*, 49.

51. Brown was present at other antislavery gatherings but there is no evidence he spoke; see for example the *Liberator*'s report on the New England Anti-Slavery Convention in June of 1849, which mentions that "Wendell Phillips" took the platform with "Henry (Box) Brown" at his side, and "eulogized his patient and disinterested heroism"; *Liberator*, June 8, 1849 (EAN).

52. *North Star,* August 24, 1849, reporting on an event that took place on July 15, 1849 (AAN).

53. *North Star*, November 16, 1849, "Henry Box Brown, in Milford" (AAN). Brown also attended a large antislavery gathering in Syracuse in January of 1850; see *North Star*, January 25, 1850 (AAN).

54. For lectures by Box Brown and Bibb together, see the *Washington Union* from January 17, 1850 (newspapers.com).

55. See Shelly Jarenski, *Immersive Words: Mass Media, Visuality, and American Literature, 1839–1893* (Tuscaloosa: University of Alabama Press, 2015).

56. Hughes, *Spectacles of Reform*, 13–4.

57. Ezra Greenspan, *William Wells Brown: An African American Life* (New York: Norton, 2014), 240.

58. See poster at American Broadsides & Ephemera, Series 1, https://commons.wikimedia.org/w/index.php?curid=9455411.

59. For more on the role of the pastoral in panoramas depicting slavery, see Michael Chaney, *Fugitive Vision: Slave Image and Black Identity in Antebellum Narrative* (Bloomington: Indiana University Press, 2008), 63 and 120–2.

60. John Banvard, *Description of Banvard's Panorama of the Mississippi River* (Boston: John Putnam, 1847), 31, Internet Archive, https://archive.org/stream/descriptionofban00banv?ref=ol.

61. Ibid., 27.

62. Hazel Waters, *Racism on the Victorian Stage: Representations of Slavery and the Black Character* (Cambridge: Cambridge University Press, 2007), 127.

63. See Erkki Huhtamo, *Illusions in Motion: Media Archaeology of the Moving Panorama and Related Spectacles* (Cambridge, MA: MIT Press, 2013), 193.

64. Josiah Clark Nott, *Two Lectures on the Natural History of the Caucasian and Negro Races* (Mobile, AL: Dade and Thompson, 1844), 8, emphasis in original. For more on this topic, see Bruce Baum, *The Rise and Fall of the Caucasian Race: A Political History of Racial Identity* (New York: New York University Press, 2006), 108.

65. David J. Meltzer, "Ephraim Squier, Edwin Davis, and the Making of an American Archaeological Classic," in *Ancient Monuments of the Mississippi Valley* (1848), ed. Meltzer (Washington: Smithsonian, 1988), 1–97.

66. See "A Scene with the Mummy," *Philadelphia Ledger*, January 13, 1851. Republished in Signor Blitz, *Vagaries of a Ventriloquist* (Philadelphia: U. States Steam Power Book, 1851), 16.

67. Huhtamo, *Illusions in Motion*, 192–3.

68. Kathleen Chater, *Henry Box Brown: From Slavery to Show Business* (Jefferson, NC: McFarland, 2020), 27.

69. Angela Miller, "The Panorama, the Cinema, and the Emergence of the Spectacular," *Wide Angle* 18, no. 2 (1996): 55 and 58.

70. It was reported that James C. A. Smith, after his falling out with Brown, also toured with a panorama in 1851; see C. Peter Ripley, *The Black Abolitionist Papers, Vol. 1: The British Isles, 1830–1865* (Chapel Hill: University of North Carolina Press, 1985), ed. Ripley, 293 and 298. I have been unable to verify this, but I do find Smith with a panorama of *Uncle Tom's Cabin* in April to May of 1853, as discussed later in this chapter. Several years later in 1855, James Presley Ball published an abolitionist pamphlet describing his panorama, "Mammoth Pictorial Tour of the United States Comprising Views of the African Slave Trade"; this panorama toured in Cincinnati, Cleveland, and Boston in 1855. And in 1858, Anthony Burns, another famous fugitive slave, also created a panorama about slavery. See Robert Hall, "Massachusetts Abolitionists Document the Slave Experience" in *Courage and Conscience: Black and White Abolitionists in Boston*, ed. Donald M. Jacobs (Bloomington: Indiana University Press, 1993), 92; and Nancy Osgood, "Josiah Wolcott: Artist and Associationist," *Old Time New England* (Spring-Summer 1998), 19, https://www.yumpu.com/en/document/read/12219434/josiah-wolcott-amazon-web-services.

71. Ruggles, *Unboxing*, 88.

72. Christine Ariella Crater, "Brown, Henry Box," *Pennsylvania Center for the Book*, Pennsylvania State University, spring 2011, https://pabook.libraries.psu.edu/literary-cultural-heritage-map-pa/bios/Brown__Henry_Box.

73. Aston Gonzalez, *Visualizing Equality: African American Rights and Visual Culture in the Nineteenth Century* (Chapel Hill: University of North Carolina Press, 2020), 115. Gonzalez also gives an excellent selection of the reviews and reactions to *Mirror of Slavery* in England.

74. See Joon Hyung Park, "From Transcendental Subjective Vision to Political Idealism: Panoramas in Antebellum American Literature" (PhD diss., Texas A&M University, 2012), 142.

75. Stephen Browne, "'Like Gory Specters': Representing Evil in Theodore Weld's *American Slavery as It Is*," *Quarterly Journal of Speech* 80, no. 3 (1994): 277.

76. Brooks, *Bodies in Dissent*, 83.

77. For a more detailed analysis of *Mirror of Slavery*, see Cutter, *Illustrated Slave*, Chapter 5.

78. "Panorama Exhibition of the Slave System," *Liberator*, April 19, 1850 (AHP).

79. *Boston Herald*, April 30 and May 1, 1850, quoted in Osgood, "Josiah Wolcott," 18.

80. *Liberator,* May 3 and May 10, 1850 (AHP); *Worcester Massachusetts Spy*, May 8 and May 15, 1850 (Ruggles, *Unboxing*, 89); *Springfield Republican*, May 22, 1850 (Ruggles, *Unboxing*, 89).

81. *Morning Star* (Limerick, ME), July 17, 1850 (AHP).

82. "Box Brown in Worcester," *Liberator*, May 3, 1850 (AHP).

83. This gives the panorama a strong effect: "This is not a mere delineation of landscape, but a succession of scenes of human action, addressed to the whole mind, and especially to the highest faculties. . . . It is at once a superior picture and a useful lesson." *Daily Evening Traveller* (Boston), April 29, 1850, quoted in Osgood, "Josiah Wolcott," 18.

84. *Liberator*, April 26, 1850 (AHP).

85. Britt Rusert, *Fugitive Science: Empiricism and Freedom in Early African American Culture* (New York: New York University Press, 2017), 17.

86. *Providence Post* (Monday Morning Edition), September 2, 1850 (microfilm).

87. *Providence Post* (Monday Morning Edition), September 3, 1850 (microfilm).

88. *Liberator*, September 5, 1850 (EAN).

89. *Boston Evening Transcript*, September 10, 1850 (microfilm).

90. *Baltimore Sun*, September 13, 1850 (newspapers.com).

91. For example, in 1842 *Prigg v. Pennsylvania* was argued in the Supreme Court of the United States; it overturned the conviction of a slave catcher named Edward Prigg in

Pennsylvania on the grounds that federal law (which allowed for the recovery of fugitive slaves) superseded state law. This case had started out in the court of quarter sessions. See *Prigg v. Pennsylvania*, 41 U.S. 539 (1842), https://supreme.justia.com/cases/federal/us/41 /539.

92. Thomas Morris, *Free Men All: The Personal Liberty Laws of the North, 1780–1861* (New Jersey: Lawbook Exchange, 2008), 220.

93. "A Fugitive Slave in Liverpool," *Liverpool Mercury*, November 5, 1850 (BNA).

94. The Fugitive Slave Compromise of 1850 was passed on September 18. As a federal law, it superseded all personal liberty laws passed on the state level.

95. Suzette Spencer, Jeffrey Ruggles and the *Dictionary of Virginia Biography*, "Henry Box Brown (1815 or 1816–1897)," *Encyclopedia Virginia*. Virginia Humanities, April 14, 2017, https://www.encyclopediavirginia.org/Brown_Henry_Box_ca_1815#start_entry.

96. For a long discussion of this conflict, see Ruggles, *Unboxing*, 132–7. Smith claimed that Brown stole money that they had earned together and was a gambler and drunkard. He also claimed that Brown had money to buy his wife, Nancy, from her enslaver but did not try to do so, and that Brown instead planned to marry a white British woman. The allegations meant that Brown was ousted from the abolition movement. However, the bitter rivalry between the two men is narrated in a one-sided way in Smith's letters to prominent abolitionists, while Brown's side of the conflict goes untold.

97. See *Liverpool Mercury*, November 12, 1850 (newspapers.com).

98. See also the *Liverpool Mercury* on November 15, 1850, where this performance is mentioned again (newspapers.com).

99. See *Liverpool Mercury*, November 22, 1850 (newspapers.com).

100. *Manchester Weekly Times and Examiner*, October 22, 1853 (newspapers.com).

101. *Huddersfield Chronicle and West Yorkshire Advertiser*, October 29, 1853 (newspapers .com).

102. *Huddersfield Chronicle and West Yorkshire Advertiser*, November 5, 1853 (newspapers.com). Also see the *Halifax Guardian*, October 29, 1853 (BNA), for a performance in Todmorden that puts Box Brown in the role of leading the group.

103. *Era*, May 23, 1852 (newspapers.com).

104. See Audrey Fisch, "'Negrophilism' and British Nationalism: The Spectacle of the Black American Abolitionist," *Victorian Review* 19, no. 2 (1993), 21. Also see Ripley, *Black Abolitionist Papers, Vol. 1*, 18.

105. *Liverpool Mercury,* November 15, 1850 (BNA).

106. *Preston Chronicle,* January 25, 1851 (BNA).

107. The *Manchester Guardian* on August 30, 1851, describes Brown's exhibiting of his panorama of the horrors of slavery as being "crowded to excess" and reports "many were unable to gain admission" (newspapers.com).

108. Ruggles, *Unboxing*, 158.

109. *Leeds Times,* May 17, 1851 (BNA).

110. Ruggles, *Unboxing*, 139–40.

111. Alan Rice, *Creating Memorials, Building Identities: The Politics of Memory in the Black Atlantic* (Liverpool: Liverpool University Press, 2010), 64.

112. Original review appeared in the *London Empire* and was reprinted in the *National Anti-Slavery Standard* 41 (March 3, 1855). See Osgood, "Josiah Wolcott," 19.

113. *Agricultural Journal, and General Advertiser*, June 16, 1857, quoted in Chater, *Henry Box Brown*, 56–7.

114. *Westmorland Gazette*, June 19, 1852; and *Hampshire Telegraph*, December 18, 1858 (both in BNA).

115. *Guardian*, October 8, 1851 (newspapers.com).

116. For more on attitudes toward Blacks in England, see Chater, *Henry Box Brown*; Nowatzki, *Representing African Americans in Transatlantic Abolitionism and Blackface Minstrelsy* (Baton Rouge: Louisiana State University Press, 2010); and Catherine Hall, "The Economy of Intellectual Prestige: Thomas Carlyle, John Stuart Mill, and the Case of Governor Eyre," *Cultural Critique* 12 (1989): 167–96. Chater contends that prejudice against Black people was rare and based on "class and education" rather than race; see 32–6. Hall and Nowatzki both believe that racism was pervasive in England during the 1850s onward, when Brown was performing; see Hall's (182) and Nowatzki's (42–79 and passim) extensive coverage of this topic.

117. Ruggles, *Unboxing*, 142. The lawsuit was against the publisher of the newspaper, William Benjamin Smith, but the editor, Brindley, attended the shows and wrote the reviews; see August 7, 1852, *Kendal Mercury* (BNA). Reprints of original libelous articles occurred in many newspapers; I quote from the *Evening Mail*, July 30, 1852, and the *Southern Times and Dorset County Herald* August 7, 1852 (both in BNA). For a different conclusion about this trial, see Chater, who believes that the publicity probably helped Box Brown (*Henry Box Brown*, 81).

118. *Evening Mail*, July 30, 1852 (BNA).

119. Coverage of the case (mostly reprints of trial transcripts) was wide but there was little commentary; see, for example: *Evening Mail*, July 30, 1852; *Shipping and Mercantile Gazette,* July 31, 1852; *Bradford Observer,* August 5, 1852; and *Kendal Mercury*, August 7, 1852 (all in BNA). Also see *Blackburn Standard*, August 11, 1852 (Gale). For one discussion of what this trial meant in terms of the British public's reading of Brown, see Fisch, "'Negrophilism.'"

120. See, for example, the *Wells Journal,* August 14, 1852 (BNA), which republishes a widely reprinted article critical of Brown first published in the *British Army Dispatch.* This would not be the first or last time that Brown would be accused of dressing in a ridiculous manner; see William Wells Brown's letter to Wendell Phillips on September 1, 1852, commenting on the conclusion of the libel action. Wells Brown notes that Brindley was certainly in the wrong, but "[Box] Brown is a very foolish fellow." When Wells Brown saw Box Brown, he had a "gold ring on nearly every finger on each hand," gold and brass around his neck, and a superfluity of ruffles on his shirt. He also had on "a green dress coat and white hat" which gave him the "appearance of a well-dressed monkey." See Wendell Phillips papers, 1555–1882 (inclusive), Harvard University, https://iiif.lib.harvard.edu/manifests/view/drs:47900027$33i.

121. *London Daily News*, August 4, 1852 (BNA).

122. *Westmorland Gazette*, June 19, 1852 (Gale).

123. *Leamington Spa Courier*, July 31, 1852 (BNA).

124. *Newcastle Guardian and Tyne Mercury*, October 2, 1852 (BNA).

125. *North British Daily Mail*, September 15, 1852 (BNA).

126. *Fife Herald*, August 19, 1852 (BNA).

127. *Greenock Advertiser*, September 7, 1852 (BNA).

128. See BNA for these articles.

129. *North British Daily Mail*, September 11 and 18, 1852 (BNA).

130. See these articles: *Bolton Chronicle*, November 27, 1852; *Morning Advertiser*, December 9, 1852; *Bell's New Weekly Messenger*, December 12, 1852; *Banbury Guardian*, December 16, 1852; *Kentish Mercury*, December 18, 1852; *Oxford Chronicle and Reading Gazette*, December 18, 1852; *Oxford University and City Herald*, December 18, 1852; *Roscommon & Leitrim Gazette* (Ireland), December 18, 1852; *Lloyd's Weekly Newspaper*, December 26, 1852; *Kings County Chronicle* (Ireland), December 29, 1852; *Kilkenny Moderator* (Ireland), January 12, 1853; and *Coventry Herald*, February 11, 1853 (all in BNA).

131. This is quoted verbatim in the December 9, 1852, issue of the *Morning Advertiser* (BNA).

132. Brown and Stearns, *Narrative of the Life of Henry Box Brown*, 1849, 54.

133. Thomas F. Gossett, *Uncle Tom's Cabin and American Culture* (Dallas: Southern Methodist University Press, 1985), 314. Arthur Riss, "Harriet Beecher Stowe," in *The Cambridge Companion to American Novelists*, ed. Timothy Parrish (New York: Cambridge University Press, 2013), 34.

134. See *York Herald,* January 1, 1853 (BNA).

135. See *Durham County Advertiser*, November 26, 1852 (BNA).

136. *Hull Packet and East Riding Times*, November 26 and December 3, 1852 (BNA).

137. *Lancaster Gazette*, May 7, 1853 (BNA).

138. KB/3: Sheffield Adelphi Playbill, May 28, 1853; see https://minstrels.library.utoronto .ca/content/brown-henry-box-28-may-1853-28-may-1853-yorkshire-west-riding.

139. See https://www.nationalarchives.gov.uk/currency-converter/#currency-result and https://www.xe.com/currencyconverter/convert/?From=GBP&To=USD.

140. However, Chater states that Scott declared bankruptcy a few months later, and Brown was still owed £34; see *Henry Box Brown*, 88.

141. *Staffordshire Sentinel and Commercial & General Advertiser*, January 21, 1854 (BNA).

142. Brown had also worked with Abecca and di Lonardo in 1852, although Abecca's name was spelt differently; see *Wolverhampton and Staffordshire Herald*, March 3 and 10, 1852 (BNA).

143. See Robert J. Allan, "Reed Organs in England: A Comprehensive Study of Reed Organs in England, Scotland and Wales," https://www.scorpion-engineering.co.uk/FreeReed /organ_book/.

144. *Staffordshire Sentinel and Commercial and General Advertiser*, February 11, 1854 (BNA).

145. See *Nottinghamshire Guardian*, May 11, 1854 (newspapers.com). Also see the *Nottinghamshire Guardian*, May 18, 1854, which compliments not only Sames and Frodsham, but also the panorama, which is said to be "of great magnitude." Brown's speech is said to be very "concise, lucid, and . . . to the point," able to produce "pity and commiseration" but also judiciously interspersed with "amusing incidents to restore the audience to their natural tone of spirit." Overall, one gets the sense that Brown was able to play the audience, to make them both cry and laugh.

146. *Nottinghamshire Guardian*, June 1, 1854 (newspapers.com).

147. *Nottinghamshire Guardian*, May 23, 1854 (newspapers.com).

148. *Leicestershire Mercury*, July 1, 1854 (BNA).

149. *Leicester Journal*, June 30, 1854 (BNA).

150. The Nottingham performances went very well, not only in terms of audience but also in terms of how Brown was received; Brown was described as "highly intellectual and possessing those pleasing powers of conversational eloquence which at once attract, as his personal appearance and manners do, attention to his class." *Nottinghamshire Guardian*, May 11, 1854 (newspapers.com).

151. See, for example, the *Taunton Courier, and Western Advertiser*, June 6, 1855 (BNA), which mentions that Brown has been performing his panorama of slavery and will, during the rest of his stay in Taunton, "illustrate the leading passages in 'Uncle Tom's Cabin'" (BNA). Also see the *Isle of Wight Observer*, May 10, 1856 (BNA), where a long advertisement for a show of Brown's slavery panorama in Ryde is said to contain "Illustrated Views of *Uncle Tom's Cabin*, painted on 50,000 Square Feet of Canvas, and comprising upward of One Hundred Magnificent Views." This advertisement also states hyperbolically that Brown's panorama of slavery has been witnessed by two million people. During this performance, Brown once again shows the "IDENTICAL BOX in which he made his Escape," sings his song describing his escape, and sells a narrative of his life, which he says has "already attained a large circulation." Also see the *Hampshire Telegraph and Naval Chronicle*, March 29, 1856 (newspapers.com), *South Eastern Gazette*, September 16, 1856 (BNA), and the *Faversham*

Gazette, and Whitstable, Sittingbourne, & Milton Journal, October 18, 1856 (BNA) for similar advertisements.

152. See Robin Bernstein, *Racial Innocence: Performing American Childhood from Slavery to Civil Rights* (New York: New York University Press, 2011).

153. Harriet Beecher Stowe, *Uncle Tom's Cabin* (Boston: Jewett, 1852), Volume II, 229, Google Books.

154. *Monmouthshire Merlin*, February 2, 1855 (BNA).

155. See, for example, an advertisement that Brown placed in the *Bristol Mercury* on April 21, 1855 (BNA): "On Monday and Tuesday April 23rd and 24th, Mr. Henry Box Brown, the celebrated American fugitive slave, will, in addition to his Original panorama of African and American Slavery, exhibit his PICTORIAL ILLUSTRATED PANORAMIC VIEWS OF UNCLE TOM'S CABIN." Notices in this newspaper also indicate that he performed both panoramas the previous week; see the *Bristol Mercury* on April 14, 1855 (BNA). See also *Exeter and Plymouth Gazette* on June 16, 1855, and *Western Times* on June 16, 1855 (BNA).

156. *Brighton Gazette*, July 31, 1856 (BNA). See also a review in the *Kentish Independent* on February 14, 1857 (BNA), where Brown again performs his *Uncle Tom's Cabin* panorama with Mrs. Woodman.

157. See *Royal Cornwall Gazette*, December 7, 1855 (BNA).

158. James Smith sometimes went by the initials "Mr. J. D. C. A Smith"; see, for example, the letter he wrote in the *Anti-Slavery Reporter* (a British publication) on April 1, 1854, 93–4, https://babel.hathitrust.org/cgi/pt?id=mdp.39015020435932&view=1up&seq=5. Smith wrote because he perceived his authenticity as a "Coloured Lecturer" with a slavery panorama had been challenged; he responded that he was not an escaped slave but had to leave the US "for the peculiar crime of aiding and assisting Slaves to escape from their terrible bondage" (94). See *Anti-Slavery Reporter*, May 1, 1854, 107–8, also at the above URL.

159. *Bolton Chronicle*, May 7, 1853 (BNA).

160. For other shows by Smith involving an *Uncle Tom's Cabin* panorama, see the *Preston Chronicle*, April 2 and April 9, 1857 (BNA).

161. *Bolton Chronicle*, April 23, 1853 (BNA).

162. *Bolton Chronicle*, May 7, 1853 (BNA).

163. *Cardiff and Merthyr Guardian, Glamorgan, Monmouth, and Brecon Gazette* (Wales), January 19, 1855 (BNA).

164. *Brighton Gazette*, July 31, 1856 (BNA).

165. Wood, "'All Right!,'" 77.

166. "Pictures and Progress," ca. 1851. *The Frederick Douglass Papers, Series One, Speeches, Debates, and Interviews*, Volume 3, 1855–1863, ed. John W. Blassingame et al. (New Haven, CT: Yale University Press, 1979), 455.

167. I find additional advertisements, notices, or reviews of Brown's panorama of American Slavery on February 7, 1857 (*Kentish Independent*); February 10, 1857 (*Maidstone Journal and Kentish Advertiser*); February 21, 1857 (*Kentish Independent* and *Kentish Mercury*); and June 15, 1857 (*Herts Guardian, Agricultural Journal, and General Advertiser* (all in BNA).

Chapter 3

1. Brown's acting was first advertised in June of 1857 (*Era*, June 28, 1857) and he performed in these plays for five months (July–November), first in Margate at the Theatre Royal (see *Era*, July 19, 1857, and *South Eastern Gazette*, August 4, 1857); then in Ramsgate at the Musical Hall (where he gave some readings that were "thinly attended"; see *Kentish Independent*, September 19, 1857); in Liverpool at the Royal Park Theatre (see *Era*, September 27 and

October 4, 1857); in Wigan at the Theatre Royal (where he gave dramatic readings of the plays for one night only; see *Wigan Observer and District Advertiser*, October 16 and 17, 1857), and finally in Hanley at the Royal Pottery Theatre, where he performed in all three dramas for a week (see *Staffordshire Advertiser* October 31 and November 7, 1857; all sources in BNA). Chater provides good context for these plays; see *Henry Box Brown: From Slavery to Show Business* (Jefferson, NC: McFarland, 2020), 111–20.

2. E. G. Burton wrote a series of plays in England from 1850 to at least 1863, but other than this little is known about him. See Volume 5 of Allardyce Nicoll's *A History of English Drama, 1660–1900* (Cambridge: Cambridge University Press, 1959), 294 and 740; and World-Cat Identities here: https://worldcat.org/identities/lccn-no95054815/.

3. On August 4, 1857, the *South Eastern Gazette* called Brown's acting in *The Nubian Captive* "powerful," continuing: "this new piece is really worthy of the highest recommendation" (BNA). The plays moved onto the Royal Park Theatre in Liverpool in October of 1857, and Brown's acting "of Hameh, as Prince of Nubia" is described as "a very satisfactory performance" that "compelled him to re-appear more than once before the curtain." This same notice describes the house being "well filled" for several days and mentions that he will appear later in the week in *The Fugitive Free, Pocahontas; or, the English Tar*, and *The Secret*. See *Era*, October 4, 1857 (BNA).

4. See *Staffordshire Advertiser*, November 7, 1857 (BNA).

5. These plays were registered with the Lord Chamberlain and performed in 1857. That year, Brown also performed in two other plays written by E. G. Burton at an earlier period—*Pocahontas* and *The Secret*—but these plays are not autobiographical or about slavery, so I do not discuss them here. *The Nubian Captive* contains an inscription indicating that Burton wrote *The Fugitive Free* first and that both plays were "Written Expressly for Mr. H. B. Brown."

6. Daphne Brooks, *Bodies in Dissent: Spectacular Performances of Race and Freedom, 1850–1910* (Durham: Duke University Press, 2006), 74.

7. Fugitivity has been defined in diverse ways by numerous theorists. See Stephen Best, *The Fugitive's Properties: Law and the Poetics of Possession* (Chicago: University of Chicago Press, 2004); and Samira Kawash, "Fugitive Properties," in *The New Economic Criticism: Studies at the Intersection of Literature and Economics*, ed. Mark Osteen and Martha Woodmansee (New York: Routledge, 2005), 277–90.

8. Janet Neary, *Fugitive Testimony: On the Visual Logic of Slave Narratives* (New York: Fordham University Press, 2016), 133.

9. Paula von Gleich, "Afro-pessimism, Fugitivity, and the Border to Social Death," in *Critical Epistemologies of Global Politics*, ed. Marc Woons and Sebastian Weier (Bristol: England, E-International Relations Publishing, 2017), 212, https://www.e-ir.info/wp-content/uploads/2017/06/Critical-Epistemologies-of-Global-Politics-E-IR.pdf.

10. Simone Browne, *Dark Matters: On the Surveillance of Blackness* (Durham, NC: Duke University Press, 2015), 21.

11. Hazel Waters, *Racism on the Victorian Stage: Representations of Slavery and the Black Character* (Cambridge: Cambridge University Press, 2007), 14.

12. According to Waters, James Hewlett (who performed at the African Grove Theatre in New York from 1821 to 1831) may have acted once or twice in England in 1824 or 1825 (*Racism on the Victorian Stage*, 87). In 1866 Samuel Morgan Smith moved from the US to England and began acting in *Othello* and other Shakespeare plays. George Dunbar, described as a "creole actor," performed in England during the 1870s; see, for example, *Wilts and Gloucestershire Standard*, September 20, 1879 (BNA). The US-born actor Paul Molyneaux Hewlett (1856–1891) acted in England in the 1880s; see *Kilburn Times*, January 26, 1883, and *Era*, February 3, 1883 (both in BNA). Hewlett also was part of a troupe of Jubilee singers who

performed an *Uncle Tom's Cabin* musical and dramatic entertainment and claimed to be "20 real freed slaves" (*Alloa Advertiser* [Scotland], March 5, 1887 [BNA]), but Hewlett was not a former slave; see *Reading Observer*, July 10, 1886 (BNA). None of these men acting in lead roles on the stage had been enslaved, and most acted onstage well after Box Brown's 1857 shows.

13. On Richard Samuel Thorne's specifically producing the plays for Brown to star in, see *South Eastern Gazette*, August 4, 1857 (BNA). On the lawsuit *Henry B. Brown v. R. Thorne*, see *Kentish Gazette*, September 22, 1857 (BNA).

14. See Henry Box Brown, *Narrative of the Life of Henry Box Brown, Written by Himself* (Manchester, UK: Lee and Glynn, 1851), 17, *Documenting the American South*, https://docsouth.unc.edu/neh/brownbox/brownbox.html.

15. In this sense, Burton's play anticipates Dion Boucicault's popular drama *The Octoroon*, which opened in 1859 in New York City. *The Octoroon* was not performed in England until 1861.

16. Grégory Pierrot, *The Black Avenger in Atlantic Culture* (Athens: University of Georgia Press, 2019), 11. Also see Waters, *Racism on the Victorian Stage*, 7–57.

17. See David Edwards, *The Nubian Past: An Archaeology of the Sudan* (Abingdon, Oxon: Routledge, 2004), 2, 90, and 106.

18. Waters, *Racism on the Victorian Stage*, 46.

19. See *Morning Advertiser*, May 8, 1857 (BNA).

20. *Obi*, ed. Charles Rzepka, Act II, Scene Six, ca. 1850, https://romantic-circles.org/praxis/obi/obi_melodrama_act2.html.

21. Jeffrey N. Cox, Introduction to *Slavery, Abolition and Emancipation*, Volume 5: Writings in the British Romantic Period (Abingdon, Oxon: Taylor and Francis, 1999), xxiii.

22. *Era*, September 8, 1852 (BNA).

23. *Era*, November 14, 1852 (BNA).

24. *Lady's Own Paper*, December 11, 1852 (BNA).

25. Waters, *Racism on the Victorian Stage*, 157.

26. See Sarah Meer, *Uncle Tom Mania: Slavery, Minstrelsy, and Transatlantic Culture in the 1850s* (Athens: University of Georgia Press, 2005), 138–9.

27. Ibid., 133–58.

28. *Morning Advertiser*, March 24, 1857 (BNA).

29. *Atlas*, January 31, 1857 (BNA).

30. See, for example, a version by Richard Shepherd and William Creswick, performed on October 27, 1852 (described by Waters in *Racism on the Victorian Stage*, 172). Also see Meer's discussion of plays in which the enslaved (and even Tom himself) revolted against Legree (*Uncle Tom Mania*, 139–40).

31. Waters, *Racism on the Victorian Stage*, 155.

32. Virginia Vaughan, *Performing Blackness on English Stages, 1500–1800* (New York: Cambridge University Press, 2005), 167.

33. Meer, *Uncle Tom Mania*, 158.

34. See Waters, *Racism on the Victorian Stage*, 87. Because no production materials for Burton's plays are available, it is impossible to know whether whites acted Black characters in Blackface. If so, this would add another layer of ambiguity to the passing plots.

35. For more on the idea of sound as part of a history of revolutionary action, see Fred Moten, *In the Break: The Aesthetics of the Black Radical Tradition* (Minneapolis: University of Minnesota Press, 2003).

36. Paul Gilroy, *The Black Atlantic: Modernity and Double Consciousness* (Cambridge, MA: Harvard University Press, 1993), 37.

37. The Slavery Abolition Act of 1833 abolished slavery in most British colonies.

38. Joseph Roach, "Slave Spectacles and Tragic Octoroons: A Cultural Genealogy of Antebellum Performance," *Theatre Survey* 33, no. 2 (1992): 168 and 171.

39. E. G. Burton, *The Fugitive Free* (1857), 42. Handwritten script obtained on microfilm. I have corrected obvious grammatical mistakes and inserted missing punctuation.

40. Ibid., 45.

41. Henry Box Brown, *Narrative of the Life of Henry Box Brown, Written by Himself*, 24.

42. Burton, *The Fugitive Free*, 49.

43. Ibid., 80–81.

44. Joseph Arthur de Gobineau, *The Inequality of Human Races*, ca. 1853–1855 (London: William Heinemann, 1915), 174.

45. See Edward Beasley, *The Victorian Reinvention of Race: New Racisms and the Problem of Grouping in the Human Sciences* (New York: Routledge, 2010), 44–80.

46. Carolyn Sorisio, *Fleshing Out America: Race, Gender, and the Politics of the Body in American Literature, 1833–1879* (Athens: University of Georgia Press, 2002), 28.

47. Burton, *The Fugitive Free*, 15–16.

48. See Moten, *In the Break*, 1–24 and 222.

49. Burton, *The Fugitive Free*, 20, emphasis added.

50. Nicholas Mirzoeff, *The Right to Look: A Counterhistory of Visuality* (Durham: Duke University Press, 2011), 7.

51. Burton, *The Fugitive Free*, 21.

52. Ibid., 22.

53. Browne, *Dark Matters*, 79.

54. Burton, *The Fugitive Free*, 54.

55. Ibid., 70.

56. Britt Rusert, *Fugitive Science: Empiricism and Freedom in Early African American Culture* (New York: New York University Press, 2017).

57. Burton, *The Nubian Captive* (1857), title page, 33, and 61. Handwritten script obtained on microfilm.

58. Burton, *The Nubian Captive*, 44–5.

59. Saidiya Hartman, *Scenes of Subjection: Terror, Slavery, and Self-Making in Nineteenth-Century America* (New York: Oxford University Press, 1997), 66.

60. Burton, *The Nubian Captive*, 49–50.

61. Ibid., 38.

62. Ibid., 52–3.

63. Ibid., 67.

64. Brooks, *Bodies in Dissent*, 8.

65. See, for example, *South London Chronicle,* March 14, 1868 (BNA).

66. Burton, *The Nubian Captive*, 80–81.

67. Amy E. Hughes, *Spectacles of Reform: Theater and Activism in Nineteenth-Century America* (Ann Arbor: University of Michigan Press, 2014), 15.

68. Mirzoeff, *The Right to Look*, 273.

69. See Sharon Sliwinski, *Human Rights in Camera* (Chicago: University of Chicago Press, 2011), 5.

Chapter 4

1. On December 17, 1864, the *Gloucestershire Chronicle* (BNA) reported that a lawyer had sent a letter to the town's Financial Committee "demanding compensation on behalf of Professor Box Brown, the wizard, because he had been allowed the use of the Corn Exchange

only one night." See also the *Ashton Weekly Reporter, and Stalybridge and Dukinfield Chronicle*, December 2, 1871 (BNA), where he is also referred to as "Mr. H. Box Brown, the wizard."

2. Henry Box Brown, *Narrative of the Life of Henry Box Brown* (Rugby: Read and Rogers, 1860), 1. Courtesy of Brandeis Library Special Collections.

3. Brown first began performing the Holy Land panorama in January of 1858; see *Hertford Mercury and Reformer*, January 2, 1858 (BNA); also see (in the same issue) Brown's advertisement for his show, which reads in part, "For a few nights only! Commencing on Saturday January 2, 1858 . . . Mr. H. Box Brown will Exhibit his new DIORAMA OF THE HOLY LAND, Comprising Magnificent Views of the Holy Land, among others, St. Peter's At Rome, the Holy Sepulcher, Crucifixion of Christ, His Resurrection, and the Destruction of Jerusalem."

4. *Daily Telegraph*, March 10, 1858 (BNA).

5. Ralph Hyde describes Mills as a "panorama artist" from London who "painted Henry 'Box' Brown's Panorama of the Indian War, exhibited in Saint Helier, Jersey, 1858." See *Dictionary of Panoramists of the English-Speaking World*, the Bill Douglas Cinema Museum (n.p., n.d.), http://www.bdcmuseum.org.uk/uploads/uploads/biographical_dictionary_of_panoramists2.pdf.

6. Ronald Hyam, *Britain's Imperial Century, 1815–1914* (Basingstoke: Palgrave Macmillan, 2002 [1976]), 135.

7. See Michelle Boyd, "The Angel of Lucknow, the Hero of Halifax: A Nova Scotian Musical Response to the Indian Mutiny of 1857–58," *Nineteenth-Century Music Review* 11, no. 2 (2014), 195–217.

8. For the performance in Maidenhead, see *South Bucks Free Press, Wycombe and Maidenhead Journal*, April 15, 1859 (BNA). During this run, Brown also exhibited "the box in which he was packed and conveyed from the land of slavery to the land of freedom."

9. Shows in 1862 in Jersey were also very well reviewed in the French-language newspapers. See *Nouvelle Chronique de Jersey*, April 23, 1862. A scan of this article and others from Jersey newspapers was sent to me by Valérie Noël, Librarian, Lord Coutanche Library, Saint Helier, Jersey, England.

10. All translations in this paragraph are my own. I reference the following articles in French-language newspapers: the *Nouvelle Chronique de Jersey*, March 10, 1858; April 7, 10, and 17, 1858; and the *Chronique de Jersey*, March 13, 1858.

11. See *Hampshire Telegraph*, December 18, 1858. For other shows in this period, see the *Reading Mercury*, June 5, 1858; *Hampshire Chronicle, Southampton and Isle of Wight Courier*, June 12, 1858; *Kentish Independent*, July 3 and July 10, 1858; and *Sussex Advertiser*, November 16, 1858.

12. See *Isle of Wight Observer*, December 25, 1858, and January 1, 1859 (newspapers.com).

13. *Isle of Wight Observer*, January 1, 1859 (BNA).

14. *West Sussex Gazette*, February 3, 1859 (BNA).

15. *West Surrey Times*, February 5, 1859 (BNA).

16. The Odd Fellows was a fraternal order dedicated to philanthropy and charity; Brown appears to have been a member in England and in the US.

17. *West London Observer*, March 12, 1859 (BNA).

18. *Windsor and Eton Express*, March 12, 1859 (BNA).

19. This issue of the *West London Observer* (March 19, 1859) contains a long description of an opening of a new Foresters' chapter in Hammersmith at which Brown was present. "Mr. Box Brown, who is a Member of the Order, here entered the room, attired in his dress of an African Prince, and excited great attention" (BNA).

20. See also the *Rugby Advertiser* on September 24, 1859, which notes that all four panoramas received "large and attentive audiences." For other performances, see the *Reading*

Mercury, April 23 and May 14, 1859, and the *Shrewsbury Chronicle*, November 4, 1859. All sources in BNA.

21. The *Shrewsbury Chronicle* on November 11, 1859, describes "Mr. and Mrs. Box Brown" as exhibiting their panorama of the slave trade and the Holy Land at Dawley and notes that "they have met with good audiences, and give much satisfaction." In Dawley, the Browns were also exhibiting the War in India panorama; see *Wellington Journal*, November 12, 1859. On January 21, 1860, the *Staffordshire Sentinel and Commercial & General Advertiser* reports that the Browns had "crowded houses" in Newcastle for the panoramas and would next perform in the Potteries and in Hanley. Also see mentions of crowded shows in the *Staffordshire Sentinel and Commercial & General Advertiser*, February 25 and March 3, 1860. All sources in BNA.

22. See *Congleton and Macclesfield Mercury, and Cheshire General Advertiser*, March 17, 1860 (BNA).

23. See Alan Rice, *Creating Memorials, Building Identities: The Politics of Memory in the Black Atlantic* (Liverpool: Liverpool University Press, 2010), 79n24.

24. Kathleen Chater reports this date for Agnes's birth; see *Henry Box Brown: From Slavery to Show Business* (Jefferson, NC: McFarland, 2020), 135.

25. See England Births and Christenings, 1538–1975, familysearch.org. The microfilms which list the family's place of residence and Brown's occupation can be found here.

26. *Burnley Advertiser*, April 20 and May 4, 1861 (BNA).

27. *Eddowes's Journal, and General Advertiser for Shropshire, and the Principality of Wales*, November 2, 1859 (BNA).

28. Christina Sharpe, *In the Wake: On Blackness and Being* (Durham: Duke University Press, 2016), 9 and 15.

29. *Huddersfield Chronicle*, December 29, 1860 (BNA).

30. Good attendance for the panorama of American and African slavery is noted in the *Windsor and Eton Express*, March 26 and April 2, 1859 (where Brown exhibits his panorama to "900 children from the various schools" on one day and "about 500 juveniles" on another); *Oxford Chronicle and Reading Gazette*, May 28, 1859; *Coventry Herald*, July 1, 1859; *Shrewsbury Chronicle*, December 9, 1859; *Staffordshire Sentinel and Commercial & General Advertiser*, February 18, 1860; *Glossop Record*, April 7, 1860; *Bury Times*, May 12, 1860; *Era*, November 11, 1860; and *Huddersfield Chronicle*, December 15, 1860 (all in BNA). From January 1861 to early April 1861, or thereabouts, the Browns appear to have taken a hiatus from performing, perhaps to spend more time with their newborn daughter Agnes. On May 4, 1861, the *Bunley Advertiser* reports that the Browns had just ended "a most successful run" that included a "juvenile band" called the Rowland Family. Brown also performed his "Panorama of America" in Bacup in June of 1861 but had only "scanty audiences"; see *Rochdale Observer*, June 1, 1861 (BNA). Other notices of Brown's performance in late 1861 of the slavery panoramas can be found in the *Era*, November 3, 1861 (newspapers.com); *Manchester Courier and Lancashire General Advertiser*, November 30, 1861 (BNA); *Guardian*, November 30, 1861 (newspapers.com); and *Manchester Weekly Times and Examiner*, December 28, 1861 (newspapers.com). By 1862, Brown was staging his Civil War panorama, but he also frequently staged his panorama of American slavery; see notices in the *Jersey Independent and Daily Telegraph*, May 7 and May 17, 1862; and *Western Daily Mercury*, September 19, 1862 (both in BNA). As late as 1863, it appears that Brown was still staging his original panorama of American slavery by itself at times; see the *Lake's Falmouth and Cornwall Advertiser* from January 24, 1863 (BNA). At some of these shows, Brown gave away presents, which sometimes caused controversy as to whether this was a lottery; see his letters to the *Western Daily Mercury* on September 18 and 19, 1862 (both in BNA).

31. *Bury Times*, June 22, 1861 (BNA).

32. *Nouvelle Chronique de Jersey*, April 23, 1862. See note 9 of this chapter.

33. *Leigh Chronicle and Weekly District Advertiser*, January 11, 1862 (BNA).

34. *Leigh Chronicle and Weekly District*, January 18, 1862 (BNA).

35. See *American Indians and the Civil War*, https://benaysnativeamericans.weebly.com /the-battle-of-wilsons-creek.html, and *The Civil War in Missouri*, http://www.civilwarmo .org/educators/resources/info-sheets/confederate-general-stand-watie-and-cherokee -mounted-rifles.

36. *Oxford Times*, October 12, 1867 (newspapers.com).

37. See *The History of the Battle of Rich Mountain*, http://www.richmountain.org/RM history.html.

38. See *Cotton Production 1860*, http://www.encyclopediaofalabama.org/article/m-4034.

39. See James M. McPherson, *War on the Waters: The Union and Confederate Navies, 1861–1865* (Chapel Hill: University of North Carolina Press, 2012).

40. *Daily Dispatch,* Richmond, April 15, 1861, https://dispatch.richmond.edu/view/secon dary-section-view.php?doc=D_019_087.

41. When Brown exhibited the Civil War panorama by itself, audiences were uneven. See, for example, *West Briton and Cornwall Advertiser*, November 14 and 21, 1862 (both in BNA).

42. *Leigh Chronicle and Weekly District Advertiser*, January 18, 1862 (BNA).

43. *Jersey Independent and Daily Telegraph*, April 21, 1862 (BNA).

44. *Jersey Independent and Daily Telegraph*, April 23, 1862 (BNA).

45. *Royal Cornwall Gazette*, November 21, 1862 (newspapers.com).

46. *West Briton and Cornwall Advertiser*, February 14, 1862 (BNA); *Royal Cornwall Gazette,* January 23 and January 30, 1863 (newspapers.com).

47. See *Western Times*, July 3, 1863 (BNA); and *Exeter Flying Post*, July 15, 1863 (newspapers.com).

48. MacKenzie gave lectures near towns in which Brown showed his panoramas, with titles such as "Origin and Objects of the Present Struggle in America"; see Jeffrey Ruggles, *The Unboxing of Henry Brown* (Richmond: Library of Virginia, 2003), 156.

49. Ibid.

50. See *Cardiff Times*, November 13, 1863 (BNA).

51. *Western Daily Mercury*, March 26, 1863 (BNA).

52. Throughout the summer of 1863 and into the late fall, Brown exhibited his panoramas of American Slavery and the Civil War. Notices appear as late as November. See *Western Times*, July 3, 1863; *Bath Chronicle and Weekly Gazette*, October 8, 1863; *Cardiff and Merthyr Guardian, Glamorgan, Monmouth, and Brecon Gazette*, October 23, 1863; and *Cardiff Times*, November 8, 1863 (all from BNA).

53. For more on this topic, see Philip J. Deloria, *Playing Indian* (New Haven, CT: Yale University Press, 1998).

54. *Thorne's Guide to Jersey: With Valuable Original Information Concerning Its History, Commerce, Climate, Scenic Beauties, &c.* (Jersey: Thorne, 1859), 67.

55. Marcus Wood, "'All Right!': The *Narrative of Henry Box Brown* as a Test Case for the Racial Prescription of Rhetoric and Semiotics," *Proceedings of the American Antiquarian Society* 107, no. 1 (1997): 77; and Daphne Brooks, *Bodies in Dissent: Spectacular Performances of Race and Freedom, 1850–1910* (Durham: Duke University Press, 2006), 69.

56. *Preston Chronicle*, May 4, 1861 (BNA).

57. *Bristol Daily Post*, October 26, 1864 (BNA).

58. *Cardiff Times*, March 11, 1864 (BNA).

59. *Oxford Times*, October 12, 1867 (newspapers.com).

60. *Monmouthshire Beacon*, February 3, 1855 (BNA).

61. Lisa Merrill, "Exhibiting Race 'under the World's Huge Glass Case': William and Ellen Craft and William Wells Brown at the Great Exhibition in Crystal Palace, London, 1851," *Slavery & Abolition* 33, no. 2 (2012): 322.

62. John Campbell Colquhoun, *Isis Revelata: An Inquiry Into the Origin, Progress, and Present State of Animal Magnetism*, Vol. 2 (Edinburgh: Maclachlan & Stewart, 1836), Google Books.

63. See Patricia Fara, "An Attractive Therapy: Animal Magnetism in Eighteenth-Century England," *History of Science* 33 (1995): 142.

64. *Jersey Independent and Daily Telegraph*, March 10, 1858 (BNA).

65. This performance was sponsored by "the Independent Order of Odd Fellows and the Ancient Order of Foresters." *West London Observer*, March 12, 1859 (BNA).

66. *Jersey Independent and Daily Telegraph*, May 7, 1862 (BNA).

67. *Bristol Daily Post*, October 26, 1864 (BNA).

68. *Merthyr Telegraph, and General Advertiser*, January 2, 1864 (BNA).

69. See *Era*, January 3, 1864 (newspapers.com).

70. *Western Daily Press*, February 22, 1864. Brown's performances were also covered in Welsh-language newspapers; see *Baner ac Amserau Cymru* (Dinbych, Clwyd, Wales), February 28 and June 22, 1864 (both in newspapers.com).

71. See *Sheerness Times Guardian*, May 9, 1868 (BNA): "Mr. Box Brown, the coloured mesmerist, gave his last mesmeric entertainment on Tuesday evening at the Co-operative Hall, before a very good audience. As on previous evenings, a number of the youths of both sexes were operated on, and were put through a variety of amusing antics, together with singing."

72. Britt Rusert, *Fugitive Science: Empiricism and Freedom in Early African American Culture* (New York: New York University Press, 2017), 139.

73. See *Star of Gwent*, April 23 and April 30, 1864 (BNA). Brown's mesmeric subjects were also accused of "abominable vulgarity" by an audience member who wrote about it in the *Monmouthshire Merlin* on April 23, 1864 (BNA).

74. Not all of Brown's shows in Wales were negatively reviewed. For example, in Pontypool, Brown was described respectfully as "a person of color" who has been "astounding the inhabitants of this town with feats of mesmerism and electro-biology"; see *USK Observer*, March 26, 1864 (BNA). The same newspaper reports that Brown gave successful entertainments in mesmerism and electro-biology in the Town Hall in Blaenavon on April 2 and 9, 1864, so Brown was in Wales for at least two weeks. Extensive performance work in Wales implies that Brown may have lived there from January to August or September of 1864. Brown performed in January, February, and March in Merthyr Tydvil; in Pontypool in March and August; in Blaenavon in April; and in Aberdare in September. See BNA and WNO, as well as Ruggles, *The Unboxing of Henry Brown*. Brown was also in Wales performing mesmerism in 1865; see *Cambria Daily Leader*, November 14, 1865 (BNA). He returned in 1866 and 1867; see *Cardiff Times*, January 5, 12, and 26, 1867; *Baner ac Amserau Cymru*, February 28, 1866; and *Monmouthshire Merlin*, April 6, 1867 (all in BNA). After the April 6, 1867, performance a man who was at one of his shows (Abraham Brimble) was indicted for the murder of a gamekeeper named George Kelly; see *Star of Gwent,* April 6, 1867 (BNA).

75. *Bristol Daily Post*, April 19, 1864 (BNA).

76. See a show in Merthyr in 1864 where Brown, described as a "specimen of the Creole tribe," gave away "sundry gifts . . . and occasionally a donkey, which draws together a good (but not fashionable) threepenny audience." *Era*, March 20, 1864 (newspapers.com).

77. *Oxford Times*, October 12, 1867 (newspapers.com).

78. See *Thanet Advertiser*, August 31, 1867 (BNA).

79. See Fumiko Hoeft et al., "Functional Brain Basis of Hypnotizability," *Archives of General Psychiatry* 69, no. 10 (2012): 1064–72.

80. *Cardiff and Merthyr Guardian, Glamorgan, Monmouth, and Brecon Gazette*, February 16, 1866 (BNA).

81. *Uxbridge & W. Drayton Gazette*, April 4, 1868 (BNA).

82. *South London Chronicle*, March 14, 1868 (BNA).

83. Frederick Douglass, *Narrative of the Life of Frederick Douglass, an American Slave, Written by Himself* (Boston: Anti-Slavery Office, 1845), 63, 27, *Documenting the American South.* https://docsouth.unc.edu/neh/douglass/menu.html.

84. Henry Box Brown, *Narrative of the Life of Henry Box Brown, Written by Himself* (Manchester: Lee and Glynn, 1851), 26, *Documenting the American South*, https://docsouth .unc.edu/neh/brownbox/brownbox.html.

85. *Sheerness Times Guardian*, May 2, 1868 (BNA). The Sheerness performance was also covered in the May 9, 1868, issue of this same newspaper; Brown had "a very good audience," hypnotized "a number of the youths of both sexes," "put them through a variety of amusing antics, together with singing," and gave away a number of prizes, including "silver spoons, frying pans well stored with beefstakes, brooches and other trinkets." The distribution of meat as a prize was not unusual; see *Southern Times and Dorset County Herald*, March 25, 1865 (BNA).

86. See *Yarmouth Independent*, October 24, 1868 (BNA).

87. *Lowestoft Journal*, May 28, 1904 (BNA).

88. W. B. Meeker and T. X. Barber demonstrate that stage hypnotism relies on the choice of highly suggestible subjects through audience screening procedures; the definition of the context as hypnosis; and the demands of the situation to role-play the suggestions. See "Toward an Explanation of Stage Hypnosis," *Journal of Abnormal Psychology* 77, no. 1 (1971): 61–70. For more recent studies of stage hypnosis, see Helen J. Crawford, Melissa Kitner-Triolo, Steven W. Clarke, and Brian Olesko, "Transient Positive and Negative Experiences Accompanying Stage Hypnosis," *Journal of Abnormal Psychology* 101, no. 4 (1992): 663–7; and James MacKillop, Steven Jay Lynn, and Eric Meyer, "The Impact of Stage Hypnosis on Audience Members and Participants," *International Journal of Clinical and Experimental Hypnosis* 52, no. 3 (2004): 313–29.

89. The charge of a lottery in Newark is reported in the *Rochdale Observer* on February 5, 1870. (BNA). Information about the previous lottery in Newark and about the trial in Rochdale comes from the *Rochdale Observer*, February 12, 1870 (BNA).

90. *Rochdale Observer*, February 12, 1870 (BNA).

91. According to Chater, Brown and his family lived in Manchester from 1870 to 1875. See *Henry Box Brown*, 172–75.

92. *Hyde & Glossop Weekly News, and North Cheshire Herald*, December 2, 1871 (BNA).

93. *Ashton Weekly Reporter, and Stalybridge and Dukinfield Chronicle*, January 21, 1871 (BNA), emphasis added.

94. See notices in the *Era* on September 2, 1866, November 29, 1868, and August 28, 1870 (newspapers.com).

95. Britt Rusert, "The Science of Freedom: Counterarchives of Racial Science on the Antebellum Stage," *African American Review* 45, no. 3 (2012): 291.

96. *Southern Times and Dorset County Herald*, March 25, 1865 (BNA).

97. All these shows are listed in BNA.

98. See Martin Staum, *Labeling People: French Scholars on Society, Race, and Empire, 1815–1848* (Montreal: McGill-Queen's University Press, 2003), 59.

99. J. P. M'Lean, *Know Thyself! Lectures on Phrenology by Dr. J. P. M'Lean . . . Subjects: How to Read Character Scientifically; Including the Physical, Social, Moral, and Intellectual Development of the Race. Public Examinations at the Close of Each Lecture.* [New York]: Office

of the "Phrenological Journal," [c. 1870], https://bostonraremaps.com/inventory/mammoth-phrenology-broadside/.

100. *Maidstone Telegraph*, April 17, 1869 (BNA). Brown's performances of "phreno-mesmerism" are also listed in the *Folkestone Express, Sandgate, Shorncliffe & Hythe Advertiser* on March 27, 1869 (BNA) and the *Bolton Evening News* on November 3, 1870 (BNA).

101. See *Heywood Advertiser*, July 5, 1872 (BNA). For another performance from this period, see the *Era* from June 13, 1869, which lists a show "consisting of magic, animal magnetism, mesmerism, electro-biology, and phrenology"; in this show Brown, a "colored gentleman," worked "in conjunction with Madame Brown" (newspapers.com).

102. Audre Lorde, "The Master's Tools Will Never Dismantle the Master's House," 1979, in *Sister Outsider: Essays and Speeches* (Berkeley: Crossing Press, 1984), 110–3, at 112.

103. For another show centered on "animal magnetism and electro-biology," see the *Hampshire Telegraph and Naval Chronicle*, July 31, 1869 (newspapers.com).

104. See the poster used by Jean-Eugène Robert-Houdin when he played in London in 1853 in Harry Houdini, *The Unmasking of Robert-Houdin* (New York: Publishers Printing Co.,1908), n.p., www.gutenberg.org.

105. Information in this paragraph is taken from Houdini, *Unmasking*, n.p.

106. See note 1 in this chapter for references to Box Brown as a "wizard."

107. See *Burnley Gazette*, March 5, 1870 (BNA).

108. See *Cardiff Times*, January 26, 1867 (BNA).

109. See *Exeter Flying Post*, March 22, 1865 (BNA).

110. See *Morning Post*, November 7, 1862 (BNA).

111. Anderson claimed that spiritualism was a "delusion that has driven ten thousand persons mad in the United States." See *Western Times*, February 4, 1854 (BNA).

112. Milbourne Christopher and Maurine Christopher, *The Illustrated History of Magic* (Portsmouth, NH: Heinemann, 1996), 111–30.

113. See *Wilts and Gloucestershire Standard*, August 10, 1867 (BNA).

114. "Miss Pauline" performed with Brown on October 25–29, 1864 (in Bristol); November 12, 1864 (in Cheltenham and Gloucester); November 19, 1864 (again in Cheltenham); March 11, 1865 (in Taunton); and March 22, 1865 (in Exeter). See BNA.

115. For Edward's christening record, see familysearch.org/ark:/61903/1:1:XTSL-RC3. For Edward's birth date and the family's address, see the register of births in the town of Bristol (Saint Paul district) in 1864, obtained from https://www.gro.gov.uk/gro/content/certificates. This register lists Edward Henry Brown's date of birth as October 28, 1864, and the family's residence as 25 Cumberland Street in Bristol. Jane Brown (formerly Jane Floyd) is listed as the mother and Henry Box Brown as the father. Brown's profession is listed as "Lecturer on Mesmerism" and the certification of birth was registered on November 24, 1864. My thanks to Kenyatta Berry for locating this document. Also see "Bristol, England, Church of England Baptisms, 1813–1918" (ancestry.com).

116. See *Exeter Flying Post*, March 22, 1865 (BNA).

117. See *Era*, November 27, 1864 (newspapers.com).

118. For a description of Brown adeptly performing "legerdemain and ventrilquism [sic]," see the *Ashton Weekly Reporter, and Stalybridge and Dukinfield Chronicle*, September 17, 1870 (BNA).

119. *Thanet Advertiser*, February 13, 1869 (BNA).

120. *Portsmouth Times and Naval Gazette*, September 11, 1869 (newspapers.com).

121. *Hampshire Telegraph and Naval Chronicle*, October 9, 1869 (newspapers.com).

122. *Hampshire Advertiser*, October 13 and 16, 1869 (newspapers.com).

123. *Hampshire Advertiser*, October 30, 1869 (newspapers.com).

124. *Era*, July 31, 1870 (newpapers.com).

125. On Brown's continuing ability to attract moderate to excellent audiences in this period, see the *Thanet Advertiser*, February 13, 1869 (BNA); *Portsmouth Times and Naval Gazette*, September 11, 1869 (newspapers.com); *Hyde & Glossop Weekly News, and North Cheshire Herald*, December 2, 1871 (BNA); and *Staffordshire Sentinel*, May 1, 1874 (BNA).

126. *Heywood Advertiser*, July 5, 1872 (BNA).

127. See also an advertisement published in the *Oxford Chronicle and Reading Gazette* on October 5, 1867 (newspapers.com); Brown hypnotized about ten people onstage and caused them "by a word or a touch to do things more or less absurd and ludicrous."

128. *Ashton Weekly Reporter, and Stalybridge and Dukinfield Chronicle*, August 12, 1871 (BNA).

129. *Hyde & Glossop Weekly News, and North Cheshire Herald*, December 2, 1871 (BNA).

130. Brown performed in Bury (Lancashire) for several evenings in January of 1870, where he delighted "numerous audiences"; see *Era*, January 30, 1870 (newspapers.com); in Oldham in late May (see *Era*, May 29, 1870, newspapers.com); in Leek in July, 1870, where the houses were sold out several times (see *Staffordshire Advertiser*, July 23, 1870, BNA); in Warrington in August of 1870 (see *Era*, August 28, 1870, newspapers.com); in Bolton in November of 1870 (see *Bolton Evening News*, November 4, 1870, BNA); in Leigh in August 1871 (see *Leigh Chronicle and Weekly District Advertiser*, August 19, 1871, BNA); in Longton in early March of 1872, where he performed for a fortnight and did "good business" (see *Era*, March 3, 1872, newspapers.com); in Hanley in late March of 1872, where his shows were "well patronised" (see *Era*, March 24, 1872, newspapers.com); in Macclesfield on May 5, 1872, where his entertainment received an ovation and was "well patronised" (see *Era*, May 5, 1872, newspapers.com); in Accrington (Lancashire) during late May of 1871, where he had "very appreciative audiences" (see *Era*, May 28, 1871, newspapers.com); and in the Gymnasium Hall in Huddersfield on June 16, 1872 (see *Era*, June 16, 1872, BNA. In Newcastle-under-Lyne he "delighted his audiences" with his Animal Magnetism and Mesmeric Entertainments during the week of April 19, 1874 (see *Era* on this date, newspapers.com). Some of his shows, however, were not as "well patronised as his abilities deserve" even though his "exploits in the art of legerdemain are truly astounding" (see *Era*, May 12, 1872, newspapers.com). So, the record is a bit uneven in terms of how well he kept an audience, as the decade progressed.

131. In 1873, Brown and members of a glee club entertained "500 adult inmates" of the Manchester Workhouse, as reported in the *Manchester Evening News* on May 9, 1873 (BNA); Brown performed "legerdemain and animal magnetism." And on February 20, 1874, the *Todmorden Advertiser and Hebden Bridge Newsletter* describes Brown's appearance at a school in West Yorkshire; Brown "delivered a very interesting lecture . . . on his early history, and on the slave-trade in general, after which he gave some experiments in mesmerism" (BNA).

132. See the *Era*, May 29, 1870, for a listing of these shows (newspapers.com).

133. According to Waters, the Christy Minstrels were extremely popular in England. In 1865 they opened at St. James Hall, which became one of best-known minstrel venues; see *Racism on the Victorian Stage: Representation of Slavery and the Black Character* (Cambridge: Cambridge University Press, 2007), 126.

134. See *Era*, March 22, 1874 (newspapers.com).

135. On Brown's use of auctions during his performances, see the *Ashton Weekly Reporter, and Stalybridge and Dukinfield Chronicle*, December 16, 1871 (BNA).

136. For notices of Brown as a ventriloquist, see the *Ashton Weekly Reporter, and Stalybridge and Dukinfield Chronicle*, September 17, 1870 (BNA); and *Rutland Daily Herald* (Vermont), April 1, 1880 (newspapers.com).

137. *Staffordshire Sentinel*, May 25, 1874 (BNA).

138. See *Leeds Times*, April 26, 1873 (BNA).

139. For the Rochdale performance, see the *Era*, February 7, 1875 (BNA). For Stockport, see the *Era*, March 7, 1865 (newspapers.com).

140. See the *Western Daily Press*, October 27, 1873, which reported that Box Brown attended a meeting in Cheltenham of the Liberal Working Men led by Mr. Freeman, and that Box Brown was one of his supporters (BNA). For the letter about regrating (rigging) of food prices, see the *Cardiff Times*, September 12, 1874 (BNA). For successful performances in 1874, see the *Era*, April 19, 1874 (newspapers.com); and *Staffordshire Sentinel*, May 1, 1874 (BNA). For continuing interest in Brown's role in the abolition movement in the 1870s, see the *Hastings and St. Leonard Observer*, March 3, 1877; and *Newcastle Courant*, May 30, 1879 (both in BNA).

141. Death Certificate, Agnes Jane Floyd Brown, Cheetham, obtained from the General Records Office in London. My thanks to Kenyatta Berry for locating this document.

142. Chater states that Mary Emma Martha Brown died from "marasmus," undernourishment caused by diarrhea; see *Henry Box Brown*, 178. She also states that John Floyd Brown died from bronchitis and convulsions at age seven months on June 2, 1872; see *Henry Box Brown*, 182. John Floyd Brown is listed in *Manchester, England, Births and Baptisms, 1813–1901* as having been born on October 28, 1871, to Henry Box Brown and Jane Brown. And John Floyd Brown is listed as dying in the *England and Wales Death Registration Index, 1837–2007*. See "John Floyd Brown" in *Manchester, England, Births and Baptisms, 1813–1901* (ancestry.com) and "John Floyd Brown" in *England and Wales Death Registration Index 1837–2007* (familysearch.com). For the year of Agnes's birth, I have used the *England and Wales Census of 1871* (familysearch.com), which lists the following as members of Box Brown's household: Henry Box Brown (head): male; 43; birthplace: Richmond, VA, United States; Jane Brown (wife): female; 36; birthplace: Perran, Cornwall; Agnes J. Brown (daughter): female; 10; birthplace: Stockport, Cheshire; Annie A. H. Brown (daughter): female; 1; birthplace: Manchester, Lancashire; and Susan Smith (servant): female; 21; birthplace: London, Surrey.

Chapter 5

1. See "Henry H. Brown" in *New York Passenger Lists, 1820–1891* (familysearch.com), https://www.familysearch.org/ark:/61903/1:1:QVSK-95GL.

2. For Brown's role in the Underground Railroad, see the *Hastings and St Leonard's Observer*, March 3, 1877 (BNA). For Brown being compared to Frederick Douglass, see the *Newcastle Courant*, May 30, 1879 (BNA). For Brown's running a tavern, see "Adjourned Licensing Sessions at Atherstone," the *Lichfield Mercury*, September 28, 1894 (BNA).

3. For Brown as part of an army that might invade the South, see the *Daily Exchange* (Baltimore) on May 16, 1861 (newspapers.com); there appears to be a confusion between Box Brown (who was in England still) and William Wells Brown (who was in the US). Coverage of the Leeds parade and unboxing was widespread in the US, in both the North and South; see, for example: *The Planters' Banner* (Franklin, LA), July 12, 1851; *Washington Telegraph* (Washington, AR), July 16, 1851; *Richmond Enquirer* (Richmond, VA), June 20, 1851; *Weekly Raleigh Register* (Raleigh, NC), June 25, 1851; *Portage Sentinel* (Ravenna, OH), July 7, 1851; *Sumter Banner* (Sumter, SC), July 16, 1851; *Buffalo Daily Republic* (Buffalo, NY), June 20, 1851; and *Newport Daily News* (Newport, RI), June 18, 1851 (all from newspapers.com). For a sample of the coverage of the Wolverhampton libel trial, see the *New England Farmer* (Boston), August 14, 1852, and *Dixon Telegraph* (Dixon, IL), August 28, 1852 (both in newspapers.com). The *Daily Delta* (New Orleans) on August 20, 1852, makes mention of the trial but also insults Brown in its racism and incredulity that he could earn excellent money performing (newspapers.com).

For coverage of Brown's acting, see the *Richmond Dispatch* (Richmond, VA), October 20, 1857 (newspapers.com), which notes that Brown, who escaped from Richmond in a box, "has been playing at Liverpool, and was quite successful." This is a reference to Brown's acting in *The Fugitive Free*, in which he directly mentions the names of several prominent Richmond-based individuals who had kept him enslaved and tormented his first wife, Nancy. For Brown as a hero, see the *Daily Dispatch*, June 9, 1870 (LOC). And for other mentions of Brown's escape-by-box, see the *Alton Weekly Telegraph*, May 26, 1859; *Burlington Free Press*, December 28, 1869; and *New Orleans Republican*, October 1, 1871 (all in newspapers.com).

4. William Still, *The Underground Rail Road* (Philadelphia: Porter and Coates, 1872), archive.org, 83–4.

5. Ibid., 83.

6. Jeffrey Ruggles, *The Unboxing of Henry Brown* (Richmond: Library of Virginia, 2003), 164.

7. See *Hartford Daily Courant*, June 15, 1872 (EAN); and *Christian Recorder*, April 14, 1881 (AAN).

8. Ruggles, *Unboxing*, 166.

9. See Andrew Ward, *Dark Midnight When I Rise: The Story of the Fisk Jubilee Singers* (New York: Amistad, 2001), 302.

10. Ruggles, *Unboxing*, 162.

11. *Spirit of the Times*, August 21, 1875: 41 (AHP).

12. *Lowell Daily Citizen and News*, October 23, 1875 (EAN).

13. *Boston Globe*, January 3, 1876 (newspapers.com).

14. A show by Brown is also listed in the *Salem Gazette* in 1875 (AHP), which was probably the same show referred to by the reviewer in the *Salem Register*.

15. *Portland Daily Press*, January 11, 1877 (EAN).

16. A performance was listed in *The Annual Report of the Selectmen and Overseers of the Poor of the Town of Bridgewater for the Year Ending Feb. 28, 1877* (AHP). This could be a show that occurred in 1876 in Bridgewater; however, no details are given.

17. *Oxford Democrat*, July 24, 1877 (LOC).

18. See *Bangor Daily Whig and Courier* (Bangor, ME), October 17, 1878 (19CN).

19. See *Argus and Patriot* (Montpelier, VT), September 5 and September 19, 1877 (newspapers.com).

20. *Religio-Philosophical Journal* 23, no. 9 (November 3, 1877): 6, iapsop.com/archive/materials/religio-philosophical_journal/rpj_nov_1877.pdf.

21. John Townsend Trowbridge, "The Wonderful Sack," *The Vagabonds and Other Poems* (Boston: Fields, 1869), 163–72, Google Books.

22. For a different interpretation of Annie's "wonderful sack feat," see Ruggles, who writes: "One imagines that this trick was a disappearance. Annie Brown would have stepped into a sack at the center of the stage. Professor Brown then pulled up the sack to cover her and tied the top. After suitable patter, Brown would have revealed the sack to be empty. Suddenly Annie Brown would have appeared at the back of the hall or walked onstage from the side" (*Unboxing*, 169). I cannot discount this interpretation, but only note that either way Annie (like Brown) would seem to have almost magical powers to transport herself via innovative means.

23. *Boston Globe*, May 31, 1878 (newspapers.com).

24. *Fitchburg Sentinel*, November 14, 1877 (newpapers.com).

25. See *Worcester Evening Gazette*, December 29, 1877, and January 1 and 2, 1878; quoted in Ruggles, *Unboxing*, 167 and 222. Also see *Portland Daily Press*, January 11, 1877 (EAN), where Brown is said to have his box onstage with him and illustrate the manner of his escape.

26. Ruggles, *Unboxing*, 159.

27. As reported in the *Worcester Evening Gazette*, Brown was onstage at Worcester's Washburn Hall for a full week, beginning on January 9, 1878. See Ruggles, *Unboxing*, 167

and 223. For the Rhode Island performance, see the playbill for Brown's show at Harris Hall, Woonsocket, February 8, 1878, Harry Houdini Papers, 21.22, https://sites.utexas .edu/ransomcentermagazine/2021/05/06/rare-ephemera-shows-legacy-of-henry-box -brown/.

28. W. J. T. Mitchell, *Picture Theory: Essays on Verbal and Visual Representation* (Chicago: University of Chicago Press, 1994), 202 and 200.

29. See *Portland Daily Press*, August 20, 1878 (LOC); and *Bangor Daily Whig and Courier*, October 17, 1878 (19CN).

30. *Essex County Herald*, December 5, 1879 (LOC).

31. See *Rutland Weekly Herald and Globe*, March 25, 1880; *Rutland Daily Herald*, April 1 and 2, 1880; and *Enterprise and Vermonter*, April 30, 1880 (all in newspapers.com).

32. *Argus and Patriot*, May 19, 1880 (EAN).

33. *Argus and Patriot*, May 26, 1880 (newspapers.com).

34. Various documents give conflicting reports of Brown's age, and Brown may not have known exactly how old he was. However, Brown contributed to this confusion by sometimes shaving many years off his age. See, for example, the *South Bucks Free Press, Wycombe and Maidenhead Journal*, April 15, 1859 (BNA), where Brown claims that he was "for twenty-one years a slave himself" (Brown was a slave until he was 34), as well as the 1860 Rugby edition of his narrative, which lists his birthdate as 1822 (earlier editions list his birthdate as 1815 or 1816). Also see the passenger manifest from the ship on which Brown arrived to the US in 1875 (note 1 of this chapter), which lists his age as 50. If born in 1815 or 1816, his age in 1875 would have been closer to 60.

35. For Brown as a candidate for aldermanic honors, see the *London Advertiser*, November 29, 1881 (POR). For Edward Brown's marriage, see the *Michigan Marriage Records 1857–1952* (ancestry.com).

36. In the proper name section of the directory, Victoria Dining Hall and Lunch Rooms is listed at 88 Dundas Street with "Prof. H. B. Brown" as the proprietor.

37. See *City of London and County of Middlesex Directory for 1883*, 19 and 49, https:// www.collectionscanada.gc.ca/obj/001075/f2/e010780540_p1.pdf.

38. See "MI Place: Cheboygan," Clarke Historical Library, Central Michigan University, https://www.cmich.edu/library/clarke/PublicPrograms/Current_Exhibit/Pages/MIPlace -Cheboygan.aspx.

39. *Northern Tribune*, February 25, 1882 (LOC).

40. See *Northern Tribune*, March 11, 1882 (LOC); this article refers to a decision reached "last Tuesday," and so likely references the February 25 performance.

41. Adrienne Shadd, *The Journey from Tollgate to Parkway: African Canadians in Hamilton* (Toronto: Dundurn Press, 2010), 190.

42. See *Weekly Expositor*, August 16, 1883 (LOC).

43. *Northern Tribune*, December 1, 1883 (LOC).

44. Edward Brown married Jane E. Price from Richmond, VA, on October 30, 1883. The marriage took place in Sault Ste. Marie, Chippewa, MI. Edward is listed on the marriage certificate as being born in about 1862 (in Bristol, England), but, as we have seen, his actual birthdate was 1864. Edward's race is listed as "A" (perhaps for African American). See *Michigan Marriage Records 1857–1952* (ancestry.com). It is fascinating that Jane Price (Edward's wife) is from Richmond. Did the Browns travel to Richmond at some point to seek out family members lost during the days of slavery? More research is needed on this topic.

45. *London* (Ontario) *Daily Advertiser*, July 19, 1881 (POR).

46. *Guelph Daily Mercury and Advertiser*, October 18, 1881 (Canadiana).

47. *Markdale Standard*, October 10, 1882 (ODW).

48. *London Advertiser*, November 16, 1882 (POR).

49. See, for example, an advertisement placed in a London newspaper for the treatment of these diseases by "Mr. Winter, author of 'Trichologia,'" *Field,* January 25, 1879 (BNA). In the US, developments in this subject were carefully studied; for example, an 1887 Michigan newspaper reports that "the Tricological society, of London, offers a gold medal and a diploma to that author of the best treatise on the various skin diseases that produce baldness." See *Alma Record* (Alma, MI), October 21, 1887 (LOC).

50. See Ria Willemsen, Johan Vanderlinden, Arlette Deconinck, and Diane Roseeuw, "Hypnotherapeutic Management of Alopecia Areata," *Journal of American Academic Dermatology* 55, no. 2 (2006): 233–7.

51. Scientists and others have studied the healing properties of mushrooms since antiquity; see Miriam de Roman, "The Contribution of Wild Fungi to Diet, Income and Health: A World Review," in *Progress in Mycology,* ed. Mahendra Rai and George Kövics (Jodhpur, India: Scientific Publishers, 2017 [2010]), 327–48.

52. See "Philters, Charms, and Poisons," in *The Druggists Circular and Chemical Gazette* 25 (November 1881): 174, Google Books.

53. Such reports are based on oral recollections and, unfortunately, unverified. But see Jim Haskins and Kathleen Benson, *Conjure Times: Black Magicians in America* (New York: Walker, 2001), 31.

54. For the Watford show, see the *Dutton Enterprise,* July 25, 1885; for Iona Sparks, see the *Dutton Enterprise,* October 2 and 9, 1884; for West Lorne, see the *Dutton Enterprise,* October 16, 1884; and for Comber, see the *Dutton Enterprise,* November 6, 1884 (all in Canadiana).

55. See *Daily British Whig,* April 30, May 3, and May 4, 1886 (DK).

56. *Brantford Evening Telegram* of February 27, 1889. Article reprinted in Angela Files, "Henry Box Brown: An Entertainer of African Culture," *Brant Historical Society Newsletter* 4, no. 4 (1997), 4 and 7. Courtesy Brant (Ontario) Historical Society. See also *Brantford Expositor,* February 25, 1889, which contains this notice of the upcoming performance: "Brown Family Jubilee Singers—These Jubilee Singers appear here on Tuesday evening in Wickliffe Hall. Endorsed by the clergy and press. 25 and 35 cents. Don't fail to see them." My thanks to Jeffrey Ruggles for this citation.

57. Gwen Bergner, "The Plantation, the Postplantation, and the Afterlives of Slavery," *American Literature* 91, no. 3 (2019): 447. Bergner is deploying Saidiya Hartman's discussion of slavery's afterlives; see *Lose Your Mother: A Journey Along the Atlantic Slave Route* (New York: Farrar, Straus and Giroux, 2007), 6. On the concept of a plantation complex that extends into our contemporary moment, also see Katherine McKittrick, "On Plantations, Prisons, and a Black Sense of Place," *Social & Cultural Geography* 12, no. 8 (2011): 947–63.

58. See "A Prosperous Colony of Former Southern Slaves," the *Chicago Tribune,* December 29, 1888, page 6, which is a reprint of a letter from Montreal first published in the *New York World* (newspapers.com) in which a "a relative of [Brown's] who resides on a farm in Hamilton" retells his story.

59. Known as RG 22-409, Equity civil suits case files, B274979: File #578-1 892: Brown vs Hospital; Description File #590-1892: Brown vs Hospital. Also see *Ontario Reports: Containing Reports of Cases Decided,* Vol. 23, 599–607 (Google Books) and *Globe* (Toronto), August 10, 1892 (Canadiana).

60. The 1900 census for Kane, McKean, Pennsylvania. 1900 United States Federal Census (ancestry.com).

61. "Cloudy at St. Lawrence," *Toronto World,* October 29, 1887 (Canadiana).

62. *Toronto World,* August 10, 1892 (Canadiana).

63. RG 22-409, Equity civil suits case files, B274979: File #578-1 892: Brown vs Hospital.

64. As reported in the *Toronto World* on January 19, 1893, a jury found Brown "guilty of contributory negligence and rendered a verdict in favor of the defendants" (Canadiana). Box

Brown's claim against TGH was covered in other newspapers; see, for example, the *Toronto Daily Mail*, August 10 and 18, 1892 (BNA); and *Globe* (Toronto), August 10, 1892 (obtained on microfilm at Toronto Public Library).

65. *Richmond Planet*, October 20, 1894 (newspapers.com).

66. For example, Brown's performance of his panorama of *Uncle Tom's Cabin* is described in an 1896 "forty years ago today" article in the *Brighton Gazette* on August 1, 1896 (BNA).

67. *Todmorden & District News*, November 28, 1890 (BNA).

68. See Theodore Raph, *The American Song Treasury: 100 Favorites* (New York: Dover, 1986 [1964]).

69. See, for example, the *Gloucestershire Echo*, June 25, 1890 (BNA), which lists "The Kentucky Minstrels" performing this song, among others.

70. *Pontypool Free Press* (Wales), March 20, 1896 (BNA).

71. For remembrances of Brown traveling around with and playing a piano in England, see the *Bournemouth Guardian*, March 3, 1894 (BNA).

72. For another possible performance, see the *Hants and Berks Gazette and Middlesex and Surrey Journal*, August 29, 1896 (BNA), describing a "Henry Brown" "efficiently presiding on the organ" for an anniversary of a Baptist Sunday School in Hampshire.

73. See *Canada Passenger Lists 1881–1922* (familysearch.com).

74. "A Prosperous Colony" (newspapers.com); see note 58 in this chapter.

75. I have contacted Historical Societies and Libraries in Hamilton to ascertain who these relatives were but have been unable to locate any additional information.

76. Martha J. Cutter, "Will the Real Henry 'Box' Brown Please Stand Up?" *Common-Place: The Journal of Early American Life* 16, no. 1 (2015), http://commonplace.online/article/will-the-real-henry-box-brown-please-stand-up/.

77. Ibid.

78. For references to Brown in the press and in books during the late-nineteenth into the twentieth century in the US, see the *New York Tribune*, February 3, 1883 (EAN); *Cincinnati Commercial Tribune*, October 31, 1885 (EAN); *Times* (Washington, DC), February 17, 1901 (LOC); *Baltimore Afro-American*, July 12, 1902 (PRO); Mifflin Wistar Gibbs, *Shadow and Light: An Autobiography with Reminiscences of the Last and Present Century* (Washington, DC: n.p., 1902), 13–4; *Omaha World-Herald* (published as *Morning World-Herald*), December 30, 1902 (EAN); *Times Dispatch* (Richmond, VA), September 29, 1911 (LOC); *Evening Star*, August 24, 1929; *Los Angeles Times*, September 22, 1929 (newspapers.com); *Oshkosh Northwestern*, July 9, 1936 (newspapers.com); *Chicago Defender*, June 4, 1938 (PRO); *Baltimore Afro-American*, August 4, 1951 (PRO); and *Capital Times*, February 17, 1972 (newspapers.com). Also see the *Jackson Advocate*, January 29, 1955, page 2, which has a drawing of Brown emerging from his box headed "Things You Should Know" (LOC). Brown also was not entirely forgotten in England. See H. M. Holbrook's recollection of a mesmeric show by Brown in which he made his subjects eat paste, the *Lowestoft Journal*, May 28, 1904 (BNA); and the extended reminiscences of Dr. Henry Watson of playing (when he was a boy) harmonium and pianoforte for Box Brown's shows and touring with him for many months in 1860, the *St. Helens Examiner*, January 29, 1910 (BNA). Also *St. Helens Examiner*, February 19, 1916; *Burnley Express*, September 12, 1925; and *Burnley Express*, May 14, 1932 (all from BNA).

79. The 1900 census for Kane, McKean, Pennsylvania (ancestry.com), lists Jane as having only one living child (not two), suggesting that Edward may have died sometime before this date. However, because there are mistakes about (for example) Jane's marital status and place of birth in this census, I do not consider this document definitive. Moreover, the 1910 census for Kane leaves the column for number of living children blank in relationship to Jane Brown, even though Annie was still alive.

80. 1900 census, Kane, McKean, Pennsylvania (ancestry.com).

81. See death certificate for Jane "Box" Brown, June 6, 1924. Pennsylvania Death Certificates, 1906–1963. Courtesy of Pennsylvania State Archives. Record Group 11, subgroup: Bureau of Health Statistics and Research; Death Certificates (Series #11.90). My thanks to Jeffrey Ruggles for locating this document.

82. See 1920 census, Kane, Ward 2, McKean, Pennsylvania (ancestry.com).

83. See *Pennsylvania, Marriages, 1852–1968* and *U.S. City Directories, 1822–1995* (both from ancestry.com).

84. See *Pennsylvania Death Certificates, 1906–1967*; Certificate Number Range: 054001-057000 (ancestry.com); and "Former Kane Girl Passes Away," *Kane Republican*, June 1, 1929 (newspapers.com).

85. See ancestry.com and Find a Grave: https://www.findagrave.com/memorial/14939051/manley-l.-jefferson.

86. See *1930* census, *Buffalo, Erie, New York* (ancestry.com).

87. See obituary of Annie [Brown] Jefferson in the *Kane Republican* (Kane, PA), April 13, 1971 (newspapers.com).

Chapter 6

1. For more on this museum's politics, see Marcus Wood, "Atlantic Slavery and Traumatic Representation in Museums: The National Great Blacks in Wax Museum as a Test Case," *Slavery and Abolition* 29, no. 2 (2008): 151–71.

2. See B. A. Parker, "627: Suitable for Children: Act Two: History Is Not a Toy," October 6, 2017, in *This American Life*, produced by WBEZ, podcast, https://www.thisamericanlife.org/627/suitable-for-children/act-two. About Box Brown, Parker says, "When I was kid, he'd pop out and wave his hand, but it scared too many kids." Huey Copeland writes, "the National Great Blacks in Wax Museum in Baltimore, Maryland . . . has since 1988 feature[d] an eerily animated effigy of Brown that emerges from and disappears into a larger postal crate marked 'Adams Express'" (*Bound to Appear: Art, Slavery, and the Site of Blackness in Multicultural America* [Chicago: University of Chicago Press, 2013], 145).

3. Alan Rice, *Creating Memorials, Building Identities: The Politics of Memory in the Black Atlantic* (Liverpool: Liverpool University Press, 2010), 51, 17, and 15.

4. For discussion of museums that attempt to depict slavery and its afterlives, see Christina Sharpe, *In the Wake: On Blackness and Being* (Durham: Duke University Press, 2016), 19–22 and 59–67.

5. Dionne Brand, *A Map to the Door of No Return: Notes to Belonging* (Toronto: Vintage Canada, 2001), 31.

6. See Marita Sturken, "The Wall, the Screen, and the Image: The Vietnam Veterans Memorial," *Representations* 35, no. 2 (1991): 122.

7. Toni Morrison, Melcher Book Award acceptance speech, *World*, January/February 1989, republished 2008, https://www.uuworld.org/articles/a-bench-by-road.

8. James E. Young, *At Memory's Edge: After-Images of the Holocaust in Contemporary Art and Architecture* (New Haven, CT: Yale University Press, 2000), 127.

9. Toni Morrison, *Beloved* (New York: Vintage, 1987), 274 and 248.

10. On guerilla memorialization, see Rice, *Creating Memorials*, 14–17 and 57.

11. Copeland, *Bound to Appear*, 146.

12. Ibid., 147. Alan Rice argues similarly that Williams's reworking of Box Brown's fugitivity offers an example of how one might break away from dominant ideas about limitations on Black freedom, while also acknowledging the barriers to doing so; see "Henry Box Brown, African Atlantic Artists and Radical Interventions," in *Visualising Slavery: Art Across the*

African Diaspora, ed. Celeste-Marie Bernier and Hannah Durkin (Liverpool: Liverpool University Press, 2016), 111.

13. Daphne Brooks, *Bodies in Dissent: Spectacular Performances of Race and Freedom, 1850–1910* (Durham: Duke University Press, 2006), 120.

14. Sharpe, *In the Wake*, 21–2.

15. Rice, "Henry Box Brown," 109.

16. Morrison, *Beloved*, 210.

17. Moira Roth and Portia Cobb, "An Interview with Pat Ward Williams," *Afterimage* 16 (1989): 17.

18. Jacques Derrida, *Archive Fever: A Freudian Impression*, trans. Eric Prenowitz (Chicago: University of Chicago Press, 1998 [1995]), 36.

19. *To Disembark* by Glenn Ligon, 1993, Sheldan Collins/Whitney Museum of American Art. Also ran at the Smithsonian Hirshhorn from November 11, 1993, to February 20, 1994; see http://www.glennligonstudio.com/to-disembark.

20. Glenn Ligon, "Glenn Ligon Reframes History in the Art of 'America,'" interview by Liane Hansen, *NPR*, May 8, 2011, https://www.npr.org/2011/05/08/136022514/glenn-ligon -reframes-history-in-the-art-of-america.

21. Saidiya Hartman, "Will Answer to the Name Glenn," in *Glenn Ligon: AMERICA*, ed. Scott Rothkopf (New Haven, CT: Yale University Press, 2011), 113.

22. Ibid., 112.

23. See http://www.glennligonstudio.com/to-disembark.

24. Copeland, *Bound to Appear*, 116.

25. Sharpe, *In the Wake*, 73.

26. Ligon, "Glenn Ligon Reframes."

27. Christina Knight, "Disembarking: Christina Knight on 'Glenn Ligon: America,'" interview by Alex Freedman, *Art21 Magazine*, April 14, 2011, http://blog.art21.org/2011/04/14 /disembarking-christina-knight-on-glenn-ligon-america/#.V8TacRRZHgU. Also see Knight, "Performing Passage: Contemporary Artists Stage the Slave Trade" (PhD diss., Harvard University, 2013).

28. Rice, "Henry Box Brown," 112.

29. Knight, "Disembarking."

30. From brochure printed for the exhibit, "Glenn Ligon: To Disembark" (Washington, DC: HMSG, 1993), unpaginated.

31. Hartman, "Will Answer," 112; Copeland, *Bound to Appear*, 117.

32. Anne Anlin Cheng, *Second Skin: Josephine Baker and the Modern Surface* (New York: Oxford University Press, 2013), 66.

33. Hannah McShea, "Wilmer Wilson IV and the Body Surface: Intersubjectivity and a Call to Decenter the Decentered," *Exposé Magazine* 2015, https://projects.iq.harvard.edu/expose /book/wilmer-wilson-iv-and-body-surface-intersubjectivity-and-call-decenter-decentered.

34. For the book, see *Henry "Box" Brown: Forever, a Narrative*, by Wilmer Wilson IV, Laura Roulet, and Jessica Bell (2013), https://issuu.com/connersmith/docs/connersmith_wilsoniv _hbbforever. For the film, see http://films4peace.com/artist/wilmer_wilson.html.

35. Wilmer Wilson IV's piece *Henry "Box" Brown: Forever* was commissioned by the DC Commission on the Arts and Humanities (DCCAH) as part of a 2012 temporary public art project.

36. Jessica Bell, "Docility and Disappearance: Wilmer Wilson's Fantastical Self," in *Henry "Box" Brown: Forever*, 112, https://issuu.com/connersmith/docs/connersmith_wilsoniv _hbbforever.

37. See, for example, Solomon Northup, *Twelve Years A Slave* (Auburn: Derby, 1853), 64; *Documenting the American South*, https://docsouth.unc.edu/fpn/northup/northup.html.

38. Wilson, essay in *Henry "Box" Brown: Forever*, 94, https://issuu.com/connersmith/docs/connersmith_wilsoniv_hbbforever.

39. Brand, *Map to the Door*, 35 and 36.

40. Laura Roulet, "Henry 'Box' Brown Forever: A Narrative," in *Henry "Box" Brown: Forever*, 101, 102, and 104, https://issuu.com/connersmith/docs/connersmith_wilsoniv_hbbforever.

41. For more on this idea, see Amelia Jones, *Body Art/Performing the Subject* (Minneapolis: University of Minnesota Press, 1998).

42. Wilson, essay in *Henry "Box" Brown*, 95.

43. Wilmer Wilson IV, "Necessity is the Placeholder of Freedom," *Philadelphia Contemporary*, 2020, https://www.philadelphiacontemporary.org/wilmer-wilson-iv.

44. Brand, *Map to the Door*, 5.

Chapter 7

1. Frederick Douglass, *My Bondage and My Freedom* (New York: Miller, 1855), 323, *Documenting the American South*, https://docsouth.unc.edu/neh/douglass55/douglass55.html.

2. Ta-Nehisi Coates, *The Water Dancer* (New York: One World, 2019), 255. Other contemporary novelists who glance at the Henry Box Brown story include Colson Whitehead in *The Underground Railroad* (2016) and Ben Winters in *Underground Airlines* (2016). Also see Doug Peterson's highly fictionalized novel, *The Disappearing Man* (2011).

3. See Jeanne Scheper, *Moving Performances: Divas, Iconicity, and Remembering the Modern Stage* (New Brunswick, NJ: Rutgers University Press, 2016), 13.

4. Wendy W. Walters, *Archives of the Black Atlantic: Reading Between Literature and History* (New York: Routledge, 2013), 5.

5. Ellen Levine and Kadir Nelson, *Henry's Freedom Box: A True Story from the Underground Railroad* (New York: Scholastic Press, 2007); Sally M. Walker and Sean Qualls, *Freedom Song: The Story of Henry "Box" Brown* (New York: HarperCollins, 2012); Carole Boston Weatherford and Michele Wood, *BOX: Henry Brown Mails Himself to Freedom* (Somerville, MA: Candlewick, 2020). I have found no secondary criticism on any of these works.

6. See Ann Preston, *Cousin Ann's Stories for Children* (Philadelphia: Merrihew and Thompson, 1849), 22–6, https://dmr.bsu.edu/digital/collection/chapbks/id/383.

7. Catherine Threadgill, review of *Henry's Freedom Box: A True Story*, *School Library Journal* 53, no. 3 (2007): 176.

8. Donald Kent Philpot, "Character Focalization in Four Children's Novels: A Stylistic Inquiry" (PhD diss., University of British Columbia, 2010), https://doi.org/10.14288/1.0071492.

9. There are no page numbers in any of the children's books I discuss in this chapter.

10. See reviews by Olu and Brittany on Amazon, https://www.amazon.com/product-reviews/B01A60Y9L4/ref=acr_dp_hist_1?ie=UTF8&filterByStar=one_star&reviewerType=all_reviews#reviews-filter-bar.

11. See review by anon on Amazon, https://www.amazon.com/product-reviews/006058310X/ref=acr_dp_hist_3?ie=UTF8&filterByStar=three_star&reviewerType=all_reviews#reviews-filter-bar.

12. Paratextual elements include a timeline that inserts Brown's story back into antislavery history through references to individuals who revolted against slavery or neo-slavery such as Denmark Vesey (1822), Nat Turner (1831), the Amistad captives (1839), Harriet Tubman (1849), Dred Scott (1857), John Brown (1859) and Homer Plessy (1896).

13. Elizabeth Alexander, *Body of Life* (Los Angeles: Tia Chucha Press, 1996), 35 and 64.

14. Ibid., 23.

15. Ibid., 24.

16. Ibid.

17. Ibid.

18. Ibid., 23.

19. Joshua Bennett, *The Sobbing School* (New York: Penguin, 2016), 47.

20. Ibid., 1. All references to Bennett's poem about Box Brown are from this page.

21. To date, I have found no scholarly discussions of Tyehimba Jess's recreation of Box Brown in *Olio*. However, my thinking about *Olio* is indebted to Emily Ruth Rutter's "The Creative Recuperation of 'Blind Tom' Wiggins in Tyehimba Jess's *Olio* and Jeffery Renard Allen's *Song of the Shank*," *MELUS* 44, no. 3 (2019): 175–96; and Brian Reed's "Defying Gravity: Tyehimba Jess's Syncopated Sonnets," *Foreign Literature Studies* 41, no. 6 (2019): 27–42.

22. Tyehimba Jess, "An Interview with Tyehimba Jess," interviewed by Anne Rasmussen, *Frontier Poetry*, April 21, 2017, https://www.frontierpoetry.com/2017/04/21/interview-tyehimba-jess/.

23. Diana Taylor, *The Archive and the Repertoire: Performing Cultural Memory in the Americas* (Durham, NC: Duke University Press, 2003).

24. Tyehimba Jess, *Olio* (New York: Wave Press, 2016), 222.

25. Ibid., 217.

26. Reed, "Defying Gravity," 37.

27. Tyehimba Jess, "Interview with NBCC Poetry Finalist Tyehimba Jess," interviewed by Wynne Kontos, *New School Creative Writing*, March 6, 2017, https://newschoolwriting.org/interview-with-nbcc-poetry-finalist-tyehimba-jess/.

28. John Berryman, *Dream Songs* (New York: Farrar, Straus & Giroux, 1969), xxx.

29. Kevin Young, "On Form," *Poetry Society of America* (originally published in *Crossroads*, fall 1999), https://poetrysociety.org/features/on-poetry/on-form-kevin-young.

30. Jess, *Olio*, 71.

31. Ibid., 69.

32. Ibid., 73.

33. Ibid.

34. Ibid.

35. Ibid., 77.

36. Ibid., 78.

37. Ibid., 218.

38. Ibid., 219.

39. Ibid., 84.

40. Ibid., 85.

41. Berryman, *Dream Songs*, 3.

42. Jess, *Olio*, 85.

43. Berryman, *Dream Songs*, 3.

44. Anthony Reed, *Freedom Time: The Poetics and Politics of Black Experimental Writing* (Baltimore: Johns Hopkins University Press, 2014), 18.

Coda

1. Dana Aklilu, "*Boxed*: A Testament to the Power of Both Perspective and its Format," *Film Inquiry*, November 13, 2019, https://www.filminquiry.com/boxed-short-review.

2. Jessica Bell, "Docility and Disappearance: Wilmer Wilson's Fantastical Self," in *Henry "Box" Brown: Forever, A Narrative* (2013), by Wilmer Wilson IV, Laura Roulet, and Jessica Bell, 109, https://issuu.com/connersmith/docs/connersmith_wilsoniv_hbbforever.

3. Christina Sharpe, *In the Wake: On Blackness and Being* (Durham: Duke University Press, 2016), 12.

4. As Chappelle has noted, at the taping of the "Black Pixies" skit a white man laughed particularly loud and long, and Chappelle worried that his show had gone from sending up stereotypes to reinforcing them. See Amos Barshad, "On the Skit That 'Killed' *Chappelle's Show*," *Fader*, July 29, 2016, https://www.thefader.com/2016/07/29/skit-that-killed-chappelles -show.

5. See the "Time Haters" skit concerning slavery: https://www.youtube.com/watch?v =iLsvH7_EF34.

6. Beatty's book *The Sellout* was turned down by eighteen different publishers, in part because of its humorous treatment of slavery and neo-slavery; see Paul Beatty, "Turned Down 18 Times. Then Paul Beatty Won the Booker . . ." interview by Charlotte Higgins, February 22, 2018, *Guardian*, https://www.theguardian.com/books/2016/oct/26/man-booker -prize-winner-paul-beatty-the-sellout-interview. For one critique of Quentin Tarantino's *Django Unchained* in part because of its humor, see Cecil Brown, "Hollywood's Nigger Joke," *CounterPunch*, January 1, 2013, https://www.counterpunch.org/2013/01/01/hollywoods-nigger -joke/; to be sure, critics have condemned this film for a variety of other reasons. For an evaluation of McBride's novel as not serious, see Justin Cartwright, "*The Good Lord Bird*, by James McBride," review, *Spectator*, January 25, 2014, https://www.spectator.co.uk/article/the -good-lord-bird-by-james-mcbride—review. In the case of McBride's novel, reviews were largely positive overall.

7. See Frank B. Wilderson III, *Afropessimism* (New York: Liveright, 2020).

8. Isabel Wilkerson, *Caste: The Origins of Our Discontents* (New York: Random House, 2020).

9. See alternate ending to *Get Out*, https://www.youtube.com/watch?v=A3JS7_OcPWQ.

10. Sharpe, *In the Wake*, 13–4.

11. Jacques Derrida, *Archive Fever: A Freudian Impression*, trans. Eric Prenowitz (Chicago: University of Chicago Press, 1998 [1995]), 36.

12. Tyehimba Jess, *Olio* (New York: Wave Press, 2016), 222.

Index

Figures and tables are indicated by page numbers followed by fig. and tab. respectively.

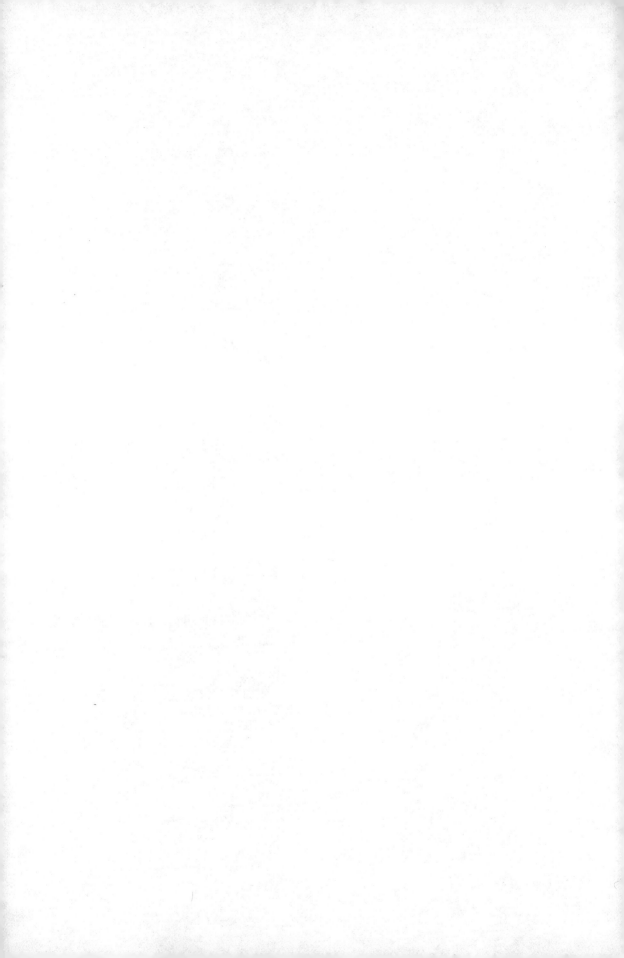